D0566219

JOHN BLAKE

FLIGHT
The Five Ages of Aviation

JOHN BLAKE

FLIGHT
The Five Ages of Aviation

ILLUSTRATED BY MEMBERS OF THE GUILD
OF AVIATION ARTISTS

Foreword by HRH The Duke of York

Introduction by Frank Wootton
PRESIDENT OF THE GUILD OF AVIATION ARTISTS

MAGNA BOOKS

A FOULIS Aviation Book

First published 1987

© BLA Publishing Ltd
© Text John Blake

All rights reserved. No part of this book may be
reproduced or transmitted in any form or by any
means, electronic or mechanical, including photo-
copying, recording or by any information storage or
retrieval system, without permission of the publisher.

This edition published 1991 by
Magna Books, Magna Road, Wigston,
Leicester LE9 2ZH, England.
Produced by the Promotional Reprint
Company Limited

ISBN 1-85422-221-X

Designed and produced by BLA Publishing Limited,
East Grinstead, Sussex, England.
A member of the **Ling Kee Group**
LONDON HONG KONG TAIPEI SINGAPORE NEW YORK

Colour origination by Waterden Reproductions Limited
Printed in Hong Kong

Contents

Foreword BY HRH THE DUKE OF YORK *page* 7

Author's note 9

Acknowledgements 10

Introduction BY FRANK WOOTTON, PRESIDENT OF THE GUiLD
 OF AVIATION ARTISTS 11

Period one: the heroic age 13

Period two: World War I, 1914–1918 24

Period three: the uneasy peace, 1919–1939 34

Period four: World War II 64

Period five: 1946 to the present day 96

Biographies of the artists 131

Index 147

BUCKINGHAM PALACE

 I am a photographer, not an artist; despite my profession, I am not even very much of an aviation photographer. Flying a helicopter does not give enough hands free time to take many pictures. However, looking at the paintings which have been selected for this book, it is clear that the paint brush frequently has a more than evocative quality than the camera ever could. These pictures recall, not just for those who were there, but also for those of us who were born long after many of the events illustrated, the unique character and atmosphere of the occasion they represent.

 I have much enjoyed the material contained in this book and hope that those who have the book in their hands will feel the same.

Andrew

1987

Dedication

Dedicated to Sir George Edwards OM, CBE, FRS,
Patron of the Guild of Aviation Artists since
its inception in 1971, with gratitude for his
unfailing support and interest in our activities.

Author's note

THIS BOOK came together as a result of a number of different factors, although at times the author was more inclined to think of them as constraints, and these have inevitably shaped the result. The intention from the first was to illustrate the work of every single Full Member of the Guild of Aviation Artists and as many Associate Members as could be accommodated within the space available. This has been done and in consequence the paintings illustrate a very wide spectrum of aviation subjects, and give a most comprehensive picture of the ability and style of the fifty-five artists whose work is represented.

In the selection of paintings for inclusion in the book the objective has been to use only work that has never previously been published and to avoid repetition of subject. With very few exceptions this has been done. While the decision not to have every second picture a Spitfire or a Mustang has meant abandoning the use of a number of excellent paintings, it has enabled us to present a retrospective exhibition of aeronautical art absolutely unique in its scope and content.

In the same way, the author has chosen to make a very personal selection in the historical narrative and has concentrated upon those aspects of each period that seem to him to be of general interest or to be worthy of more detailed treatment than they usually receive in the standard histories.

The captions to each painting have been given considerable attention, in order to extend the narrative into closer detail. If the comment upon the artistic merit of a painting or upon the particular style of an artist is conspicuous by its absence, it is only partly because the limitations of the subject seem to breed a certain similarity of approach among aviation painters. It is much more because the author finds the jargon of artistic criticism, like that of wine and food, beyond his simple soul to express.

Acknowledgements

ALTHOUGH it is not possible to list every person and every source of reference that has contributed to this short history of aviation, there are certain persons and organizations that must be mentioned. Foremost among these are the artists who contributed works, the Secretary of the Guild, Mrs Yvonne Bonham (who did all the dull administrative bits), and Mrs Valentine Vanstone, who was responsible for collating the biographies.

Organizations outside the Guild that I would particularly thank for permission to use works in their copyright or possession include the Royal Engineers, the Royal Air Force Club, the Fleet Air Arm Museum, and Messrs Solomon and Whitehead. A.C. Cooper Limited, fine art photographers, have been of great assistance in providing colour work.

While the author would like to record every one of the many sources he has consulted, space, as they say, does not permit. However, he would wish to acknowledge his debt in particular to Chris Chant's *Air Forces of World War I and World War II*, published by Galley Press; *Histoire de l'Aviation Militaire Française*, published by Lavauzelle (various authors); *The Soviet Air Force* by Alexander Boyd, published by Macdonald and Janes; and that admirable work, recently reprinted, *The Rise and Fall of the German Air Force*, published originally for the Air Ministry by what was then His Majesty's Stationery Office.

With this truncated list of sources, dear reader, I fear you must rest content.

Introduction

THIS BOOK will surely afford a great deal of pleasure to those interested in aviation. Since man achieved the conquest of the air – often at the cost of life and limb – through the centuries with a variety of aeronautical devices from balloons in 1783, powered aeroplanes in 1903, and rockets since 1961, there were some recognizing a new dimension and who felt a romantic affiliation with these remarkable men striving to fly in their astonishing and elaborate machines.

Their earliest achievements were recorded by artists using engravings for reproduction in those days before the camera took over. With the successful employment of photography, it is not surprising that artists relinquished their efforts and turned their art to more traditional forms of transport.

Nevertheless, the creative faculties of more adventurous artists were inspired by the third dimension in space. It was one thing to paint a conventional and traditional sky and compose it around a landscape, but far more of a challenge to become airborne and, with sympathetic curiosity, create something never before attempted. The few imbued with a crusading attitude towards the direction their art should follow sought to convey their particular emotion, delighting in the inspiration of this new element with its broader perspective. At the same time they recognized its significance and impact on world affairs.

Unfortunately, this third dimension in travel was not available to artists such as J.M.W. Turner, Claude Monet and Camille Pissarro, although they were inspired to paint the forms of transport of their day, namely ships and trains. Sir John Lavery made occasional ventures into the flying theme, but all too few.

Not surprisingly, World War I attracted many artists, some of whom saw active service, others being commissioned by the War Artists Advisory Council to portray the work of the Services. From the works collected in museums and recorded in books, it is apparent that, faced with the considerable hardship of working under difficult conditions, very few took to the air; most simply looked for an extension of their work in portraiture or figure composition. Admirable as they turned out to be as a furtherance of their own artistic development, historians must regret the conspicuous lack of examples of World War I aviation. Doubtless this could be explained away as proportionate to the distinguished past attached to the army and navy.

Between 1918 and 1940, the Royal Air Force was not only fighting politically for its independent existence, but also exercising peaceful control in the Middle East and on the North West Frontier. By 1940, after the depression of Dunkirk, the junior service was in the forefront of the battle, fighting alone in Western Europe, and was to hold that superior position until D-Day 1944.

It was during this period that the Royal Air Force looked to the War Artists Advisory Committee to make its role known to the general public. Not altogether happy with those allotted by this body, the RAF sought to employ artists within its own ranks. From that time, more realistic and technically correct paintings, having a greater affinity with the RAF, began to appear. For some time after the war, such paintings were in constant demand, both as records and for reconstruction of episodes found by historians to be inadequately covered during the heat of battle. At the same time, civil aviation and private flying claimed the interest of those who were devoted to that form of travel.

In 1954, a Society of Aviation Artists was formed by a handful of artists with the support of a number of Marshals of the Royal Air Force and heads of the aviation industry. The first exhibition of their work was held at the Guildhall, London in that year, by kind permission of the Corporation of London. One hundred and forty-eight paintings were shown, creating great interest in this new aspect of art. There followed a period

when the Society lost a number of its members and it almost stalled into oblivion. However, it regrouped under the banner of The Guild of Aviation Artists, created in 1971, which has gone from strength to strength.

It was to be the first of its kind in the world. Other countries have seen the work of the Guild and have been inspired to form their own groups of aviation artists. Canada and America are forming their own societies of aviation-minded artists. Holland too has its Club van Nederlandse Luchtvaart-schilders, thus pointing to the growing interest in aviation art.

This book, hopefully, will also contribute and continue to inspire further interest in the fascinating art of painting aircraft.

Frank Wootton

PRESIDENT, GUILD OF AVIATION ARTISTS

Period one: the heroic age

Where you start a history of aviation is largely a matter of personal choice. There are several thousand years of legend and a few hundred years of monotonous failure to choose from; failure either to grasp the fundamentals or smooth out the landing. Every now and then, however, someone would turn up a scientific fact to advance the solution to mechanical flight.

The first sound engineering drawings for the aeroplane, the helicopter and the parachute emerged from the notebooks of Leonardo da Vinci in the fifteenth century. They caused no stir at the time and apart from a brief follow-up on the parachute by Veranzio, led to nothing. Leonardo, himself, explored man-powered flight, which was the only power then available, but evidently found it unpractical.

In 1680 the relationships between lift, thrust and drag were published by Borelli in *De Motu Animalium* in a perceptive and detailed observation of the flight of birds. (Did you know that birds sleep with their heads under their wings to keep their centre of gravity over their feet so as not to fall off the branch?)

Sir George Cayley published the results of experiments in aeronautics that took place between 1792 and 1817 in a paper, 'On Aerial Navigation'. In it he sketched out a modern-looking tractor monoplane, described the advantages of a cambered wing, explored the problems of stability and the significance of the movement of the centre of pressure of a wing. He designed a helicopter and two successful gliders and investigated the problem of engines, rejecting steam for its unsatisfactory power/weight ratio and suggesting research into air, gas and electric motors. Rightly, he is regarded as the father of aviation.

He was only ten years old when the first manned balloon was launched but the event influenced him greatly. Although he had no time for spherical balloons he declared that the elongated dirigible airship would be the first practical air vehicle and backed the statement with a visionary design.

The theory of the balloon took shape with the discovery of hydrogen, known to be lighter than air. Tiberius Cavallo, in 1781, investigated a globe large enough to lift a man's weight but failed to find a gas-proof fabric for its manufacture. The brothers Etienne and Joseph Montgolfier, paper-makers of Annonay in France and students of the physical sciences, had been following this and observed that hot air, which also rises, did not leak through paper. Stealing a march on the 'scientific' party, they produced the first successful flying machine in the world.

Unmanned trials were followed by the ascent of a duck, a sheep and a cockerel. After a successful landing the cock, seen to be looking a touch thoughtful about the whole thing, was suspected of suffering from altitude sickness, but it turned out that the sheep had trodden on him. On 21 November 1783, the Marquis d'Arlandes (passenger) and François Pilâtre de Rozier (pilot) took off from the Château de la Muette in Paris in a 'Montgolfière', to become the first men to travel through the air. The 'scientifics', were not far behind; on 1 December Professor J.A.C. Charles and his passenger, Professor Robert, made the first ascent in a hydrogen balloon from the Tuileries (from which event the gas balloons became known as 'Charlières').

The following year the first ascents in Britain were made by (respectively) a Scotsman, an Italian and an Englishman and on 7 January 1785, Jean Pierre Blanchard of France and Dr John J. Jeffries of the United States crossed the English Channel from Dover. Eight years later, on 9 January 1793, Blanchard made the first ascent in America, from Philadelphia.

The thoroughly dangerous Montgolfière, bearing aloft in its fire basket the seeds of its own destruction, soon vanished from the scene, all too often quite literally, to be reborn 170 years later with the advent of the propane bottle, but the Charlière flourished. Once the initial scientific and social interest died down, however, it tended to become a showman's slightly erratic entertainment until the mid-nineteenth century. The Victorian thirst for scientific knowledge and exploration led to many highly respectable voyages. Salomon Andrée set out from Spitzbergen in July 1897, accompanied by two scientists, to fly over the North Pole. The silence that followed their departure was broken with the discovery of the balloon on White Island, well short of their goal, in 1930. Photographic plates, preserved for thirty-three years in the cold, yielded perfect prints.

Two English scientists, Henry Coxwell and James Glaisher, reached a reputed 22000 feet (5700 metres) nearly killing themselves in the process and in 1900 the Comte de la Vaulx covered a record 1196 miles (1925 kilometres) in a straight line, raised – or stretched – in 1913 to 1896 miles (3052 kilometres). All balloon records (fairly obviously) were in a straight line, where later aeroplane distance records were initially over a closed circuit. Given the prevailing European winds, it is not surprising that most long balloon flights finished in Russia.

Balloons went to war early. Captain Coutelle of the French Republican Army became the first military aviator, in an observation balloon at the battle of Fleurus in 1794. On a subsequent occasion, the same balloon was sufficient nuisance to cause the Austrians to invent the anti-aircraft gun.

The Union army took a Balloon Corps into action with General McClellan's Army of the Potomac in 1861; the balloons appeared again at the crossing of the Rappahannock and at the battles of Fair Oak and Chancellorsville. An early scientific experiment was the first wireless transmission from a balloon by Thaddeus Lowe while on observation duties in 1861.

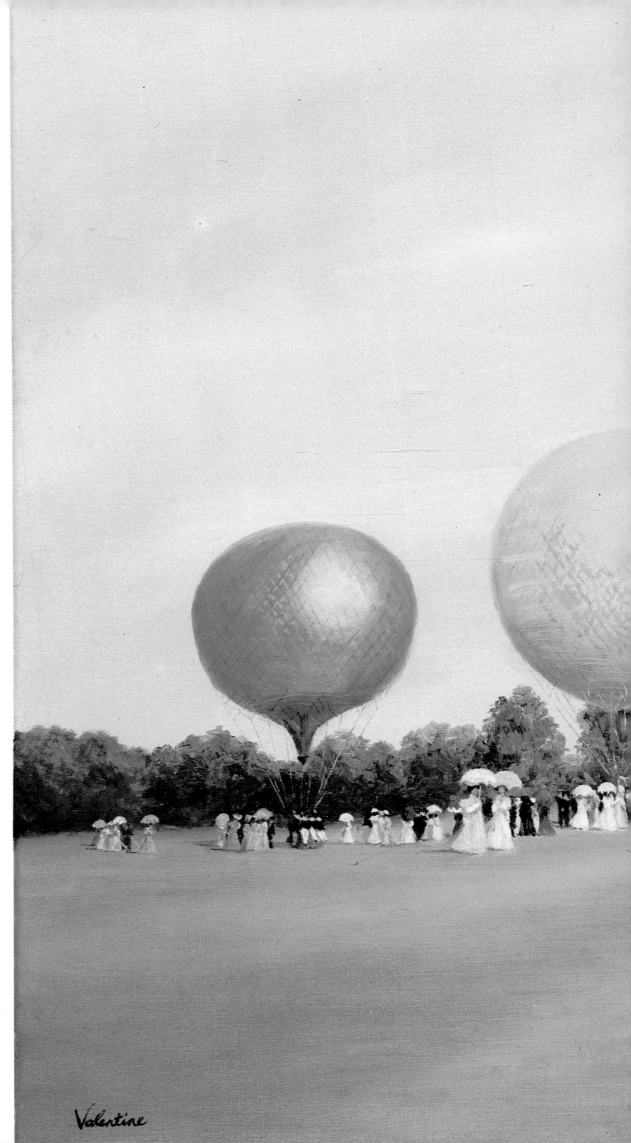

Rolls' Rise from Ranelagh
VALENTINE VANSTONE GAvA
A balloon meet of 1906.

A typical Edwardian balloon meet. Ballooning, cycling and motoring saw the entry of women into a hitherto exclusively male world. *Enchantress* belonged to the Hon. Charles Rolls (of Rolls-Royce fame), tragically killed on a modified Wright Flyer in 1910. He had a single-seat balloon, *Imp*, that lived on the luggage grid of his Silver Ghost.

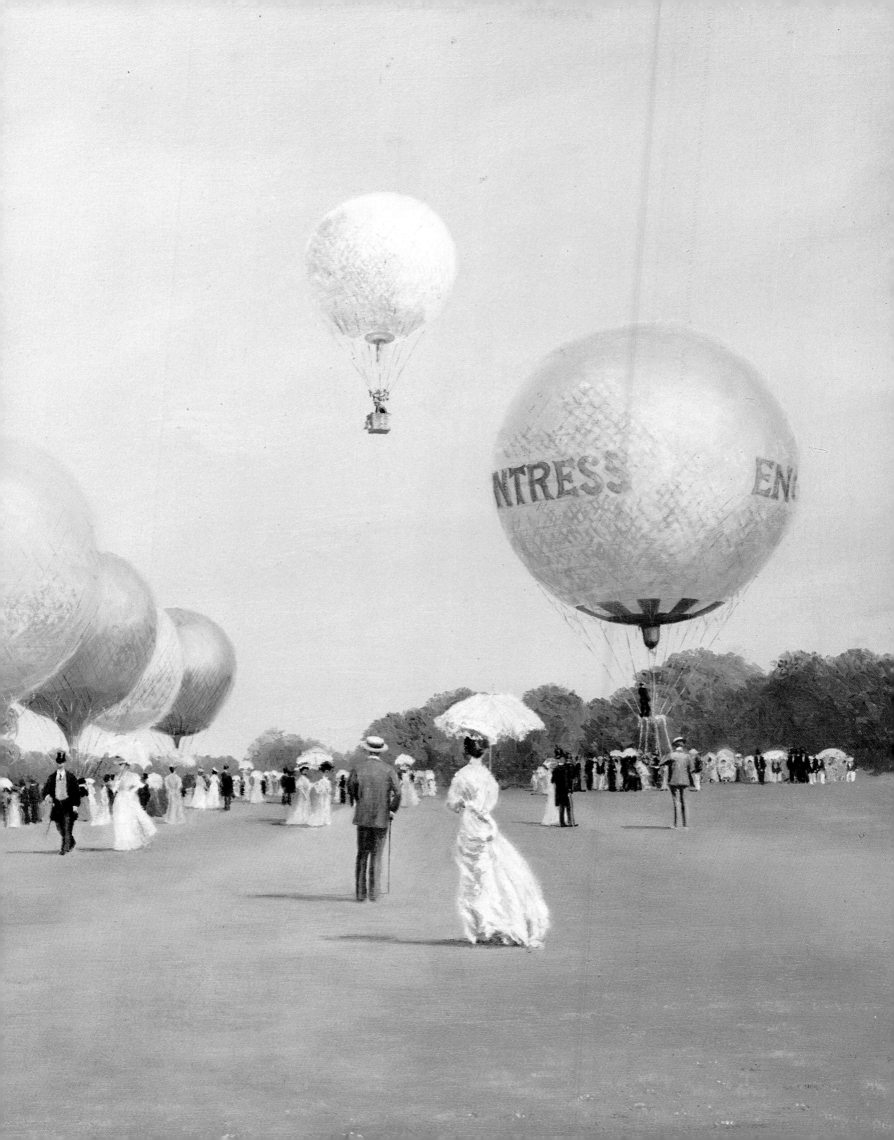

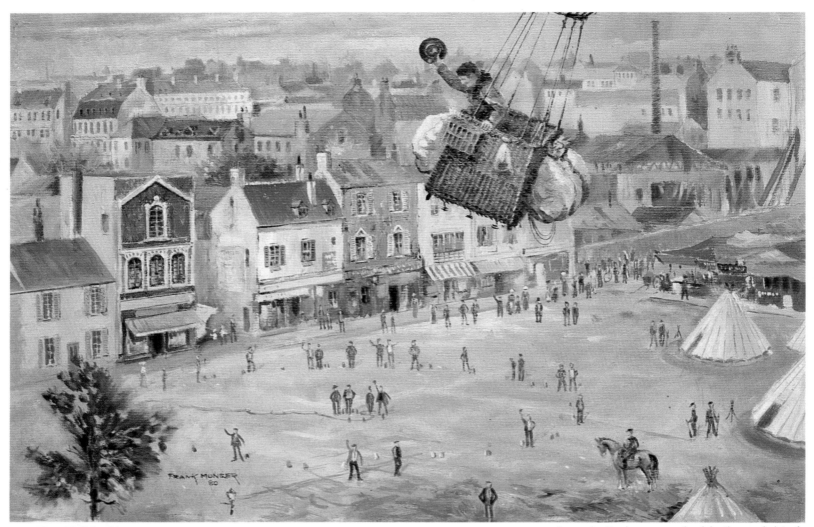

The First Mail by Air FRANK MUNGER GAvA
The siege of Paris, 1870-71.

The first of sixty-six balloons, largely built on the spot, left Paris to cross the Prussian lines on the fifth day of the siege, 22 September 1870, carrying 250 pounds (113 kilograms) of mail. During the four-month siege only six fell in enemy lines. Frank Munger is an artist who produces both watercolours and watercolour drawings of great delicacy. His training as a technical artist on cutaway drawings has given him a strict regard for truth and lightness of touch, qualities much to be admired in the genre.

Balloons played a part in the siege of Paris between September 1870 and January 1871. In sixty-six ascents from the encircled city, 102 passengers escaped and three million letters were carried. A return service of micro-filmed letters was carried by pigeons taken out in the balloons.

In 1905, at the siege of Port Arthur in the Russo-Japanese war, both sides employed balloons, the Russians introducing the elongated and more stable kite balloon.

The first successful airship appeared in 1852 in France, designed by Henri Giffard. It was a steam-driven semi-rigid, with a long keel to distribute suspension loads. Early small airships could rely on internal gas pressure to maintain envelope stiffness, but with the larger gasbags needed to lift the ponderous steam engines of the day, external stiffening was required.

The airship, at this time and for some time to come, enjoyed a great advantage over an aircraft. While the large static lift required for powered flight was largely a function of size, and the whole assembly and its control fairly unsophisticated, the achievement of even moderate dynamic lift from the first aircraft was a matter of considerable difficulty and required great skill. For this reason , the airship was to dominate the sky for sixty-five years.

Giffard's engine, with an hour's fuel and water, weighed 462 pounds (210 kilograms) and even with a top speed of only 7 mph (11 km/h) the ship was steerable in light winds. Much more successful was the electric powered design of the Tissandier brothers. The engine of their non-rigid airship gave one-third of a horsepower, but the batteries weighed 496 pounds (225 kilograms). Another successful design was Renard and Krebs' *La France*, whose batteries were double the weight of the Tissandier batteries, but which contained all the design features of future ships. On 9 August 1884, the year in which both these airships were built, *La France* accomplished the first out-and-back, circular flight.

Still in France, for some time the leading aeronautical power, the Lebaudy brothers, wealthy sugar refiners, who took to aviation in 1899, built their first airship in 1902. *Le Jaune* was the most efficient craft yet produced and stimulated military interest. Once adopted as a war machine, a thriving domestic and export business built up for the Lebaudys and other French constructors.

In Germany, Ferdinand Graf Zeppelin founded an airship company in 1898. His interest in the air came from a balloon ascent in the United States of America in 1861 and now he commenced the first of a huge family of rigid airships. Unlike everyone else, he enclosed the lifting gasbags in a long tubular skeleton of aluminium enabling his ships to grow to quite remarkable sizes and generate the lift for more motors and increased fuel – and, a little later, bombs.

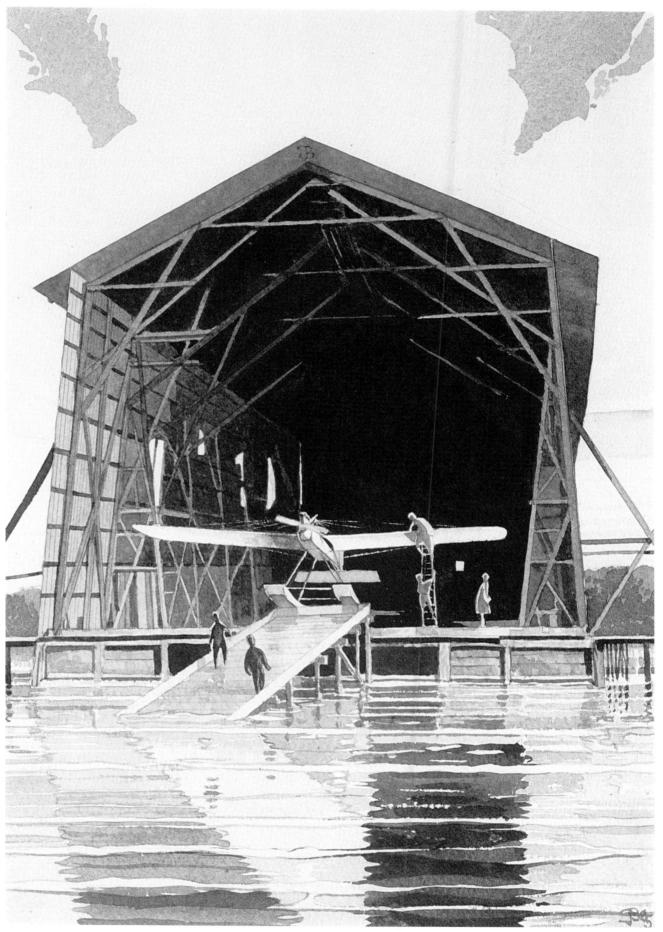

Preflight Inspection
JOHN BLAKE GAvA
Friedrichshafen FF 8 (Argus,
65 hp engine) flown by
Kohnert in the Bodensee
Wettbewerb, 1913.

The original hangars on the
shore of the Bodensee soon
became inadequate for the
ever-larger Zeppelins being
built at Friedrichshafen and by
1911-1912 were being used to
house seaplanes. The picture
has been built up with a series
of flat washes, over a careful
pencil drawing, sea and sky
kept flat and without
perspective so that the only
recession concentrates
attention on the hangar.

Already an elderly man, he struggled against structural and financial disaster in the early years, but the German people saw his imposing great ships as a symbol of their new Imperial power and gave him unstinted support. By 1914 there were twenty-five Zeppelins built or being built and Delag, the world's first airline, was operating civil ships on scheduled services, carrying 35 000 passengers over 170 000 miles (273 590 kilometres) between 1910 and 1914.

The second half of the nineteenth century, so fruitful for the lighter-than-air brigade, was a period of continued failure and partial success for the aeroplane. As we have seen, most of the theoretical base was available, but a suitable motor was still lacking – and, in fact, when power was available, as it turned out, much of the data extrapolated into tables of performance was suspect.

In 1857 a Frenchman, Joseph le Bris, launched a glider that was remarkable for having variable wing incidence and a movable tail. (The standard means of control for the next forty years would be by the primitive method of relying on weight shift of the pilot's body – a system with obvious limitations.) In 1874 Felix du Temple made the first powered take-off (steam) but no subsequent flight and in Russia in 1884, the same year that saw *La France's* triumphal flight, Alexander Mozhaiski managed, using a ramp, to fling his steam monoplane briefly into the air. Another steam launch was that of Clement Ader in 1890 but a further attempt in 1897 under official supervision was less successful. In 1891 Hiram Maxim, an American living in England, managed to demonstrate that his monster aircraft would get off the ground if given the chance. It weighed three and a half tons, had a crew of three and two 180 hp engines, driving 18-foot (5.5-metre) propellers.

Votes For Women VALENTINE VANSTONE GAvA
An episode of the Suffragette movement, when on 21 June 1908 leaflets were dropped on the House of Commons for the opening of Parliament. The airship is probably the Spencer No. 3 (Simms, 5 hp engine).

Ballooning like bicycling – though never attaining the popularity of the latter sport – marked the beginning of female emancipation. The period before the first world war, and the gentle, silent world of the balloon with its attendant background of rich and elegant participants and awe-struck spectators, is Valentine's own. Her pictures are very carefully researched and historically accurate and her enthusiasm for period costume and a firm and authoritative style convey admirably the calm of those last golden years.

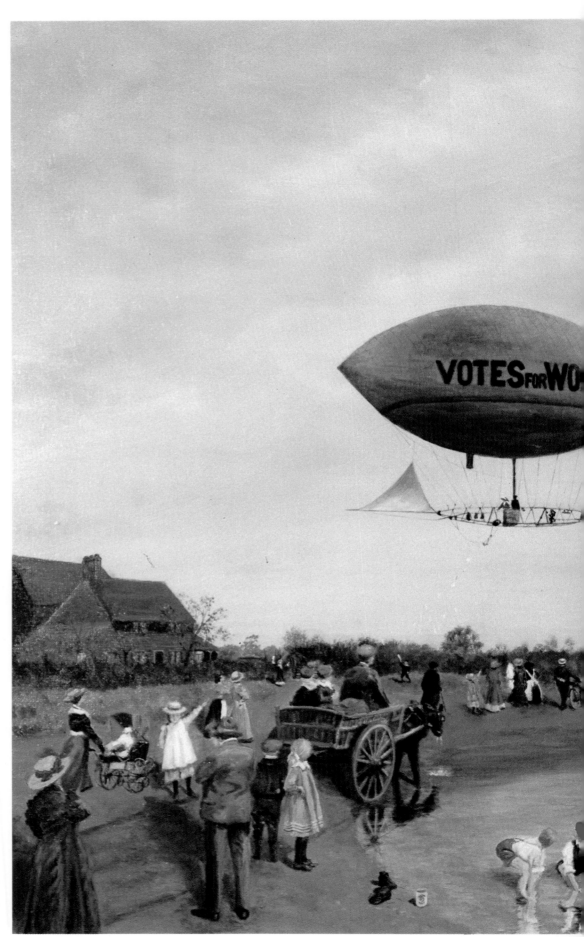

Restrained from flying by guard rails on its track, one run generated lift enough to burst them. Its staggering 4000 square feet (370 square metres) of canvas, 500 square feet (46 square metres) more than Columbus's *Santa Maria*, would have been totally uncontrollable, so it was just as well that it was meant only for ground runs.

In retrospect it is a little surprising that men clung so long to the impossible steam engine. The Belgian Jean-Joseph Lenoir had been marketing a lightweight gas engine for road carriages since 1860, but it was not until the end of the century that any thought was given to using it in an aircraft. Two men, Otto Lilienthal in Germany and Percy Pilcher in Britain, were nibbling at the idea of such use in their gliders; both were killed before anything came of it.

Lilienthal, the most important experimenter of his generation, began gliding in Germany in 1891 and in five years was flying up to 750 feet (230 metres), using an artificial launching hill. Percy Pilcher, who began following his example in 1895, the year before Lilienthal's death in a crash, suffered the same fate in 1899. Lilienthal was a sensation in his day, his experiments making a great impact upon the scientific world, and the increasing ease and speed of communication making the dissemination of new ideas swifter than ever before.

Responsible for much of the promotion of Lilienthal's ideas was an American engineer, Octave Chanute. Fifty-nine years old when the German began gliding, Chanute, using the well-known Pratt-truss to improve the rather rudimentary biplane structures of Lilienthal, designed successful gliders, his age inducing him to let others fly them. All three men, Lilienthal, Pilcher and Chanute, had grasped firmly the important principle that with the state of the art, only prolonged gliding practice could give the essential facility of control required for powered flight. Chanute, moreover, had advanced beyond the others' primitive weight-shift control to advocating built-in stability. This, though certainly a step forward, could never substitute for pilot control, a fact recognized by Wilbur and Orville Wright in America, but not appreciated in Europe for nearly a decade.

Chanute travelled much between Europe and America, bringing to the Wright brothers news of Lilienthal's progress and stimulating their interest, writing numerous articles and a book, and lecturing on aviation. A devoted friend of the Wrights, he was to carry the first authentic information about their successful Flyer to the Europeans. And so, with the airship still firmly in the ascendant, we enter the twentieth century.

That the Wright brothers were the first

men to achieve true, sustained powered flight is one of the better known facts on the subject. Inspired by Lilienthal and encouraged by Chanute, who provided them with much of the data collected up to that time, they set to quietly and in 1900 produced their first glider. Their approach was sound; the time was ripe; the internal combustion engine was available. Somebody was about to solve the problem; many people had already nearly succeeded. What put the Wrights ahead was the astounding breadth of their investigations and their grasp of certain basic principles that seem to have evaded everyone else. Equally astonishing, in its way, was the manner in which, having burst upon the aviation world and shaken it from its slumber, they faded quietly away, having no apparent interest in developing their Flyer.

They rejected the body weight-shift system and automatic stability. Positive control at all times was, they were sure, the answer to the problem, and to force this made their craft aerodynamically unstable. They did, however, adopt Chanute's trussed biplane structure.

Finding their predecessors' data, as well as their principles, unsound, they constructed their own tables, using a home-designed wind tunnel, and working out their own data for propellers.

At Kitty Hawk, on the coast of North Carolina, where they had gone to glide, using the strong, steady winds, their observation of birds' behaviour led them to mastering control in roll — fundamental to successful flight, but until now not even seen as a problem — by helical twisting of the wing tips. The next, and even greater step, was the discovery of the relationship of control in roll and yaw simultaneously. In the attempt to overcome the secondary yaw effect of their high-drag roll control, they experimented with fixed and movable vertical rudders, eventually stumbling on the correct solution of using 'top rudder'.

They designed and built a lightweight engine and in 1903 were ready for the first powered flight. On 17 December they flew four times, the last and longest, with Wilbur 'up', covering 852 feet (260 metres) in fifty-nine seconds. Although each season's flying time was short, they progressed rapidly, the first circular flight being in September 1904 and in 1905 their Flyer III, the first really practical aircraft in the world, was covering twenty-four miles (39 kilometres) and staying airborne for over half an hour.

A great deal of nonsense has been written about the Wrights and their impact on the aviation world. Initially they never concealed what they were doing; they wrote and published papers and the details of

their work were spread over Europe by the indefatigable Chanute. It was not their fault if the Europeans failed to grasp reality. The French, in particular, for so long the acknowledged leaders in aviation, seemed unable to believe the odd stories about these two obscure mechanics.

In 1905 the Wrights were ready to commercialize their invention. They were also beginning to keep their own counsel to protect their interests. This was, for the moment, their undoing. While the governments of Britain, France and Germany were sufficiently enlightened to negotiate (the Flyer had already been offered to the United States government), negotiations with governments always take time and the insistence of the Wrights that their claims be taken on faith until contracts were signed did not help. The brothers went back to theoretical work, and Europe went on pottering vaguely about.

In 1908 the Wrights emerged again with the Type A two-seat Flyer. The American government, spurred on by President Theodore Roosevelt, were now prepared to order one and the brothers came to Europe, this time with an aircraft (brought over the previous year, but left in a crate when negotiations fell through). The effect was all they could have wished. The first tottering flight in France was made in 1906 by Alberto Santos-Dumont, a very small, very wealthy, very popular Brazilian who had endeared himself to Paris with his airship adventures. The first observed circular flight was made in 1908 by Henri Farman. And here, eight months later, was a *real* aeroplane, wheeling, turning, climbing, circling, staying up apparently for ever, and even carrying passengers. A flying saucer could have had no greater effect. Europe perceived suddenly that all was yet to do.

Governments hastened to buy Flyers and negotiate licences. In Britain the Short brothers, balloon makers to the gentry, saw the light, acquired a licence, and set up the world's first aircraft production line with six Flyers. Within two years, a hundred were in use. By that time crude and out-of-date, the Flyer retained a nostalgic popularity, later paralleled by the T-model Ford, long after its brief moment of ascendancy was over. For by then the scores of European constructors were in full cry, with the definitive types that were to carry the world aloft for the next decade emerging from the ateliers.

In France, the Voisins (yet another pair of aeronautical brothers) were selling serviceable great pusher biplanes, based on the 1893 box kites of Australian pioneer Lawrence Hargrave. Later the design was perfected by Farman. Léon Levavasseur and Louis Blériot were building clean, efficient tractor monoplanes – the universal shape of years to come – with Blériot

winning undying fame, £1000 from the *Daily Mail*, and a great many orders when he flew the English Channel in his Type XI on 25 July 1909. A month later the first international aero meeting in the world was held near Rheims. Everyone was there, pilots, *beau monde*, military and politicians, and the records fell like ninepins. When the meeting closed, on 29 August, the fastest speed was 48 mph (77 km/h), the distance record 112 miles (180 kilometres) and the altitude record 508 feet (155 metres). Much of the success was due to the now reasonably reliable 50-60 hp engines in use. During the meeting Farman introduced the revolutionary Gnome rotary, designed by the Seguin brothers, its cylinders whirling weirdly round a fixed crankshaft, but light, and adequately cooled. Its successors were

to rise to 200 hp and still be in front-line service after the first war.

Strangely, in the United States, the pace was not the same. The Wrights never really followed up, though their aircraft sold well. Wilbur, indeed, was to die in 1912 and Orville had been badly injured in a 1908 crash at Fort Myer on the first Army Flyer, when Lieutenant Selfridge was killed. Although he lived until 1948 he never again took an active part in aircraft design.

A new star had arisen, however. Glenn Curtiss, working with the Aeronautical Syndicate in Canada, had successfully flown his third design, the *June Bug*, in 1908 and began to attract considerable attention in the United States. While the Wrights were in France, he won the Gordon Bennett speed prize at 47 mph (76 km/h)

and he was in the front rank of winners at Rheims. In 1910 Eugene Ely, flying a Curtiss pusher, made the first flight from the deck of a ship, the USS *Birmingham*. Three months later, in February 1911, Curtiss, who had begun building seaplanes, landed alongside USS *Pennsylvania* in San Diego Bay, was hoisted on board, returned to the water and flew away; the beginning of a long association with the United States Navy.

Britain started late in the flying game. The first flight in the United Kingdom was in October 1908 (by Samuel Cody, an American citizen at the time) and the first Englishman flew the following year. In Germany, too, with Zeppelin and several other airship builders dominating the scene, aeroplane work was slower to start, but by 1912 the methodical Germans had established standard types – tractor monoplanes and biplanes and developed a sound national aero-engine industry.

Between 1910 and 1914 the aero-industry grew up. Coverage in detail of the hundreds

The Wright Biplane in France, 1908 FRANK MUNGER GAvA
Wright Flyer Type A (Wright, 30 hp engine) at Hunaudières.

Wilbur Wright flew for just under one hour and ten minutes on 10 October 1908, with M. Painlevé as passenger. At this time the best solo French flight was forty-four minutes and the average around fifteen minutes.

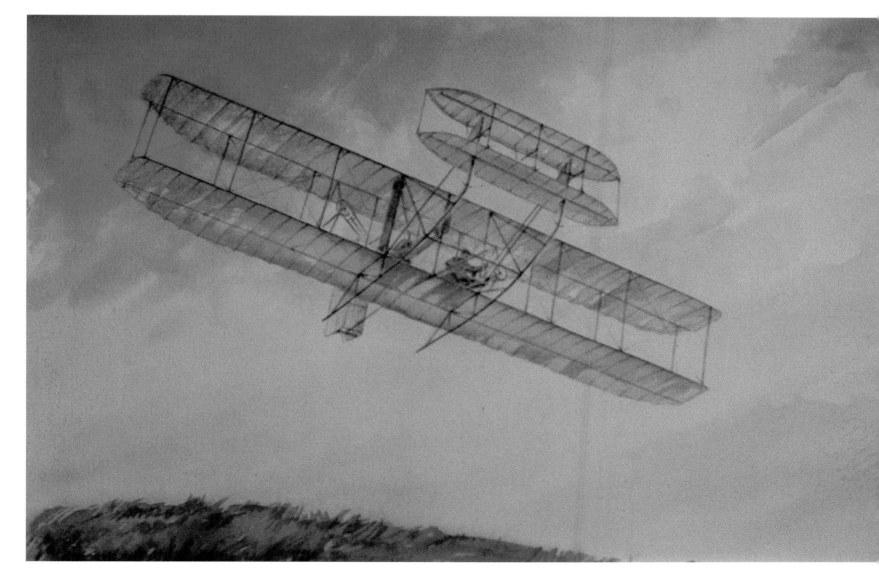

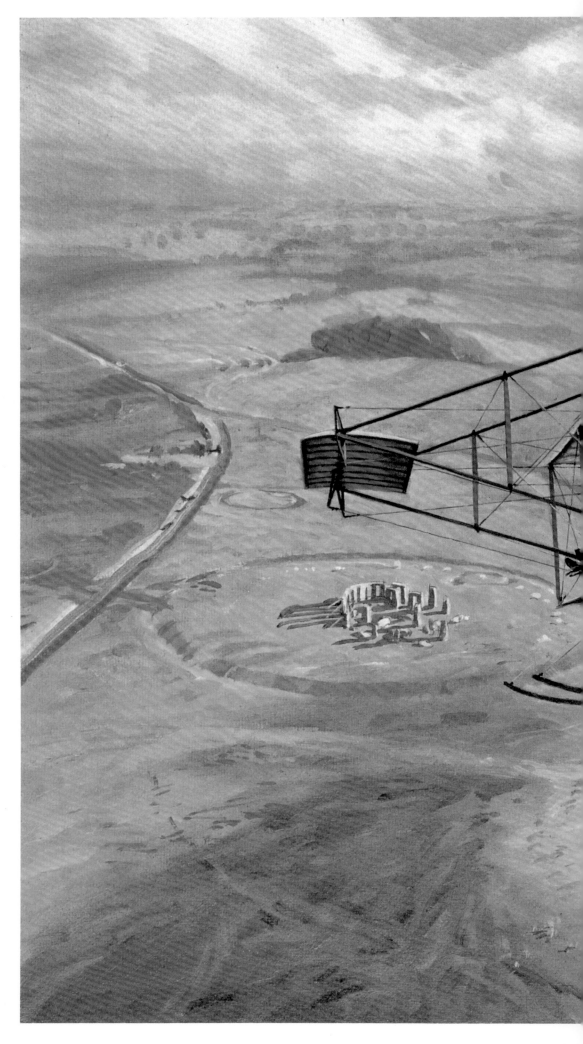

of aircraft that flew in that period is not possible here, but the pattern was now established for the next twenty-odd years. With a few exceptions the tractor biplane and to a lesser extent, the monoplane, were now the norm. Engines, both the air-cooled rotary and the more solid vee or in-line liquid-cooled stationaries were producing up to 160hp, the laws of aerodynamics were more firmly grasped and the braced box-girder had a stranglehold on constructional methods.

In England, young men like A.V. Roe, the first great British pioneer, were getting into their stride. Geoffrey de Havilland was working at the Aircraft Factory at Farnborough. Louis Bréguet in France was designing advanced metal biplanes with variable pitch airscrews, and Morane was building fast and manoeuvrable monoplanes.

With increasing competition in the enlarging market, performance became more important; the winning of a race or setting of a record was good national and commercial publicity. The first race for the Coupe Schneider, destined to become one of the most famous races in the world, took place in 1913 in Monaco and was won by Prévost on a Deperdussin. In 1914 it was taken by an Englishman, Howard Pixton, on a neat and workmanlike biplane from Tom Sopwith's factory. The win caused Britain to be taken seriously for the first time as an aeronautical influence and started a long line of Sopwith fighters in the coming war.

In 1914 world records stood at 127mph (203.86km/h) for speed, 627 miles (1010 kilometres) for distance and 20078 feet (6120 metres) for altitude. In ten years the aeroplane had become fast, reliable and useful to mankind. The first airmail was started in 1911 and commercial flights about the same time. It was also about to become dangerous, destructive, and a portent of universal doom in the next four years.

In the Beginning KENNETH McDONOUGH GAvA Bristol Boxkite (ENV, 50hp engine) Captain Bertram Dickson, the Larkhill instructor, over Stonehenge.

The Bristol Boxkite, at the Larkhill and Brooklands Schools, trained nearly half of the pilots who gained Royal Aero Club Certificates before the war – 308 out of 664. The schools and aircraft were then taken over by the military, who had ordered their first four Bristols in 1911. A straight copy of the Farman, it was so much better built as to escape any legal proceedings for poaching by being declared an 'improvement'. Ken McDonough paints in acrylic in a loose, instantly recognizable style. Noted for meticulous research, he frequently builds (and flies) models of aircraft he intends to paint.

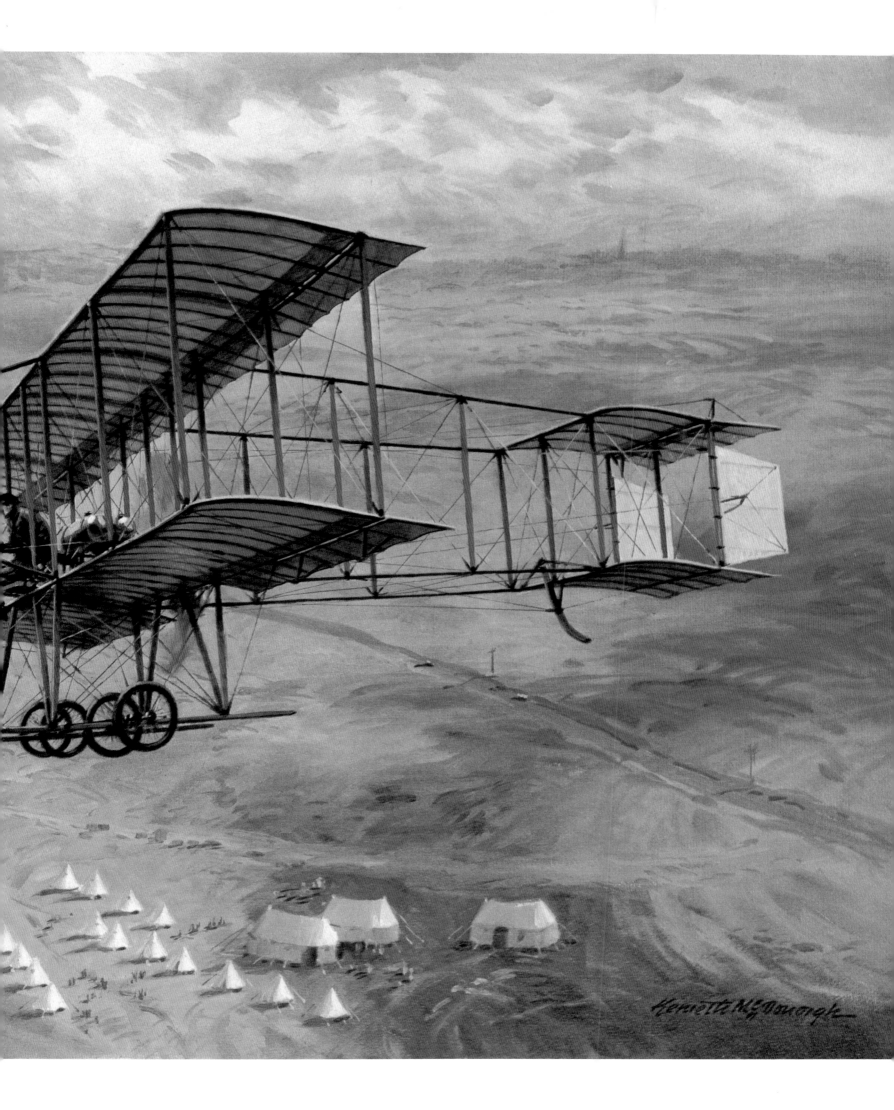

Period two: World War I, 1914-1918

Preparations for war in the air had begun some four years before hostilities broke out. France, Britain, Germany and Russia all had practical military experience of the value of balloons for reconnaissance, and the airship, by 1910, was a reliable and useful way of seeing further 'over the hill'. It had not escaped the Germans that it could also carry bombs.

It has become a cliché to sneer at military authority for not grasping the potential of the aeroplane sooner, but this is by no means a true picture. While the airship had developed strongly; the aeroplane, a creature still of moods and delicate construction, had not. Its range was short, its temper uncertain and its management such as to leave the occupant little time for military duties aloft. The first practical demonstrations had come only in 1908 and 1909. All in all, considering that they were spending public money, the reaction was fairly rapid – except for the British, who were a bit slower than the rest and twice as parsimonious, to say the least.

As early as 1906 the French government was negotiating with the Wrights, obtaining a licence for the Flyer in 1908, and rapidly adding native products from Farman and Blériot. The French army, large, professional and recovered from the catastrophes of 1870, gave serious thought to aviation. It had been at Rheims and was impressed. By the end of 1910 it had acquired thirty-one aircraft and had ordered twice that number. Apart from an embarrassing moment when it was discovered that the artillery had started a private air force, the new arm was solidly founded. Given a large degree of independence, the Aéronautique Militaire was backed by an industry turning out astounding numbers of aircraft (over 1200 in 1913) and by 1912 had devised a structure of squadrons homogeneously equipped and backed by a net of training schools, with allocation of units at army corps level, under corps command. It was also sending strong support to France's colonial possessions

and discovering the uses of the aeroplane in keeping law and order.

The Aéronautique Militaire possessed one rather indifferent rigid airship, but from the factories of Astra, Clement-Bayard, Lebaudy, Zodiac and the government works at Chalais-Meudon had taken on charge fifty-nine semi-rigids and non-rigids; the navy had another twenty-five.

The first British military aircraft was a balloon, bought in 1878 for £71. On the sound military principle that any weapon too big to pick up was given to the Royal Artillery and anything too complicated for the common soldier to the Royal Engineers, the Sappers took charge of the balloon. (The principle is still broadly true today.) Delighted with their new toy, they took it on manoeuvres in 1880, had a factory established at Farnborough by 1891, and took balloons on various campaigns with varying success. The factory is still there though now called the Royal Aircraft Establishment with rather broader duties.

Farnborough built five airships for the army. The Royal Navy acquired two non-rigid Willows (a native product), a German Parseval and a French Astra-Torres. Impressed, like the Germans, by its reconnaissance potential, the navy eventually fielded fifteen rigid airships. None of these was better than mediocre until careful study had been made of Zeppelins which had been shot down. Also under the driving stimulus of Admiral Fisher the navy deployed a total of ninety-six non-rigids for coastal patrol and convoy protection. The latest and best, the North Sea type, could patrol for twenty-four hours and reach 58 mph (93 km/h).

The infant Royal Engineer balloon section became the Air Battalion on 1 April 1910 (not a joke, but the beginning of the military accounting year) with lighter-than-air and heavier-than-air companies, so progress was not all that slow. In 1912 a unified command for naval and military aviation was set up as the Royal Flying Corps, but the navy had definite ideas on the control

of naval air, even then, and soon formed an independent force that became the Royal Naval Air Service. It also opted for independent sources of supply and where the army was restricted to the stable and somewhat pedestrian products of the Royal Aircraft Factory, it enlisted private constructors. In consequence, it received excellent seaplanes from the Short brothers (there were three of them, unlike all the numerous other aviation brothers who came in pairs) and a whole series of first-class fighting scouts from Tom Sopwith.

From 1912 to 1914 the motley collection of aircraft of the Royal Flying Corps took part in manoeuvres, went to camp, and developed their cross-country ability. They also convinced the cavalrymen in high command that they would not frighten the horses and acquired a reputation for reliable information.

The German High Command decided early that the aeroplane and airship were useful weapons in its command. From 1907 it began to acquire airships: three naval and one military Gross-Basenachs, eight naval and four military Parsevals, and nine naval and ten military Schutte-Lanz – the latter, ingenious rigids with geodetic wooden frameworks.

But it was the Zeppelin that held pride of place. Altogether 126 were built for the two services; only six survived to be handed over to the Allies in 1918.

One of the problems of the historian in the early part of the war, incidentally, was a tendency for any airship, whatever its nationality or shape, to become a 'Zeppelin' to the troops. They fired enthusiastically and impartially on anything that looked in range – a privilege soon extended to aeroplanes as well. The first 'Zeppelin' shot down over England and widely reported as such, on 12 August 1916, was actually the Schutte-Lanz SL 11.

By the end of 1911 the German army owned thirty-seven aircraft, was using them on manoeuvres and beginning to put organization and purchase on a proper

The First Patrol JOHN YOUNG GAvA
Blériot Type XI (Gnome rotary, 50 hp engine) Compagnie Belge des Aviateurs

One of the first professional artists to support the Guild, John is well known for his lively and very English acrylics. The date of this pictured reconnaissance is 4 August 1914, the pilot Jan Olieslagers and the aircraft his own, which joined the service with him. The four official Blériots ordered by the Belgian government, that were to form the 3me Escadrille, did not arrive until the 12 August.

military footing. It arranged its structure vertically, as did the French, with reconnaissance flying companies attached to army and corps commands, each with its own attendant schools and supply parks. It also experimented with artillery co-operation and the arming of aircraft.

When the war started, the British RFC took every serviceable aircraft it owned — sixty-three of them — to France. As this was only one-third of the aeroplanes it possessed, the rest being more or less junk, some unpleasant questions were asked on the subject. France stood with 136 front-line (that is, serviceable) aircraft and Germany with 246, of which about half

were militarily unsuitable Taube monoplanes. The Taube's moment of glory was brief; one dropped bombs on Paris in August 1914 and another in Dover harbour in December. After that they achieved little.

The scouting virtues of aircraft were early realized; the first RFC reconnaissance of the German armies took place on 19 August and on 22 August it brought warning of von Kluck's movement through Belgium. Later its reports enabled the British Expeditionary Force to slip out of the German trap and revealed the German II Corps' fatal turn short of Paris, which resulted in the battle of the Marne and the end of the German advance.

This battle, which settled both sides into trench warfare, came as a great relief to the RFC, fleeing westwards in a series of bewildering moves. By October, when its Aircraft Park was established in St Omer, it had suffered sixteen major upheavals. Lieutenant Barrington-Kennett, swept from the Grenadier Guards to become Deputy Assistant Adjutant and Quartermaster-General, pondering the altogether too likely and novel chance that the RFC might have to fight to defend an airfield, was moved to suggest laagering the aircraft at night within a ring of vehicles. Optimistically he thought that headlights, switched on at the psychological moment, might stampede hostile cavalry.

Settled in, so to speak, the RFC began to repair some of its more glaring deficiencies; squadrons were grouped into wings and wings into brigades, allocated to army corps on the prevailing system. Faced with the fact that virtually nothing

had been done to assure the provision of fresh aircraft and engines, it was fortunate that the highly efficient French industry could supply its friends as well as itself, though this took some time to implement. Proper training channels were also set up.

With the arrival of wireless and cameras, reconnaissance become more effective, but it soon became obvious that in the sky, as in other places, one would have to fight for information. The earliest air battles were casual, impromptu affairs, the participants armed with whatever personal weapons they could find. Three RFC aircraft, totally unarmed, flew round and round a German two-seater until the wretched pilot was forced to land. Captain Nesterov, a Russian and the first man to loop the loop, rammed an Austrian aircraft in mid-air. But on 5 October 1914, two Frenchmen, with a machine-gun in the nose of their pusher Voisin, shot down a German Aviatik and the game was on.

Aside from the general sporting British feeling that after the twelfth of August even mechanical birds were fair game and the more logical German reaction that if enemy aircraft did enter your airspace there was no need to have them wandering about, it was the French who first took steps to use aircraft for more than scouting. Under the energetic Commandant Barés, fighting and bombing units were organized and in the spring, machine-gun armed scouts were introduced.

The simplest way to shoot from a single-seater is to fix a gun on the cowling and point the aircraft at the target. This requires a device (an interrupting or synchronizing gear) to keep rounds out of the airscrew. The earliest patents for such a device date back to 1913, but the cruder device used by the French ace Roland Garros in April 1915, and seized upon by Fokker after Garros' capture, was very different. Raymond Saulnier, co-designer of Garros' aircraft, a Morane-Saulnier Type L parasol monoplane, devised an interruptor gear, but after problems with the linkage and poor ammunition was forced to back it up by deflector plates on the airscrew to divert stray rounds. Garros and others ditched the heavy gear and relied on the plates.

Nevertheless, it was the Germans who first took advantage of the new weapon. Fokker's monoplane, ironically, was originally developed from the Morane, but there is no doubt that the first practical interruptor gear, whatever its origins, came out of his works at Schwerin. The first of these E type Fokkers arrived at the front in May 1915 and by November there were twenty-six in service. They were scattered in ones and twos at first, to protect two-seaters. Under Immelmann, the Germans

began to group them into fighting units of three and later, inspired by Boelcke, into much larger groups. Throughout the summer of 1915 the Fokkers dominated the air; RFC casualties, especially, among the defenceless and over-stable corps two-seaters, became appalling under the 'Fokker scourge'.

Towards the end of the year, the first RFC fighting squadron equipped with a single type appeared. No. 24 Squadron, its pusher DH2s armed with forward-firing Vickers with no need for any gears, arrested the German advantage and the tide began to turn. The battle for Verdun opened in February 1916, the air combat as savage as that on land. While the enemy's initial aggression won him command of the air, Commandant de Rose formed the first of a series of 'élite' units. This fighting circus was equipped with the Nieuport Bébé, the Type 11, armed with a Lewis gun on the top wing, which mastered the now obsolete Fokker E and drove the German bombers back across their own lines.

Colonel Trenchard, the aggressive commander of the RFC, had noted the French success at Verdun but saw it as only a defensive victory. The battle of the Somme was about to begin and he saw also that the side that held the air over the battle held the key to success on the ground. The RFC was reorganized, with a fighting force operating behind the German lines and letting the corps and artillery aircraft get on with their job. This offensive attitude, carried remorselessly through, resulted in heavy casualties although 1916 was still a year of Allied domination in the air.

New fighting aircraft, superior to the Fokker E and the neat Halberstadt DII that followed it, began to enter squadron service: the Sopwith 1½ strutter and the nimble Pup, the French Nieuport 17, which was more powerful than the 11 and the solid, sturdy SPAD VII. Each was armed with a synchronized Vickers gun.

As victories mounted up, the first aces appeared; Ball, first of the British heroes, Nungesser, Guynemer, and many others. While British authority frowned on personality cults and never admitted the ace system, France gloried in her fighting airmen and following de Rose's example at Verdun, the first special squadron of

élite fighting men appeared, Les Cigognes. This squadron was later to expand to three full groups.

The German response was to step up the size and numbers of their mobile fighter formations, moving them around to where the local pressure was greatest, from which came their nickname of 'circuses'. But they were outnumbered almost three to one and increasingly on the defensive. These *Jagdstaffeln*, or *Jastas*, were first formed under Boelcke and multiplied rapidly, later being grouped into *Jagdgeschwader*. Boelcke by then was dead, killed in a mid-air collision, and there was a new star in the German sky, Freiherr Manfred von Richthofen.

With the first *Jastas* new equipment appeared, Thelen and Schubert's revolutionary Albatros DI and DII. Long respected for successful two-seaters, the firm's new fighter was every bit as good, with a finely streamlined wooden monocoque fuselage (though by contrast the wings were weak and the Albatros was dived with caution). The powerful 150/160hp engine gave a top speed of about 110mph (177km/h) and enabled two machine guns to be carried. Less manoeuvrable than lighter, earlier types, it was a stable gun platform and had twice the fire power.

Fast, compact, powerful and two-gunned, the Albatros was the prototype of all fighters for the next twenty years and when it was followed into service in the early part of 1917 by the Albatros DIII, the pendulum swung back in Germany's favour. By May there were over 300 in service and they had wrested control of the air back from the Allies. There were nearly forty *Jastas* on the job and the slaughter of the two-seaters was terrible. The same inept Factory designs were still in production and they were desperately easy prey. Sixty were lost in the one month that has gone into history as 'Bloody April'. But there was nothing else. And the squadrons never faltered.

That spring was the high-water mark of the Imperial Air Service. New Allied aircraft, designed round Marc Birgkit's Hispano-Suiza engine began to appear. Folland's SE5a reached squadrons in June. By the end of the war no less than 2700 were on charge. From Louis Béchereau

Dangerous Sky BRIAN KNIGHT GAvA
Nieuport 11 (le Rhône 9C, 80hp engine) and Aviatik C1 (Mercedes DIII, 160hp engine).

This tightly organized combat scene portrays the early days of the American-French squadron No. 124 – the Lafayette Escadrille. Flying these early Nieuports they distinguished themselves in the fighting over Verdun. The early use of the Indian Head insignia is interesting as at that time the Nieuport 11s mostly carried personal insignia. The Aviatik C1 was the first German two-seater to become well known to the Allies (for some time every biplane was an Aviatik, until recognition got better). It shared with early British two-seaters a lunatic arrangement of having the gunner in the front seat, surrounded by struts. The discomfort of this particular Aviatik is therefore understandable.

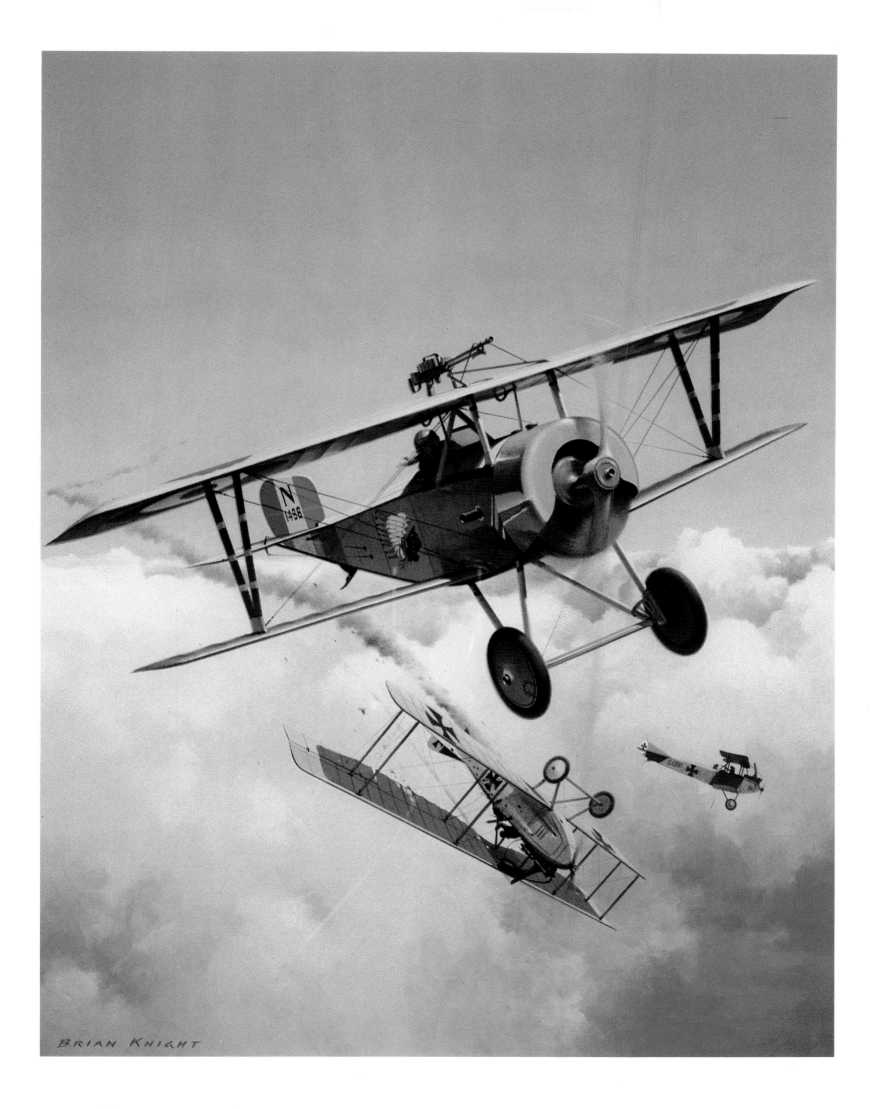

BRIAN KNIGHT

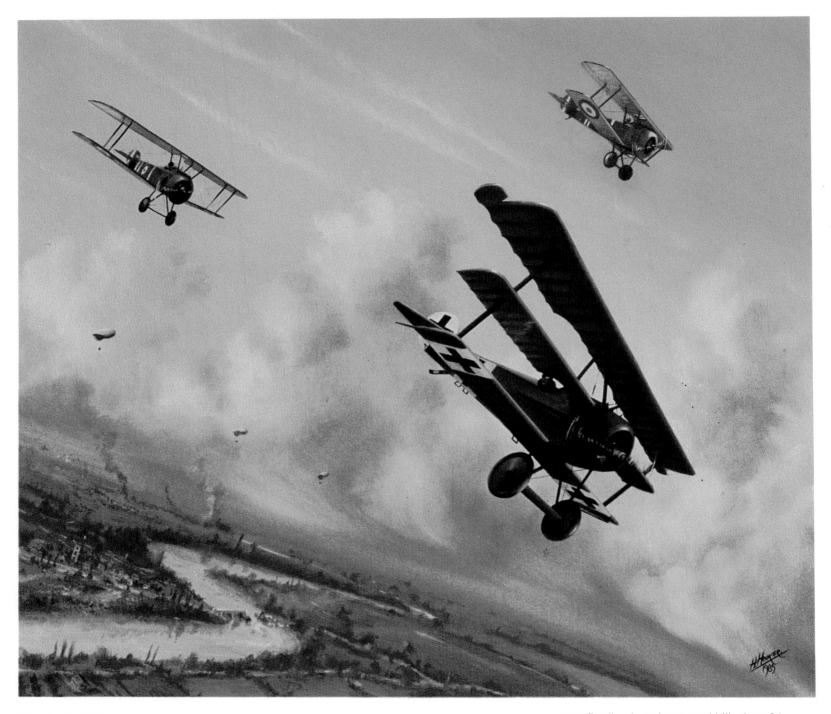

21st April, 1918 H.M. HOOKER
The death of Richthofen. Fokker Dr I (Oberursel UR II or Thulin/le Rhône, 110hp engine).

Following a confused mêlée between the three flights of No. 209 Squadron, Royal Air Force (three weeks previously it had been Naval 9 of the Royal Naval Air Service) and Richthofen's Jastas 5 and 11, the baron had followed a new boy out of the fight. Uncharacteristically, he clung to the twisting Camel until they were down to below 200 feet (61 metres) over the Somme, crossing the Australian lines. Pursued by Captain Roy Brown of 209 (officially credited with the kill) and fired at by everybody in sight – they were so low one man even drew his revolver – to this day no one is absolutely sure who shot the Red Baron down.

came the big, 235hp Hispano-powered SPAD XIII, of which 8427 were built and with them came the first of the new American pilots. In July the Sopwith Camel arrived, lighter and more nimble than the SE5a, with the 130hp Clerget rotary.

These were the aircraft that finally won the air war, in the latter half of 1917. Albatros countered with the DV and Fokker was back in the game with his fast-climbing, manoeuvrable Triplane. This was the favourite mount of Richthofen, who

was finally shot down and killed on 21 April 1918. But the Germans could not regain the initiative. The Jastas multiplied, and there were eighty-one of them when the March offensives opened. A new fighter, the incomparable Fokker DVII appeared with an 160/185hp engine and nearly 800 had been produced by the Armistice. But the March offensives failed, the sullen armies fell back and it was too late.

The air war was not entirely a titanic struggle of aces over the lines. As early as October 1915 the Germans were planning long-range bomber formations, disguised under the unlikely name of the Ostend Carrier Pigeon Unit, to carry the war to

southern England when the Channel ports fell. But that never happened and when the airships, and later the big bombers, did raid England it was from more distant bases in Flanders.

With little requirement for scouting for the High Seas Fleet and their manifest vulnerability over the trenches, naval and military airships became available for raiding. Starting in January 1915, the few ships then to hand had been sporadically bombing English targets, as moon, weather and serviceability permitted. They caused casualties and dismay and fighting units were pulled back from France to oppose them. After two years the defence had their measure; casualties among the airships were heavy and in the raids of 1917 and early 1918 they were replaced by twin-engined Gothas and the occasional multi-engined Giant. Again the defence prevailed; they were forced into night bombing and then faded away.

The French, their bombing squadrons created early in the war, were carrying the war to Germany some time before the RFC got into its stride, though such offensive action was never far from Trenchard's mind. With the arrival of the splendid DH4 in early 1917, especially the Rolls-Royce Eagle version, day bombing began to build up and when the RFC and the RNAS were merged into an independent Royal Air Force in April 1918, it acquired the big twin-engined Handley Page 0/100s of 5th Naval Wing at Dunkirk. These

The Destruction of Zeppelin L22 NORMAN APPLETON GAvA

Zeppelin LZ64 Type Q (German navy L22) (four Maybach, 240 hp engines). Curtiss H 12A Large America (two Rolls-Royce Eagle I, 275 hp engines).

The Curtiss H 12 was the best known of the Curtiss flying boats used by the Royal Naval Air Service. From 1917 it conducted an aggressive war over the North Sea in the hands of the War Flight and Boat Flight at Great Yarmouth and the Flight at Killingholme. Despite its span of nearly 93 feet (28 metres) and 5 ton loaded weight, it was remarkably agile. The incident painted by Norman Appleton from official reports concerns the first (ever) flying boat victory over a Zeppelin. H 12 No. 8666, was commanded by Flight Lieutenant Galpin and flown by Flight Sub-Lieutenant Leckie when they found L22 off Texal Island. Leckie dived 3000 feet (914 metres) winding the boat up to 90 knots and Galpin raked the Zeppelin with the bow Lewis guns, setting her alight before his guns jammed.

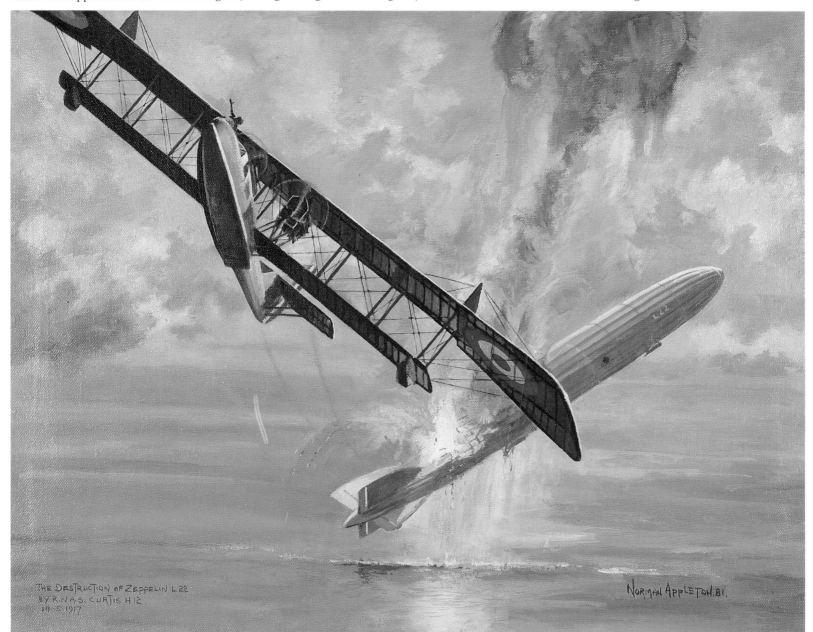

THE DESTRUCTION OF ZEPPELIN L22
BY R.N.A.S. CURTIS H12.
14.5.1917

NORMAN APPLETON.81.

sustained the offensive of VIII Brigade and when it became the Independent Force, RAF, new Handley Pages, the 0/400s, became available.

Another important aspect of the air war was the development on both sides of direct support for ground troops, either the contact patrols, keeping touch with forward units or the more aggressive 'trench strafing' patrols. For the latter the Germans developed armoured and, eventually, all-metal aircraft; despite this, casualties, inevitably, were severe. And through it all, up and down the front for four years, the reconnaissance aircraft, the corps squadrons, the photographers and the artillery observers, wove their lonely and dangerous circles and figures of eight,

exposed, vulnerable and far from the public glamour of the single-seater squadrons.

Right from the beginning of the war both British and German naval thinking included integral air power. Both sides employed airships (the Royal Navy had fifteen rigids) but most British long-range scouting was done by big, twin-engined flying boats over the North Sea. The Germans retaliated with squadrons of fighting seaplanes based in Flanders.

To the Admiralty, however, the aircraft, like the submarine, was something that should keep up with the Grand Fleet and work with it (though the submarine end resulted in only the K class of steam-powered dinosaurs). Ships were fitted out to carry seaplanes that could be launched

and recovered. An old cruiser, *Hermes*, thus converted, was sunk at the beginning of the war, but a number of fast packets were turned into seaplane carriers and did good work in the North Sea and at the Dardanelles, where the first successful torpedo attack was made. The trouble was that it was a clumsy and uncertain way of employing aircraft at sea and other methods of transporting them were tried out. Battleships and cruisers began to carry defensive fighters on launching platforms over their turrets. Sopwith Camels were towed to sea on lighters behind destroyers to attack Zeppelins, achieving one success. But the secret of real air power at sea lay with the true carrier, launching and recovering her own aircraft.

The first take-off from a moving ship had been made on 9 May 1912, at the Naval Review and the cross-Channel/Irish Sea packets later received launching platforms forward. In 1917 a flying-off deck was fitted forward of the bridge on HMS *Furious*. (The ship was one of Lord Fisher's more lunatic contributions to naval warfare, intended for use in the shallow waters of

Russian Adventure RICHARD JONES GAvA
Short 184 (Sunbeam, 260hp engine) operating in the North Russia campaign against the Bolsheviks, 1919, from HMS *Pegasus*.

Richard Jones has been well known in the Guild for many years for his unique, divisionist style of painting. This is one of his more conventional works of more recent date. Six cross-channel steamers and three short sea ships were converted into seaplane carriers, most going to the Mediterranean after initial North Sea service. Generally speaking, the game of hoisting seaplanes in and out was an operational flop. Their use spilled over into the abortive campaign to bolster the White Russians.

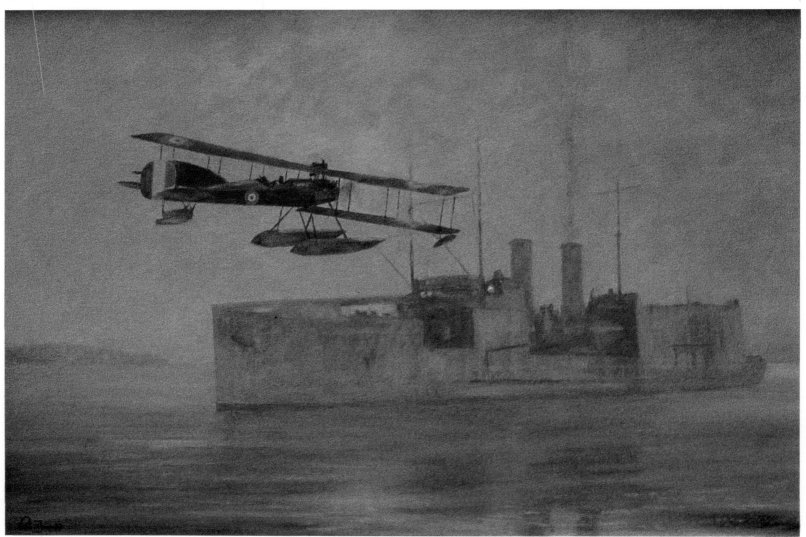

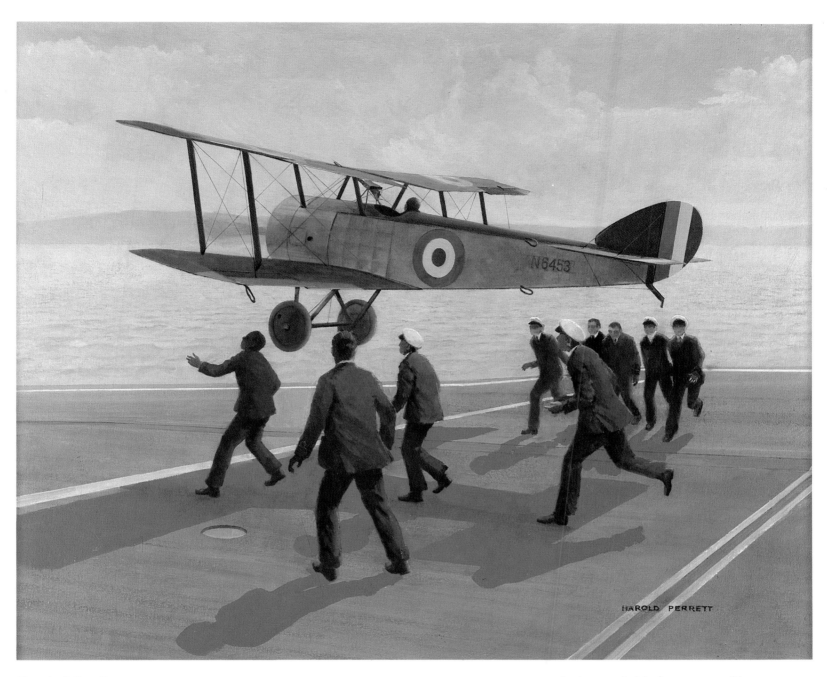

Dunning's Landing HAROLD PERRETT
Sopwith Pup (le Rhône, 80 hp engine). Flight Commander Dunning landing on HMS *Furious*.

On 2 August 1917, Dunning made the first (ever) landing on the deck of a moving ship. HMS *Furious* was steaming at 26 knots and in order to land on it Dunning had to overtake, flying down the side of the ship and scraping round on to the foredeck. In a second attempt, five days later, he stalled, went over the side and was killed.

the Baltic but unemployable elsewhere.) Shortly after Flight Commander Dunning had made a successful landing on this, but killing himself in a second attempt, a landing or flying-on deck was added aft. Funnel gases and turbulence made this arrangement hazardous so the offending superstructure was removed and the deck made continuous. Britain had invented the aircraft carrier.

While this was going on, a half-completed Italian liner was taken over and rebuilt as

the world's first purpose-built carrier, joining the Grand Fleet just before the end of the war

When World War I started, military aviation in the United States was in a fairly poor shape. Of seven squadrons authorized, only one was in (precarious) existence when America entered the war on 6 April 1917. Astronomic sums were instantly voted to build up the world's largest air force in as little time as possible. But there were no factories, no

designs suitable for war conditions, no engines, no anything. So the army decided to build trainers for the moment and acquire fighters and bombers from the Allies. This it did, and did it so effectively, that at the Armistice it had 740 aircraft in France in forty-five squadrons and ten squadrons were flying American-built de Havilland 4s. Its top ranking ace, Captain Rickenbacker, had chalked up twenty-six victories.

It is very easy to regard the United States' initial intervention in the air war as faintly comic. They tried to do far too much, far too quickly, initiating aircraft building programmes that were pure wishful thinking and getting terribly muddled over training and supply. But they started in a state of primal innocence about the war

because the Allies were not at all keen to let them see anything before they joined in. Basic training was no problem; the Curtiss JN-4 was available and large numbers were built. The equivalent of the British Avro 504, it was designed, curiously, by a man who had worked on the Avro. Advanced training took place in France where experienced instructors were available, but the new boys had to wait while Allied training commitments were met first. In August 1917, the first American schools were set up in France and were coping with the requirements of the Aviation Section (of the Army's Signal Corps).

The muddle over aircraft procurement was such that in 1918 the Bureau of Aircraft Production was formed, as part of a short-lived independent Air Service, the operational side being the Division of Military Aeronautics.

The first American-trained fighter unit, the 94th Pursuit, came to France in April 1918; the first unit to reach the front was the 1st Aero Squadron in September 1917. Commanding the United States Air Service, American Expeditionary Force, was Lieutenant-Colonel William Mitchell. A man who believed fervently in strategic bombardment and had some very advanced ideas, he proposed a two-tier air arm, one part subordinated to army requirements in the old fashioned way, the other an independent force for long-range bombing. This accorded with the ideas of Trenchard, who set up the 41st Wing in October 1917 for precisely that purpose – forerunner of VIII Brigade and the Independent Force.

The war was over before Mitchell had a chance to do more than start on his planned offensive, although he commanded large forces of aircraft in the St Mihiel offensive with great success. Had it gone on into 1919 some very interesting operations might have been seen. But it didn't. And everyone went home and began to dismantle the whole structure of air power as fast as they could get at it.

Overshoot: Name? Number?
FRANK WOOTTON, President GAvA
Royal Aircraft Factory RE 8 (RAF 4a, 140 hp engine), its pilot in difficulties.

Frank Wootton's comfortably English style is far too well known to at least two generations to require comment here. President of the Guild since its inception, he has always given freely of time, advice and experience to all who asked. This painting is one of a number of recently completed World War I scenes (in 1980, in fact). Accidents were fairly common in those early days, and overshoots in the small airfields not infrequent. To take someone's marquee with you would be tactless and would certainly sour the disposition of the owners towards the luckless pilot.

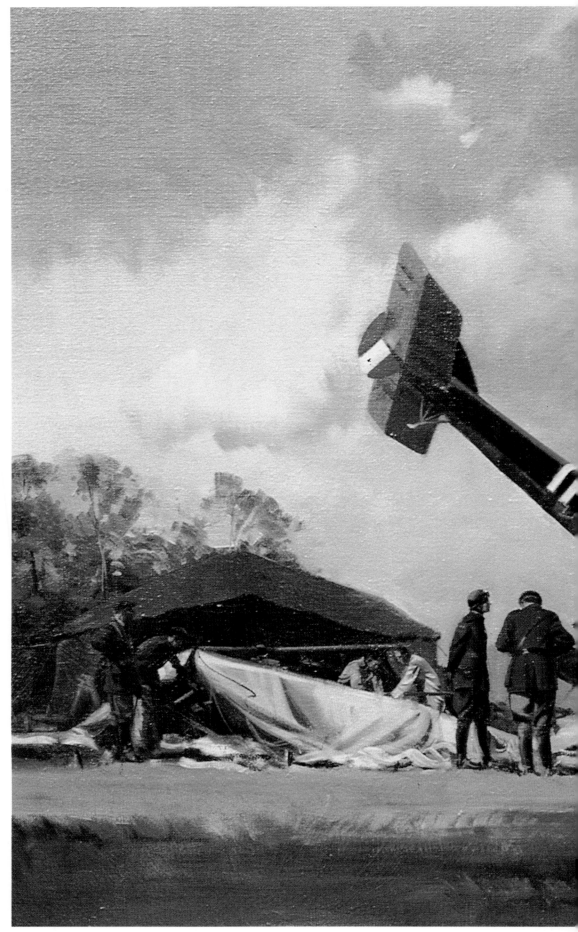

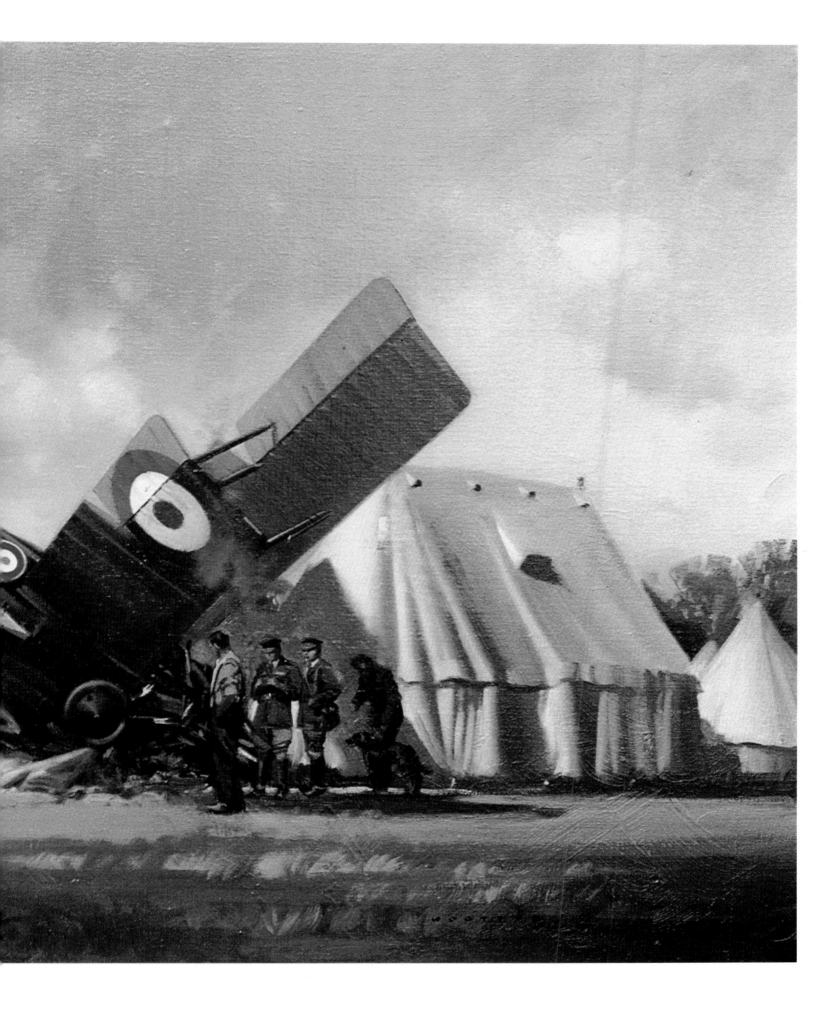

Period three: the uneasy peace, 1919-1939

The years immediately after the first world war saw the almost total dismantling of the huge air fleets that had been built up. When the armies stood down in November 1918, the Royal Air Force had under its control 200 operational squadrons, 22 647 aircraft disposed throughout the world on around 700 airfields and a personnel strength of 290 743. This huge force was dismantled swiftly and the great majority of the wartime personnel returned to civilian life as soon as possible. In addition, inevitably, the huge wartime contracts for thousands of aircraft were cancelled with great promptness. The emasculated peace-time Royal Air Force already possessed far more modern aircraft than it could possibly want, and this cancellation of contracts and the total drying up of orders for new designs put a large part of the young aircraft industry effectively out of business.

The major pioneer companies largely survived. Tom Sopwith, with his customary financial shrewdness, wound up the Sopwith Company and started off afresh with Hawker Aircraft Limited (named after his Australian-born chief test pilot). Geoffrey de Havilland, who had been the first aircraft designer taken on by the Balloon Factory at Farnborough in 1911 – it did not become the Aircraft Factory until later – had been designing for Airco, or the Aircraft Manufacturing Company, since the summer of 1914. Airco did not survive the post-war cessation of orders and de Havilland set up his own company. Good management and brilliant designing enabled him to survive the slump in aero-nautical affairs, a particularly impressive achievement since he was building almost entirely for a civil market that could barely be recognized as existing.

There were plenty of signs that commercial aviation was about to become a practical business. But the availability of vast stocks of aircraft, spares and engines through the Aircraft Disposal Company, which had been set up to dispose of most of the Royal Air Force's assets, did nothing for eager young designers with new types to sell.

On the credit side for the air force, its founding father and chief protagonist, Major-General Sir Hugh Trenchard, had returned to his old post of Chief of the Air Staff, following an uncomfortable time in the wilderness of political action after commanding the Independent Force. Just before the end of the war, he had been appointed Commander-in-Chief of the newly created Inter-Allied Independent Air Force but, like his opposite number, Brigadier-General William Mitchell, who had become Chief of Air Service, United States Third Army, at the end of the war, had no opportunity to try out his strength.

Trenchard was therefore in precisely the right position to defend the Royal Air Force from the multi-directional pressures aimed at its extinction. There was wide opinion in the military hierarchy that with the return of peace there was no need for a third service; moreover, the very stringent financial restrictions upon military spending made many feel that the available money could be better spent elsewhere. The Royal Navy, by now thoroughly convinced of the value of air power and beginning to recognize the aircraft carrier as a potent weapon, was, as it had always been, clamorous for control of naval air operations and equipment.

The fact that Winston Churchill, a 'former naval person', was simultaneously Secretary of State for War and for Air, must have been a source of some anxiety to Trenchard. However, the Royal Air Force did survive as an independent service and within quite a short space of time was able to demonstrate its effectiveness.

A reduction in size was inevitable and initially the new force became extremely thin on the ground. This did not matter particularly, as it was inconceivable that anyone was going to start up another war in the immediate future. It led, however, to pieces of official logic that were to cause some unnecessary problems later. Lloyd George's post-war government took the period of ten years as a safe 'no war in this time' period. The trouble was that each year the period was happily brought forward, and until 1932 virtually nothing was done to update or increase preparations for either offence or defence. By 1932 a scheme (the first of many) for increasing the strength of the Royal Air Force home defence squadrons and ancillary organ-izations was prepared. Now a defence scheme has to be pointed at someone; in this case, the power most able – if not most likely – to attack. This happened to be France. So all the defences pointed at Britain's immediate neighbour. Later, it was realized that the principal threat came from Germany and the whole thing had to be re-orientated. The joke here, of course, was that when Britain did have a need for defence, the Germans were in France.

The gradual process of bringing the Royal Air Force up to something like adequate strength continued right up to 1939, never quite meeting the goals announced by the politicians. In many respects, though, the service was more fortunate than those of other nations. Its independence gave it the opportunity to develop its own staff structure and to work out methods of control based on the indivisibility of the air – Trenchards's great preaching point. Outside home defence the increasing commitments to safeguard Empire communications gave the air commanders, and the industry that supplied them, considerable practice in long-range and far distant operations. Some of the Empire burden was removed during the 1920s when the air forces of Australia, Canada and New Zealand became autonomous bodies within the countries' own armed forces. Royal Air Force responsibility remained strong in India and in the provision of flying boat bases along the Imperial routes.

On 1 October 1922, the Royal Air Force took over military control of Iraq, at considerable savings of money by the Treasury and of sweat and blood by the

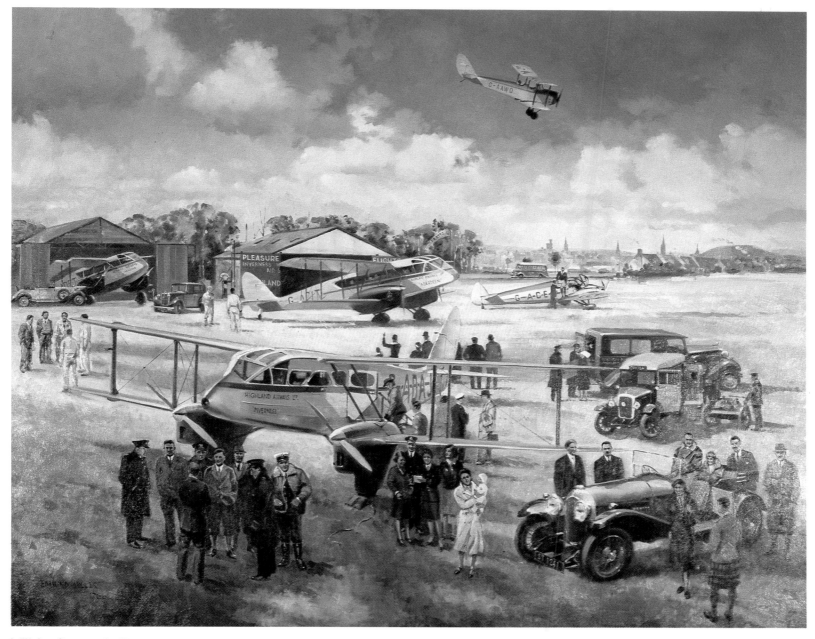

A Flying Start to the Day EDMUND MILLER GAvA
DH Dragon Rapide (two DH Gipsy Queen, 200 hp engines), General Aircraft Monospar (two Pobjoy R, 85 hp engines), DH Dragon II (two DH Gipsy Major, 130 hp engines), Highland Airways.

Eddie Miller is one of the more versatile members of the Guild, equally at home with shining aircraft portraits set in delightful, rolling cumulus cloudscapes or with carefully-composed and authentic groups of people, aircraft and vehicles in ground scenes. Highland Airways was founded in April 1933, by Captain E.E. Fresson, one of the great pioneers of British domestic airlines, who created a network of services among the highlands and islands.

army. The scheme largely worked well and was a valuable piece of positive propaganda for the service in its relations with the other two services. The mobility and swiftness of air power meant that the Royal Air Force was to provide support wherever there was trouble; indeed, it is doubtful if it was ever totally at peace during the twenty years that followed the Armistice. Apart from the need to send expeditions to northern and southern Russia in the ill-conceived effort to bolster White Russian forces, there was trouble in

Ireland and sporadic outbreaks all over the Middle and Far East that kept the squadrons busy.

In 1922, the main strength at home was in No. 1 Group, commanded by a certain Air Commodore Hugh Dowding, and consisting of five bomber squadrons and one of fighters. A further fighter squadron had gone to Turkey over the Chanak crisis. There were two squadrons of Bristol Fighters at Farnborough, eighteen aircraft at North Queensferry (the complement of HMS *Argus*), and two coastal and torpedo

squadrons at Gosport. There were three squadrons in Egypt, two in Palestine, and in Iraq, where the Royal Air Force was in charge, a squadron of Snipes, four of DH9as and one each of Vimys, Vernons and Bristol Fighters. In India were four squadrons of Bristol Fighters, one of DH9as and one, No. 60, with the twin-engined DH10s. There was a squadron in the Mediterranean, one at Aden, three in Ireland and five temporarily at Constantinople. That was the operational strength of what had been, four years earlier, the largest air force in the world.

All the aircraft were wartime types. The new aircraft that would have fought the campaigns of 1919 never got beyond prototype stage. This was partly for the financial and other reasons already mentioned, but also from the embarrassing fact that the new Dragonfly radial engine that was to have been used, 11000 of

which had been ordered, turned out to be a monumental and irremediable flop. Not until the appearance in the mid-twenties of the heavy but reliable Armstrong-Siddeley Jaguar radial could new designs be adequately powered. The few fighter squadrons continued to fly rotary-powered Sopwith Snipes.

The Salisbury Committee's report in 1923 recommended an increase to fifty-two home defence squadrons. Ten years later, only twenty-four had been added and from 1932 to 1934 none were added at all. Disarmament conferences, the League of Nations, and a strong 'peace at any price' lobby enabled politicians successfully to evade embarrassing subjects like defence.

The emergence of the new German air force, the Luftwaffe, from the shadows instilled rather more sense of urgency and when that country left the League and the more-or-less permanent Disarmament Conference in 1933, it was announced that the goal for Royal Air Force expansion was now to be seventy-five squadrons, with forty-one new ones, including eight for the Fleet Air Arm, in the next five years. By 1936, when a massive re-organization of the Royal Air Force into a series of operational commands took place, only fifteen more had been created while the grand (and paper) total was being constantly revised upward in a series of expansion schemes, some of which sank without trace. Annual production of aircraft was about 1000, or rather less than that of France in 1913.

In 1936, when the peril of another war was becoming very real, a scheme of 'shadow' factories was introduced, to harness the production capabilities of the

Cold but Carefree MICHAEL JOSEPH
De Havilland DH60X Hermes Moth (ADC Cirrus Hermes I, 105 hp engine).

The early Moths were powered by the Aircraft Disposal Company's neat four-cylinder engines (basically one cylinder block from a war-surplus Renault). They sired a series of light aircraft that spanned the world and brought practical flying to the private sector. This one, seen being flown from the Shuttleworth Trust aerodrome at Old Warden, belongs to Stuart McKay, Chairman of the DH Moth Club.

Michael Joseph and his identical twin brother Graham (both pilots with British Caledonian Airways) are prolific and steady supporters of the Guild. They paint mostly in watercolour and specialize in the light aircraft that they fly for pleasure and recreation. Recently they have been joined as exhibitors by their brother John, who is neither identical nor a British Caledonian pilot.

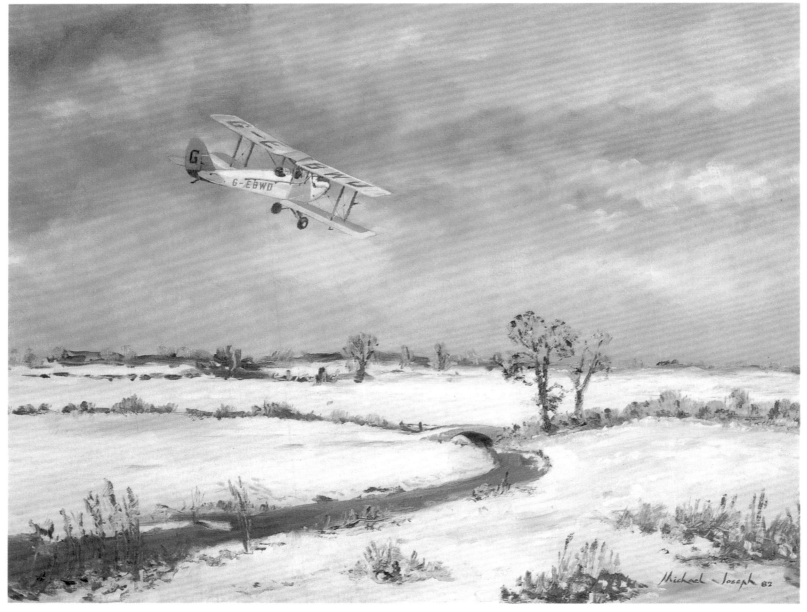

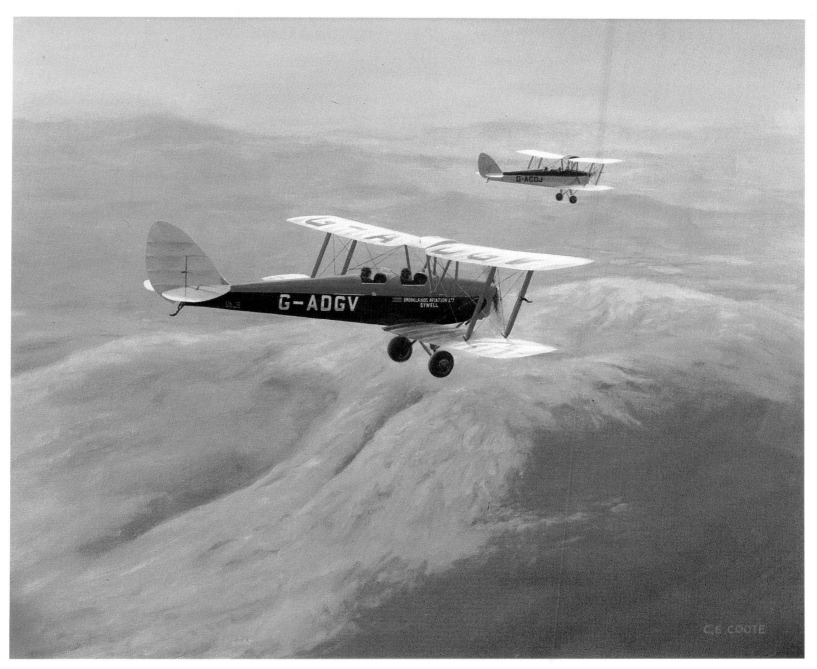

Next Stop Strathallan CHARLES COOTE GAvA
DH 82a Tiger Moths (DH Gipsy Major 1c, 130 hp engine).

The DH Tiger Moth, developed from the popular Gipsy Moth, was originally produced in 1931 for the RAF as a trainer. The top wing was brought forward to make access to, and exit from, the front seat easier in an emergency. This resulted in weird re-adjustments in sweep-back incidence and stagger, to keep c.g. and c.p. properly related. Although some were built for civil use before 1939, most of the post-war horde of Tigers that equipped flying clubs and belonged to private owners were ex-RAF aircraft. G-ADGV of Brooklands Aviation served with No. 6 Elementary Flying Training School until 1942, when it went to the Royal Navy. It was at RNAS Roborough, Plymouth, in 1960 and subsequently became the property of Air Commodore Wheeler, then Chief Trustee of the Shuttleworth Trust. It continued to carry its pre-war colours, and is seen *en route* to the Moth Rally at the Strathallan Museum in 1979.

motor industry to aviation needs. In 1938, a second scheme provided for government-funded increases in the capacity of the aircraft companies. The desired upswing in production was very much an eleventh hour affair, but it did provide mass production of airframes and, even more

important, Rolls-Royce Merlin engines on a scale that would have been impossible for private companies to finance.

The disadvantage, and it was a very real one, was that whatever aircraft were in the pipeline were 'frozen'. In the urgent need to equip more and more squadrons,

obsolescent types like the Whitley, Hampden and Blenheim, and totally unsuitable types like the Battle, which was badly underpowered, continued to be built and issued. In addition, the restrictions on size imposed by the dimensions of hangars and by the official refusal to consider the purchase of land to enlarge aerodromes, presumably to avoid the accusation of being warlike, resulted in ridiculous compromises in new designs. The first of the four-engined bombers, the Stirling, being designed about this time, suffered particularly from these unfortunate circumstances.

During the 1930s, however, the fortunate fact of the RAF's independence enabled much progressive thinking to be put into effect. As a result the fighters of 1939

carried powerful armaments, although it must be admitted that no successful heavy machine gun had yet been developed. Radar was becoming a practical weapon and was far-sightedly melded into Britain's defence structure. Far more basic, and far more important, that independence of thought and action sent the RAF into action in 1939 with the most highly developed, centrally-controlled command, defence and staff structure in the world. These things were to be of paramount importance in the Battle of Britain.

Technical progress, as elsewhere, was generally slow in the inter-war years. The Hawker Hurricane, Britain's first multi-gun monoplane fighter, reached the first squadron at the end of 1937. It was built on the same lines as its predecessors, the Pup and the Camel, although steel tube replaced the wooden structure of the fabric-covered fuselage. Even that had its advantages, as the Hurricane got into service much quicker than the more advanced but complex Spitfire.

Defence of the United Kingdom was only one of the many tasks that dispersed the effort of the RAF. Defence of Empire communications, policing operations all over the world and the requirements of naval aviation all stretched the available resources. Moreover, the requirements of colonial operations had produced a whole breed of aircraft totally unsuitable for any other purpose. Only from the requirement for very long-range, large flying boats did benefit flow, for the Sunderlands of Coastal Command, and the expert knowledge of their handling, would become a key factor in the U-boat war.

At the end of World War I France found herself with a large and well-organized air arm. She had perfected the grouping system of aerial units in which up to a dozen fighter and bomber squadrons, arranged in wings which were organized in *groupements*, might be under the tactical hand of one commander. Her factories had built over 52000 aircraft during the war and there were something like 3200 operational aircraft deployed at the Armistice, 1400 of them fighters in eighty-three squadrons, 480 bombers in thirty-two squadrons.

Like the Royal Air Force, the French Aéronautique Militaire suffered a considerable decline after the war, although retaining many more squadrons than the RAF. It was not until 1928, however, that an Air Ministry was set up. Prior to that, aviation had continued to be in the hands of the Army General Staff, who had other things to think about. Despite the appalling casualties and the shattering blows to its morale, culminating in the 1916 mutinies, the army was still France's chief glory and

her first line of defence. The air arm, 60 per cent of whose total strength had become casualties during the first world war, suffered almost total neglect until 1933 when mounting public pressure forced the creation of a separate force, the Armée de l'Air. Unfortunately, although the drive for new *matériel* was undertaken, it resulted in a bewildering variety of prototypes and little real production. In 1936, the military side of the aircraft industry was nationalized by a socialist government and regrouped in a series of large regional organizations, a move which initially aggravated the situation. By 1939, although a number of good aircraft were leaving the factories, they were too late to influence the campaign of 1940. Large orders for modern American fighters and bombers to fill the gap were also too late.

Italy, which had joined the Allies in 1915, had an air force of eighty-four squadrons with 1683 aircraft at the end of World War I. With the importance of the Adriatic in the naval war, it was not surprising that there was a large naval air arm, of forty-four squadrons, with fifteen airships. Starting the war with virtually no experience, and having throughout the war to equip her fighter squadrons with French aircraft, Italy had built up an impressive bomber programme based on the huge Capronis, which were also used by the British and Americans.

Within ten years the air force, renamed Regia Aeronautica when it became independent in 1923, had acquired around 1200 aircraft, which had more than doubled by 1940. Some limited experience was acquired operationally in the 1935 Abyssinian campaign (against no opposition) and in the Spanish civil war of 1936-9, when Italy sent numbers of aircraft to Franco's assistance. Like her German companions in that convenient testing ground, she drew a number of erroneous conclusions, one of which was to confirm a conservative preference for the handy but out-dated biplane fighter. Adherence to this policy put Italy about three years behind Britain and Germany in the second world war.

On the other side of the world, Japan was stirring. Her army and naval air forces had been trained and equipped in the 1920s by French and British missions. Not surprisingly, in view of her location, Japan started early in aircraft carriers, at the same time as Britain, commissioning her first, the *Hosho*, in 1922. In the same year the first British purpose-built carrier, *Hermes*, was commissioned. A series of wars or warlike actions – Manchuria in 1931, Shanghai in 1932 and China in 1937 – gave Japan the opportunity to train the force that was to fight World War II. At the same time she built up a strong aircraft

industry in an early example of her industrial coming of age.

All military aviation in Germany, even a token air defence force, was forbidden by the Treaty of Versailles, which came into force just a year after the Armistice was signed. Seven police air patrol units, organized on a local basis, were all that were allowed and, together with any remaining air organizations, they were disbanded the following May by General von Seeckt, Commander-in-Chief of the army, at the request of the Ambassadors' Conference in Paris. Twenty thousand aircraft, including 2400 in the front line had been on charge in 1918; three-quarters of these had been immediately surrendered.

In 1922 the Ambassadors' Conference also imposed restrictions on civil aircraft (not mentioned in the Treaty), to be enforced by the Inter-Allied Military Control Commission, adding further curbs in 1924. In 1926, when the Paris Air Agreement replaced the Treaty of Versailles, all these restrictions were withdrawn.

The German General Staff, determined to rebuild an air force, even if in skeleton form, began to circumvent the Treaty limitations. Clandestine recruitment and training began in 1920. Training discussions began with the Russians in 1921 and German manufacturers set up factories to build new designs in Italy, Spain, Switzerland, Sweden and Turkey – some of which survived for many years. In 1923, one hundred aircraft were ordered from Fokker, now comfortably established in his native Netherlands, largely for equipping the secret training base being set up at Lipezk in the Soviet Union. The first training course there began in 1926 and in 1928 testing was arranged there for the new military prototypes on order from German industry.

At the same time, the German authorities encouraged the new sport of gliding, boosting national pride in achievement in this permitted field of activity. When the national airline, Luft Hansa, came into being, it quickly became a focus for military training and expansion. Production, recruiting and training proceeded apace and in the next three years a huge re-equipment programme took place, so that in 1939 Germany was better equipped for offensive action than any other country in the world.

From the beginning, the Luftwaffe was an independent service (von Seeckt, the army commander, had laid that down in 1923) but its major duties were seen to be, as in the 1914-18 war, support of military operations, rather than independent action. Because of this, in such matters as fighter range and bomber load, it was at a disadvantage later on.

Like the French, Russians and Italians, the Germans sent aid to Spain. Franco's initial airlift of troops from Morocco was in twenty Ju 52s; the Legion Condor, a self-sufficient force of some strength, arrived in 1936; and during its time in Spain the Luftwaffe rotated large numbers of pilots and virtually all its combat aircraft types. In Spain, the young fighter pilots who were to hold command in the Battle of Britain and afterwards, worked out successful tactics. But the lack of opposition caused the Luftwaffe to believe that its lightly armed day bombers were adequately protected from fighter attack.

When its official life began, the Luftwaffe mustered 1888 aircraft. By August 1938, it had 2900 and a year later, on the eve of the war, 3750.

That portion of the Signals Department of the United States Army that was devoted to aviation was not, as we have seen, either large or well-equipped in its early days. When America entered the war on 6 April 1917, it had thirty-five pilots and fifty-five aircraft of a sort. It also acquired, in a Congress vote on 24 July, an appropriation of a staggering $640 000 000 – the largest single sum ever voted in the history of that august body.

For a very brief period at the end of the war, the service became independent but it was re-absorbed into the military bosom by the Army Re-organization Act in 1920, becoming the Army Air Service. At that time the total strength had come down to around 10 000 bodies, although the Act authorized considerably more, and it stayed at about that level for the next six years, until it became the Army Air Corps. An expansion programme was then organized that was intended to raise its strength to 16 650 of all ranks. A whole series of programmes was subsequently initiated, the series continuing to this day, to build the service up to the number of groups required.

Small though the service remained for many years, under the initial drive of Brigadier-General Mitchell a series of development and training programmes was initiated. The use of radio and parachutes was investigated in 1919, flights right round the American coastline and borders were accomplished, dive-bombing experiments carried out (with a DH4B) and a whole series of altitude and long-distance records set up, partly for training and partly to advertise the service. Also in 1919, trials took place with leak-proof fuel tanks, reversible and variable pitch propellors and tests with bombs and 37 mm cannon were made against armoured vehicles. A long-suffering DH4 was rigged with no less than eight machine guns.

In the summer of 1921, Mitchell's bombers took a dramatic hand in bombing trials by the army and navy against moored warships, upsetting not only several ships but also the naval and military establishment. Mitchell's actions sparked off a 'bomb versus battleship' argument that raged for years and did little for the relationship between army and navy – always inclined to be tense and competitive. It must be admitted that there was still room for doubt about Mitchell's claims. It took three attacks, the last with 2000-pound (907-kilogram) bombs, to deal with an inert and motionless battleship and even then she took all day to sink.

In 1921 a 4300-pound (1950-kilogram) bomb was dropped from an aircraft. Record flights continued to hit the headlines: a world altitude record of 34 508 feet (10 518 metres) the same year; in 1922, the first border-to-border flight, and the first trans-continental flight within twenty-four hours, was made by a Lieutenant J.H. Doolitt'e. The first jettisonable auxiliary fuel tank was

Jimmy Doolittle takes off RICHARD HALFPENNY
Lieutenant (later General) James H. Doolittle and the Curtiss R3C-2 (Curtiss V-1400, 565 hp engine).

The United States entered the Schneider Trophy contest for the first time in 1923, fielding a government-backed (navy) team – another innovation. Winning this, they sportingly declared a bye in 1924 when no opposition came to the line. This cost them the Trophy, as Doolittle won for the United States Army in 1925, his (navy) team mates dropping out with engine problems. Britain's white (literally) hope, the Supermarine S 4 developed wing flutter and crashed and the Italians and the remaining British entry were not fast enough. The painting reproduces dramatically the awesome surge of power, spray and general uncontrollability generated on opening the throttle in these hairy aircraft.

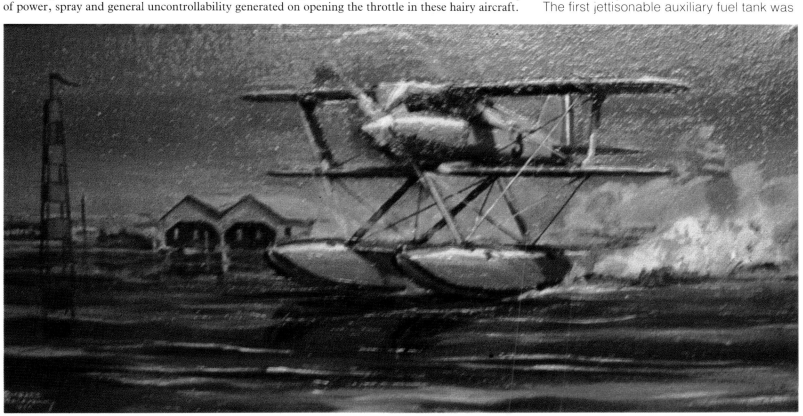

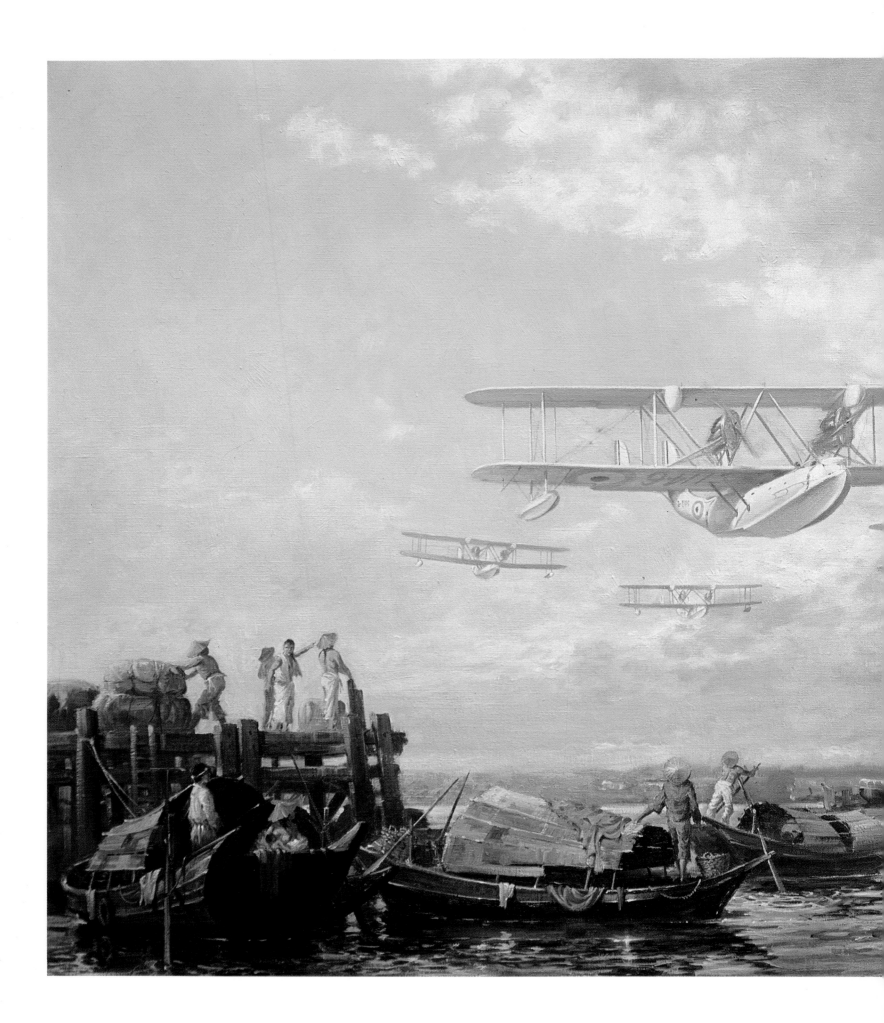

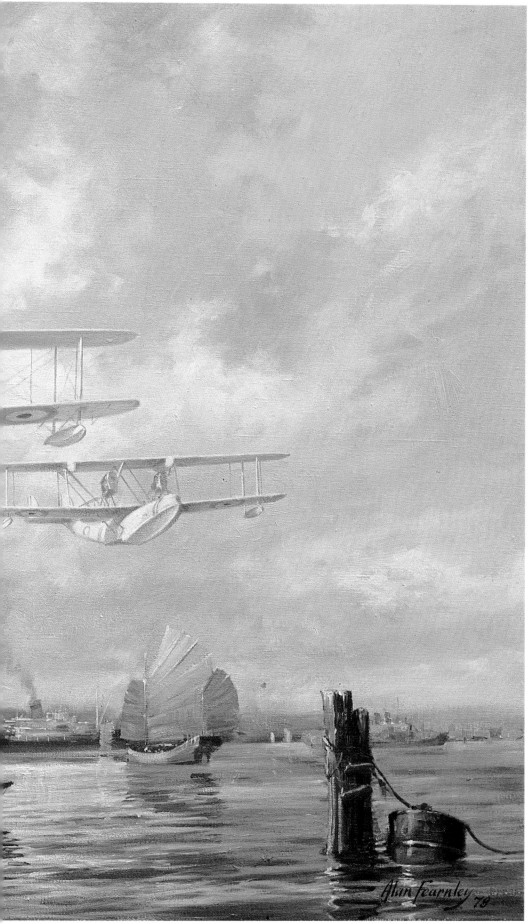

Far East Flight ALAN FEARNLEY GAvA
Supermarine Southampton II, (two Napier Lion V, 502 hp engines).

With twelve years of operational life in the Royal Air Force, the Southampton was one of a long line of successful Supermarine flying boats designed by R.J. Mitchell (whose crowning glory was the Spitfire). Four squadrons were equipped in the Coastal Area and one in the Far East. The home squadrons, No. 201 at Calshot, No. 203 at Cattewater, No. 204 at Mount Batten and No. 210 at Felixstowe, with a second base at Pembroke Dock, were all ex-Royal Naval Air Service units, re-numbered in the 200 series when the Royal Naval Air Service and Royal Flying Corps merged to become the Royal Air Force in 1918. The overseas squadron, No. 205, at Singapore, was formed from the Far East Flight in 1929. The chief claim to fame of the Southampton lay in the series of very long-distance flights about the British Empire made by groups of these boats. The most famous of these groups was the Far East Flight, which flew from Felixstowe to Australia, via Singapore and Hong Kong in 1927, returning to Singapore and covering a distance of over 27 000 miles (43 451 kilometres) in the process. These flights served to promote the world-wide coverage of the Royal Air Force and acted as useful episodes in the process then known as 'showing the flag'. They also gave the Coastal Area – later, in 1936, to become Coastal Command – very useful experience in long-range flying-boat operations.

The painting shows the Far East Flight, commanded by Group Captain Cave-Browne-Cave, in the course of their epic journey.

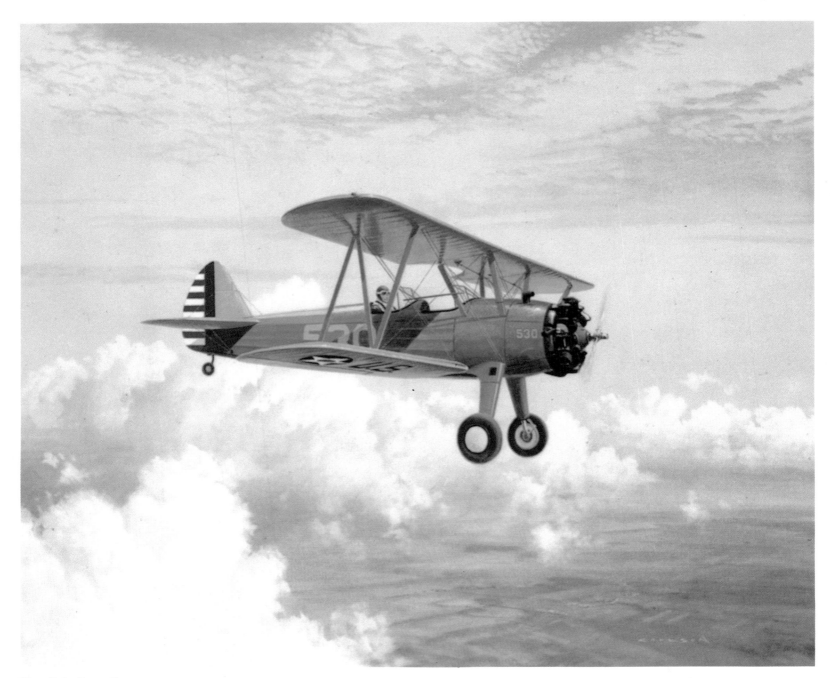

First Solo Cross Country GERALD COULSON GAvA
Stearman PT-17 (Continental R-670-5, 220hp engine).

The first Stearman Model 75 produced for the army flew in 1936, the PT-13. The later, and most numerous version, the PT-17, had a different engine (a variety were installed in the different marks). A total of 3769 were employed for both army and navy training. One of the best- known primary trainers, it carried over its useful life into crop-dusting, barnstorming, aerobatics and plain fun-flying. Although production stopped in 1944, six years later there were still 4125 of all marks on the United States civil register. The pre-war trainer markings shown in the painting were retained until early 1942. As Boeing took over Stearman at the beginning of the war, this aircraft could be either a Boeing or a Boeing-Stearman PT-17 – but to most people they were always Stearmans.

Gerald Coulson's famous portraits of aircraft are far too well known to need introduction and have been selling as a series of prints for many years. He has recently begun to vary his presentations of aircraft showing them against a fairly formal background and using heavily recessive perspective in his compositions. A pilot himself, he has achieved a mastery of cloud painting.

tested in 1923 and Lieutenants Kelly and Macready flew non-stop, coast to coast in the Fokker T-2, covering 2520 miles (4055 kilometres) in twenty-six hours and fifty minutes. Other activities included skip-bombing tests, blind flying and blind landing experiments, high altitude precision bombing, and flight refuelling.

Although the number of aircraft on charge remained small (only 118 new aircraft were delivered in 1926, the year of

the Air Corps Act), a large programme of experimental and prototype aircraft persisted throughout the period. In 1933 the first formal proposals were laid down for a new four-engined bomber that was to become the B-17. The prototype first flew in 1935. Boeing had already produced for the army in 1930 a 188mph (302km/h) twin-engined bomber, the B-9, and in 1932 the Martin B-10 appeared, with a top speed of 213mph (343km/h). A year later

Boeing introduced a 234mph (376km/h) metal monoplane fighter, the P-26. All these entered service and kept the Air Corps well in the forefront of technology.

Unfortunately, from the point of view of the Air Corps, the official policies of the United States were firmly isolationist. The need for a strong, far-reaching air force was very difficult to convey to a government occupied with the slow recovery from the depression and determined to stay aloof from any European entanglement. Mitchell, whose public campaign for a strong air arm had resulted in his court-martial and dismissal, tried to convince President Roosevelt in 1936 but without success. Sadly, Mitchell died shortly afterwards.

Another piece of publicity backfired heavily. In an attempt to draw attention to the potential of their new bombers, a formation of B-17s carried out a practice interception of a liner, the Italia Societa di Navigazione's crack 51000 ton (51816 tonne) Rex, over 700 miles (1126 kilometres) out in the Atlantic. Unfortunately, it drew

the navy's attention to what it considered poaching in its waters and in 1938 the Air Corps was reminded that it was there for defence, not aggression. It was pointed out that anything more than 100 miles (161 kilometres) offshore belonged to the navy and that, anyway, it was not yet clear that one B-17 was a better investment than two or three smaller twin-engined bombers.

Fortunately, authority then woke up to reality, assisted by the patent facts of the Spanish Civil War and by fascist re-armament, and rather late in the day (a general failing among democracies) in April 1939, Congress voted $300 000 000 – half the 1917 vote – for 6000 aircraft. But there were still only twenty-five B-17s on charge when Europe went to war in 1939.

The Russian bolsheviks inherited around 2500 aircraft when they dropped out of the war in November 1917 and negotiations for a separate peace started the following month. Within the next few years they had very largely allowed the lot to fall into ruin. Only a small number of the officers of the Imperial Air Service would still be serving and after the White Russians had been seen off and Poland had successfully defended her independence, there were more immediate problems, like survival. In any case, most of the serviceable aircraft had fallen into German hands in the final offensive before the Treaty of Brest-Litovsk.

The remnants of the forty or fifty four-engined bombers, designed by Sikorsky and used with conspicuous success during the war, were kept in employment against the White Russian general, Wrangel. Their influence on battles so impressed the commanders of the Red Air Fleet that the heavy bomber became something of an article of faith in the twenties and thirties. The original tactical employment of the Sikorskys may have had something to do with the failure to develop a strategic attitude. In any case most of the new bombers were obsolete by 1941 and employed to transport the large forces of parachutists who never seem to have had much of a military future themselves.

In 1924, while Western air forces were beginning the first faint stirrings of revival,

Fairey Flycatcher Replica BRIAN PETCH

G-BEYB/S1287 (Pratt and Whitney Wasp Junior, 450 hp engine). Full scale replica.

This aircraft was built by John Hall and Maurice Gilbank to the original Fairey drawings for its owner/pilot, John Fairey, the son of the Company's founder, Sir Richard Fairey. The replica first flew in 1979 and lives at the Fleet Air Arm Museum at Yeovilton. The original first flew in 1923 and was the first new aircraft to enter the services and the first specifically designed to fight from carriers. It was also the last aircraft to fly off a gun-turret platform and to use HMS *Furious'* slip deck. It had a 425 hp Armstrong-Siddeley Jaguar IV engine. The replica carries the serial and markings of an aircraft of No. 405 Flight, HMS *Glorious*, in 1930.

Brian Petch is a Kent artist, known for landscape as well as aviation and railway subjects. He adopts a naturalistic style for most of his paintings which is retained even when dealing so successfully with mechanical subjects.

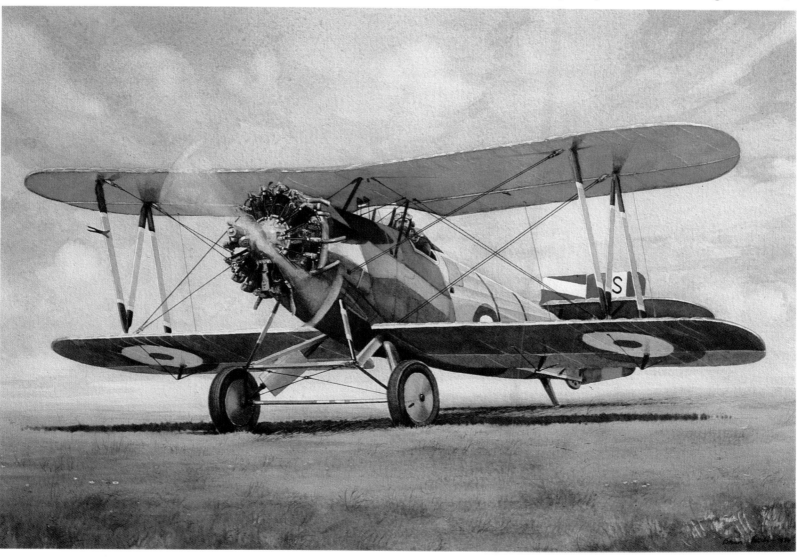

the Soviet industry produced thirteen aircraft. The total strength of the Red Air Fleet was 322 (including thirty-six naval aircraft). Patently this would not do, and a start was made by concentrating on a bomber/reconnaissance aircraft – basically a licence-built DH4 with a local version of the 400hp American Liberty engine. Nearly 2000 were eventually built as R-1s.

A useful trainer was acquired by dismantling, studying and putting into production an Avro 504 that had fallen into Soviet hands – a process carried out by Sergei Ilyushin and later to be copied by Tupolev in 1944 with the Boeing B-29.

Large numbers of foreign aircraft were bought to bolster local production and fill gaps. Fokker received considerable orders for fighters , some of which went to stock the German training base at Lipezk.

Gradually things improved. Personnel selection was better organized, as was training, and a national campaign of support for the Air Fleet got under way. The first two five-year plans presented a dramatic improvement in aircraft procurement. Figures of Russian strength in this or most other periods have never been terribly reliable. As an American general once said: 'There are no experts on the Soviet Union – only varying degrees of ignorance'. But there were nearly 3000 aircraft of all types in 1933 and (according to Soviet sources) 4700 combat aircraft in 1936. A German educated guess in 1938 gave a front-line total of 6000 aircraft. By this time the aircraft industry had virtually caught up with the rest of the world and Soviet designers were capable of turning out respectable aircraft.

Like the French, the Russians sent substantial air aid to the Republican forces in Spain and the I-15 and I-16 fighters, SB-2 bombers and R-5 reconnaissance aircraft were probably the best the Spanish Government had at their disposal. The first twenty-five Polikarpov I-15s arrived in time to take part in the defence of Madrid at the end of 1936; a further thirty-one arrived in February and eventually 287 were built in Spain by CASA. Eight squadrons were formed. The first I-16 monoplanes arrived in November, flown by Russian pilots and quickly began to deal with the Nationalist Ju 52 bombers. About 250 were delivered.

At the end of the first world war, naval aviation was just beginning to settle into the operational pattern that it was henceforward to follow. The use of seaplane carriers and their very unsatisfactory employment was beginning to give way to the aircraft carrier proper and the first attacks using torpedoes had been made by naval aircraft.

The Royal Navy found itself in a most

unfortunate situation in 1919. Work on the development of aircraft carriers was well under way, with HMS *Furious* fully converted into a flush deck vessel. HMS *Argus*, the first ship completed as a full carrier had come into service in 1918 and two others HMS *Eagle* and HMS *Hermes* were being built; they were completed in 1920 and 1923 respectively. All four fought in the second world war but only the first two survived it. The unfortunate part was that since the formation of the Royal Air Force in 1918, the navy had lost control of its flying squadrons and relied entirely upon a junior service (which certain naval elements were striving to supress) for the supply of pilots and the support of flying units. The admirals (some of them, anyway) conducted a prolonged campaign to regain naval air and the controversy dragged into the mid-twenties in a welter of committees and propaganda. In spite of this, and the anomalies of naval officers having to 'join' the Royal Air Force to learn to fly and Royal Air Force officers spending large portions of their careers serving on ships, at the operational level on carriers and in squadrons the system was made to work.

The pattern of post-war development paralleled that of the junior service. In 1919 there was precisely one naval squadron and some scattered flights. Re-equipment and expansion followed slowly; in 1923 the squadrons were re-mustered in more handy packets of six-aircraft flights and in 1924 the name Fleet Air Arm (of the Royal Air Force) became official. Squadrons were re-introduced in 1933 as the service expanded. Tactics and suitable aircraft for them were worked out and new and better carriers came off the slips; *Courageous* and *Glorious* were converted from the last of the 18-inch gun battlecruisers in 1924-30, the *Ark Royal* – the first truly modern carrier – was launched in 1937 and the first of the big '*Illustrious*' class fleet carriers was laid down in 1939. British carriers carried relatively small complements of aircraft and earlier ones were handicapped in size not only by financial stringency but by the provisions of the Washington Naval Disarmament Treaty of 1922. One significant advantage they did possess which was to be of vital importance: heavily armoured flight decks, a feature that was to save ships under bombing attack.

The French navy did not take to naval flying with the same initial enthusiasm as the British, its role being somewhat different. Two ships, *Campinas* and *Rouen* were converted to seaplane carriers and served in the eastern Mediterranean and one other, the *Pas de Calais* served in the Flanders area. An old cruiser, the *Foudre*,

was also converted to carry flying boats.

Between the wars, only one aircraft carrier was built, a conversion from a '*Normandie*' class battleship, the *Béarn*. Completed in 1927, she carried forty aircraft in three dive-bomber squadrons. Two other carriers, *Joffre* and *Painlevé* were laid down in 1938 and 1939 but, as in so much of the French effort, were initiated too late and were never completed. The rest of French naval air power consisted of one seaplane carrier, the *Commandant Teste*, completed in 1932.

Two other smaller navies also clung to the outmoded seaplane carrier; the Spanish *Daedalo* and Swedish *Gotland* were virtually the only other examples of the type. Neither Germany nor Italy showed much interest in carrier-borne aviation, though the Germans started on the *Graf Zeppelin* in 1938. Lacking any tradition of carrier work, progress was sporadic and the carrier was never finished.

The first United States naval aviator, Lieutenant T.G. Ellyson, was trained by Glenn Curtiss. Along with Eugene Ely and Curtiss himself, they laid the foundation of American naval air power in 1910-11, with the first catapult launches and shipboard operations. The first take-off from USS *Birmingham* on 14 November 1910, by Eugene Ely, was the start of the carrier story. Just over two months later, on 18 January, he made a landing and take-off on USS *Pennsylvania*. The first Marine aviator, Lieutenant A.A. Cunningham, started flying duties in May 1912 and by January 1914, the Marines had their own air arm.

At the end of World War I, the naval air arm controlled 2107 aircraft and 230 balloons and dirigibles with a strength of 37409 personnel. Post-war cutbacks and the general reaction affected naval flying as much as military. The Washington Treaty severely limited ships and under President Coolidge virtually all development work on aircraft was stopped and the navy was left with only six air bases in the whole continental United States. Enthusiasm and essential training in the navy, as in the Air Corps, were kept going by spectacular record flights, including the first flight across the Atlantic. In 1925, attempting the first crossing of the Pacific to Honolulu, Commander John Rogers with a PN-9-1 flying boat, flew 1841 miles (2962 kilometres) and then running out of fuel, sailed the aircraft 450 miles (724 kilometres) to his destination.

The navy's main strength lay in its large fleet of twin-engined flying boats, developed by Curtiss and by the Naval Aircraft Factory with British-designed hulls, and in single-engined seaplanes. Both classes trained for work with the fleet, and

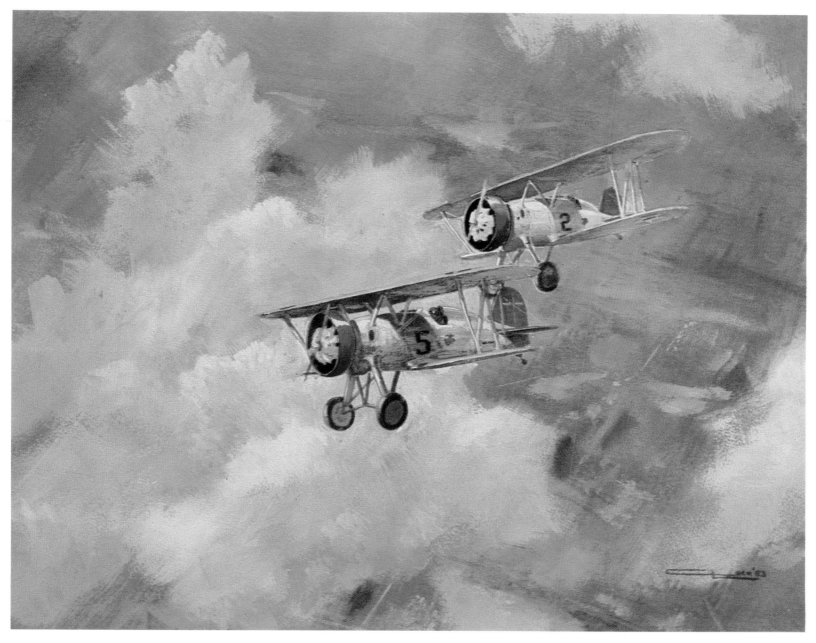

F4B-4s of VF-9M, USMC CHARLES LOCK
Boeing F4B-4 fighters of a US Marine Corps squadron (550 hp Pratt and Whitney Wasp engine).
Developed from a company private design intended to re-equip both army and navy, the F4B series
was the last of the classic fixed-undercarriage, biplane fighters to serve the United States armed forces.
It was followed by a number of unique retractable-gear biplanes tailored to ship-board take-off
restrictions. For the army they were the P-12, for the navy the F4B. Five hundred and eighty-six were
built. The first F4B-4s went to navy squadrons VF-3B (USS *Langley*) and VF-10M (USS *Saratoga*).
The first land-based Marine squadrons were VRF-9M and VF-10M. Some survivors flew on odd jobs
until 1941, including one of the earliest conversions to a radio-controlled target drone.

experiments in torpedo work and bombing
were kept up. On 26 October 1921, the
first catapult was successfully tested and
major warships began to be equipped with
catapults. The British had been carrying
aircraft on battleships, battlecruisers and
cruisers since June 1917. At the Armistice
they had over a hundred embarked aircraft,
flown from platforms on gun turrets. Unlike
the British, and much to their advantage,
however, the United States Navy retained
control of its air power, establishing a
Bureau of Aeronautics on 12 July 1921. In
its first commander, Captain W.A. Moffett,
it had a man determined to see naval
aviation come into its own.
 The first American carrier was the USS

Langley, a conversion from a collier dating
from March, 1922. As a result of
experimental work on the *Langley* and
under the drive of Admiral Moffett, by now
firmly convinced that a strong carrier force
was America's best defence, the navy
received its first two fleet carriers in 1929.
The USS *Saratoga* and *Lexington* were
converted from battlecruisers scrapped
under the Washington Treaty. A special
clause was inserted to cater for their
33 000 tons (32 479 tonnes), the limit for
new building having been set at 27 000
tons (26 574 tonnes).
 With these big ships, carrying ninety
aircraft each, the United States Navy
worked out carrier techniques, employing

both in the fleet manoeuvres of the 1930s.
They were joined by the USS *Ranger*,
launched in 1933, and the USS *Yorktown*
and *Enterprise*, the first ships of a new
class, in 1936. The last two were 20 000-ton
(20 320-tonne) ships, steaming 34 knots
and carrying 100 aircraft each below their
800-foot (244-metre) wooden flight decks;
they marked a great step forward.
 New names began to appear among the
makers of aircraft for the navy – Vought,
Douglas and Boeing among them. The
size of the new carriers enabled the fleet
to work every kind of aircraft and gave
great flexibility to naval air. Unlike the Fleet
Air Arm, which struggled on between the
wars with grossly inferior aircraft, the
Americans saw no reason why the fleet
should not have aircraft of comparable or
better performance than the army. The vast
distances in the Pacific area gave added
impetus to performance improvements.
 The Washington Treaty, which exercised
such baleful influence on the future of sea
power, acknowledged the existence of
Japan as a naval power and its provisions
raised her into third place after Britain and

the United States. As Japanese ambition in the Pacific grew, so did her navy. She withdrew from the Treaty in 1934 (it expired anyway, two years later, unwept) and from the earliest days her plans included a carrier force. British influence was dominant after World War I, with a British mission overseeing the build-up of naval air power. The first Japanese carrier, full-decked and converted from a tanker, was the *Hosho*, completed in 1922 and later given the fully flush deck popular with Japanese designers. She was followed by the *Kaga*, a battleship conversion completed in 1926 and carrying sixty aircraft, as did the *Akagi*, completed the following year. Some ten more fleet and escort carriers had been launched before Pearl Harbour and an extensive programme for further ships had begun. Supported by a fleet of aircraft transports, the carriers were destined to form the principal striking force of the Imperial Navy.

The growth of commercial flying in Europe and in the United States followed similar patterns. Experimental services with mail and largely military passengers were undertaken in 1919, linking the Army of Occupation and Britain. Similar trials took place elsewhere, but it was to be many years before travel by air was to be anything but adventurous. The 1920s, in particular, and the early 1930s were a period when the majority of stories about aviation concerned record-breaking and air racing, neither subject particularly inclined to encourage the fare-paying public.

Air Mail to Cologne TERENCE CUNEO, Vice-President GAvA
Royal Air Force de Havilland DH9 (Beardmore-Halford-Pullinger BHP, 240 hp engine).

This painting, the property of the Royal Engineers, shows the operation of the British Army's mail service to the troops occupying Germany. Started on 1 March 1919 to Maisoncelles, the service was extended to Cologne, the subject of the painting, in May. No. 1 (Communication) Squadron with DH9 and No. 120 Squadron with DH9a aircraft pioneered these flights from Hawkinge in Kent.

Terry Cuneo's interests embrace steam locomotives, horses and military subjects as well as aviation; in the latter field he is probably best known for his factory production paintings for the aircraft industry. Comment upon his unique and lively style would be superfluous.

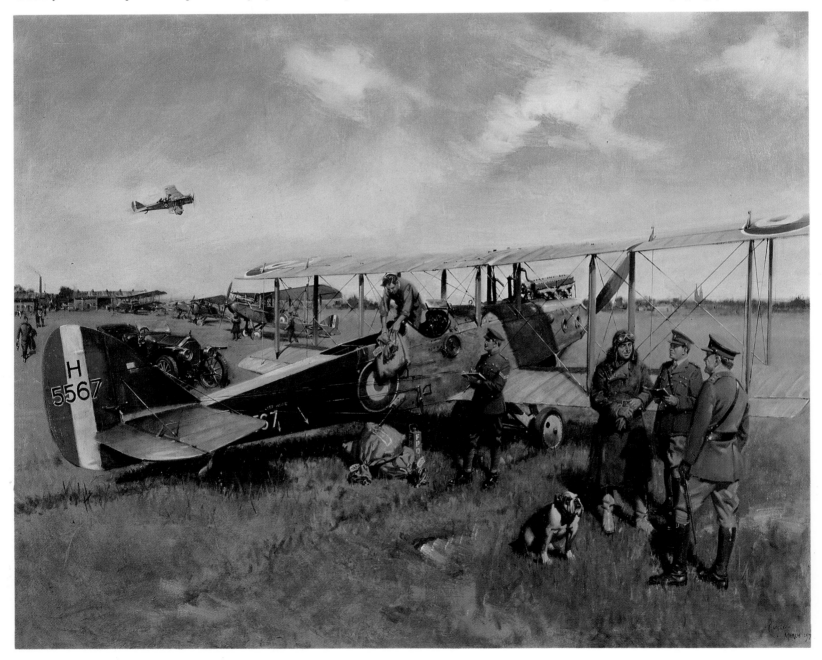

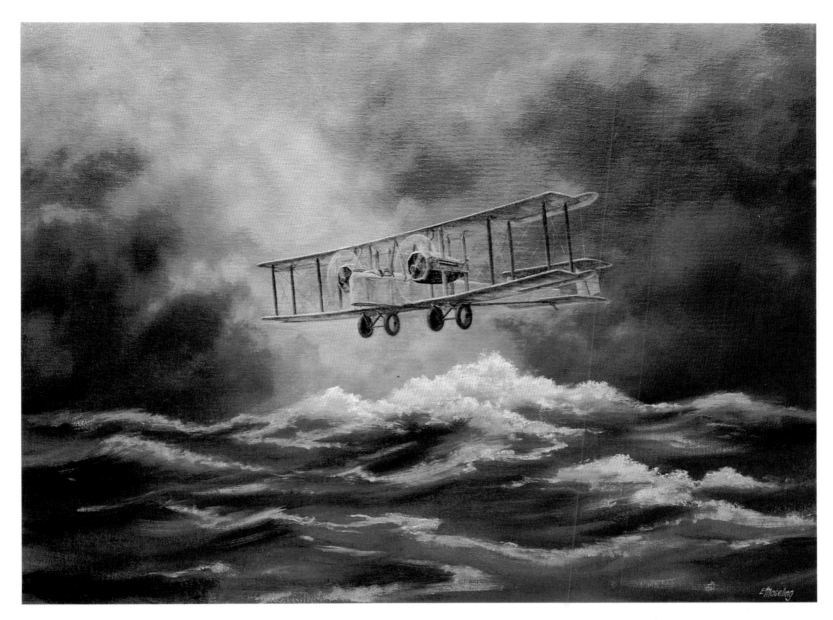

Against the Elements E.R.J. MOSELING
The Vickers Vimy (two Rolls-Royce Eagle VIII, 360 hp engines).

Captain John Alcock and Lieutenant Arthur Whitten-Brown made the first non-stop crossing of the Atlantic, from Newfoundland to Clifden, County Galway, on 14-15 June 1919, winning knighthoods, the Air Force Cross and a cheque for £10000 from the *Daily Mail*.

The artist has convincingly conveyed the essential frailty of this ex-bomber, stripped of military equipment and fitted with extra petrol tanks, battling the cold, impersonal strength of the elements. The style has something of the quality of a tapestry and echoes the almost naive formality of some nineteenth century marine artists.

The *Daily Mail* of London had put up a £10000 prize in 1913 for the first direct crossing of the Atlantic and a few optimistic souls were working on the idea when the war intervened. The offer was renewed in 1919 and several competing teams began to assemble in Newfoundland for the attempt. Prevailing North Atlantic weather made the west-east crossing sensible and most early attempts took advantage of the westerly winds. The first actual crossing took place between 16 May and 27 May via the Azores, to Lisbon, Portugal,

subsequently continuing to London. Two three-engined and one four-engined Navy-Curtiss flying boats made the attempt. Only the latter, NC-4, reached its goal, commanded by Lieutenant-Commander Read, USN, who went on to a distinguished career in carriers.

The NC-4 did not qualify for the big prize and indeed, was not entered for it. After a spectacular failure and rescue of Harry Hawker (of Sopwith and Hawker fame) and Commander Grieve in the Sopwith Atlantic in the first prize attempt,

the non-stop crossing was achieved by Captain John Alcock and Lieutenant Arthur Whitten Brown. On 14-15 June 1919, they flew a Rolls-Royce-engined Vickers Vimy to a sticky but triumphant landing in an Irish bog.

The Australian government announced a similar prize for the first Australians to return home by air before the end of 1919. This was accomplished by Captain Ross Smith, his brother Lieutenant Keith Smith and two engineers, in another Vimy, between 12 November and 10 December, with five days four hours flying time.

In July 1919 the first airship crossing and the first double crossing of the Atlantic were made by the navy's Beardmore – built R34, the last of the naval rigids. The 108 hours 12 minutes of the east-west crossing, compared to the 75 hours 3 minutes of the return, emphasize the wind problem.

The South Atlantic was first crossed in 1922, between 13 May and 16 June by

Captain Cabral and Vice-Admiral Couthino of Portugal in British Fairey seaplanes.

In the United States, record-breaking assumed even greater importance in those early years, with army and navy in fierce competition for the honours and the publicity. Major Moseley won the first Pulitzer prize, destined to become a prestigious trophy, with a speed of 178 mph (286 km/h) in 1920. Major R.W. Schroeder, who had already set an altitude record 19 500 feet (5943.6 metres) in 1919, set an official two-seater record of 31 821 feet (9699 metres) on 4 October,

and raised it to 33 113 feet (10 092 metres) on a Lepère-LUSAC biplane on 27 February 1920. He raised it again to 34 508 feet (10 518 metres) on 28 September 1921, winning the Mackay Trophy. In 1923, Lieutenants J.A. Macready and O.G. Kelly set new duration and distance records of over 36 hours and 2516 miles (4049 kilometres) and in the same Fokker T-2 they made the first non-stop trans-continental flight. The first non-stop, border-to-border, north-south flight took place the same year.

Between 6 April and 28 September 1924,

the first round-the-world flight was made by four Douglas World Cruisers of the Army Air Service, two of the original four completing the flight.

France was not far behind the British and Americans. On 11 August 1919, Lucien Bossoutrot and Louis Coupet flew a Farman Goliath 1243 miles (2000 kilometres) from Paris to Casablanca and in 1921 a young Frenchwoman, Adrienne Boland, flew an aged Caudron G III over the Andes – the first of many spectacular flights by French pilots in South America. Captain Pelletier d'Oisy flew from Paris to Tokyo between 24 April and 9 June, in a new Breguet, the XIX, destined to support many long-distance records in years to come. The speed record went to France in 1924, when Adjutant Bonnet in the Bernard-Ferbois racer raised it to 278 mph (447 km/h).

The magic of the speed record was only surpassed by the non-stop distance record, with added kudos if the attempt was made solo. Apart from the many military flights, the light aeroplane began

Southern Cross THEO FRASER
Fokker F VIIB-3m Southern Cross (three Wright Whirlwind, 300 hp engines).

The most famous of all the popular F VII-3m aircraft was this one, used by Captain (later Air Commodore Sir Charles) Kingsford-Smith. Bought secondhand from Sir Hubert Wilkins, the Southern Cross piloted by 'Smithy' made the first air crossing of the Pacific Ocean from 31 May to 9 June 1928. Coming just a year after Lindberg's solo Atlantic epic, the flight made Kingsford-Smith the hero of his native Australia. The flying time, over 7300 miles (11 748 kilometres), was 83 hours, 38 minutes. 'Smithy' broke several other records over long distances with this aircraft, many in the course of his 1930 world flight. Flown by eight nations as an airliner and built under licence in six, the F VII-3m was one of the best of its kind, prior to the introduction of the Douglas Commercials.

This spirited and evocative painting, with its near-abstract isolation of the aircraft and successful symbolism, won for Theo Fraser the first award for the Aviation Painting of the Year in 1985.

to intrude upon the scene. Bert Hinkler, a young Australian pilot, flew over the Alps to Turin from England in 1920, in a tiny single-seater Avro Baby, fitted with a pre-war engine of only 35 hp. But it was not until the arrival of the de Havilland Moth in 1925 - the first true light aircraft in the world - that light aircraft record-breaking got into its stride and for the next ten years or more provided endless headlines.

Hinkler flew solo to Australia in fifteen and a half days in 1928; Amy Johnson (the first woman to attempt the flight) did it in nineteen and a half days in 1931, and New Zealander Jean Batten flew her rakish Percival Gull over the distance in 1936 in a staggering 5 days 21 hours 19 minutes. Jim Mollison flew from Australia to England in 8 days 22 hours 19 minutes in 1931 and from London to the Cape in 4 days 17 hours 30 minutes in 1932. Record after record fell in those adventuring years and in 1939 Alex Henshaw, in a still unbeaten flight in its class, flew the single-seat Mew Gull London-Cape-London in 4 days 10 hours.

It was in 1927, though, that the most astonishing flight of them all took place - astonishing not only in itself, but for the tremendous effect it had on the world's imagination. On 20 May 1927, Charles Lindberg flew solo from New York to Paris to win himself the Raymond Orteig prize and assure his place in history. The effect of this young man's flight transformed America almost overnight into a nation of aviation enthusiasts. Most of the 150-odd transatlantic attempts between the wars took place after Lindberg's flight, and at one period the casualty rate was such that official action was taken on both sides of the water to discourage the sillier attempts. The first east-west North Atlantic aeroplane flight was made in 1928 by the German-Irish crew of a Junkers monoplane, and Costes and Bellonte of France made the Paris-New York trip on 1-2 September 1930. The big Breguet XIX Super 'flying petrol tank' they used had already regained for France the world's distance record in 1929.

And so it went on. Bert Hinkler flew solo from New York to London, via the South Atlantic, in 1931 and Mollison made the east-west flight from Dublin to New Brunswick, solo, in 1932 in 30 hours 15 minutes.

In 1932, on 14 November, Roscoe Turner set a new trans-continental record from New York to Burbank in 12 hours 33 minutes. The following year Wiley Post made the first solo flight round the world in his big Lockheed, covering 15596 miles (25098 kilometres) in 7 days 18 hours 49 minutes.

Most of these 'firsts' were unofficial, although some of the long-distance flights were officially observed for FAI purposes. The FAI (Fédération Aéronautique Internationale) is the body charged with registering and confirming all official record attempts at height, speed or distance. While there are scores of different classes and sub-classes for every kind of aircraft, including balloons, a look at the progress of the major categories gives a very good impression of the progress of aeronautical science.

The first speed record officially recorded, in 1906, was 25.657 mph (41.29 km/h); after the war, a series of French pilots drove it up to 211.911 mph (341.023 km/h), set by Sadi Lecointe in a Nieuport-Delage in 1922. It was then taken by General Mitchell in a Curtiss Racer at 222.98 mph (358.836 km/h). Americans and French competed for it until the first of the seaplane records in 1927; these were set by the Coupe Schneider competitors, and the last, set by Agello of Italy in 1934, stood at 440.702 mph (709.209 km/h). Taken then by the Germans at the

outbreak of World War II, it was held by Flugkapitan Fritz Wendel at 469.242 mph (755.138 km/h) in a specially-built Messerschmitt (announced for propaganda purposes as a Bf 209 fighter).

Not until 1908 did the official distance record reach .62 miles (1 kilometre), although the Wrights were exceeding that handsomely, and in 1913 it stood at 627.6 miles (1010 kilometres). The first post-war aeroplane distance record fell to the Breguet XIX in 1925 at 1967.5 miles (3166.3 kilometres) between Etampes and Villa Cisneros. It topped 6214 miles (10000 kilometres) in 1937 - the last pre-war record - with a flight of 6300 miles (10148 kilometres) by two Russians, Colonel Gromov and Commander Youmachev, in the specially-built ANT-25, between Moscow and California.

The altitude record, like the straight line distance record, was held by a balloon in the early days - a height of 35510 feet (10800 metres) set up at Berlin in 1901. It was not passed by an aeroplane until 1923. Starting at 508 feet (155 metres) in 1909, the aeroplane record crept up, past 3281 feet (1000 metres) in 1910, to 10170 feet (3100 metres) later the same year. In 1920 it stood at Major Shroeder's height of 33113 feet (10093 metres) and was taken again by a balloon of Professor Piccard's in 1931 to a height of 51774 feet (15781 metres); balloons continued to hold this record until 1957. The last pre-war record was set at 72394 feet (22066 metres) by Captains Anderson and Stephens of the United States Army Air Corps in the balloon *Explorer II* at Grand Rapids, Dakota. The comparable aeroplane records were set in 1937 by Flight Lieutenant Adam of the Royal Air Force at 53936 feet (16440 metres) and Lieutenant Colonel Pezzi of the Regia Aeronautica in 1938 at 56045 feet (17083 metres).

The other great sporting events to catch the headlines were the air races. Various racing events took place before 1914 in Europe and in the United States, but the great period was between 1919 and 1939. In England, the first race for the King's Cup, presented to stimulate light aircraft design was run under a peculiarly British handicap system that appears to put a premium on luck and cunning and leaves little to technical improvement. Racing, and competitive rallying under what might be called 'cruising rules' flourished in Europe, with several long-distance events, such as the Oasis Rally round North Africa, and tours of Europe.

These rallies were highly competitive events to complex formulae and to win required considerable design and piloting ability which stimulated technical competence. One of the earliest was the

Deutschlandflug, run from 1925 as a German-only competition, part of the national effort to get their industry and the flying movement off its knees. It served in later years to test the very advanced Messerschmitt Bf 108 four-seater, which introduced many of the features of the Bf 109 fighter. Although from 1933 it

became more of a test of flying ability and in this was patterned after the International Tourist Challenge meetings, the Germans did not cease to use such occasions as propaganda. A team of prototype 109s was produced, with military pilots, which had considerable success at civil meetings. The Italians had much the same

idea and Bruno Mussolini led a team of Savoia three-engined bombers in the Tour of the Oases.

Two outstanding events occurred during this period - the international race series for the Coupe Schneider and the England-Australia race for the MacRobertson Trophy. The race for the Coupe Schneider (it is not a cup at all, but a rather rorty piece of silver sculpture) for marine aircraft first took place in 1913. It was confined to marine aircraft on the general grounds that if speeds increased greatly it would be difficult to find suitable land aerodromes. The first race was won by Maurice Prévost of France, in a Deperdussin and - to everyone's surprise, as no one took British designs seriously - by Britain in 1914. The series continued after the war. Great Britain hosted the 1919 meeting but as the seaworthiness trials

D'Arcy Greig's S 5 JOHN PAGE
Supermarine S 5 (Napier Lion VIIB, 875 hp engine).

John Page is a comparatively new member of the Guild, but has already exhibited a number of promising works. The Supermarine S 5 was designed by R.J. Mitchell for the 1927 Schneider Trophy, an all-metal aircraft with braced wings, following the disastrous flutter problem with the cantilever, wooden S 4. Flight Lieutenant Greig was not a team member at that time, but subsequently took over the aircraft in 1928 for a record attempt after the death in a crash of S.M. Kinkhead. Greig flew the S 5 in the 1929 Contest, which was won by Flying Officer Waghorn at 328.629 mph (528.862 km/h), achieving a creditable third place at 282.11 mph (453.999 km/h) on the older aircraft. Three S 5s were built and Flight Lieutenant Webster (later Air Vice-Marshal Webster, CBE) won the 1927 race at 281.655 mph (453.267 km/h). The big Napier Lions driving 7-foot 7-inch (2.31-metre) propellors caused tremendous swing on take-off (as John Page has convincingly suggested) and departures tended to be anything but straight in the earlier stages.

damaged the aircraft and the course was totally obscured by fog, it was far from being a memorable occasion. The only finisher, an Italian, was disqualified for missing a turn.

The first nationally-sponsored team was entered by the United States Navy in 1923 and this saw the start of government sponsorship generally. Costs had risen considerably, as had performance, and government prestige and research benefited while no private company could stand the financial pace. The main competition was between Italy, Britain and the United States; France, who had originated the series, dropped out. Curtiss designed special racers (or research aircraft, depending on the audience). Three consecutive wins, if no challenger appeared within five years, gave the holder permanent possession, and the United States might have won the series but sportingly declared a bye when no foreign entries materialized. The series continued until 1931, when Great Britain won outright.

In 1927 and 1929, the British and Italian teams fielded some of the most exotic and beautiful racing seaplanes ever seen; the Macchi series, designed by Mario Castoldi and the Supermarine racers designed by Mitchell. Later, shortly before his untimely death, he was to design the Spitfire. Fiat and Rolls-Royce produced thunderous monsters of sprint engines and the speeds set can be seen from the official world records of the time. 1927: Commandant di Bernardi, 1000 hp Macchi M.52 – 473.82 km/h (294.431 mph), raised in 1928 to 512.776 km/h (318.639 mph). 1929: Squadron Leader Orlebar, 1900 hp Supermarine S 6 – 575.7 km/h (357.739 mph). 1931: Flight Lieutenant Stainforth, 2600 hp Supermarine S 6B – 55 km/h (407.017 mph). In 1934, Lieutenant Francesco Agello, flying the 1931 Schneider Macchi M 72, with a 2800 hp Fiat-Zerbi A.S.6 engine, took the record to 709.209 km/h (440.702 mph). Bear in mind that service single-seat fighters at that time, powered by engines of 850 hp were turning in top speeds of around 402.325 km/h (250 mph). It must be admitted, though, that it would take ten years and a drop of 600 hp before the Rolls-Royce racing engine became a mass-production service unit.

The 'Great Race', however, was always the 1934 England-Australia event. The race, for the MacRobertson Trophy, was part of Melbourne's centenary celebrations and attracted enormous attention. Entries were received from thirteen countries and totalled sixty-three; after the 'funnies' had been weeded out the field fell to twenty-one. Main entries, as expected, came from Australia, Britain and the United States, with the Netherlands, New Zealand, Eire and Denmark also represented. Eight of fourteen British entries made it to the starting line at Mildenhall, headed by the specially-designed and rapidly-built de Havilland Comets including one flown by Jim and Amy Mollison, three of the eight Australians, and only three from the original eighteen American entries.

British aircraft firms had taken very little interest in the race. Only Geoffrey de Havilland's sporting interest - and business shrewdness - carried his co-directors and in spite of an order book and factory full of normal work, the racers, good for 200 mph (321 km/h) and 300 miles (482 kilometres), were ready within nine months. In the event, it was C.W.A. Scott and T. Campbell Black, in one of the Comets, who were first home in a startling seventy-one hours - first in both speed and handicap sections. Eligible for only one section, they opted for the speed prize, and number two across the line. The big Douglas DC-2 entered by Royal Dutch Airlines, took the handicap prize, with another American airliner, Roscoe Turner's Boeing 247, in third place overall. There was a lesson in that, but somehow the British failed to see it.

In the United States, air racing took a rather different form. Petrol was extremely cheap, big was beautiful, and the army and navy for a number of years took part in the races with current or prototype fighters, a fine sense of inter-service rivalry and an eye on the publicity.

The first major racing prize, the Pulitzer Trophy, was competed from 1920 to 1925. A pure speed event, it attracted thirty-seven starters, and all but one were by Curtiss, either PW-8 pursuits (the other big race, the Mitchell Trophy, was flown by ten PW-8s) and a brand new Curtiss R3C-1 each for the army and the navy, specially ordered from the factory. Sadly, after that, the services were told to stop spending money on racing aircraft and that was the end of the Pulitzer.

The National Air Races continued, and military entries continued to race in various events, competing against civilian entries in the 1927 event for the first time since 1922. This was the famous meeting at which Charles 'Speed' Holman looped a Ford Tri-Motor - very close to the ground. In 1930, the first of the fabulous Thompson Trophy closed circuit races was run and won by Holman in the Laird Solution at 201.9 mph (324.9 km/h). The following year the long-distance Bendix Trophy race was added. The course was from Burbank, California to New York. Three low wing Lockheeds, two Orions and an Altair, were entered, the latter piloted by Ira Eaker, who would achieve high command in World War II, and a small Laird Super Solution, with a tweaked Pratt and Whitney Wasp, flown by Jimmy Doolittle. At a record-breaking average 217 mph (349.2 km/h), he won the event.

These two events saw the beginning of a new and fantastic era of racing, with private entries taking on service fighters on level terms and with engines of 500 to 800 hp. The series continued right through to 1939. That year the Thompson was won by Roscoe Turner in a 1000 hp Laird-Turner at lap speeds up to 293 mph (471 km/h) and the Bendix by Doolittle with his Super Solution, driving over a 2043 mile (3288 kilometre) course at an average 223.038 mph (358.935 km/h) and continuing over the 2450 miles (3943 kilometres) to New York for a new trans-continental record.

The British Government began to look into civil aviation problems while the war was still in progress, appointing a Civil Aerial Transport Committee in May 1917. The Committee's report, issued the following year, concentrated in its planning on the requirements of Empire routes, rather to the exclusion of international European ones.

The Royal Air Force ran a military service across the English Channel after the war. It was operated by No.1 Communication Squadron, largely for the delegates and officials attending the Peace Conference in January 1919, and to carry mail to the Army of Occupation. In February the French ran a flight between Paris and London, using a converted twin-engined Farman bomber and carrying military personnel. Air Transport and Travel began regular passenger flights over the same route from 25 August. Significantly, that date also marked the inaugural meeting of the International Air Traffic Association, with delegates from six countries attending. The controllers were moving in early.

There was a small initial scramble to get in on the act. Most airlines were subsidized by their governments except for the British. By the end of 1920 no British companies were flying to the Continent at all. For two years, from March 1921, subsidies were granted and as the end result was rather an unregulated muddle, the scheme was revised and routes allotted to four of the more promising airlines. In 1924, they were merged into a national flag carrier - Imperial Airways. The time was ripe for such a move; most European countries had done the same (it was in that year that the rationalization of the railways into the 'big four' also took place) and as routes lengthened and traffic increased some tidying-up was required. Although some

new equipment was available, there was still a clutter of ex-military aircraft of many different types, making maintenance a problem. When new British aircraft were designed for Imperial Airways, that august instrument of government was primarily committed to developing the Empire routes and held very conservative ideas on the subject of aircraft. One might be forgiven for thinking that, with the enormous distances involved, some long-distance transports would have been ordered, but the various constraints put upon the routes in the 1920s and early 1930s split them up into short segments, so the requirement did not appear. Weather was a factor, as was the comfortable Imperial habit of landing passengers for the night; night flying was anyway then very poorly developed in Europe. Moreover, it was very difficult to arrange over-flying rights with some governments (Italy was a notable example) and until as late as 1937 some sections of the eastern routes might have to be covered by ship or train. British manufacturers were very unadventurous, continuing to produce vast, slow, high-drag biplanes. Even when the new monoplanes appeared, the Armstrong-Whitworth Atlanta in 1933 and the Ensign in 1938, they were badly underpowered and, designed for the specialized requirements of Imperial Airways, were unsaleable to any other airline. The Ensign was two years late into service, largely as a result of the customer constantly changing his mind - a situation not unfamiliar in more recent British aircraft production.

While on the subject of equipment, two very important aircraft appeared just after the war: the German Junkers F13 first flew on 25 June 1919, and the Dutch Fokker F II in October. The Junkers, developed from the military monplanes of 1917-18

French Airliners at Croydon, 1929

KENNETH McDONOUGH GAvA

Breguet 280T (Renault 12Jb, 500 hp engine) and Blériot 165 (two Gnome-Rhône Jupiter 9Ab, 420 hp engines).

French airliners of the inter-war period and Croydon airport being among Ken McDonough's minor passions, he has chosen here to combine the two. Both aircraft are operated by Air Union on the London-Paris run, 'Rayon d'Or' ('Golden Ray') being the Company's fleet name. Air Union, like other companies, was later merged into Air France, and set early standards of luxury on the prestigious inter-capital route. One of its Lioré et Olivier airliners, in collaboration with the Compagnie Internationale des Wagons-Lit et Grand Expresses Européenes (who else, indeed?), introduced the first full restaurant service on board.

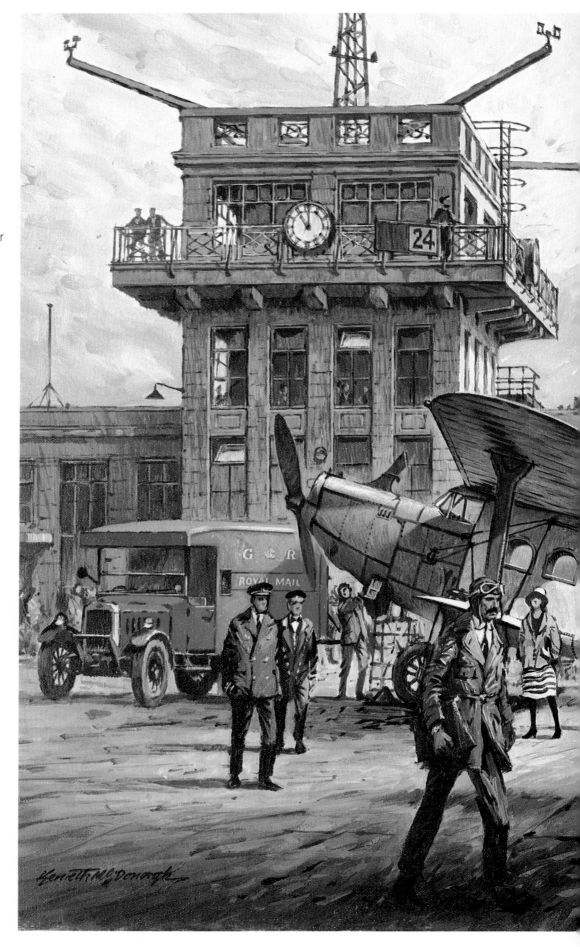

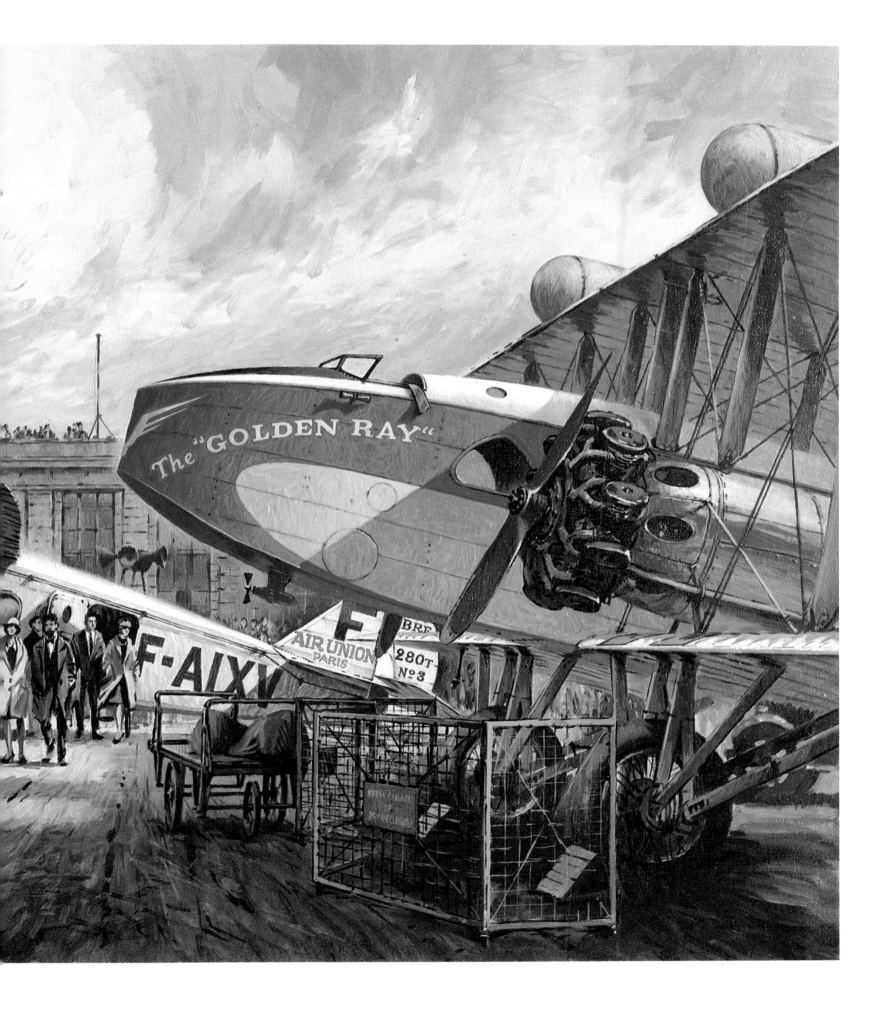

and employing the advanced and very strong corrugated metal construction that Junkers had pioneered, was a four-passenger, two-pilot monoplane with a 185/200 hp engine. Among its more advanced features were passenger seat belts - a Junkers speciality. Apart from a short period when civil aircraft production in Germany was stopped by the Inter-Allied Aeronautical Control Commission and Junkers quietly had it built abroad, it was continuously in production until 1932 and 322 were sold. It had an enormous influence, pioneering commercial flying all over the world, its structure being virtually indifferent to extremes of heat and cold. Further, it led directly to the three-engined Junkers Ju 52/3m, which had a universal success that was halted only by the advent of the DC-2.

The Fokker, designed by the same Reinhold Platz who was responsible for the formidable wartime fighters, was of similar capacity and power to the F13, but was a high wing monoplane, built of wood. It entered service with the Dutch national airline, KLM, in 1920 and although only about fifty were built, they were popular and also led to developed versions, including the three-engined FVII/3m. Outside France, Italy and the United Kingdom, each with native industries to support in this field, most European lines used one or the other of these families.

France, whose aircraft industry had a

Heracles at Croydon RODNEY DIGGENS
The first of the four HP 42Ws supplied to Imperial Airways (four Bristol Jupiter XFBM, 550 hp engines).

Handley Page built eight of these airliners for Imperial Airways from 1930. Four were used on the eastern Empire routes to the Middle East (HP 42Es) and four, more powerfully engined, on the London-Paris service (HP 42Ws to Imperial, HP 45s to the makers). The standard of luxury they set was very high – cabins spaced ahead of and aft of the wings to decrease noise and vibration and decorations like the Blue Train, which they somewhat resembled. They cruised with great dignity at a sober 95 mph (153 km/h). Heracles carried 160 000 passengers in eight and a half years of service, disgracing herself only once when she sat down on her stomach at a Royal Aeronautical Society garden party in 1932. Six of the eight survived until written off in World War II. This acrylic portrait captures the sparkle and majesty of the period and of the aircraft, even if, by American standards, British airliners were antediluvian.

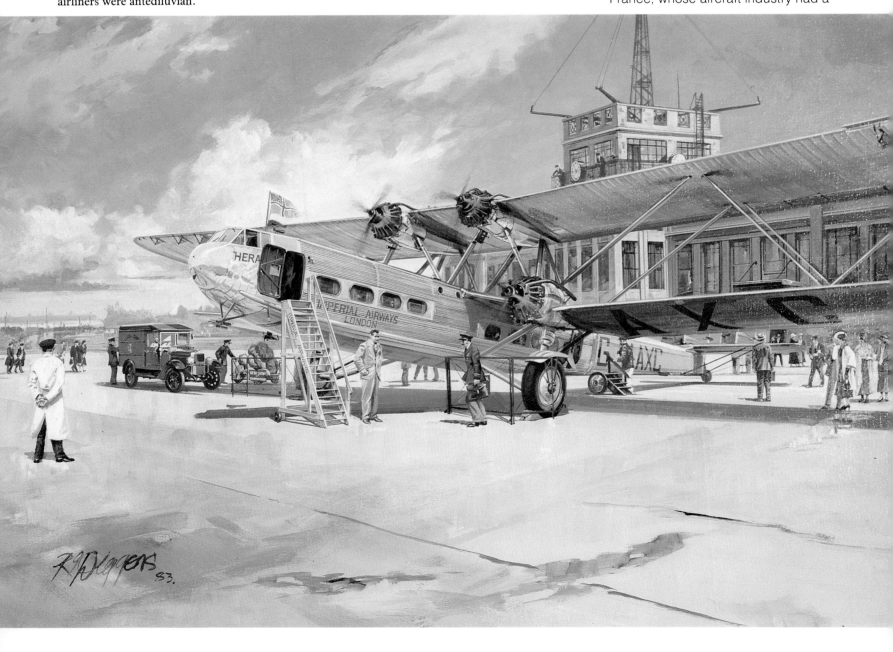

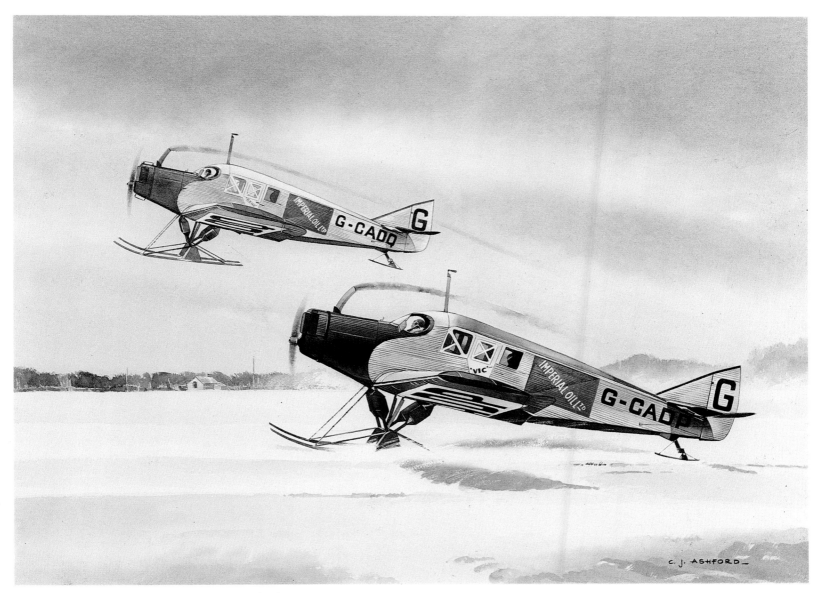

The Furthest Flight into the North-West Territories COLIN ASHFORD GAvA
Junkers F 13a (various 185 hp engines.)

The sturdy, all-metal Junkers F 13 was responsible for opening up most of the remoter areas of the world in the 1920s and 1930s, from Canada to Papua New Guinea. The aircraft shown here are Junkers-Larsen JL 6s, built for the United States Post Office, originally, by the John Larsen Aircraft Corporation. Built in 1920, they received their old-style (G-CA) Canadian registrations in January 1921. 'DQ was written-off in August that year; 'DP survived until 1929 when she was seized by the Royal Canadian Mounted Police (one wonders why – smuggling?) and scrapped.

Colin Ashford paints meticulously accurate water-colours, with a limited, characteristic palette, conceding nothing to 'artistic licence' yet never descending into pedantry.

compulsion to build even uglier and more awkward aircraft than Britain, was opening up her own colonial empire routes, along the route to the Far East and in a network across Africa. Interest in South America had been roused by Adrienne Boland's Andes flight and the short sea crossing from equatorial Africa encouraged the French to open up airlines there. In particular, it was the dream of aircraft manufacturer René Latécoère, who had started his own airline to Casablanca and later saw it extended across the South Atlantic. The early flights across the Andes provided many of the epics of French commercial aviation. Latécoère's airline folded in 1925, but Aéropostale, its successor, eventually moved across the Andes in 1928. It was a demanding and not very profitable area and Aéropostale in its turn gave up in 1931. But the line was by then emotionally and nationally important and Air France, brought into existence in 1933 as a national carrier, took over, flying the first commercial flight over the South Atlantic the same year. Previously the water crossing had been made by mail steamers.

Germany had no imperial routes to open up or to give her preferential treatment, but she had a good working relationship with the Soviet Union, and also began to challenge the French in South America. Using the admirable three-engined Ju 52, she started a network of local lines in that area and eventually opened up an eastern route clear through to Peking. She also had her own ideas about transatlantic operations, at least over the South Atlantic with its shorter crossing and more favourable wind patterns. The first idea was the reintroduction of the rigid airship. Starting in 1934, scheduled services from Friedrichshafen, the Zeppelin base, to Recife, Brazil, were operated, using the *Graf Zeppelin* and later the *Hindenburg*. The former made 144 crossings up to 18 June 1937. The *Hindenburg*, starting with an experimental flight on 4 March 1936, flew the summer schedule over the North American route until she was destroyed by fire at the mooring at Lakehurst, New

Jersey, on 6 May 1937. She had made some twenty Atlantic crossings in sixty-three flights. A third Zeppelin had been built, *Graf Zeppelin II*, which made thirty internal flights up to August 1939, before being retired to the Berlin Museum.

In 1933, Lufthansa, the German airline, introduced catapult ships in the South Atlantic off Bathurst, Gambia. Dornier Wa1 flying boats, heavy with fuel and mail, made 328 crossings with the aid of the catapult launch. North Atlantic crossings began with a second ship in September 1936. After eight trial flights she was shifted south and between 1937 and 1939 assisted in another sixty-five flights.

By 1937, serious attention was being paid to non-stop flights across the North Atlantic. That year the new four-engined Empire flying boats, built by Shorts, came into service on the African routes of Imperial Airways and a series of North Atlantic flights with mail was inaugurated. In June, services between Bermuda and New York were commenced by Imperial and by Pan American Airways. In December of that year, both companies had flown their boats out to New Zealand as well. Imperial had now virtually completed its Empire network, using the new boats and flew the first through

Hindenburg at Lakehurst KEITH WOODCOCK
Luftschiff Zeppelin LZ 129 *Hindenburg* (four Daimler Benz DB602, 900 hp engines).

Keith Woodcock is probably best known for his portraits of classic aircraft published in magazines, but has painted a wide variety of aeronautical subjects of all periods and all types. There is a quality of stillness about his compositions; even his storms seem to be waiting in the wings. This painting won the second award for the Aviation Painting of the Year in 1986.

LZ 129, still unnamed on her maiden flight, was designed for transatlantic commercial use and in fourteen months from her first flight on 4 March 1936 until she exploded at Lakehurst, New Jersey, on 6 May 1937, she carried out sixty-three flights. Ten trips to Lakehurst were scheduled and made in 1936, and seven to Rio. In 1937, two months after she started the South American route, she was lost on the first of eighteen scheduled crossings to Lakehurst. *Hindenburg* carried seventy passengers. She weighed 242 tons (246 tonnes) at take-off, carried 65 tons (66 tonnes) of fuel and contained 7 062 100 cubic feet (199 977 cubic metres) of hydrogen. With a length of 804 feet (245 metres) and a diameter of 135 feet (41 metres) she was the largest aircraft ever built.

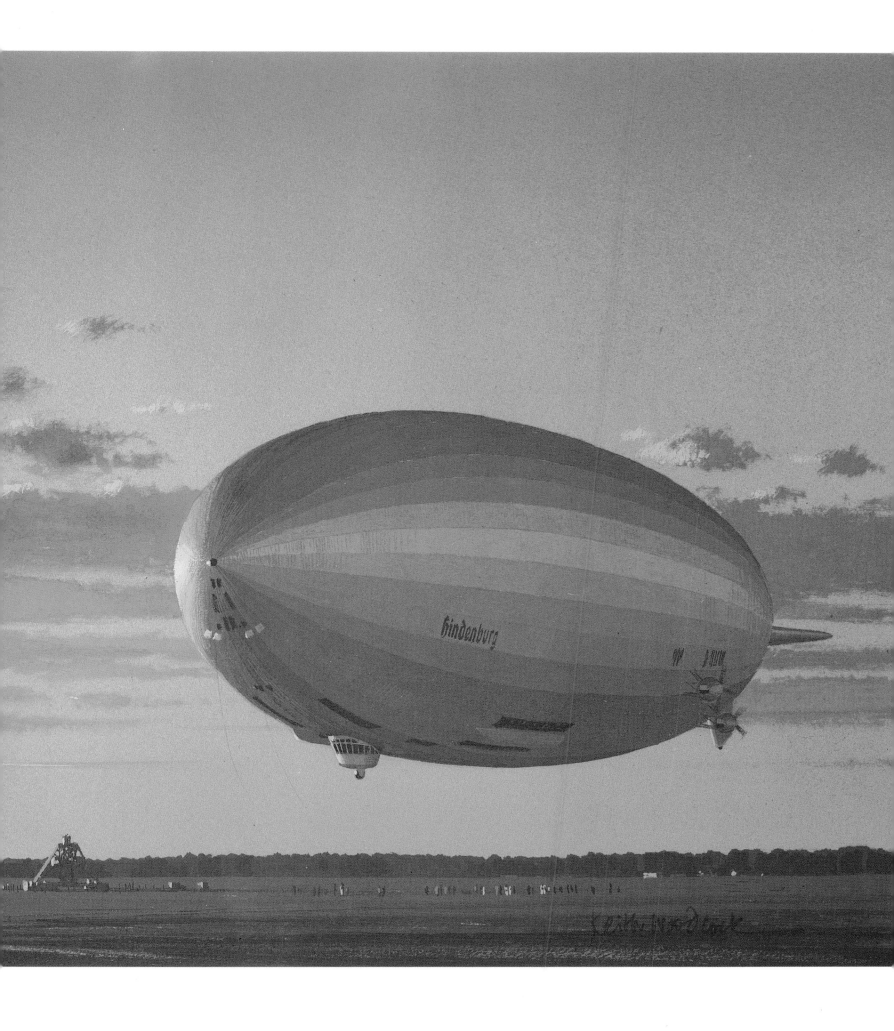

The First Trans-Atlantic Air Mail DUDLEY BURNSIDE GAvA
Short S 30 C-Class (four Bristol Perseus XII, 890 hp engines).

The S 30 were long-range versions of the original S 23
Empire flying boats that were employed by Imperial
Airways on their routes around the world. It was just
beginning to dawn on the British that the days of Imperial
preference on air routes, where performance was sacrificed
to comfort and dignity, were at an end. Competition from
the vastly superior American aircraft was beginning to bite.
The Short C-class boats were the first attempt to modernize
Imperial's equipment. For transatlantic mail and passenger
work the bigger and more powerful G-class were being
built, but when the Pan-American commercial crossings
began, they were not yet ready, and the early mail flights
were made with C-class boats. They were refuelled in flight
by Sir Alan Cobham's ingenious equipment from a Harrow
tanker. Dudley Burnside's painting shows G-AFCV (Royal
Mail Aircraft Caribou), commanded by Captain
J.C. Kelly-Rogers, on the first experimental weekly mail
crossing from Southampton on 5 August 1939.

Dudley Burnside works in a swift, open style, with a
very limited palette but with complete control over the
process of creating fresh and lively compositions with great
economy of means.

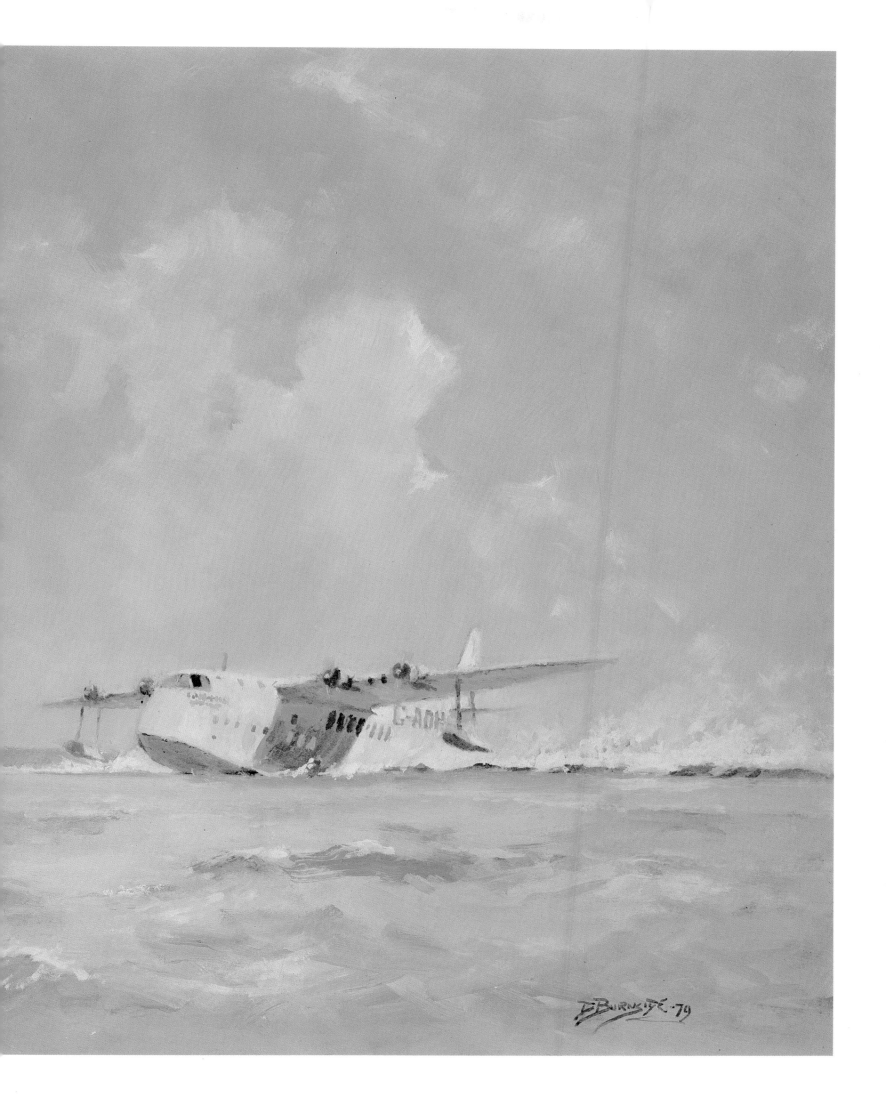

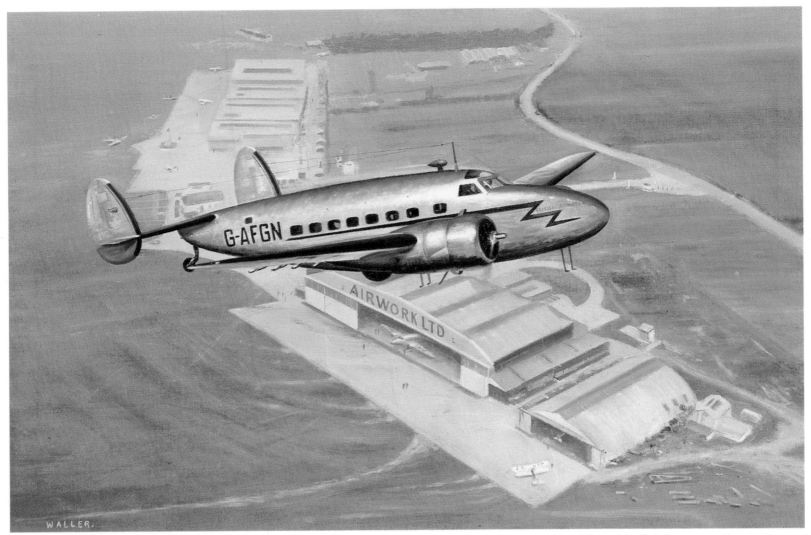

WALLER.

Chamberlain's Peace Initiative C.E. WALLER GAvA
Lockheed Model 14-WF62 Super Electra (two Wright Cyclone, 900 hp engines).

Lockheed had been building twin-engined transports for some time when they introduced the Model 14 in 1937. Faster and more advanced than the DC-2, it gave only a speed margin over the DC-3, which carried half as much again and was more economic. Four were ordered by British Airways (who already operated earlier Lockheed twins) planning to use their high speed on West African and South American routes. KLM already used them on their Far East routes, where similarly fast passage was more profitable than high capacity. In the event, the British Airways aircraft went on to the run to Stockholm. Nine were ordered altogether – most of which crashed. G-AFGN, the first delivered, is seen climbing out of Heston on 15 September 1938, bearing Prime Minister Neville Chamberlain on his famous peace initiative to Hitler.

service to Sydney on 26 June 1938, in conjunction with QANTAS, the Australian line, who operated the route east of Singapore.

Pan American, using the huge Boeing 314 flying boat (it was built round the wing and engine combination used for the unsuccessful B-15 bomber) completed a proving flight to Southampton from New York on 4 April 1939. Pan American inaugurated a regular mail service over the route on 20 May and commenced a regular weekly service on 28 June. The British mail service, planned to start on 1 June, was delayed because of the non-delivery of the big G-class flying

boats. A weekly service was started on 5 August, employing flight refuelling and C-class Empire boats.

France also had her plans for the North Atlantic and prototypes were ordered of the Lioré et Olivier H-49 and Latécoère 631, neither of which was built before the war ended civil flying. Germany, which had been operating the four-engined Blohm und Voss Ha 139 off the catapult ships since 1937, had the Dornier Do 26 running with mail to North America, but after eighteen crossings these, too, were halted by the war.

In the United States, commercial flying got under way in a more leisurely fashion.

Apart from local airlines, mostly maritime, only the mail went regularly by air. The Post Office started running mail by air in 1921 and many well-known pilots, including Lindberg, flew the service. The United States Army had its own Model Airway, starting in 1922 and working coast-to-coast by 1926. It took over the mail for a short period in the early thirties when trouble developed over mail contracts, but without any marked success.

Not until 1925-26 did legislation go through Congress for the proper development of commercial aviation. The air mail contracts provided the main source of income and the development of a trans-continental network was greatly assisted by the establishment of beacon lighting, at three-mile intervals along the route, completed in 1930.

Under the system in operation during the early thirties, airframe and engine manufacturers were beginning to group together and also to operate airlines for which they built the equipment. Boeing was in early on the scene, operating the lucrative western section of the trans-continental mail with the Boeing

Mailplane. Unlike many operators, he encouraged passengers as well as mailbags. Boeing teamed up with Pratt and Whitney Engines and Hamilton Propellers, into the conglomerate United Airways. Other manufacturers did the same, before such groups were broken up by legislation.

The Americans realized under the spur of cut-throat competition, that survival and profit depended on economic aircraft. Boeing's Mailplane enabled him to undercut other bidders for his route. Stout Airlines put into service the comfortable and reliable all-metal Ford Trimotor (based on the Fokker FVII/3m) and began to pull in the increasingly important passenger

trade. National Air Transport, who operated one section of the New York-San Francisco route, which United wanted to complete its hold on the whole airway, bought the luxury biplane Curtiss Condor to consolidate its appeal. The struggle ended abruptly in 1930 when United bought NAT. On the southern route across the continent, Transcontinental operated the Trimotor until its Condors came along. Unlike Europe, the more cohesive market in the United States was forcing operators to go for one-type fleets and the key operational factors of speed and comfort were bringing more and more efficient aircraft from the factories.

In 1928, the first of a remarkable series

of fast, single-engined monoplanes, born of the fertile brain of John Northrop, began to emerge from the Lockheed factory. Beautifully streamlined and capable of carrying six passengers at 135mph (217km/h) the Altair was followed in 1931 by the low wing Orion, capable of 200mph (322km/h) and really showing up the slow Fords and Condors. American Airways and Northwest operated them. Northrop, now designing on his own, supplied the not dissimilar Northrop Alpha to TWA, and Boeing built the Monomail for his own airline. These small luxury aircraft were, however, not economical – their only fault – and in 1933, Boeing came out with a new airliner, the 247. Small (ten passengers) with 525 hp engines, it was based on his B-9 bomber and put United ahead of the pack immediately. Transcontinental crossings were taking under twenty hours, nearly seven hours better than the Trimotors of the opposition – TWA.

This put TWA in a difficult position. United had ordered sixty of the Boeings, and with the relationship with Boeing, no one else would get an order in for some

White Start CHARLES LOCK
Stinson A tri-motor of Delta Airlines (three Lycoming R-680, 260hp engines), 1930.

Before the Boeing 247 and Douglas DC-2, three-engined airliners were very popular, combining enough power for greater loads with greater safety. Stinson built a number of aircraft, of different designs, as late as 1935, of which the 'A' was the most famous. Designed to a nine-seater specification from American Airlines, it actually entered service first with Delta Air Corporation (Delta Airlines) in 1935. It was also operated in Australia and India. One aircraft was surviving in 1987, in the United States.

Charles Lock's work is seldom seen by Guild members, as he lives and exhibits in the United States, where he has been painting historical scenes such as this for some time.

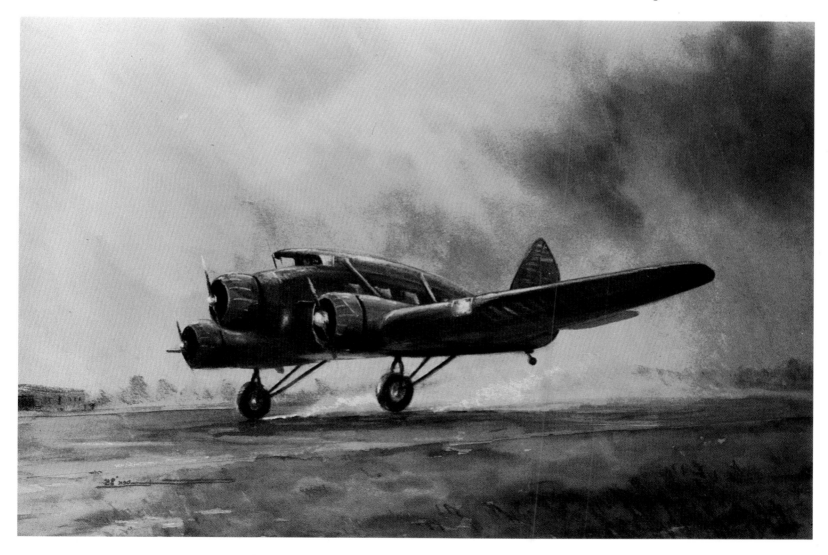

time. The solution was to order a better aircraft from someone else to TWA's specification. The specification, originally for a three-engined aircraft, was given to Donald Douglas, a complete outsider in the transport field. The result, with the more powerful Wright Cyclone engines, all the advantages of the 247 and a few more, was the DC-1/DC-2. The production DC-2 started service in the summer of 1934 and that was the end for Boeing. That same year, a KLM Douglas beat the 247 to

Australia in the Great Race; all over the world airlines began to re-equip with this brilliant aircraft.

American Airlines, which was equipped with a sleeper version of the Curtiss Condor and wanted the advantages of the new aircraft, approached Douglas for a wide-bodied sleeper version of the DC-2 – the DST or Douglas Sleeper Transport. When a day version was introduced with twenty-one seats, the DC-3, it was found that the increase in size, with good

aerodynamics, gave such economic value as to bring profits out of passengers to airlines that had had to compete for air mail contracts to survive. Of its impact, all that need be said is that by the time of Pearl Harbour, 80 per cent of domestic airlines were flying the DC-3. A corresponding foreign market grew up with operators replacing their DC-2s or more elderly Fokker and Junkers three-engined aircraft.

As a final look at the inter-war period, the end of one story and the beginning of another must be mentioned, if only briefly. With the destruction of the *Hindenburg*, the era of the great rigid airships came to an end. France, Britain and the United States persisted with the rigid after the war, drawing on German technology and, in the case of France and America, using ships turned over as reparations by Germany.

The French *Dixmude* (ex-Zeppelin L72) was lost over the Mediterranean in 1923 and her sister ship *Mediterranée* was

Hanworth Dash MAURICE MARTIN
Lockheed Vega (Pratt and Whitney C1 Wasp, 450 hp engine) DL-1 Special, five-seater.

Allan Loughead's Aircraft Manufacturing Company folded in 1921, but was re-born in 1927 as the more familiar Lockheed Company. His designer, the celebrated Jack Northrop, came up with the first of a long line of staggeringly successful, very fast, single-engined monocoque airliners that dominated United States commercial flying for several years, and influenced Europe as well. The first design, the Vega, sold in large numbers and its performance resulted in many records. Wiley Post flew one round the world in 1931 in 8 days 15 hours 51 minutes. G-ABGK was specially built for Lieutenant-Commander Glen Kidston and was the only one on the United Kingdom register. It was also a very early example of an out-of-sequence registration, bearing the owner's initials. Based at Hanworth, it was used for several records and completed part of the 1934 England-Australia race. Its top speed was around 185 mph (298 km/h). It survived, in Australian civil and military service, until 1945.

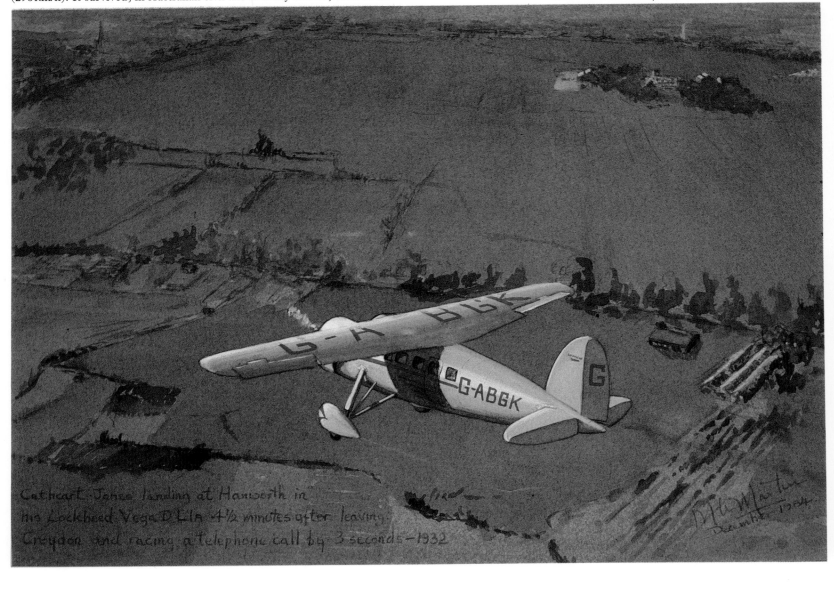

Cathcart Jones landing at Hanworth in his Lockheed Vega DL1a 4½ minutes after leaving Croydon and racing a telephone call by 3 seconds – 1932

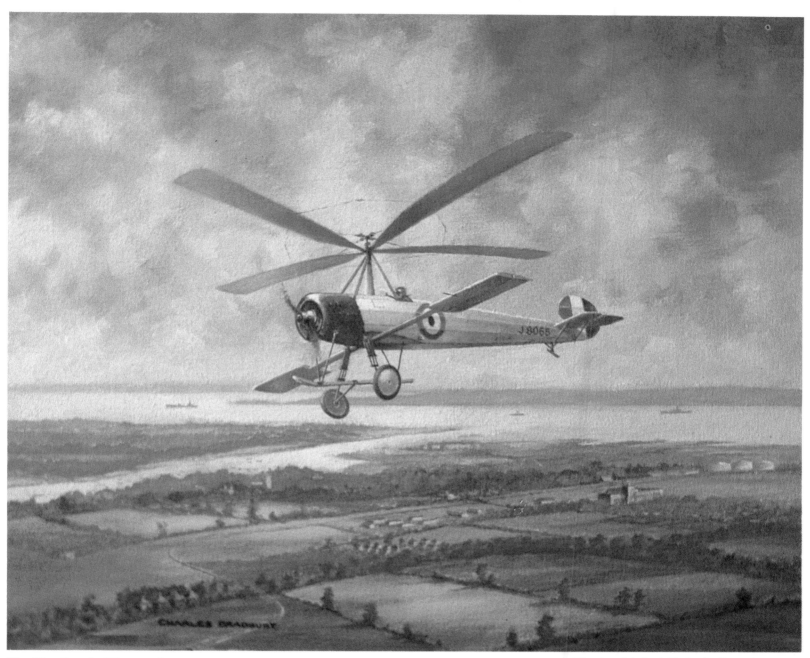

The First Practical Rotorcraft CHARLES BRADBURY GAvA
Cierva C 6 (le Rhône rotary, 110 hp engine) over Hamble, 1926.

Juan de la Cierva was a brilliant Spanish designer who built and flew a long series of successful
rotorcraft after the first world war. They were autogiros, not helicopters – that is, there was no direct
drive to the rotor so that vertical take-off and descent were not possible. Between 1926 when he came
to Britain to set up a factory and 1936 when he was tragically killed in a (fixed-wing) aircraft crash,
Cierva had solved most of the complex problems surrounding rotor and rotor head design. The C 6,
based on an Avro 504K fuselage, was the first fully practical rotorcraft and flew at Farnborough in 1925.

broken up in 1926. The *Shenandoah* was
lost in 1925; the British-built R38 destined
for the United States broke up in the air in
1921; the *Akron* was lost in 1933 and her
sister ship *Macon* in 1935. Of all the
United States Navy airships only the
German-built *Los Angeles* (LZ126) was left
and she remained in service until 1938. In
Britain, after the wartime ships were
broken up, there was no activity until the
new designs of 1929, the R100 and the
R101. R101, a highly troubled ship, crashed
in France in 1930 and her more successful
contemporary was immediately broken up.
It did rather look as if only the Germans
had the touch – or the luck. Non-rigids, on
the other hand, were employed throughout

the whole period by the United States
Navy, using a series of good designs by
Goodyear; the French navy did not
abandon lighter-than-air until 1937.
 On a more cheerful note, this period saw
the beginning of what has become a major
success story – the helicopter. Helicopters
had been designed since the days of
Leonardo da Vinci, but the mechanics
were too involved for the early pioneers.
Endless experiments were carried out, but
the first very brief flights were not made
until 1907 to 1910, by Bréguet and Cornu
in France. In 1924 Oemichen and Pescara,
also working in France, achieved the first
serious flights and later, around 1928 to
1930, Asboth (Hungary), D'Ascanio (Italy)

and Pitcairn (United States) all made
successful flights. During the 1930s Hafner
in Britain, Flettner and Focke in Germany
and Bréguet in France were all achieving
satisfactory performances and the
helicopter was now a practical device, if
not exactly a thing of beauty. In 1939 the
Russian emigré Igor Sikorsky resumed the
helicopter experiments he had conducted
unsuccessfully before the war and built
and flew the first modern configuration
helicopter, the VS-300 with main and
tail rotors.
 One more pioneer must be mentioned.
In 1919 Juan de la Cierva built in Spain the
first of a long series of gyroplanes, or
autogiros. With the rotor independent of
the engine and requiring forward
movement to lift off, they did not have true
vertical capability, but they were extremely
successful. Cierva was killed in an airliner
crash in 1936, but he had by then overcome
virtually all the problems associated with
rotor control and aerodynamics, a legacy
of considerable value to the helicopter
designers who followed.

Period four: World War II

The two years before the start of the second world war were, for all the major powers involved, a time of re-equipment, the degree of urgency depending on how the respective governments viewed the situation.

In Britain, the March 1938 White Paper on the re-armament which was now getting firmly under way, stated that the Royal Air Force had sixty-eight squadrons of bombers, thirty of fighters, and for what they were worth, fifteen general reconnaissance and ten army co-operation squadrons. More important, flying training schools had been nearly trebled, from four to eleven. The first squadron of Hurricane fighters had just been formed and the Spitfire would be in service the following year. The remaining fighter squadrons had biplanes, with two or four guns, capable of 230-250 mph (370-402 km/h). German bombers of the period had a slight edge on this at height. In August 1937, the control of the Fleet Air Arm was finally transferred to the Admiralty. The new monoplane bombers had around the same speed as the old fighter, 250 mph (402 km/h), though the Whitley was slower. Medium day bombers, the Blenheim and Battle, were also slow and very poorly armed.

In April 1938, Air Commodore A.T. Harris (later to head Bomber Command) took a team to America to look for aircraft to bolster this somewhat mixed force; the first fruits, announced in June, were orders for 200 Lockheed Hudson reconnaissance bombers and 200 North American Harvards for training for the new fighters. In July, negotiations were begun for mass-production of British bombers in Canada. Recruiting was stepped up and a joint Air Ministry-Industry-Treasury Committee formed to enable the Air Ministry to order aircraft up to the maximum output available without delays.

Elaborate air exercises in 1937 and 1938 tested the defences, but the majority of participating defence aircraft were obsolescent and they tended to confirm the false premise that the new Battle and Blenheim bombers could cope with fighters in daylight. The main element on the positive side was the conviction that the RAF's infrastructure of control and organization was sound, even if material comparisons with enemy equipment were unsure.

In September 1938, the Munich crisis occurred and the Royal Air Force went to its action stations; but Prime Minister Neville Chamberlain came back from the Conference proclaiming belief in 'peace for our time'.

The final expansion scheme before the war planned for fifty fighter, eighty-five bomber and twenty-eight reconnaissance squadrons; in September 1939, fifty-seven fighter squadrons were theoretically available. Four of these, with ten squadrons of Battles, four of Blenheims and five of Lysander army co-operation aircraft, were sent to France to bolster the French air force.

France, from having a powerful air force backed by a massive industry in the first world war, was by 1939 in a very poor situation. While admirable prototypes of fast, modern fighters and bombers were designed and built from 1935, production never got under way in time. Actual aircraft in front-line service in September 1939 with the 1st Army, facing the Germans, included only 312 modern fighters (ninety-four of them American Curtiss 75s), and eight modern bombers (three Potez 633s, five LeO 45s). There were over 1000 reasonably modern aircraft in France, but many were still in factories or not yet delivered to units; most of the bomber force was only fit to fly by night and reconnaissance aircraft were mostly elderly. Far more important was the lack of any coherent policy for training or employment and the fact that production of modern aircraft not only was begun too late but lagged by around 50 per cent of planned output.

Attempts were made to make up the deficiencies with massive orders from the United States. A mission under Jacquin-Thouvenot in 1939 requested 1000 fighters, 1900 bombers and 1200 trainers. By the end of 1939 French orders in America rose to 4700 aircraft, most of them, inevitably, never arriving before the Armistice. Of the 980 that did arrive, 469 were taken on charge by the air force. One very important result of this 'panic' buying, however, was to gear the American industry for massive production long before they themselves entered the arena. Another benefit was that the Royal Air Force was able to take over many of the French orders, although the performance and armament of some of the earlier aircraft made them unfit for combat use.

The German Luftwaffe was far better prepared in many ways. Production of fast, modern fighters and bombers antedated the Allies by at least a year and production was accelerating. The Messerschmitt Bf 109, Heinkel He 111 and Dornier Do 17 had been tested in Spain and fighter and ground support tactics perfected. By the time of Munich, the Luftwaffe had 1669 front-line and training aircraft, including 453 fighters and 582 bombers; in addition it had 159 of the dive-bombers in which it was beginning to specialize. At the outbreak of the war it had, in the year of grace given by Munich, increased totals to 1170 bombers, 1320 fighters and 335 dive-bombers in a force of 3750 aircraft.

On the debit side, it was primarily a tactical force, with no strategic capacity - indeed, it never really acquired any - and was not geared for a long war. The command structure had been brought into confusion by the manoeuvrings of Goering. Nevertheless, at lower echelons, it was a professional and ruthlessly competent force.

Initially, the Luftwaffe swept all before it, once war was declared. A recent re-organization of the greatly expanded force into four Air Fleets, on a territorial basis each with balanced and self-contained fighting units, increased its operational

capability. The system was quite different from that of the Royal Air Force, which since 1936 had been organized into Commands on a purely functional basis - Fighter, Bomber, Coastal and Training; a system that gave greater flexibility and capability of worldwide expansion.

Taking Aim JOHN HELLINGS GAvA
Messerschmitt Bf 109E (Daimler-Benz DB601A, 1175 hp engine).

The Messerschmitt Bf 109E was the single-engined fighter with which the Luftwaffe fought the Battle of Britain. (Bf stood for Bayerische Flugzeugwerke who built Messerschmitts; not until later did it change to Me 109.) The aircraft in the butts for gun harmonization, Black 12, with no *gruppe* symbol, would belong to 3 *Staffel*, I *Gruppe* of its *Geschwader*. The camouflage is standard for 1940, the yellow cowling being a tactical and temporary marking. Over 33000 of these aircraft were built of various marks and it was in production in different countries for twenty-five years. Only the Russian Il-2 exceeded it in total production.

For the attack on Poland, by Luftflotten 1 and 4, extra units were drawn in from the other Fleets. Each Fleet normally contained around 1000 aircraft at full strength. Other elements integrated into the structure included signals, which were for the period highly developed, and anti-aircraft artillery (flak) which remained extremely effective throughout the war. On the other side of the coin, development of radar and ground control of fighting aircraft never reached the level that the Royal Air Force maintained.

The opening campaign on 1 September 1939, against Poland, lasted twenty-eight days. The main Polish defence was in the hands of eight squadrons of 250 mph (402 km/h) PZL P11s and one of 197 mph (317 km/h) P7s; four bomber squadrons flew the fast twin-engined PZL Los and five the slow single-engined Karas. Apart from a few survivors that fled to Romania, the force was overwhelmed (it was not caught

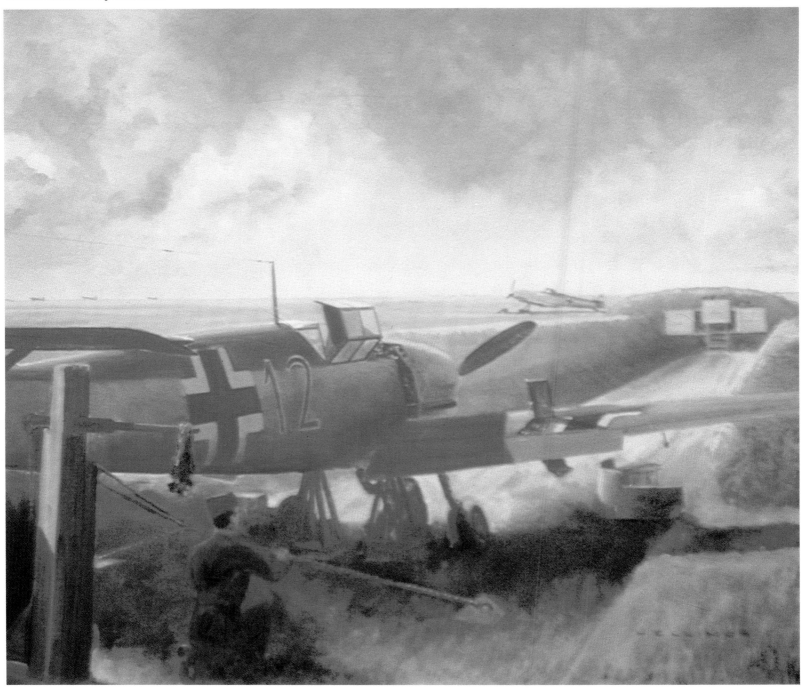

on its airfields, as is often said, but had dispersed to wartime fields). It also inflicted 285 losses on the Luftwaffe.

The campaign confirmed German doctrine completely. Nothing in the campaigns that followed did anything to change their ideas. Norway, where the transport force and parachutists were first employed, paved the way for the triumphant battles over Belgium and Holland. About half the 1000 aircraft of Fliegerkorps X in the Norwegian campaign had been transports - the sturdy Junkers Ju 52/3m, 'Auntie Ju' to the airborne soldiers. Transport needs in the Low Countries were met by 475 aircraft and 45 gliders were available for assault landing. Losses were heavy, but the Germans continued to use air transport lavishly in all theatres throughout the war. The French campaign opened with an exuberant Luftwaffe firmly in control of the skies ahead of the swift German armies.

The Battle of France was fought by Luftflotten 2 and 3. A significant part was to be played by Generalmajor Richthofen's Fliegerkorps VIII, whose dive-bombers had been a major factor in the Polish success. Some 3530 aircraft were employed out of a front-line strength of 4500, including 1300 bombers, 380 dive-bombers and 1210 fighters, of which 350 were twin-engined, long-range Messerschmitt Bf 110s, from which much was expected.

The role of a defending air force with a retreating army is a difficult one; the RFC found *that* out in 1914 before the front stabilized. In France in 1940 it stabilized on the Channel coast, which was fine for the RAF but not for the Armée de l'Air. With the attack on Belgium and Holland on 10 May 1940, which eliminated their air forces on their airfields, came heavy bombing of British and French bases. Further bombing disorganized communications and movement and the highly developed German long- and short-range reconnaissance units kept the invaders continuously informed of their opponents' affairs. Over the narrow front of advance – about 200 miles (322 kilometres) – the Luftwaffe could keep a heavy concentration of air effort, even with the constant forward movement of bases and supply problems. About 550 single-engined fighters were operating at this time - about half the available total.

The twenty-five modern bombers, and the seventy-odd obsolete ones, of the French air arm in the battle area were soon destroyed, as were the Blenheims and Battles of the ten squadrons of the Advanced Air Striking Force. The French and British fighters fought hard, but were virtually annihilated. Six fresh Hurricane squadrons were sent to the air component, to the fury of Air Marshal Dowding, husbanding his meagre forces for the battle he saw coming over England. How much good they did (apart from being a political sop to the French) is debatable, but by the end of the campaign on 20 May the Fighter Command was the poorer by 195 Hurricanes, nearly a third of which were abandoned on the ground.

The only bright spot came over the beaches of Dunkirk, where RAF squadrons from English bases - and including Spitfires in the battle for the first time - shot down 189 enemy aircraft for the loss of ninety-nine. It was a portent for the immediate future, but Goering, convinced that the war was all but won, took no note. If the campaign had confirmed the German's belief in their tactical power, it did nothing to expose the fatal vulnerability of the Ju 87 dive-bomber and the Bf 110 against determined opposition. It also blinded the Luftwaffe to the need for strategic bombing capability and, in the general relaxation and running-down after 20 May, opened up a gap in production, development and training that the Germans were never to make good.

For the defeat (and, if really necessary, the invasion) of Britain, the Germans applied their standard continental methods. First, the enemy air force must be annihilated; Goering, in his pride, told Hitler that the Luftwaffe alone could bring Britain down and was, effectively, told to get on with it. (Nevertheless, an invasion was, if only remotely, considered.) The Luftwaffe had done it several times already and it should not be difficult - an attitude summed up in the Air Ministry's post-war study 'The Rise and Fall of the German Air Force': 'There was, in the German conception, only one difference, that the RAF, being the most powerful single air force yet encountered, would necessarily require for its destruction some time longer than the twelve to forty-eight hours previously allotted to other air forces'.

Luftflotten 2 and 3, now settling into French bases and facing half-right across the Channel, were to do the job. They possessed 1200 long-range bombers (70 per cent of which were available), 280 stukas (dive-bombers) and 760 single-engined fighters, plus 220 Bf 110 (some 90 per cent of which would be available at any given time). Four days were allotted for the destruction of the RAF in southern England (No 11 Group of Fighter Command) and four weeks for the rest of the RAF. Simultaneously, the bombers would wreck the aircraft industry. Initially, the main purpose of all sorties was to draw the RAF into combat and destroy it.

The story of the Battle of Britain in the summer of 1940 is probably the best-recorded combat in aviation history. German losses mounted steadily, though initially production could cope with these. Goering frequently changed strategic aim, switching from fighter fields and radar stations to the bombing of factories and ports, cutting off each before decisive results had been obtained. Intelligence served the Luftwaffe badly. It had believed that the total ground control of RAF fighters would make them inflexible, whereas it was the other way round; it over-estimated British losses and under-estimated production.

The pressure fell almost entirely on Keith Park's squadrons in No.11 Group. Dowding, determined not to have his whole force drawn into the arena, fought the battle with a few increasingly exhausted squadrons and faced acute shortages of pilots. But he wore the Luftwaffe down and losses of bombers grew so bad that increasingly large fighter escorts were tied to it, denying it the freedom of manoeuvre essential to success.

In the first five weeks, while probing the defences, the Germans lost 244 aircraft against 188 RAF losses in Fighter Command. During the subsequent attacks on radar installations and fighter bases (abandoned too soon, fortunately for the RAF) the comparative losses were 403 to 303. The Germans then turned to heavy bomber attacks on industry and airfields, with large fighter escorts. This phase cost them 378 aircraft; RAF losses were 262.

The shortcomings of the German aircraft – too short a range for the fighters, too light a load and poor defence for the bombers – and the elimination of the Ju 87 and Bf 110, were now apparent; losses were becoming too severe to accept and the Luftwaffe was becoming exhausted. So for that matter was Fighter Command, but on 7 September, in retaliation for RAF bombing of Berlin, Hitler ordered an all-out onslaught on London, taking the pressure off No.11 Group's battered squadrons and allowing them to regroup to counter the new threat. Damage to London was considerable, and was to be continued during the night blitz that followed through the winter, after the Germans were forced to abandon daylight raids. For a period during October they tried to sustain the day campaign with fighter-bombers but by the end of the month the Battle was over, with the loss of a further 435 aircraft. RAF losses were 380. The night attacks that followed caused the Germans little loss, British night-fighting success awaiting the arrival of powerful twin-engined fighters and the development of airborne radar. British losses in lives and production and stores were grievous but bearable and

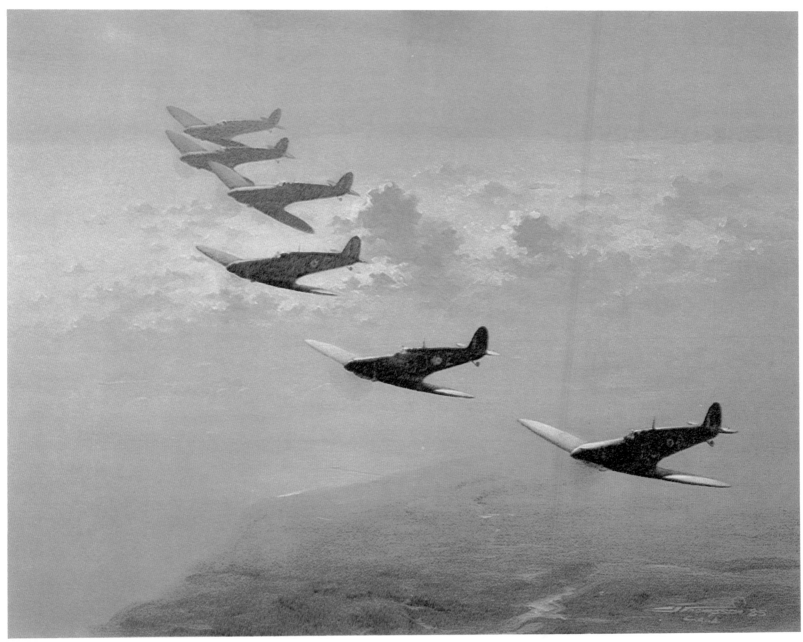

Southend Sentinels CHARLES THOMPSON GAvA
Vickers Supermarine Spitfire Mk Ia (Rolls-Royce Merlin II/III, 1030hp engines).

Charles Thompson paints in oils and has become well known for his meticulously-executed canvasses, planned down to the last square inch and for his interest in texture and reflected light.

No. 19 Squadron, whose Spitfires are seen here patrolling over Southend in October 1940, were the first unit to receive the new fighters, in July 1938 at Duxford. The Mk Ia differed from the original Mk I in having a three-bladed, variable-pitch airscrew instead of the archaic wooden two-blade fixed pitch ones. Later into production than the less-advanced design from Hawker Aircraft, the Hurricane, the RAF had equipped only nine squadrons with Spitfires by the outbreak of war. There were only nineteen Spitfire squadrons when the Battle of Britain started. The Spitfire continued in production until 1947, 20 351 being built, with parallel Seafire construction and was used by many air forces. From the introduction of the Mark XII power was provided by the Rolls-Royce Griffon, delivering up to 2050hp.

eased by one fact: by the spring of 1941 the Luftwaffe was in full preparation for its next adventure, 'Fall Barbarossa' - the invasion of the Soviet Union.

The planned invasion was delayed during a crucial period by the need to turn aside and deal with the situation in Jugoslavia and Greece, in the latter case because Hitler had been forced to come to the aid of his incompetent ally Mussolini. Italy declared war on France and Britain on 10 June 1940, hoping for easy pickings and the plans for Barbarossa included the participation of Italy on the southern flank.

Mussolini, however, started the invasion of Greece, which was not on the agenda and became badly embarassed by Greek resistance, backed by such help as Britain could provide from the Middle East - which was not much.

By the time Germany had cleaned up the mess and taken Crete, with such staggering losses among the aircraft and men of General Student's XI Fliegerkorps that Hilter forbade all future airborne operations, the summer was passing. In Jugoslavia, the revolt against the pro-German government in April, while the battle for Greece was on, interrupted the transfer of several hundred Luftwaffe aircraft from France to the Balkans.

In the actual attack on the Soviet Union, Luftflotten 1, 2 and 4 were involved, using 775 long-range bombers, 310 dive-

bombers, 920 fighters of which 90 were twin-engined, and 710 reconnaissance aircraft. The recce role of the air force still formed a very large part of its duties. Including other aircraft, 2770 were involved, from a total strength in front-line aircraft of 4300. Opposing them would be an air force still in the throes of modernization, technically and operationally no match at all for the confident and highly tuned Luftwaffe. What had been seen of Soviet capability in the Finnish war did not inspire

her new allies or trouble her enemies.

The Russians had about 7700 aircraft in the west, of which 1445 were new types introduced in the past year. Most of these were massed on the frontier and orders for dispersal, hurriedly issued at the last moment, never reached most commanders. From 0315 hours on 22 June 1941, German attacks commenced on sixty-six airfields, housing 70 per cent of the Soviet air force in the west. The figures for the results are very nearly unbelievable: by mid-day 1200

aircraft destroyed, 900 on the ground. By the end of 27 June, 3820 were destroyed and on the 29 June German claims had reached 4017 for Luftwaffe losses of 150 machines. A Russian statement on 5 October admitted the loss of 5316 aircraft.

Desperate measures were taken by the Soviet command; the elderly I-15 and I-16, heroic aircraft of the Spanish Civil War, went back into production, the evacuation of aircraft factories to the centre of the Soviet Union, discussed in August 1941, went into operation, and fighter pilots began to resort to ramming their opponents (though this was later forbidden with expensive modern fighters). And winter came early that year.

The Russian radial engines were better adapted to winter conditions than the German glycol-cooled power plants, and their aircraft better adapted to rough airfields and harsh conditions. Even the archaic Hucks ground starter made firing up engines easier. Although the evacuation of factories caused a considerable loss of production and made the supply of raw materials difficult, production gradually rose to massive figures.

Lack of metal caused most Soviet aircraft to be made of wood and laminates, while

Condor at Stalingrad HARRY PETERS
Focke-Wulf Fw 200 Condor (four BMW 132H, 830hp engines).

When General Wever was killed in an air crash in 1936, the driving force behind the development of a long-range strategic bomber for the Luftwaffe was gone. The Do 19 and Junkers 89 were cancelled and although Heinkel was given the task of developing a large bomber, nothing came of it. Lufthansa, however, had ordered a four-engined transport from Focke-Wulf (the only four-engined aircraft the firm ever built) when the DC-2 began to enter service in Europe. Designer Kurt Tank produced the fast and elegant Condor, losing a bet of a case of champagne (by eleven days) that he would have it flying within a year. Military interest was stimulated by a Japanese order for a reconnaissance version and just before the war began, work started on a long-range recce version for the Luftwaffe. The structure was never meant to absorb the increasing weight of bombs, guns and military equipment and Condors frequently broke their backs. But they operated against shipping from their Biscay bases and snooped for the U-boats with such success that they were known as the 'Scourge of the Atlantic'. Pressed into various transport tasks, they were involved in the attempted air supply of Stalingrad where numbers were lost, along with irreplaceable trained crews.

The painting shows an aircraft of KG 40, from the Atlantic coast, landing at Pitomnic in January 1943. The aircraft was operating four or five tons (tonnes) above the permissible all-up weight so that its tyres overheated in spite of the landing in deep snow.

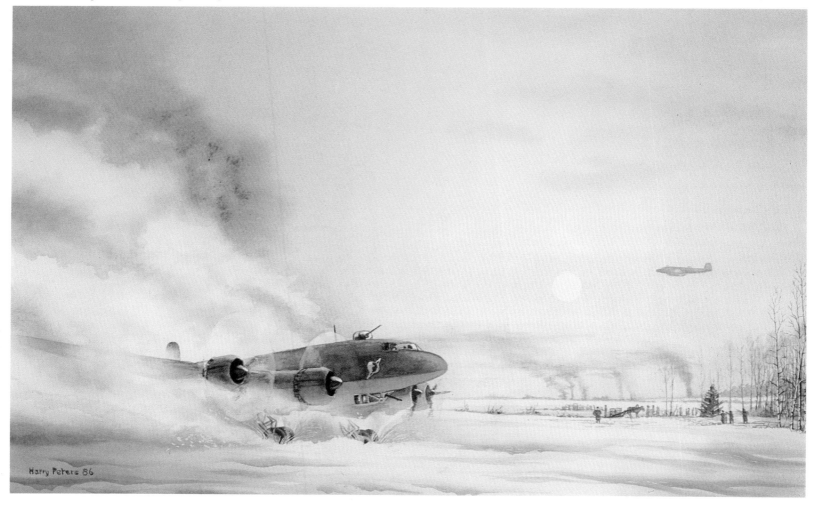

Harry Peters 86

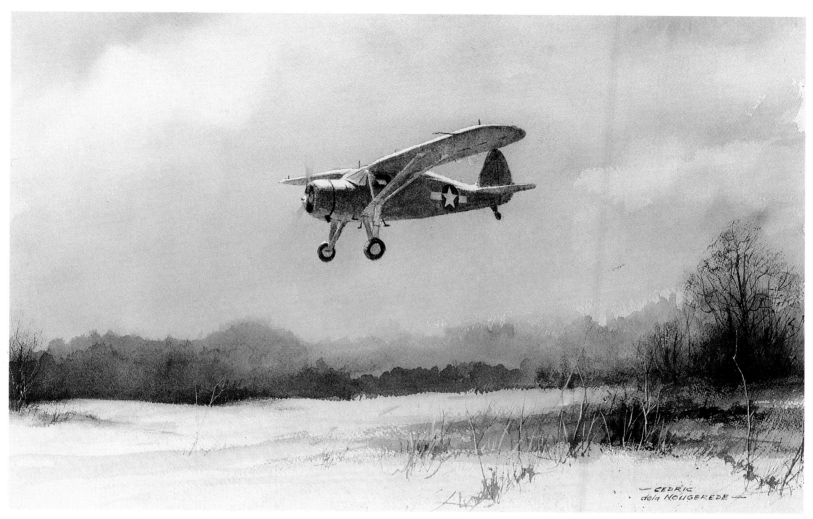

Running Home CEDRIC DE LA NOUGEREDE GAvA
Fairchild 24W-41 (UC-61) (Warner R-500-1, 145 hp engine).

The Fairchild Model 24, first introduced in 1932, was steadily enlarged, improved and made more powerful. By 1937-1938 it was available in a de luxe version, powered by the Ranger in-line six cylinder 6-390-D3 of 150 hp, and the more popular radial-engined standard version with the 145 hp Warner Super-Scarab. Like most American aircraft of its time it would accept a variety of radial engines of similar power. Several hundred were built of different marks. From 1941 the Model 24W was produced as a military communications aircraft, under the designation UC-61 Forwarder. All but two were sent to Britain under Lend-Lease, and used worldwide under the name Argus. All were powered by the radial Warner R-500-1 and a number were allotted to Air Transport Auxiliary for pilot ferrying. There were 306 Ranger-powered versions also built and many civil aircraft impressed. Production resumed after the war and many still fly in the United States.

the comparatively low-powered engines available forced reduction of structure weight with the dropping of all but bare essentials in equipment. The aircraft were, however, very manoeuvrable and would absorb considerable punishment, though inferior in performance to the opposition until very late in the war. Supplies gradually built up.

Only slightly more than 1000 aircraft, mostly fighters (the bomber arm was a late starter), were delivered in January 1942, but the year's total was 25 400 (15 735 aircraft had been built in 1941). In 1943, 35 000 were built and in 1944, 40 300. In all, some 125 000 aircraft were turned out during the war; over half were fighters and three-quarters of the remainder, the Il-2 Sturmovik ground-attack aircraft.

By the end of June the Germans had made their customary comfortable assessment that the opposition had ceased to exist and turned the Luftwaffe

on to close support of the advancing armies. As the campaign went on they were disillusioned; they were disagreeably surprised, as the rest of the world was increasingly encouraged, by the stubborn and savage Russian defence. On the ground, as in the air, Russian losses were appalling.

German losses, too, were mounting, as much from the weather as from Soviet action and in January 1942, the first of a series of actions that were to help break the back of the Luftwaffe in the East took place when air supply of encircled units at Kholm and Demyansk was undertaken.

The Demyansk operation was successful, but anti-aircraft and fighter attacks shot down 262 Ju 52s (about half the year's production) and killed many experienced aircrew and instructors. Less than a year after that, the German 6th Army was trapped at Stalingrad and attempts at air supply and the evacuation of wounded

cost 488 aircraft of all types and over 1000 aircrew between 24 November 1942 and 31 January 1943, just before the final surrender. Losses included 266 Ju 52/ms, 165 He 111s and nine Focke-Wulf Fw 200s.

One interesting Russian operation at the end of 1941 involved the dropping of 9500 parachute troops in an attempt to encircle German forces. Losses were heavy. At that time the Soviet air force had few escort fighters for the transports – lumbering, 180 mph (290 km/h) G-2 four-engined monsters – and there was virtually nothing that could be achieved in the face of poor navigation, insufficient aircraft and dreadful weather. Like the Germans, the Soviets disbanded their airborne forces (eight airborne corps) the following summer. Most ended up fighting in Stalingrad as guards divisions.

As the Russians went over to the offensive, air battles became larger and they began to build up not only a competent command structure, but by July 1943 could field 8300 aircraft including large numbers of Lend-Lease fighters and bombers. Eventually 14 833 American and 4570 British aircraft were supplied. The Germans now faced odds of over two to one.

The tide turned in 1943, with the failure and falling back of the German armies and despite continued bitter fighting, the end was no longer in doubt.

1943 was a turning point for the Allies in other theatres. One of the most savage

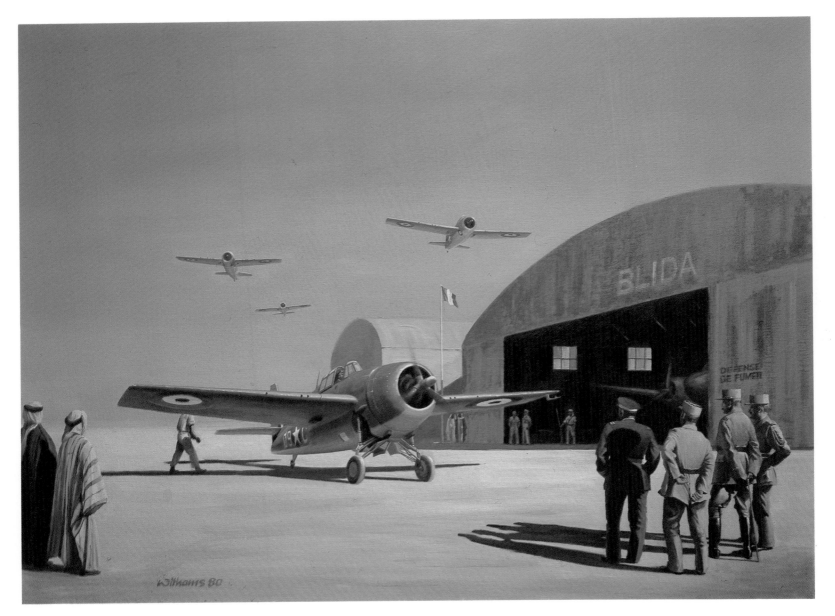

Surrender of Blida Airfield BRIAN WITHAMS GAvA
Grumman Martlet (Pratt and Whitney R-1830-86 Twin Wasp, 1200 hp engine).

Brian Withams is one of the most consistent contributors to the Guild's Annual Exhibitions. He paints
with an enthusiasm for detail in his composition and a nice eye for the shape of things. During the
Allied landings in North Africa HMS *Argus* and HMS *Avenger* provided cover over the beaches and
were tasked to 'look after' the airfields at Maison Blanche and Blida. To quote Hugh Popham's *Into
Wind*, 'The honour of capturing the first was shared between an American Regimental Combat Team,
an RAF advance party, a Fulmar of 809 Squadron and eighteen Hurricanes from Gibraltar: the honour
of capturing the second belonged exclusively to a section of Martlets of 882 Squadron from *Victorious*
whose leader, Barry Nation, spotted a number of gentlemen waving white flags and landed...'.

The Martlet (in the United States it was called the Wildcat) served with several Fleet Air Arm
squadrons and was the first American aircraft in British service to score a victory. With its 300 mph
(483 km/h) speed and four 0.5-inch (12.7-millimetre) guns it was a considerable advance over previous
British fleet fighters.

and critical battles in the West, the Battle
of the Atlantic, had been in progress since
1940, when the German navy and Luftwaffe
acquired bases on the French Atlantic
coast. From initial reconnaissance
missions to aid surface raiders and
U-boats, made with a small number of
Focke-Wulf Fw 200 Condors, German
operations expanded into a long-range

offensive with bombs and cannon against
merchant ships. In this they were highly
successful, sinking thousands of tons of
shipping (including crippling the 42 500-ton
(43 180-tonne) Empress of Britain, which
was finished off by U32). Two hundred
and sixty Condors were built and during
their initial operations, with virtually no
opposition, they caused havoc. At first the

only counter-measures consisted of
Hurricanes mounted on catapults on
merchant ships in convoy, but the gradual
introduction of escort carriers and
longer-range fighters – and a high attrition
rate caused by structural weakness and
gross overloading – gradually mastered
the threat.

The greatest threat to merchant ships,
however, was always the U-boat. Initially,
there had been too few boats to be really
effective but Doenitz, admiral commanding
the U-boat forces, soon introduced the
'wolf-pack' tactics that enabled several
boats to concentrate against the convoys
instituted by the Royal Navy at the
beginning of the war.

Anti-submarine weapons and detection
apparatus were under-developed at that
time and surface escorts were always in
short supply. It became increasingly
obvious that the most effective counter-
measure was the aircraft, in the hands of

Coastal Command. (As a matter of historical accuracy, the first U-boat sunk by aircraft was disposed of by a Blenheim of No. 82 Squadron, Bomber Command.) But aircraft, too, were in short supply. Only the Sunderland had adequate range for the Atlantic. Proper depth charges and anti-submarine weapons were also lacking.

By the end of 1940, things were improving. Naval depth charges had been adapted – and adopted – as a primary weapon and radar sets, temperamental and in short supply still, were becoming available. But still there was a lack of long-range aircraft and there was a three-hundred mile (483-kilometre) gap in

the central Atlantic that could not be covered. Catalinas were coming into service, though, and they had a range of up to 4000 miles (6437 kilometres). Ordered at the beginning of the war, they entered service in the spring of 1941 (one from No. 209 Squadron spotted the Bismarck on 26 May) and they were joined in September by the Liberator, four-engined, powerfully-armed and carrying 12 800 pounds (5806 kilograms) of bombs nearly 1000 miles (1609 kilometres). With a reduced load for maritime operations the range was 2290 miles (3685 kilometres). Eventually, Coastal Command was to deploy nine squadrons of Catalinas and

twelve of Liberators in the U-boat war.

Until the Atlantic gap could be somehow closed, it was impossible to attack U-boats on operational station, and efforts were concentrated on the areas of sea through which they had to pass going to and from their bases. In addition, from the autumn of 1941, the first of the escort carriers, HMS *Audacity*, converted from an ex-German freighter, appeared on the convoy routes. These small ships, 'Woolworth carriers' as the Americans called them, eventually appeared in large numbers. *Audacity* herself was sunk by a submarine on her return maiden voyage, but thanks to her American Martlet fighters added to a powerful escort, four U-boats were sunk for the loss of two merchant ships in addition to the carrier (by then down to three of her original six aircraft).

In the twelve months ending July 1942, three and a half million tons (3 556 000 tonnes) of shipping were sunk, most of it off the brilliantly-lit American coast. But newer weapons were coming into service and there were some gleams of hope.

Although the advantage still lay with the submarine, and the Germans seemed to

Climb out from Perimbi MILES O'REILLY GAvA
Short Sunderland Mk I (four Bristol Pegasus XXII, 1010 hp engines).

The military Sunderland followed the civil C-Class flying boats at Short Brothers Rochester works. The first squadron to receive them was No. 230, one of whose Mk Is is shown leaving Perimbi, Singapore. The first aircraft was flown out to Singapore in 1938, arriving on 4 July. Later versions carried dorsal powered turrets instead of the hand-held guns of the Mk I, and Sunderlands when well handled were often a match for German long-range fighters over the Bay of Biscay. One, on convoy duty, shot down three of eight attacking Junkers 88s. Mostly employed on convoy and anti-submarine work, the three squadrons in Coastal Command in 1939 had become twenty by the time the last of the 749 built retired from the Royal Air Force – most appropriately at Seletar, Singapore – on 15 May 1959, the type having served nearly twenty years.

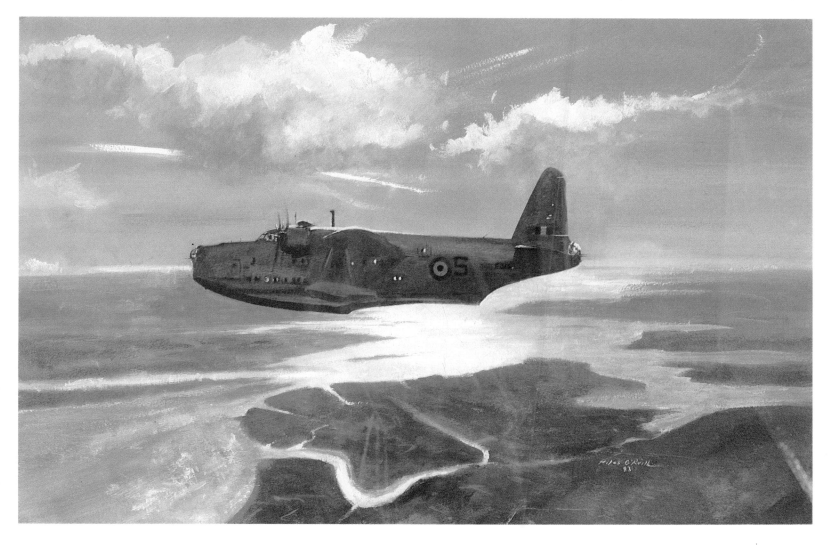

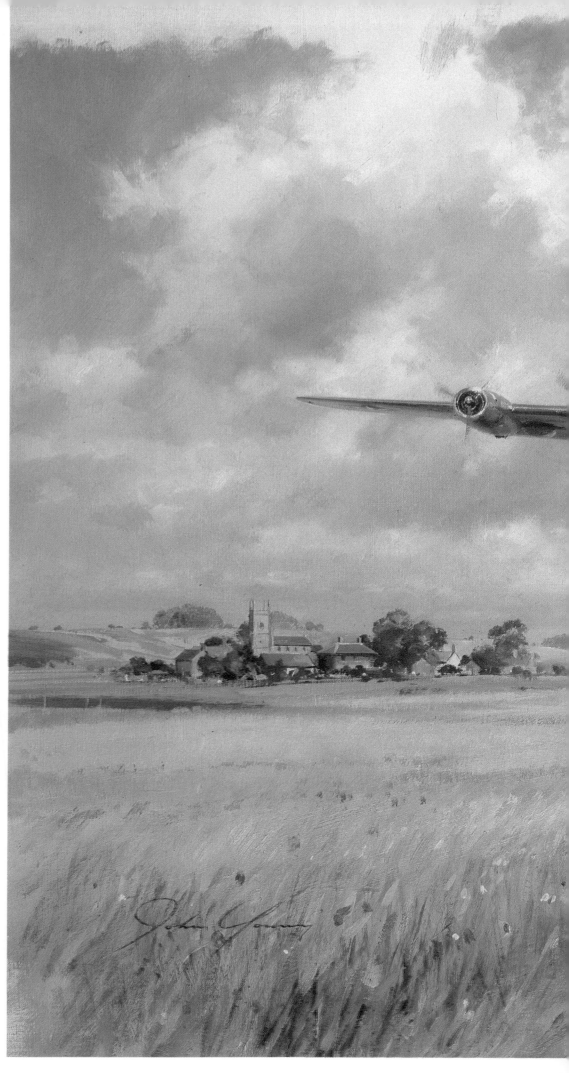

The Sword and the Ploughshare

JOHN YOUNG GAvA

Consolidated B-24J Liberator (four Pratt and
Whitney R-1830-65, 1200 hp engines).

John Young has been one of the most stalwart
professional supports of the Guild since its early
days, a prolific exhibitor, active committee member
and Chairman in 1987. His style is conservative and
traditionally English with a deep feeling for the
construction and material of each aircraft that
brings the subject alive on the page. A landscape
and portrait painter as well as aviation enthusiast he
delights, like fellow Guild artist Denis Pannett, in
placing his aeroplanes in an English country setting
– usually somewhere not far from his native heath.
In the painting, the Liberator is just taking off, the
landing gear cycling, flaps at take-off setting.

The B-24 was the aircraft requested of
Consolidated to give greater speed and range than
the B-17 then being built. The company held the
licence for the Davis wing design, which gave high
lift at reduced angles of attack (hence better range
and reduced drag), and used it as the basis of the
design. Eight thousand pounds (3629 kilograms) of
bombs could be carried in the huge fuselage – twice
the load of the Fortress – and a tricycle landing
gear was used. Work on the design began in 1939
and the first aircraft entered service two years later.
By the end of the war forty-five groups, comprising
6000 aircraft, were operating, mainly in the Pacific.
Twelve B-24 groups served in the 8th Air Force in
Britain and the aircraft's great range made it a
valuable asset in Coastal Command.

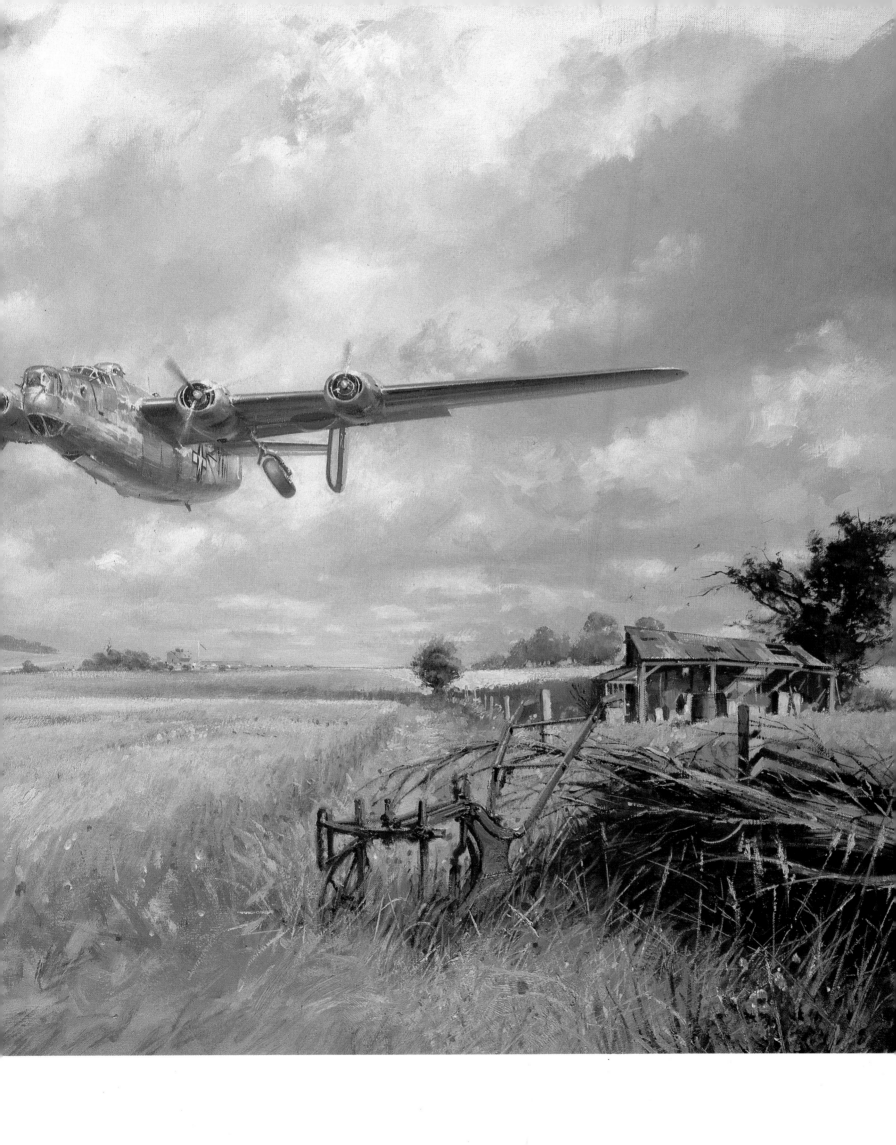

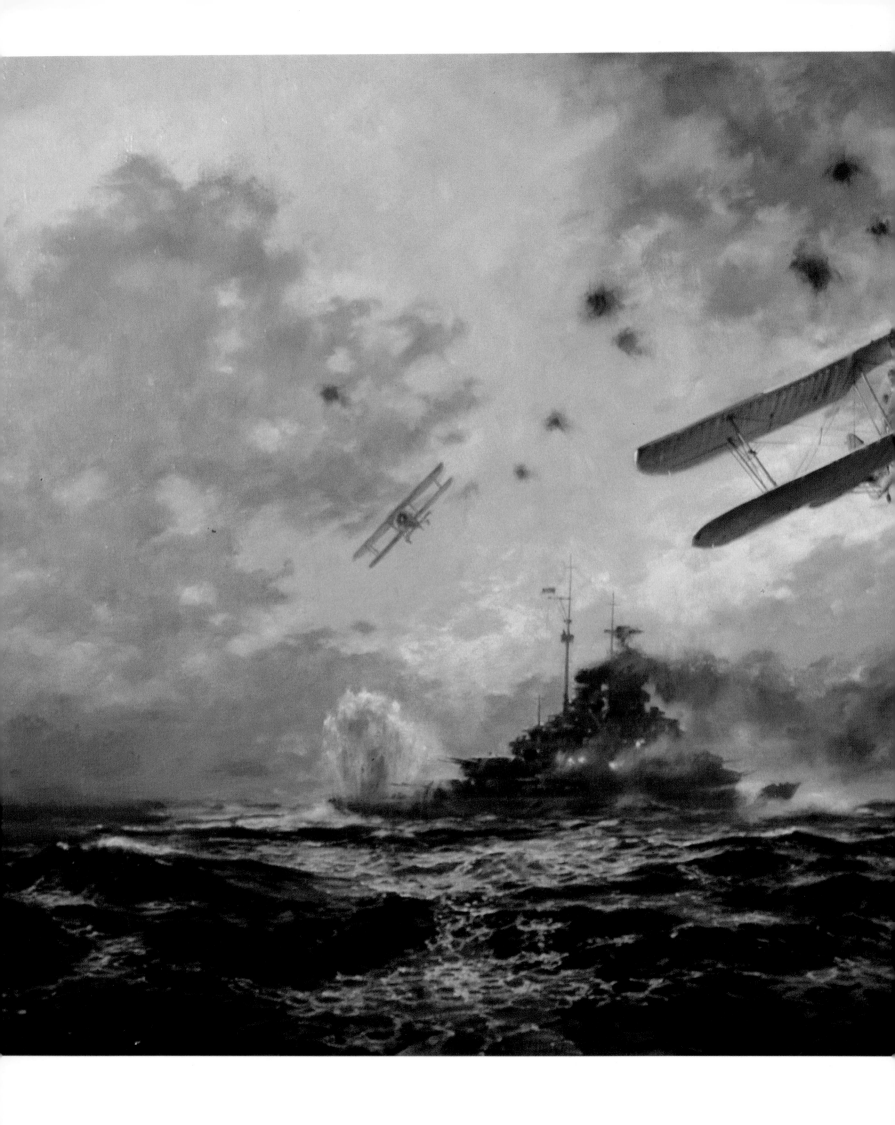

find a counter to every new detection device, electronic devices were supplementing radar (and radar-controlled searchlights in the attacking aircraft) and a new weapon, the rocket, was entering service. Because of the need for speed in either traversing areas of sea under air watch or in order to catch a convoy, U-boats were spending more time on the surface, confident in the protection of their new and powerful anti-aircraft armament. The rocket could be launched some distance from the target and was a devastating weapon against a surfaced boat.

Problems still existed and the supply of suitable long-range aircraft and radar was constantly blocked by Harris's demand that Bomber Command should be given everything. Even so, while only twenty-eight submarines were sunk in the first half of 1942, eighty-one were lost in the second; although shipping losses were no smaller. By the summer of 1943, however, centimetric radar and considerable numbers of Liberators, with the ability to cover the Atlantic Gap and armed with homing torpedos, improved depth charges and new detection devices were available. Moreover, the escort carrier was back, in the shape of HMS *Biter*, with Grumman Wildcats and Fairey Swordfish on her small deck, to accompany convoys, along with HMS *Bogue*, HMS *Archer* and others. Figures, quoted by Alfred Price in *Aircraft*

Swordfish Attacking the Bismarck
ALAN FEARNLEY GAvA
Fairey Swordfish (Bristol Pegasus, 750 hp engine).

The Fairey Swordfish was an aircraft that should never really have been allowed into the second world war. Certainly it was obsolescent by 1939 and its successor, the Albacore, was about to enter service. But the Swordfish survived and outlived the Albacore. It was designed to the Torpedo-Spotter-Reconnaissance role, with a crew of three (or two and a long-range tank) in the vast cockpit – it was possible to stand up in the back and lean over the pilot's shoulder. The 'Stringbag', as it was known because you could cram everything into it, pottered about the war absorbing every job it was given. Swordfish destroyed the Italian fleet at Taranto, confirming the idea of the Japanese that Pearl Harbour was practical. They dive-bombed, they fired rockets at submarines, carried huge radar sets, laid mines and flung themselves off and on tiny escort carriers, sometimes using rocket assistance. Flying from HMS *Ark Royal*, under conditions so bad that the stern of the flight deck was rising and falling over sixty feet (eighteen metres), they twice attacked the *Bismarck*, running hard for the shelter of Brest. A torpedo strike that jammed the rudders of the *Bismarck* left her circling helplessly until the Home Fleet came up and finished her off.

versus Submarine mark the turning point in the Battle of the Atlantic: in fourteen days ten convoys passed through the mid-Atlantic with the loss of only three escorted ships. Thirteen U-boats had been lost, seven to aircraft and two to joint air-sea action. Doenitz moved out of the North Atlantic.

Trying his luck in the South and West Atlantic, against what had been rich pickings in American waters, Doenitz found not only numbers of escort carriers but a new menace – non-rigid airships. As in World War I, these 'blimps' were perfect convoy escorts, keeping U-boats away even if they attacked few. Back nearer home, in

the Bay of Biscay, mounting losses were forcing U-boats to travel submerged and at night. The fact that the aircraft was the submarine's prime enemy was now established. New designs of boat and new equipment were being prepared, faster underwater, armoured and longer ranged. But the second front opened, construction of the new boats was held up by Allied bombing and before any entered service, the opportunity for their use was gone.

Before turning to the fighting in the Far East, attention must be turned, if only briefly, upon the war in the air in the Middle East. Initially, from 10 June 1940, when the Italians entered the war – actually at midnight – the desert air war was a self-contained affair between the three fighter squadrons (flying Gladiator biplanes) and five Blenheim bomber squadrons of the Royal Air Force and the far larger Italian air force in Libya. The Italians had 282 aircraft in Libya; five *gruppo* (a swollen equivalent of an RAF

Misty Marauder JOHN YOUNG GAvA
Martin B-26 Marauder (two Pratt and Whitney Double Wasp R-2800, 2000 hp engines).

Emerging from the muddles of aircraft procurement procedures in World War I, Glenn Martin set up as an independent manufacturer and from 1918 supplied the United States Army with a succession of twin-engined bombers, a commission that was to last until the 1960s, when he was building a modified version of the English Electric Canberra as the B-57. In 1939 he started work on a new bomber to an official specification, and received orders for 1100 of them off the drawing board. The B-26, as it was to become, fulfilled a very demanding specification at the inevitable expense of trading low-speed handling for high performance and big capacity. Initial aircraft were extremely 'hot' with high landing speeds and critical handling and the type began to gain a reputation as the 'widow-maker'. Subsequent alterations to the design, including a bigger wing to lower the highest wing loading of any aircraft in service, improved things dramatically and the Marauder won itself an enviable reputation as one of the foremost medium bombers of World War II. It flew initially in the Pacific area, but later carried out many successful operations in the European theatre. Two squadrons of the Royal Air Force used them in the Middle East and they also equipped French and South African units.

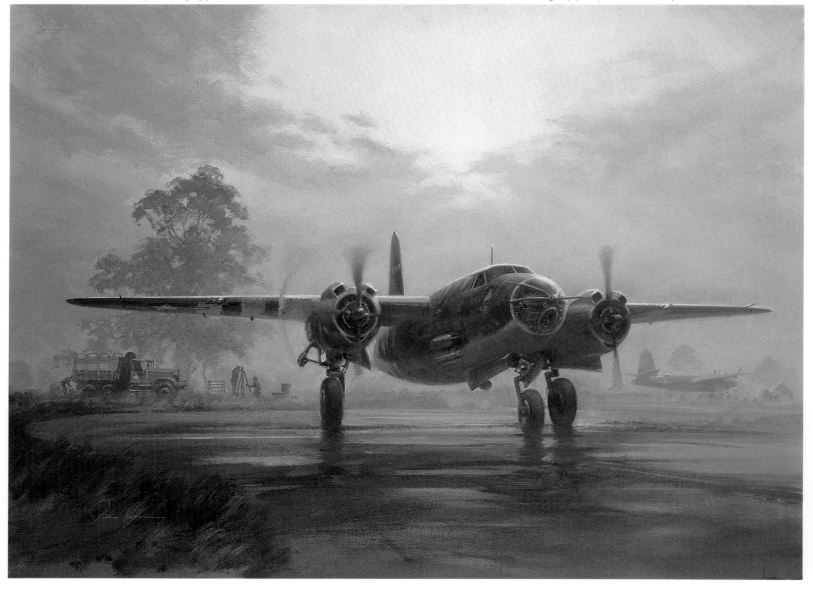

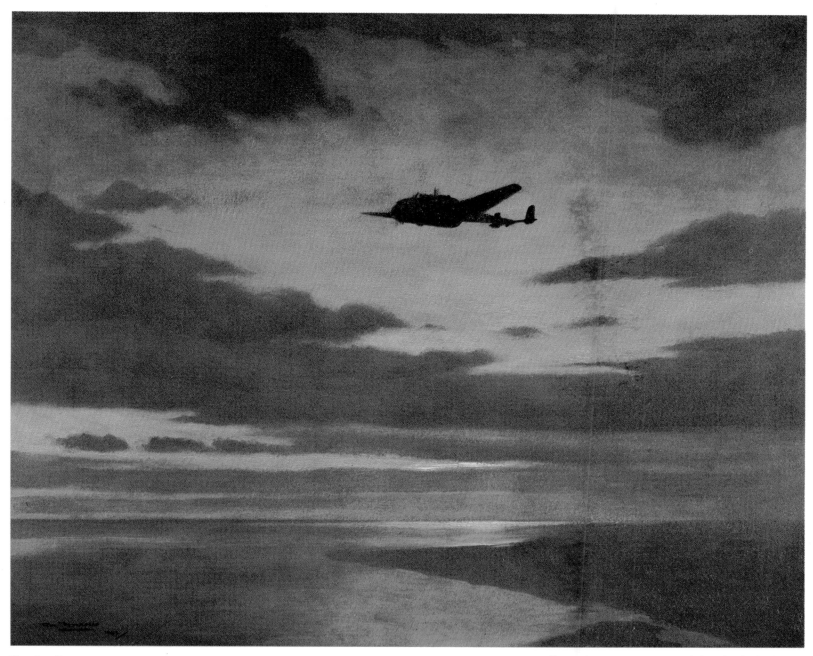

Evening Departure ROY NOCKOLDS GAvA
Handley Page Hampden (two Bristol Pegasus XVIII, 1000hp engines).

The late Roy Nockolds, famous for his beautiful acrylic paintings of veteran and classic car races, centred on his beloved Brooklands, took to painting aircraft during the second world war, almost as an offshoot of his camouflage duties and became one of the best-known war artists. Like Frank Wootton (and almost no-one else) in that band, he had a love of aircraft for themselves and developed a magnificent facility to portray sky and cloud.

The Handley Page Hampden, when it first appeared (to a specification issued in 1932) proved to be faster than the Blenheim light bomber, while carrying double the load over twice the distance. Unfortunately, too much was sacrificed to attain its top speed of 254 mph (409 km/h); the slender fuselage cramped and tired the crew and if the single pilot was hit there was no way of getting at the controls. The lack of power-operated turrets made the Hampden extremely vulnerable, despite its agility, although it must be remembered that in 1932 the idea of power turrets was not fully accepted. Like the Whitley, Blenheim and Wellington, it continued in production long past its prime, rather than risk the long delay in introducing replacement types. Production, in fact, continued until 1942 and later that year they left Bomber Command to continue a useful career as minelayers. In England 1270 were built, and another 160 constructed in Canada.

squadron) of biplane fighters, ninety-six of the three-engined Savoia Marchetti SM 79 bombers, and seventeen SM 81 bombers – respectively the equivalent of the Blenheim and the bomber-transport Bombay which equipped one RAF squadron. There was little difference in performance between the two sides; Italian bombers carried more load further but were slower than the Blenheim. Number 202 Group, Royal Air Force, however, rapidly pushed the Italians on the defensive but was hampered by the need to conserve scarce resources. While the enemy could reinforce from the 1 200 front-line aircraft in Italy, Air Chief Marshal Longmore had to spread 300 aircraft in twenty-nine squadrons (including No. 202 Group) over a command that included Egypt, Sudan, Palestine, Trans-Jordan, East Africa, Aden and the Balkans, as well as the Mediterranean, Red Sea and Persian Gulf.

Initially, in East Africa and the Desert, the enemy were held. The Italian invasion of Greece bled off four precious squadrons of Gladiators and Blenheims. (In the desert, the solitary Hurricane in the command leapt about from airfield to airfield to impress the Italians). As the war spread, the squadrons were stretched even more, despite the arrival via Takoradi of 73 Squadron's Hurricanes and two squadrons of Wellingtons via Malta. The failure to take out Malta before it could be re-inforced was among the greatest of many Italian errors.

More squadrons went to Greece and in December 1940, the first German units of Fliegerkorps X arrived in Sicily. Almost at once, determined attacks on Malta and on convoys and their escorts began to build up, resulting in much damage to ships and heavy casualties. The Germans brought seventy-seven bombers and sixty-one

dive-bombers, besides fighters into the assault on Malta, which continued until late in 1942. The Germans never entirely neutralized the island as a base from which torpedo and bomber squadrons could strike German supplies. Eventually losses in this area became crucial to eventual German defeat. A proposal to capture the island with two parachute divisions was abandoned.

Moonlight over the Enemy Coast DENIS PANNETT GAvA
Vickers Armstrongs Wellington Mk Ic (two Bristol Pegasus XVIII, 1000hp engines).

The Wellington was designed to the same 1932 specification as the Hampden and Whitley, but thanks to the inspired work of Rex Pierson, chief designer, and Barnes Wallis, was considerably superior to both. The geodetic method of construction, first used on the Wellesley for service aircraft, was strong and light, absorbed considerable battle damage and could be easily repaired. Fortunately for the Royal Air Force, designers were permitted to go outside the singularly archaic provisions of the original specification. Powered by the excellent nine-cylinder radial Pegasus, Wellingtons carried most of the burden of bombing Germany until the arrival of the heavies, and by the winter of 1941 Bomber Command had no less than twenty-one squadrons of them. Like the Halifax, the Wellington had a useful career with Coastal Command, attacking shipping and U-boats (often equipped with the Leigh Light for night assaults on the latter) and carrying torpedoes and mines. After the war, the final version, the Mk X, was used for navigation training.

Denis Pannett is a highly successful painter of watercolour landscapes in the traditional English manner, as well as being a popular aviation artist. Like most of the professional members of the Guild, he gives freely of his time and skills to help fellow members.

Throughout 1942 reinforcements to the Royal Air Force, Hurricanes, Spitfires, Curtiss Kitthawks and Douglas Bostons, built up into a formidable Desert Air Force to hammer Rommel's forces; and by the time that the North African campaign ended after the landings in Tunisia, co-operation between air and land forces reached a peak of efficiency it was never to attain again. As an example of the weight of Allied air power achieved by the Battle of Alamein in October 1942, there were ninety-six squadrons in the Middle East (eight of them in Malta), of which sixty were British, thirteen American and the rest Allied and Dominion, disposing 1200 aircraft in Egypt and Palestine alone against Rommel's serviceable total of some 350 out of 689 in Africa.

The United States entered the war on 7 December 1941, when Admiral Nagumo's First Air Fleet struck at Pearl Harbour, main

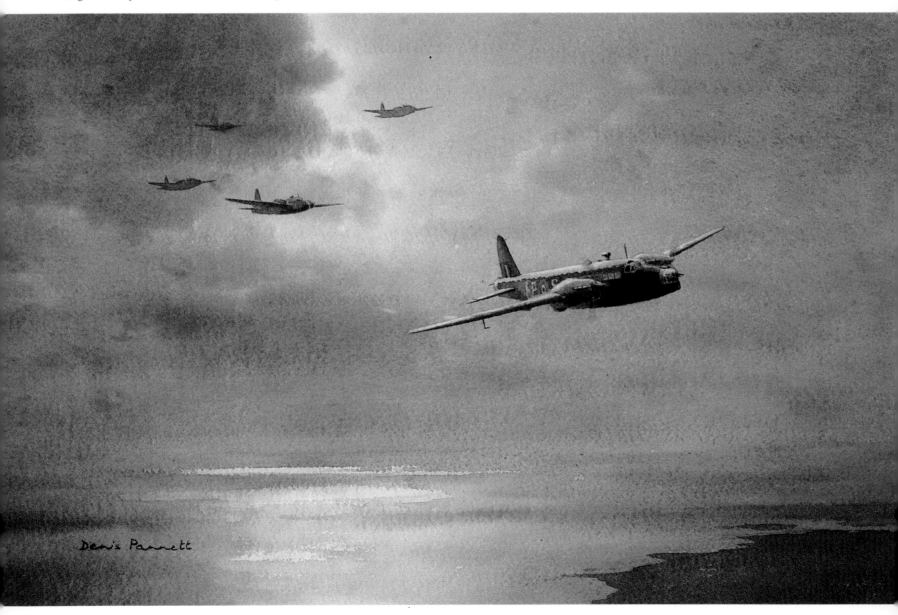

Last Quiet Moment GERALD COULSON GAvA
Short Stirling (four Bristol Hercules XVI, 1650 hp engines).

The Short Stirling, like other aircraft of considerable significance, has been hard done by in the pages of history, its achievements overshadowed by those of the more glamorous aircraft that were to follow it. The first four-engined monoplane bomber in the Royal Air Force, it was designed to a 1936 specification and was broadly based on the wing/engine layout of the Sunderland flying boat already comtemplated for the RAF. With a final loaded weight of around 31 tons (31.4 tonnes) and the restrictions on span imposed by the need to get in and out of standard RAF hangars, the wing loading was kept reasonable by building a very low-aspect mainplane, but this cut the service ceiling to 17000 feet (5182 metres). Combined with a bomb bay construction that did not permit the carriage of the heavier bombs developed during the war, this restricted the usefulness of the Stirling considerably.

No. 7 Squadron was the first squadron to be equipped in August 1940 – and was to retain its Stirlings until almost the end of the war. Twelve squadrons of Bomber Command, in No. 3 Group, flew the aircraft. In the course of the prolonged attacks on the *Scharnhorst* and *Gneisenau* through 1941, No. 3 Group operated them by day – the only Bomber Command aircraft to do so then – and it was found that the three powered turrets gave good defence against fighter attack, although from June escorts were provided. They also took part in the offensive daylight sweeps over Northern France. As Halifaxes and Lancasters replaced Stirlings in Bomber Command, the latter began a new and profitable career as glider-tug, transport and special-duties aircraft, with Transport Command and No. 100 Group. Stirlings flew fuel for fighters into Normandy and carried parachutists and towed gliders and dropped supplies in the major airborne operations.

Gerald Coulson has selected a dramatic moment for his painting of a Bomber Command Stirling , as the crew prepare to board the aircraft and get ready for the coming night's operation.

base of the United States Pacific Fleet, with 350 aircraft launched from six carriers. Failing either to destroy the irreplaceable shore installations or sink the heavy carriers *Enterprise* and *Lexington*, which were at sea, the attempt to neutralize the Pacific Fleet failed, despite the elimination of the eight battleships.

At the initial meetings of the British and American leaders the decision was taken to eliminate Germany first; while this was eventually to include landing in Europe, initially only aircraft could strike at the German enemy. This was a view already held by Bomber Command, and one which, from the appointment on 22 February 1942, of Air Marshal A.T. Harris as its Commander-in-Chief, rapidly became an aggressive religion. It was to be some time after that date, however, before the pressure on the enemy became more than slight and sporadic.

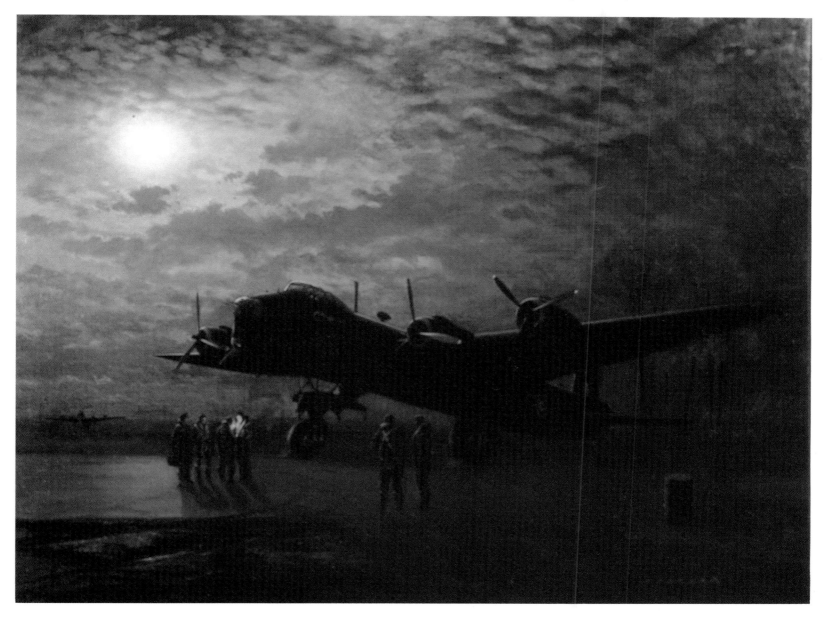

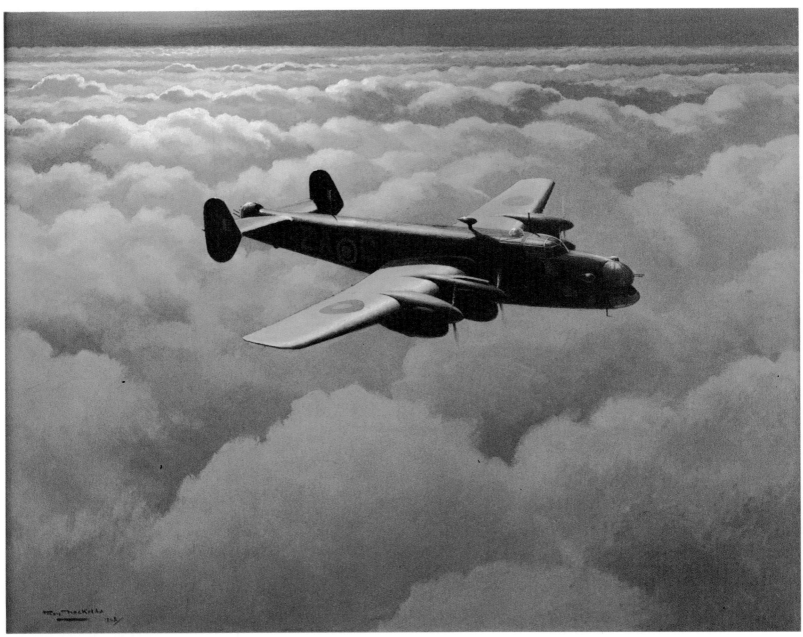

Above the Clouds ROY NOCKOLDS GAvA
Handley Page Halifax Mk I (four Rolls-Royce Merlin X, 1280 hp engines).

Following the requirement that resulted in the Hampden, in 1936 the Air Staff advertised for a new twin, to be powered by the powerful Rolls-Royce Vulture (as yet an unknown quantity). Fearing a shortage of the new engine, the Halifax was designed round four Merlins, which was just as well as the Vulture turned out to be a disappointment. The Halifax came into service just after Short's Stirling, the first squadron, No. 35, equipping from November 1940. Despite a number of early problems, resulting in numerous design changes, the Halifax was a useful partner to the Lancaster in the long and bitter battle over Germany (and was the first four-engined heavy to bomb Germany). Nobody could have pried a Lancaster loose from Air Marshal Harris and Bomber Command, but Halifaxes undertook numerous other duties. They served with Coastal Command from late 1942, as glider tugs in airborne operations, dropping arms to partisans and as electronic counter-measures aircraft with No. 100 Group. A final, post-war, transport version and general reconnaissance service stretched the first-line career of the aircraft to 1952.

Prior to September 1939, all air forces had believed implicitly in the ability of bombers to operate successfully in daylight in close formation. Nothing in the Spanish or other 'interim' wars had dispelled this cosy assumption. As one result, nobody developed a useful long-range fighter (not even the Germans, who had used drop tanks on He 51s in the Spanish War and knew about them since 1918). Reality proved the theory hopelessly wrong. The British Blenheims and Wellingtons attacking the German Fleet, the Blenheims and Battles of the Advanced Air Striking Force in France and the Dorniers and Heinkels in the Battle of Britain were all savaged unmercifully by defending fighters. Both sides turned to night bombing, but where the Germans had developed radio guidance methods for finding targets, the RAF had not.

German success in early night operations was also helped by the proximity of the main targets to their French bases and the impossibility of missing London, but increasing night fighter efficiency and the distractions of Barbarossa caused the early shut-down of the offensive. Bomber Command, however, conscious though it was, as was everyone else, that it consititued Britain's only strategic weapon, had problems of its own. The twin-engined 'heavy' bombers could carry only miniscule bomb loads to targets in Germany five times further away than the German targets; navigation remained at the level reached in the first world war; and the winter of 1940/1941, like the one to follow, was appalling. In addition, German anti-aircraft guns, controlled by the Luftwaffe, were hideously effective, unlike the feeble British effort in this direction.

Daylight raids continued, largely upon anti-invasion targets in French ports and later, when the Battle of the Atlantic became a top priority in March 1941, with attacks on the *Scharhorst* and *Gneisenau* tucked up in Brest, resulting in 1665 tons (1681 tonnes) of bombs being dropped in eight weeks – with four hits on the ships.

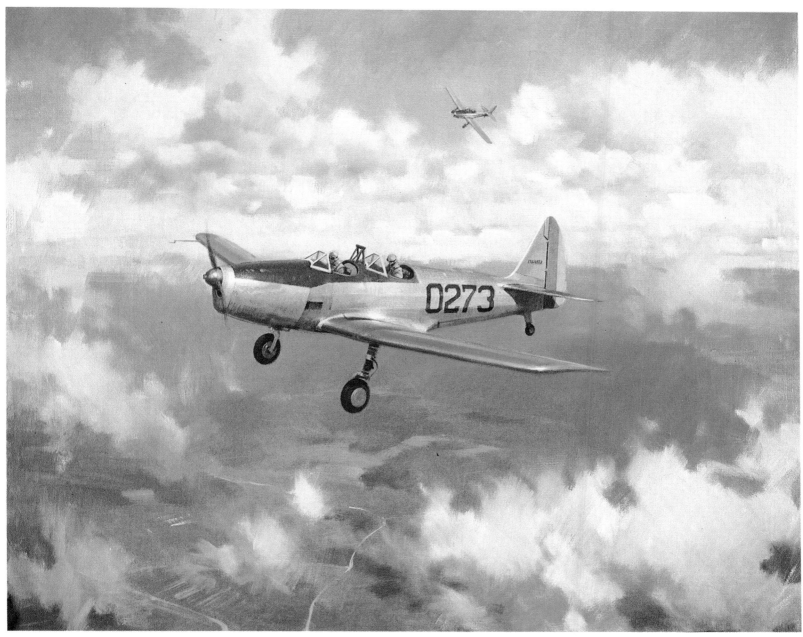

Fairchild Cornell MICHAEL TURNER GAvA
Fairchild PT-19 (Ranger L-440-1, 175 hp engine).

Michael Turner, like Roy Nockolds, became famous for his paintings of racing cars before he turned to aircraft, maintaining, like Roy, a permanent 'one man' exhibition in the Old Steering Wheel Club. This painting of a Brazilian Cornell is less typical of his work, or at any rate less familiar, than the boldly-brushed, crisp strokes of his most published pictures. His authoritative statements in paint, more particularly in detail of marking and codes, make his work very easy to identify and are, one suspects, the despair of less gifted members of the Guild.

The Fairchild Cornell was built in almost as great numbers as its contemporary, the Stearman PT-17, and was a breakaway from the general preference for biplane trainers at the time. The first orders (powered by the 200 hp -3 Ranger) came in 1940 to help cope with the huge expansion of the United States Army Air Force that was beginning. Other companies also built the aircraft and a total of 3703, with a further 917 blind-flying versions were produced. A further 945 were fitted with the radial Continental R-670-5 when Ranger production was not sufficient.

Naval targets also took priority in night bombing, up to February 1942, with heavy (50-150 aircraft) raids on seaports which, apart from anything else, were easier to find. This distraction from the main programme of priority targets continued in one form or another for some time, with diversion of squadrons to the Middle East, ferrying duties and the demands of Coastal Command aggravated by an unavoidable dilution in training to keep up with replacement. But the main disappointment

came with the most reluctant admission, based on photographic reconnaissance, that at least half the bombs dropped fell in open country.

Primitive navigation and savage weather were the main culprits and the announcement in July 1941 that main objectives were transportation targets and 'destroying the morale of the civil population' was an admission of inability to strike at any but the largest area targets. The Americans, when this policy was

explained to them, were not impressed.

In the summer of 1941, Bomber Command deployed thirty-seven operational squadrons, many with only partly-trained crews; half of the Command's 800 aircraft were normally available and the average nightly sortie rate was sixty, though this was as much a product of bad weather as anything else. From this time, however, things began to improve; the four-engined heavies were coming into service, the first Stirling squadron (No. 7) having been operational from February 1941, the first Halifax squadron from March 1941 and the first Lancaster squadron from March 1942. By 1944 the latter aircraft had established itself as the finest aircraft the Command had received; it dropped 132 tons (134 tonnes) of bombs per aircraft lost, against 56 tons (56.8 tonnes) for the Halifax and 41 tons (41.6 tonnes) for the Stirling (which was obsolete for bombing by then).

During this period new navigational aids were introduced, including radar; saturation techniques defeated flak by concentrating effort in space and time (though presenting the efficient German night fighter arm with

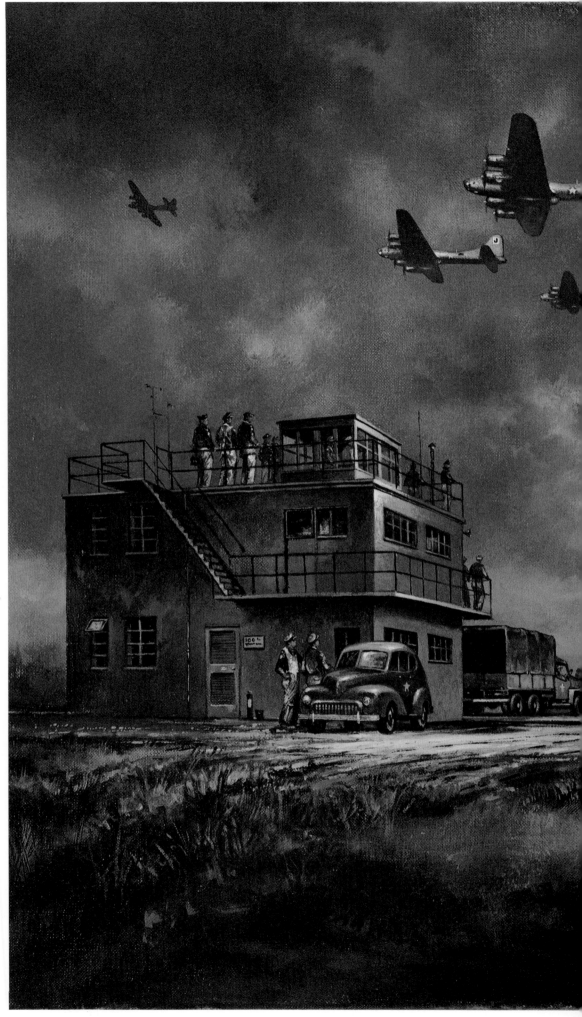

easier targets); new and very powerful bombs of 8000 pounds (3623 kilograms) 12000 pounds (5433 kilograms) and 22000 pounds (9979 kilograms) were produced; and a new weapon, in the shape of the Mosquito, was brought to squadron use. This twin-engined, unarmed, 380 mph (611 km/h) light bomber succeeded the Blenheim from May 1942 and re-introduced daylight and precision bombing, bringing precision to the night bombers as well when the Pathfinder Force was formed in August that year. The use of Oboe blind bombing equipment revolutionized accurate bombing through cloud and marking techniques transformed Bomber Command from a bludgeon to a rapier.

In the meantime, what of the United States? On 23 April 1942, Brigadier-General Eaker was appointed Chief, United States Army Bomber Command in Europe; on 2 May, Major-General Spaatz assumed command of its operational end, the 8th Air Force; and on 27 May, General Arnold, Chief of Staff, United States Army Air Force, arrived in London to co-ordinate policy – the Royal Air Force was to continue increasingly heavy and accurate attacks by night (but still area bombing) while the B-17 Fortresses and B-24 Liberators of the

Royal Flush Comes Home JOHN RAYSON GAvA Boeing B-17F Flying Fortress (four Wright R-1820-65 Cyclone, 1000 hp engines).

With its less-publicized sister, the B-24 Liberator, the Fortress carried the daylight offensive of the United States Army Air Force into Europe with increasing weight and competence. The B-17 was originally intended for very long-range attacks on enemy naval forces, for which reason it had tremendous range but, by Royal Air force standards, a small bomb load. Although employed in its original role in the Pacific (in General MacArthur's patch), it was to rise to its greatest fame in the long, bloody battles over the Fortress of Europe. It should be appreciated that from the end of 1942 until the beginning of 1944, the 8th's bomber groups conducted running battles deep into Germany, over hostile territory from the French coast and with only short range escort over France, against a dedicated and undefeated Luftwaffe fighter arm. Having bombed, they then had to turn and fight their way back against re-armed and re-fuelled enemy squadrons. Until the P-51 arrived in 1944, and even after, casualties could be very heavy.

The artist has painted a typical scene at Framlingham, in the late summer or autumn of 1943. Crowds have gathered to watch – and count – the returning bombers; four of the resident 390th Bombardment Group orbit the field, giving way to a lone aircraft of the 100th Bombardment Group, with wounded aboard (indicated by the red flares). The latter unit was known as the 'Bloody Hundredth' because of its spectacularly heavy losses.

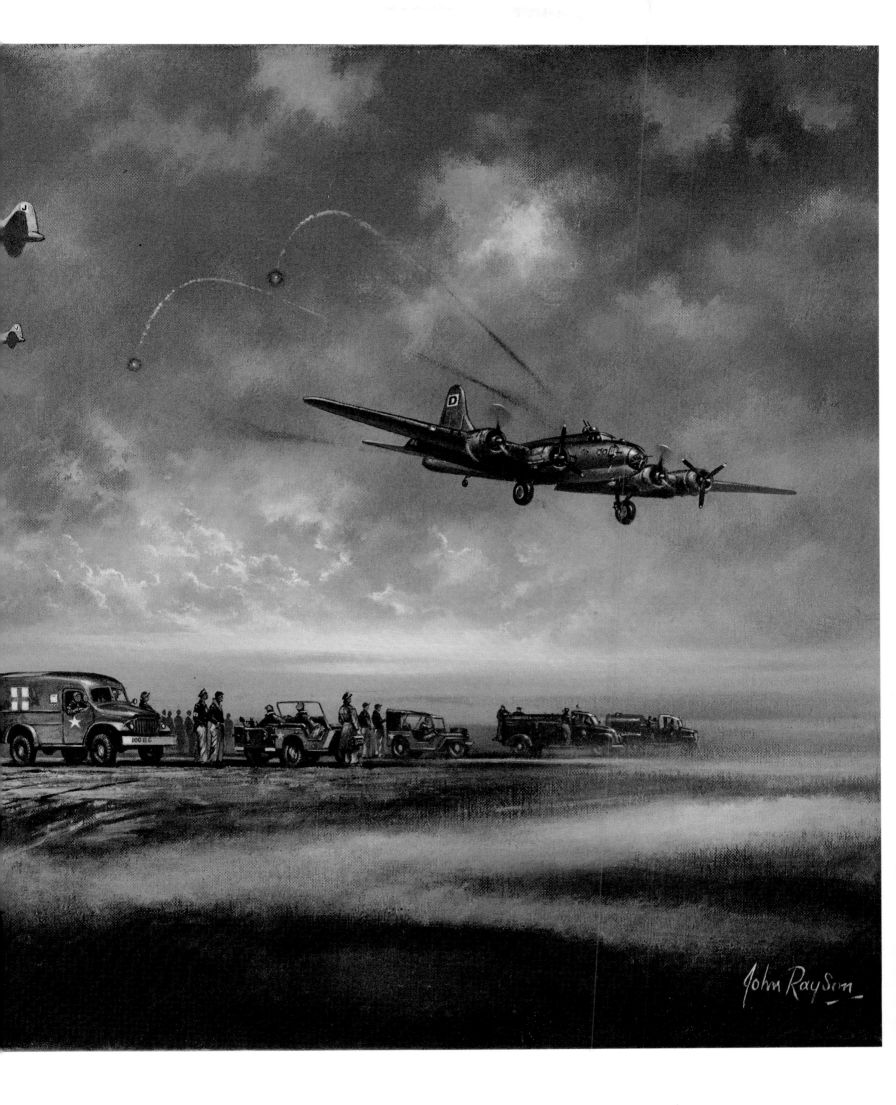

John Rayson

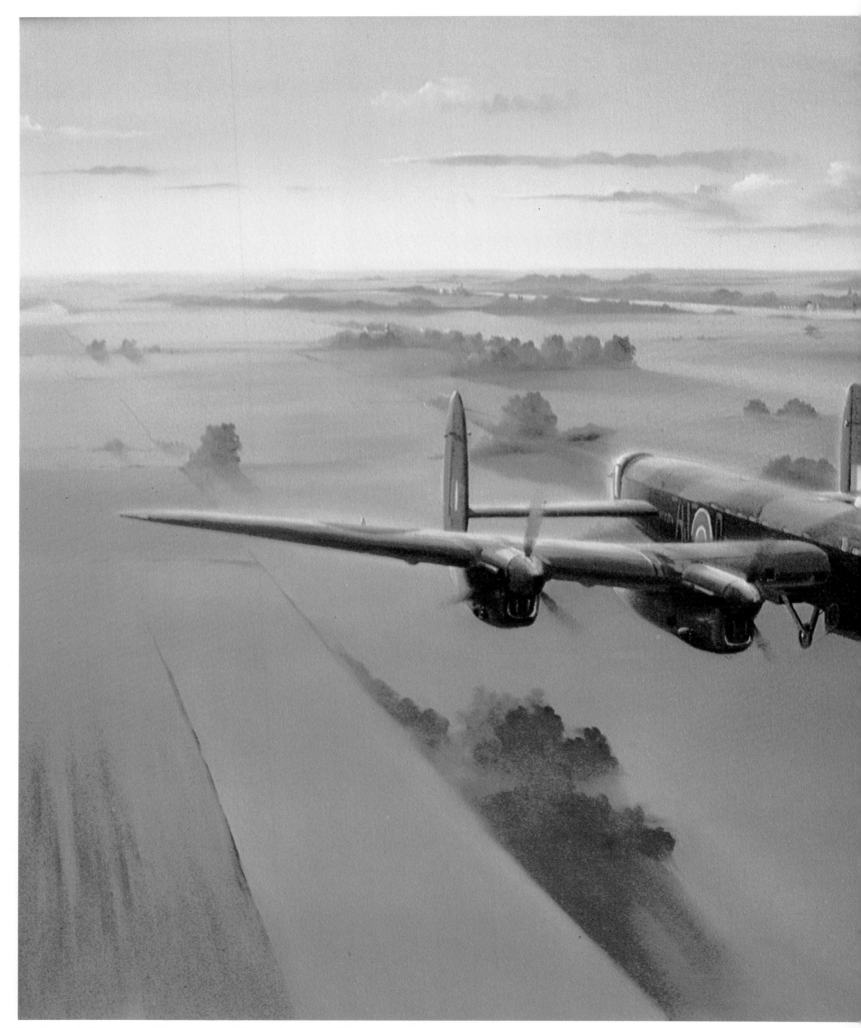

Dambuster's Return MAURICE GARDNER (full caption on page 86)

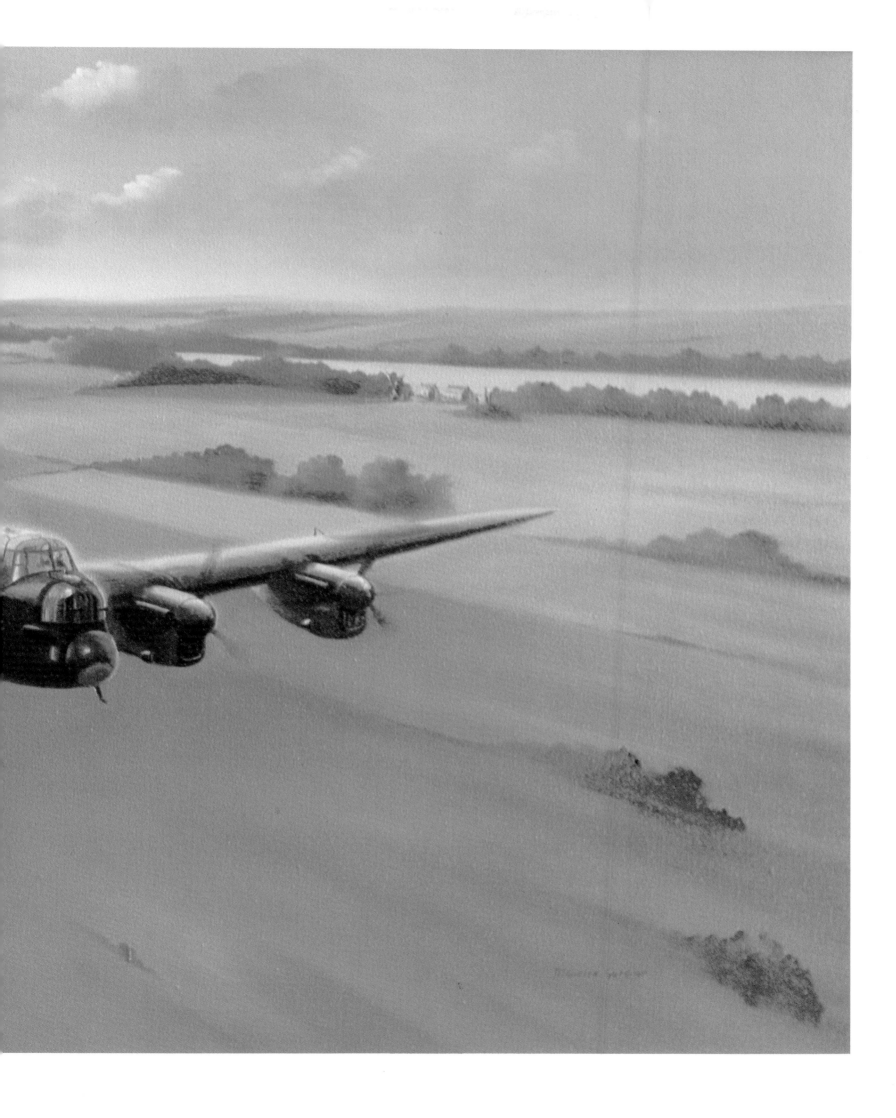

Dambuster's Return MAURICE GARDNER
Avro Lancaster III (four Rolls-Royce Packard Merlin 28, 38 or 224; 1300, 1480 or 1640 hp engines).

The Lancaster, designed by Roy Chadwick, was the third, and greatest, of the British four-engined heavy bombers in the second world war. It chalked up not only a most impressive total of operations (156 000 between 1941 and 1945, dropping 608 612 tons (598 996 tonnes) of bombs), but amassed some impressive special events. It was the only aircraft that could carry the 12 000-pound (5443-kilogram) 'Tallboy' bomb, with which the *Tirpitz* was sunk. It also lifted the awesome 22 000-pound (9979-kilogram), 'Grand Slam', or earthquake bomb, that destroyed the Bielefeld Viaduct. Of the Lancaster's impressive record one operation, however, stands out above all the rest – the attack on the Möhne and Eder dams. This was carried out by fourteen aircraft from the specially-formed No. 617 Squadron, on the night of 16/17 May 1943. Equipped with the special bomb designed by Barnes Wallis, they breached both dams, but eight aircraft were lost. No. 617 Squadron was, later in the war, to complete a very successful series of accurate attacks on other targets.

The painting shows the Lancaster ED886/G, 'O-Orange', flown by Flight Lieutenant Bill Townsend, who was detailed to attack the Ennepe dam, racing home against the growing light of the dawn, heading for the Dutch coast.

United States Army Air Force, confident in their heavily-armed aircraft and the gyro-stabilized Norden bomb-sight, were to undertake precision attacks by day.

On 17 August, the 8th Air Force made its first strike – a Spitfire-escorted attack on rail yards near Rouen. Historically, the first United States aircrew to bomb Europe manned six RAF Bostons in a raid on Holland on 4 July, the date no doubt inspiring the event.

Early raids on close targets did nothing to shake American confidence. Attacks on Germany (and encounters with the main Luftwaffe fighter defence) began in January 1943; in February only two out of ninety-seven aircraft were lost when U-boat yards were successfully attacked. The Germans were now getting the measure of the attack and units were withdrawn from the Eastern Front to bolster the fighter arm. Losses began to mount as the Luftwaffe probed the weak points of the defensive 'boxes' of four-engined bombers.

Like the RAF, the 8th Air Force suffered delays in build-up; aircraft were diverted to other theatres, whole units promised to the 8th switched to the Near or Far East. Operations were also taking their toll. A sustained effort during July with the fifteen groups available reduced the total strength to less than 200 aircraft, with the loss of 100 aircraft and ninety crews. Exhaustion slowed the scale of attack and when a major effort was mounted on 12 August 1943, weather and smoke screens split up the strike and twenty-five heavies were shot down. Worse, however, was to come. On the first anniversary of their first operation, 147 B-17s of 4th Bomb Wing were to strike Regensberg and go on to land in Africa. First Wing were to strike Schweinfurt as a diversion and P-47 Thunderbolts would provide cover to the German border. Weather upset the delicate timing (the fighters had to get back, refuel and go out to meet the returning 1st Wing) and those escorting the rear of the huge train of bomber groups failed to

rendezvous. Savage Luftwaffe attacks, mostly head-on, where B-17 defence was weak, eventually shot down fifty-nine heavies and at least as many were damaged so badly as to be beyond repair. Returing to Schweinfurt on 14 October, the 8th Air Force had lost sixty aircraft out of 291, with 138 of the survivors damaged.

These staggering reversals sparked off political enquiry in the United States and finally convinced the Air Force that unescorted long missions could not be maintained. Fortunately, the answer was available from the beginning of 1944; the North American P-51 Mustang, conceived to a British specification to take advantage of lessons learned in France in 1939-40, attracted the attention of the United States Army Air Force. When the first squadrons arrived in Britain for the 8th Air Force they came equipped with the first successful long-range tanks. These had been available for the P-38s and P-47s, but had proved to be badly made and unequal to the task.

From January, the bomber offensive got under way again, the heavies now protected by swarms of fighters right to the target and back and losses became bearable again. In February, the 8th launched 'Big Week', intended to draw up and destroy the élite German fighter force by attacking no less than twenty-six aircraft factories – a ploy that had failed the Luftwaffe in 1940 against the RAF. With the 9th Air Force in Italy, some 2000 heavies were available; in five major raids 228 aircraft were lost, but 355 defending fighters were shot down, with their irreplaceable crews lost, and the defence was never the same again.

The vital nature of the Mustang's contribution is underlined by two occasions when they were unavailable. Sixty bombers were lost on one raid and on another occasion over Berlin (a distracting target disliked by the Americans) when only a few fighters managed to reach the target, sixty-nine heavies were shot down – the worst single loss of the war.

Fighter Command, in the years between

the end of the Battle of Britain and the formation of the tactical air forces that were to accompany the invasion of Europe, was chiefly occupied in aggressive sweeps over Europe, in an attempt to pin down large German forces that might have gone to the East. In fact, it failed to achieve this and fighting over hostile territory, suffered fairly heavy casualties. Better, more powerful versions of the Hurricane and Spitfire were introduced and a new 2000 hp fighter, the Typhoon, made its début during the Dieppe raid. A fighter version of the Mosquito was introduced, taking over night defence from the Beaufighter in 1942. The latter became a powerful strike aircraft for Coastal Command, attacking convoys and U-boats with torpedoes and a new weapon, the 60-pound (27-kilogram) rocket, which proved to be equally devastating against buildings and tanks. Shortly after the Battle of Britain the 20 mm Hispano cannon began to replace the rifle-calibre Brownings in fighters and remained the standard aircraft weapon of the RAF fighter until the 30 mm Aden in the 1950s.

With the launching of the invasion on 6 June 1944, all fighter and bomber units in Europe turned to its support and tactical employment was the order of the day. In the slow slogging match up Italy over the past year, the British and American air forces had done little else. Hampered by shortages of fuel, equipment and pilots, the Luftwaffe was quite unable to do much about Allied domination of the air and it was largely the skilful and stubborn

Gibraltar Stopover JOHN HELLINGS GAvA
Douglas C-47 Dakota (two Pratt and Whitney R-1830-92 1200 hp engines).

A dramatic representation of a night stopover at Gibraltar by a Dakota or C-47 (Dakota was the British name). The artist has chosen an unusual and vividly contrasting form of back lighting to add emphasis to the occasion.

Gibraltar airfield, while being one of the most tricky places to land because of the often violent turbulence off 'The Rock', was a major Allied base during the war. Apart from normal Coastal Command operations against submarines, 'The Rock' housed various peripatetic units and on occasions like 'Operation Torch' (the North African invasion) was crammed to the edges with fighters and other aircraft. The C-47 was the military version of the DC-3 airliner; it served wherever the Allies went, as transport, troop carrier, paratroop dispenser and ambulance aircraft. Its military service continued into the Vietnamese war, where it became an aggressive gunship known as 'Puff the Magic Dragon'. The Royal Air Force received 1928 of these aircraft; during the Arnhem operation Flight Lieutenant Lord won a posthumous Victoria Cross flying a Dakota. Douglas built 10654 DC-3s and variants.

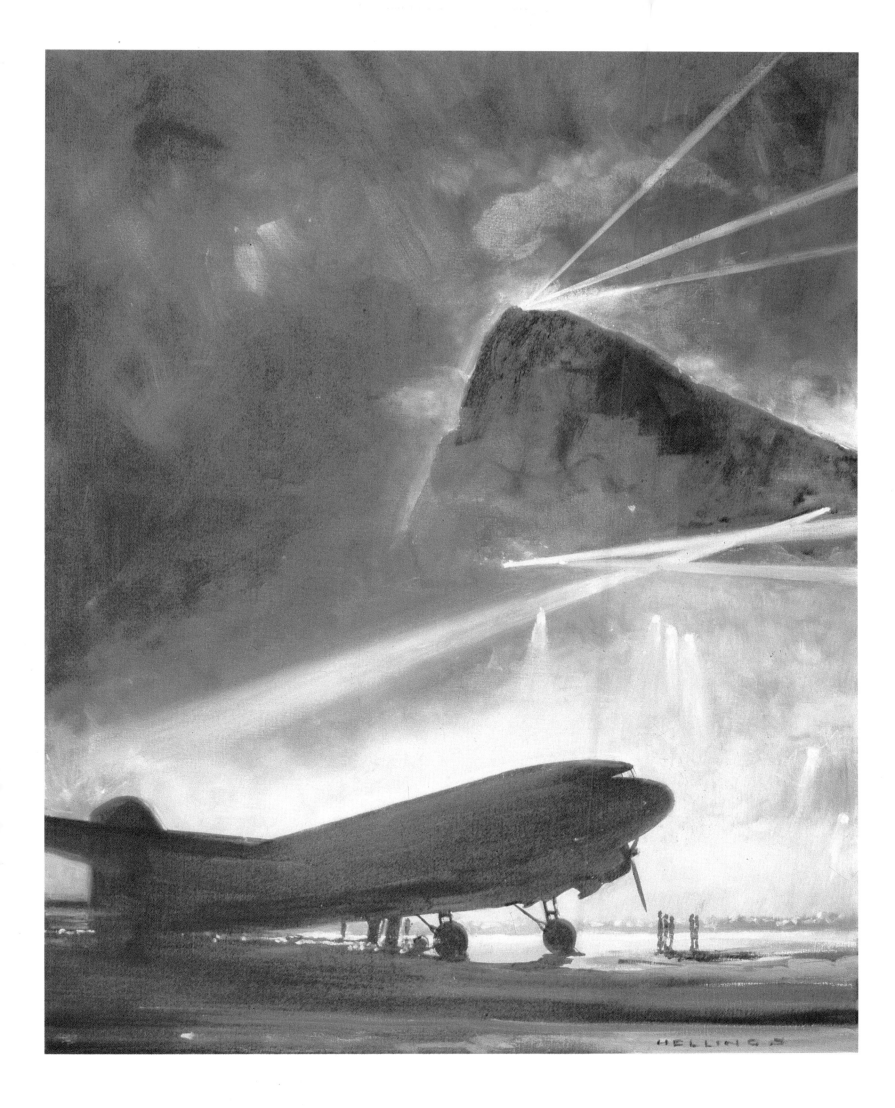

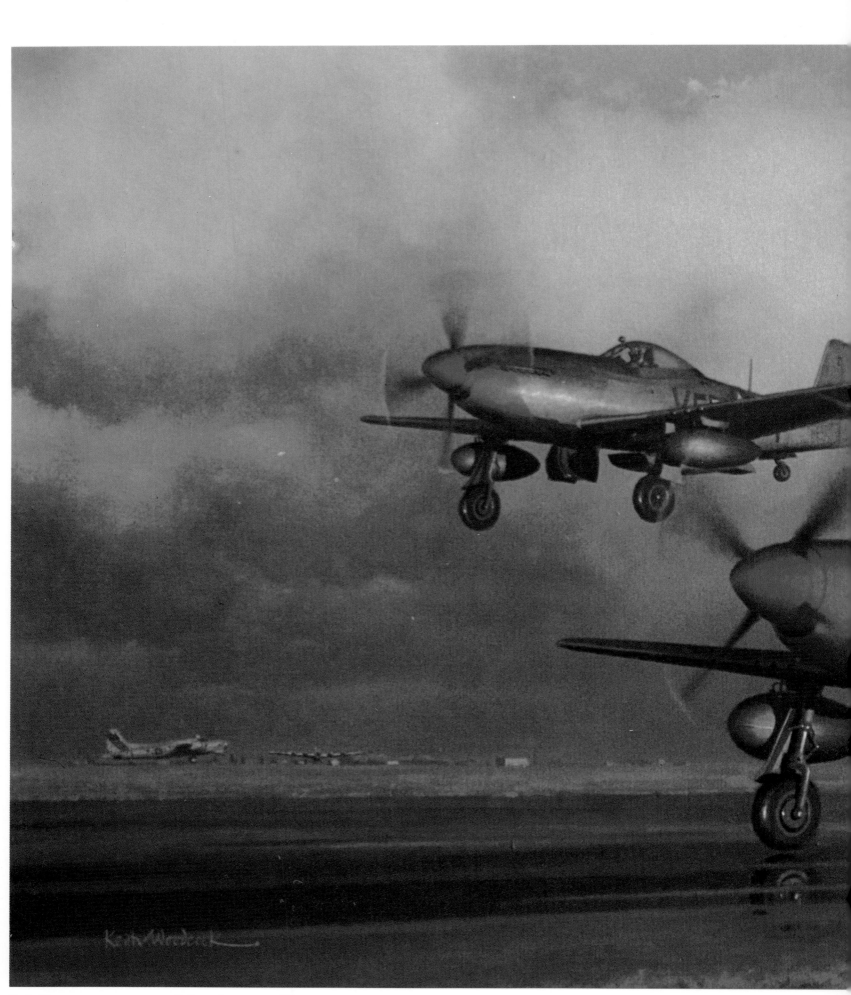

Early Risers KEITH WOODCOCK (full caption on page 90)

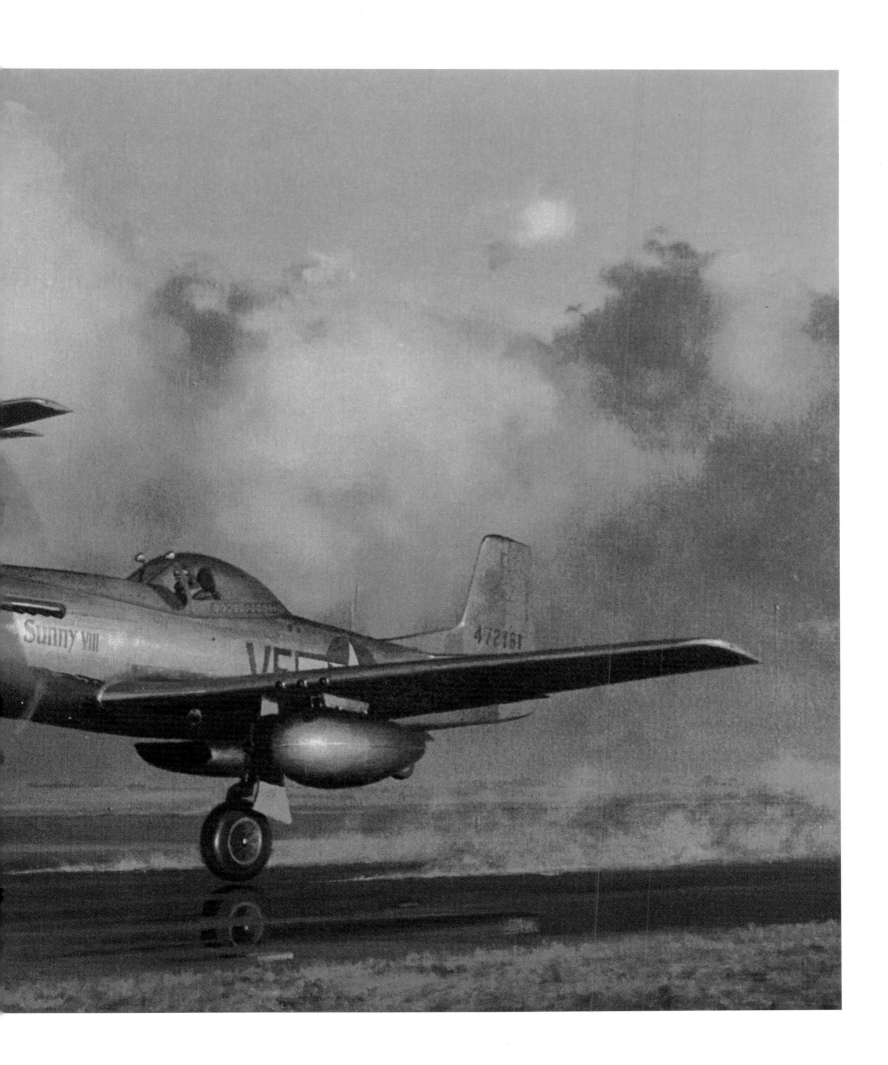

Early Risers KEITH WOODCOCK
North American P-51D Mustang (Packard-Rolls Royce V-1650-7 Merlin, 1490 hp engine).

Three things contributed heavily to the success of the North American Mustang: the very advanced, semi-laminar flow wing, that gave it great economy in fuel; the Packard-built Rolls-Royce Merlin engine; and the 110-US gallon drop tanks. By December 1943 when the Mustang arrived in Britain, it carried 269 US gallons of internal fuel, giving a range of 1300 miles (2092 kilometres); with a pair of drop tanks this went up to 2080 miles (3347 kilometres). For the first time, the bomber force of the 8th Air Force had fighter cover all the way to and back from the target. Altogether some thirty-three squadrons eventually flew P-51s in the European theatre. Armed with the 0.5-inch (12.7-millimetre) machine gun (six of them) and in large numbers, they eventually wore down the German defence.

The two P-51s shown taking-off in Keith Woodcock's painting are from the 336th Fighter Squadron, 4th Fighter Group, 8th Air Force. The group was known as 'The Eagles'. Its component squadrons, the 334th, 335th and 336th, the Royal Air Force Eagle squadrons of United States pilots, had been Nos. 71, 121 and 133 of Fighter Command – until they were transferred to the United States Army Air Force on 29 September 1942. The 4th Fighter Group was the first to form in the 8th Air Force, the first to penetrate German air space and the first to fight over Berlin and, as it happened, over Paris.

defence of the battered German army that prevented a swift end to the war in the West.

The war in the Pacific and Indian Ocean against Japan was fought in two clear and usually distinct parts. The United States Army Air Force and the Royal Australian Air Force conducted a long and gruelling campaign of ground support for the armies climbing painfully back up the island chain (enlivened for the Americans by high-level bombing of naval targets with indifferent success). Meanwhile, the carrier forces of Japan and the United States were wheeling across the vast distances of the Pacific, drawn together by the need to back up the land campaign and tangling in a series of fierce and mutually destructive battles fought by carriers alone, neither side ever glimpsing its opponents at sea-level.

Japan had fought a successful naval war against China (over Korea) in 1895 and the building of a modern navy and aspirations to greatness began from there. In 1905, at Tsu-Shima, she inflicted a crushing defeat on the Russians, annihilating their main fleet and in 1937 she invaded China, an act of aggression that alarmed the United States. When in 1939 the Americans commenced a huge building programme, including eleven aircraft carriers, the Japanese contemplated a similar expansion, but could not sustain a comparable fleet on their limited resources. In order to acquire the oil, metals and rubber needed, the Greater East Asia Co-Prosperity Sphere, to be established by force from the current owners, was planned. This would, inevitably, involve Japan in war with the United States, the British Empire and the Netherlands. Fortune played into her hands. Britain was stretched to the limit by the war with Germany; the Netherlands had been overrun; and the strike on Pearl Harbour was to take care of the American Pacific Fleet. Meanwhile the Japanese army would fortify the perimeter of the new island empire.

The first Japanese aircraft carrier, *Hosho*,

entered service in 1922 and, with three other later ships, formed the sole survivors of the twenty-eight fleet carriers built during the war. By December 1941, Japan had nine fleet carriers and the first of a small number of escort carriers in commission. The United States Fleet at that time deployed two carriers in the Pacific, *Enterprise* returning to Pearl, *Lexington* on her way to Midway; of the others *Saratoga* was at San Diego and *Wasp*, *Yorktown*, *Ranger*, *Hornet* and the escort carrier *Long Island* were with the Atlantic Fleet.

For some months the Japanese carriers were busy supporting landings to establish the boundaries of the new empire. On 19 February 1942, Admiral Nagumo took them south to raid Darwin and in April struck across the Indian Ocean, attacking Colombo and Trincomalee, outmanoeuvring Admiral Somerville and sinking the British carrier *Hermes* and two cruisers.

These activities gave the United States time to transfer *Wasp*, *Hornet* and *Yorktown* to the Pacific. In mid-April the Japanese carriers were back at their home bases while Admiral Yamamoto, commanding the Imperial Navy, planned his next moves. Yamamoto dreamed of a great battle of annihilation, somewhere near Midway, in which the United States Fleet would be destroyed; he knew that the alternative war of attrition must be won by his opponents. The Midway operation was very complex, for Yamamoto had a fatal passion for elaborate diversionary moves and for splitting his forces.

As it happened, a diversion of another kind forced his hand; the army wanted to expand southwards through New Guinea to protect the new conquests and the naval air arm had to cover the seaborne invasion forces. Admiral Takagi took the big carriers *Ziukaku* and *Shokaku*, and the light carrier *Shoho* for this task. The Americans, whose intelligence was good, countered with Task Group 17.5 (*Yorktown* and *Lexington*) with a cruiser and destroyer screen. A peculiarly

unsatisfactory and messy battle resulted.

The American carriers became separated and as they were near the line dividing Admiral Nimitz's part of the Pacific from General MacArthur's (into which Nimitz was forbidden to fly, believe it or not) reconnaissance cover was incomplete. Takagi, for some reason, used his short-range ship's catapult aircraft only for search. The Japanese mistook an oiler for a carrier and launched an all-out, two-carrier strike on the wretched vessel. Eventually, among all the manouevring, both forces found each other (the United States carriers were together again by this time). Ninety-three aircraft from these attacked the light carrier *Shoho* and sank her; the Japanese attacked the United States carriers, while the latter's second strike made for the *Shokaku* and *Zuikaku*. In this, their first encounter, American attacks were poorly co-ordinated and their defence weak; the more experienced Japanese sank *Lexington* and damaged *Yorktown*. Both the Japanese carriers were hit and retired. More to the point, they were in consequence unavailable for Midway.

Yamamoto attacked Midway early on 4 June. Island defences struck back, including B-17s, Marine Corps dive-bombers and four startled, and probably terrified, Army B-26 bombers armed with torpedoes. A second strike at the island would be needed. Nagumo was set to attack the United States naval forces he knew to be in the area, but fatally changed his mind and began to re-arm for the Midway strike with two of his four fleet carriers. (Two light carriers accompanied the invasion force.)

Then enemy carriers were reported and Nagumo changed his mind again. In the few minutes required to swap over aircraft from hangar to flight deck, Admiral Spruance struck at extreme range with 116 aircraft from *Yorktown*, *Enterprise* and *Hornet*. It was probably the most costly Japanese mistake of the war.

The United States carrier strike was still disorganized; not until the lessons of Midway were assimilated did they become truly proficient. The slow and vulnerable torpedo bombers became separated from the rest and attacked alone between 0930 and 1024. Six out of forty-one returned and no hits were scored. By very good fortune the dive-bombers were able to concentrate on the wildly manoeuvring Japanese carriers (*Enterprise*'s group nearly missed the fight) and while enemy fighters and anti-aircraft guns were busy with the torpedo attack, the Dauntlesses struck vertically out of the sky. By 1030 *Akagi*, *Soryu* and *Kaga*, ripped apart by 1000-pound (454-kilogram) bombs, were ablaze from end to end and doomed.

The fourth carrier, *Hiryu*, was not spotted, having become separated from the others, and launched an attack on *Yorktown* (also now on her own), inflicting severe damage but losing all but fifteen of her aircraft. The final strike to finish off *Yorktown* was postponed for the crews to eat. During their meal, thirteen dive-bombers came at her out of the sun and four hits turned her into a blazing wreck. With her loss, ended any hope of a successful sea battle for Yamamoto. Although the hard-hit *Yorktown* also sank, torpedoed by a submarine, the two surviving carriers were too much to take on. The Japanese hankered after a night action, at which they were infinitely superior, but their main forces were too far

Typhoons in Normandy, 1944 FRANK WOOTTON, President GAvA
Hawker Typhoon IB (Napier Sabre II, 2200 hp engine).

The Hawker Typhoon was an aircraft that finally 'made good' after a start so difficult and so unpromising that the type was very nearly scrapped. Born in 1937 and employing 1937 technology – which did not include any knowledge of the drag and compressibility effects of very high-speed flight – it was one of two parallel designs from the Hawker Aircraft Limited design office that were to employ the new 2000 hp engines then contemplated. One of these engines, the Rolls-Royce Vulture, proved a disappointment and development was stopped; the Hawker Tornado offered up to it therefore never entered production. It is of interest that it was the failure of the Vulture to meet service requirements that transformed the twin-engined Avro Manchester into the four-engined Merlin-powered Lancaster. The Typhoon received the new Napier Sabre and entered service with Fighter Command in 1941 with No. 56 Squadron. Although the Sabre gave it the speed to catch tip-and-run fighter-bomber raiders, which the Spitfires had trouble in intercepting, the numerous teething troubles of the engine and design problems with the aircraft, made its future uncertain. Its low-level performance, battleship strength and load-carrying capabilities, however, made it the ideal ground-support aircraft in the 1944 campaign in Europe. With four 20-millimetre cannon and 2000 pounds (907 kilograms) of bombs or eight 60-pound (27-kilogram) rockets, it was devastatingly successful.

Frank Wootton painted several pictures of Typhoons in Normandy, this one showing a rocket-armed squadron taking off in the all-pervading dust of the invasion summer.

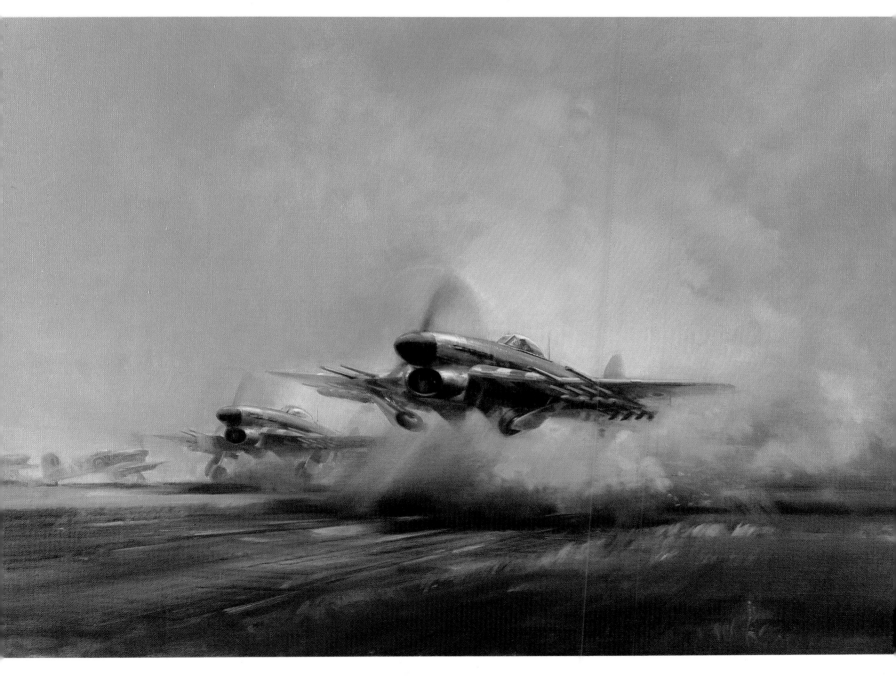

away and they would not fight in daylight without air cover.

While the Japanese forces were relentlessly pushed back towards the home islands, the United States Fleet perfected its carrier drill. The final clash came in September 1944, with the Battle of Leyte Gulf. The imminent invasion of the Phillipines

called forth most of Japan's remaining naval strength, as the Americans had guessed; the Japanese plan was to use the Mobile Force carriers (almost denuded of aircraft) under Admiral Ozawa, to draw off Admiral Halsey's formidable carrier force while the navy executed a pincer movement on the United States invasion force.

The United States 3rd Fleet Fast Carrier Force contained nine heavy and eight light fleet carriers with nearly 1200 aircraft. Formed into groups of ships centring on the carriers, they were screened now by a formidable battle line of six battleships, whose fire would break up any enemy attack on the carriers. The battle opened, as the full Japanese surface forces swung into their prepared plan, with diversionary air attacks on the American carriers, sinking the *Princeton*. Most of the Japanese aircraft were shot down which left Kurita's fleet wide open. Two hundred and fifty-nine carrier aircraft struck continuously throughout the day (24 October). *Musashi* (with her sister *Yamato* the largest warships in the world) sank under twenty torpedo and seventeen bomb hits. Kurita, retiring

Secret Success ANTHONY HAROLD

Heinkel He 178 (Heinkel He S 3A, 1000-pound (453.6-kilogram) static thrust 1000 hp engine).

When the first Allied and enemy jet fighters began to appear, towards the end of the war, the full story of the pioneering British effort was released. The Gloster G40, designed to Specification E.28/39 and based on the Power Jets W 1 engine, first flew on 15 May 1941. Not until the war was over was it discovered that the Germans had actually flown the first jet aircraft in the world, the He 178 V1, for the first time on 27 August 1939. The Germans flew the first twin-engined jet fighter, He 280, on 2 April 1941. Eight prototypes of the He 280 were built and flown by July 1943, but an order for 300 was cancelled (Heinkel did not have the production capacity to build them) in favour of the Me 262. The first British jet engine to take the air was designed by Group Captain Frank Whittle and bench-run in 1937 – some months before the Heinkel jet designed by von Ohain.

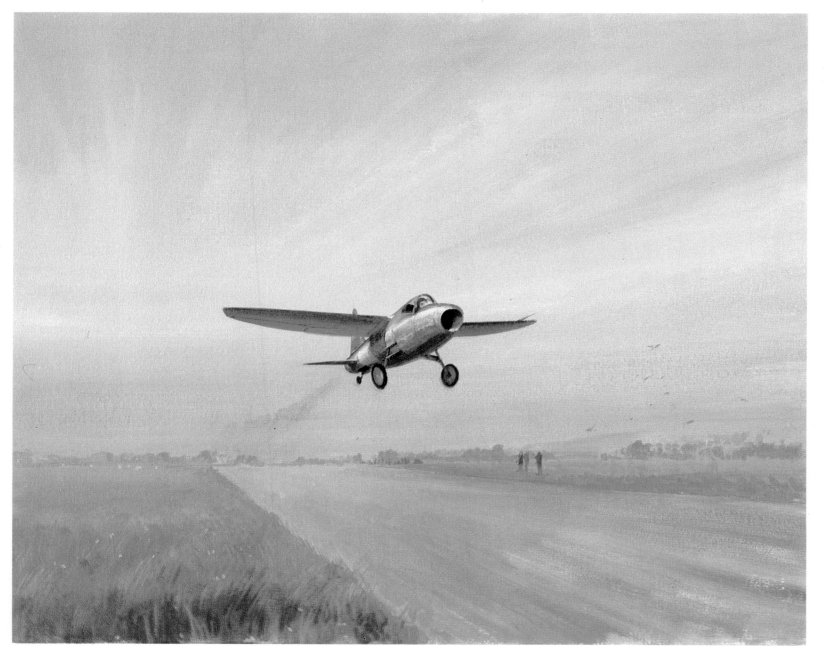

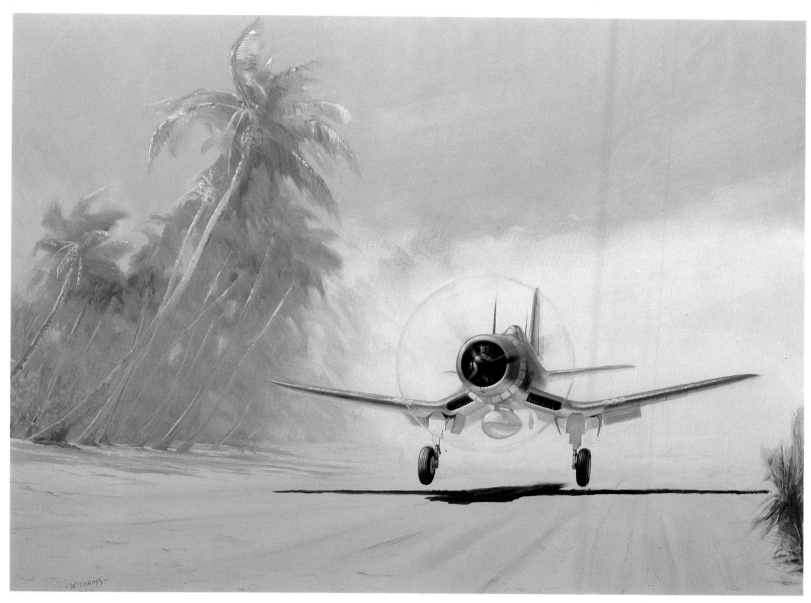

Cranked Wings and Coral Dust BRIAN WITHAMS GAvA
Vought Corsair F4U (Pratt and Whitney R-2800 Double Wasp, 2000 hp engine).

The United States Navy saw much earlier than anyone else that the aircraft carrier was to become the core of battle fleets. As the war went on it devised its Pacific strategy on the basis of independent carrier groups that could be combined as needed, protected by their own ring of battleships, cruisers and destroyers. It also saw no reason to operate aircraft inferior to land-based types and with that in mind, Vought designed the Corsair, basically the smallest airframe that could be attached to the most powerful engine available – the Double Wasp. The result was a forty-one-foot (twelve and a half-metre) span, seven-ton fighter, the wings cranked to give a reasonably short undercarriage and still keep the tips of the vast propeller off the ground. Ground, not deck; the view was so bad and the Corsair so awesome that the United States Navy declared it impossible as a carrier fighter and gave it to the Marines, who flew it from shore bases. It also gave the Corsair to the Royal Navy, who received over 2000 under Lend-Lease. The Fleet Air Arm re-designed the undercarriage and cockpit and took it into action off the armoured deck of HMS *Illustrious* covering the 3 April 1944 attack on Tirpitz, convincing the US Navy of its carrier compatability.

considerably hurt, expected to have to meet Halsey's Task Force 38 but the latter had taken Ozawa's bait and gone speeding off to the north, failing even to inform the rest of the fleet.

Ozawa was doomed, and knew it. His carriers, *Ziukaku*, *Chitose*, *Zuiho* and *Chiyoda*, had 108 aircraft between them; most were sent off to attack Phillipine airfields and he had thirteen fighters to fend off wave after wave of bomb and torpedo attacks from Halsey's five carriers.

Chitose sank at 0830, *Zuiho* around 1400 and *Chiyoda* at 1547, under gunfire from surface ships. *Zuikaku*, last of the Pearl Harbour and last of the Japanese fleet carriers, sank under bomb and torpedo attack at 1314. The Japanese carrier arm had ceased to exist.

Germany surrendered unconditionally on 7 May 1945, with the Russians on the Elbe. The Luftwaffe, by early March, was down to 2278 aircraft, of which 1704 were serviceable and 1487 fighters - in almost equal proportions of day and night fighters. Large numbers of brand new aircraft were at the factories, but there were no means of collecting them. Petrol, oil and transport had vanished under the blows of the Allied air forces. Training schools, the instructors

mostly killed in combat, were idle. And although German figures showed the production of 2552 aircraft in January 1945, there was no way of employing them.

It was curious that the Germans, professionally far ahead of the Allies as military commanders and planners, should have failed so signally to grasp the realities of air power. Over-confidence from early victories seemed to stultify the growth of creative planning; even the aircraft of 1945, for the most part, were basically those that had fought in the early campaigns, though some of the designs for the next generation

were remarkable. When they did grasp the problem it was already too late; the initiative had long since passed to the heirs of Trenchard and Mitchell, who never lost sight of the principles of air power so clearly set out by the pioneers.

If Germany had fallen, there still remained Japan, and all effort was now turned her way. Although the principal Royal Air Force effort was now devoted to support for the divisions of the forgotten 14th Army in Burma, a powerful British Pacific Fleet was formed and went into action with the United States Fleet, centred round the four

fleet carriers *Indomitable, Illustrious, Victorious* and *Indefatigable*. These were armed with powerful American aircraft, Hellcats, Corsairs (the Royal Navy had pioneered that remarkable aircraft in carrier operations) and Avengers. In addition they carried two squadrons of Seafires, whose conversion to naval operations had always been fragile, and the new Fairey Fireflys two-seat strike aircraft, considerably more powerful than the Fulmar they replaced.

The efforts of the Royal Air Force in India and Burma largely escaped public notice. Nevertheless, despite the drain of aircraft to the Middle East at that time and horrendous problems with heat exhaustion and malaria in an unusually torrid season between March and June 1942, its strength increased from five to twenty-six squadrons. Most important was the arrival of the Beaufighter, with its long range and heavy firepower. Two squadrons of Dakotas flew supplies everywhere, including back-up to Wingate's Chindit columns. By the summer of 1943 there were thirty-eight operational squadrons, with modern equipment. A year later Air Marshal Peirse's Combined Air Force fielded sixty-four British and twenty-eight United States squadrons - including 400 mph (643 km/h) Spitfire VIIIs, against

Monsoon Strike MICHAEL TURNER GAvA
Republic P-47 Thunderbolt II (Pratt and Whitney Double Wasp, 2300 hp engine).

Sixteen squadrons of the Royal Air Force were equipped with the mighty Thunderbolt, the first 2000 hp fighter to enter United States service and a familiar sight to 8th Air Force bombers *en route* to or from targets in Europe. Weighing 7.5 tons (7.6 tonnes) and standing over 12 feet (3.6 metres) high, with six 0.5-inch (12.7-millimetre) machine guns, 2000 pounds (907 kilograms) of bombs and a capacity for absorbing apparently infinite punishment , it was known as the 'Jug' – short for juggernaut. It became famous for ground attack as well as escort duties and was used mostly for the former duty in Burma, where all the RAF P-47 units served, the first squadron forming in 1944. Under Lend-Lease, all the survivors of the 830 supplied to Britain were returned at the end of the war and the type saw no RAF peacetime service. The painting shows a Thunderbolt II of No. 134 Squadron taxying on an airstrip in Burma during the monsoons. No. 134 Squadron had flown Hurricanes with No. 151 Wing in northern Russia in 1941 and took the type to Burma from the Middle East in 1943, converting to Thunderbolts in August 1944.

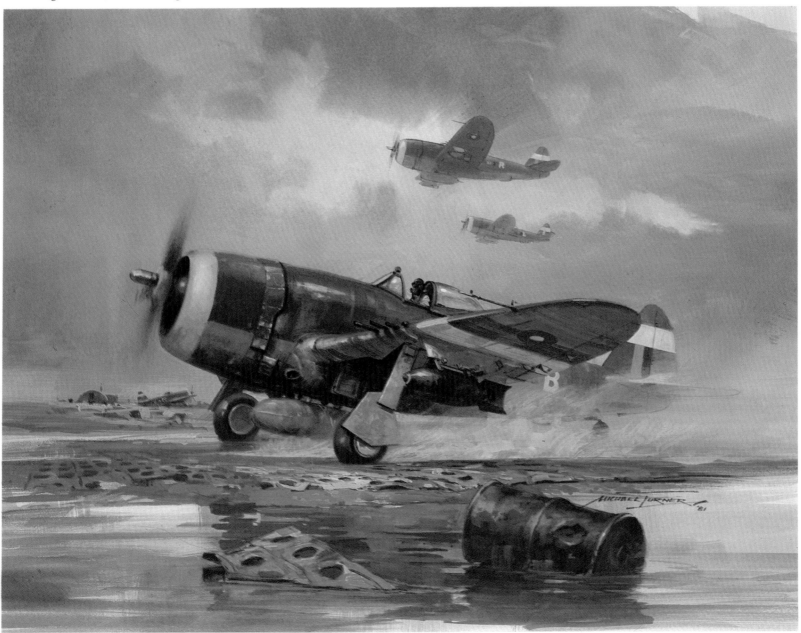

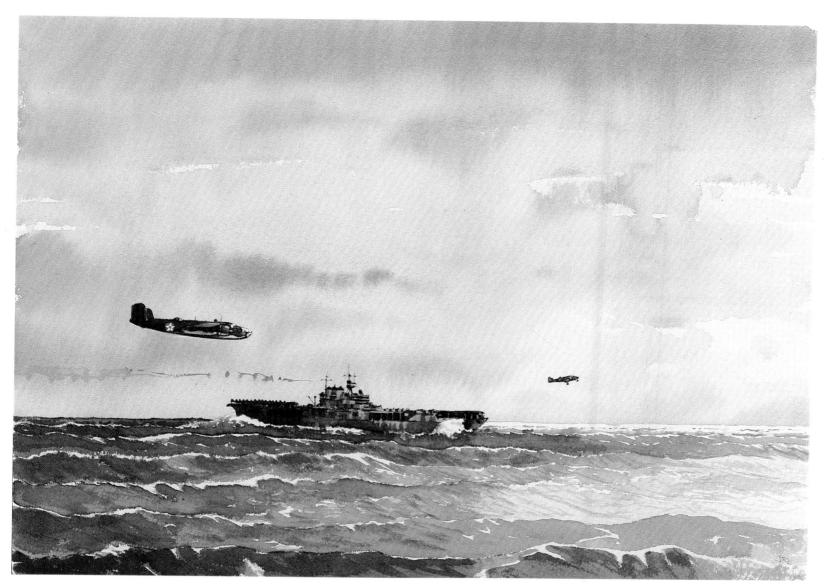

The Tokyo Raiders JOHN BLAKE GAvA
North American B-25B (two Wright R-2600-9, 1700 hp engines).

Probably the most outstanding medium bomber of World War II, the B-25 served in every theatre of the war and almost 11 000 were built, more than 1000 of these going to Allied air forces. Named Mitchell, after the tempestuous American prophet of air power, the B-25 first went into service with the 17th Bombardment Group (Medium) in 1941 and it was from this unit and from the 89th Reconnaissance Squadron, that were selected the sixteen crews who took part in the startling raid on the Japanese homeland on 18 April 1942. Led by Lieutenant-Colonel James Doolittle the bombers, carrying 2000 pounds (907 kilograms) of bombs, were launched from the USS *Hornet* 800 miles (1287 kilometres) from Tokyo and struck targets in the Japanese capital, Kobe, Yokohama and Nagoya. To avoid the alerted Japanese defences (which had necessitated a launch further from target than intended) the aircraft flew 15 to 20 feet (4.5 to 6 metres) above the sea. All the aircraft crashed or force-landed in China but Doolittle and the majority of the crews survived. The raid raised American morale enormously at a time of great difficulty and was an eloquent tribute to the qualitities of the Mitchell. The aircraft could carry over 5000 pounds (2268 kilograms) of bombs and could – and did – double as a torpedo bomber. It became the most powerfully-armed medium bomber in the world when the B-25G and H were equipped with a nose-mounted 75-millimetre gun and later versions packed no less than eighteen 0.5-inch (12.7-millimetre) machine guns, fourteen of them firing forward.

some 370 Japanese front-line aircraft in the immediate front area in Burma. Behind the bomber and fighter squadrons of the Allies were the transports - vitally important in this theatre - and maritime aircraft ranging the Indian Ocean.

To this theatre, en route to bases in China, came a most remarkable aircraft. Back in 1939 Congress voted funds for a hemisphere defence bomber, designed to carry 2000 pounds (907 kilograms) of bombs 5000 miles (8046 kilometres). The project came out of the Kilner Report on future requirements, one of whose

members, newly returned from an examination of Axis air power, was Colonel Charles Lindberg. Early in 1941, the contract was placed with Boeing for two prototype XB-29s (and a full-scale mock-up) costing $3 615 095. The bomber spanned over 141 feet (43 metres), carried eleven 0.5-inch (12.7-millimetre) machine guns in five remotely-controlled turrets with centralized, computer-controlled fire control and could lift 21 000 pounds (9526 kilograms) of bombs. By February 1942, Boeing had orders for 1600, to be reserved solely for striking at the Japanese home

islands (normally well out of reach to everything else, despite General Doolittle's raid on Tokyo with sixteen B-25s flown off the USS *Hornet* on 18 April 1942).

In June 1943, the 58th Very Heavy Bomber Wing was formed to receive the new aircraft and the 20th Air Force was activated in November to operate it. Operations were initially from Chinese bases, pending capture of the Marianas. Despite great difficulties, with unsuitable bases, the business of humping every pound of stores, fuel and bombs over the mountains from India and constant engine problems (which accounted for most of the 267 non-operational losses), the 20th dropped 11 477 tons (11 660 tonnes) of bombs in forty-nine missions. From November 1944, bases in the Marianas were in use, and after some unsatisfactory high-level operations, a series of devastating low-level fire raids on Tokyo and major cities was initiated. The last mission took place on 14 August but by then the war was effectively over. At 1915 hours on 6 August 1945, the first of two atomic bombs was dropped from an aircraft of 509th Bombardment Wing.

On 2 September, on board USS *Missouri* in Tokyo Bay, the surrender of Japan was signed and the last enemy had been beaten. It was over.

Period five: 1946 to the present day

A particularly important event that happened towards the end of the second world war has not yet been mentioned: the invention of the jet engine. In fact, the story began even earlier than that, in the period between the wars, but it is easier to treat the whole development in one piece.

In Britain, research into jet engines began at the Royal Aircraft Establishment (RAE) in 1926 and at Cranwell – co-incidentally – in 1928, with the exploratory work of Flight Cadet (later Air Commodore Sir Frank) Whittle. Whittle's theory embraced the gas turbine engine and the use of pure jet thrust for propulsion where Dr Griffith at RAE was working on an axial-flow turbine, geared to a propeller. Whittle, who took out his first patent on the subject early in 1930, should therefore be considered the 'true and onlie begetter' of the jet engine.

His experimental engine made its first test run on 12 April 1937. A later engine, the W1, delivering 850 pounds (385 kilograms) of thrust, powered the first British jet aircraft to fly. This was the Gloster G 40 (more usually known by its offical specification number, E.28/39), which first flew on 15 May 1941. By September 1942, Whittle's engines were giving 1755 pounds (796 kilograms) of thrust (the W 2/500s); Rover took over production and early in 1943 passed the job on to Rolls-Royce. The current engine, the W 2B/23, became the Welland and the W 2B/26 the Derwent. Rolls concentrated on the manufacture of this engine, two of which powered the majority of the first production jet fighters – the Gloster Meteor F 1, producing 2000-pound (907-kilogram) thrust and giving the aircraft a top speed of 475 mph (764 km/h).

The Meteor was the only Allied jet to see service in World War II, and equipped No. 616 Squadron from July 1944. Its speed made it ideal for its main task – destroying the V1 or flying bomb. Later, in April 1945, the unit commenced ground attack missions in Europe, being joined by No. 504 Squadron, also with Meteors, shortly afterwards.

In Germany, a parallel development was taking place. A student of physics at Göttingen University, Hans-Joachim von Ohain, began work on a gas turbine engine design for aircraft. There was nothing new about the gas turbine, which had been known since the beginning of the century in practice, but its application to aircraft design certainly *was* new. For production of a practical engine von Ohain went to Heinkel and the first bench-run of the resulting HeS 1 took place in March 1937, just before Whittle's 'U' prototype engine appeared. The production of a developed version, the HeS 3B, giving 1100 pounds (499 kilograms) of thrust, enabled Heinkel to fly it in the He 178 on 27 August 1939, anticipating the Gloster by some eighteen months – a fact that did not become known until after the war.

Junkers was also developing a jet engine and this, the Jumo 004A, giving 1850 pounds (839 kilograms) of thrust, powered the Messerschmitt Me 262. With two engines of slightly greater power, the Jumo 004Bs of 1980-pound (898-kilogram) thrust, the Me 262 had a top speed of 527 mph (848 km/h) and first saw action on 3 October 1944 against 8th Air Force bombers. A number of different versions of the 262 became operational, as cannon-armed fighters, rocket-armed fighters and bombers. But they were tricky to fly, very vulnerable during the landing phase and not so fast that the far more numerous North American P-51 escorts – the P-51H having a top speed of 487 mph (784 km/h) – could not shoot them down. All the same, their combat record was impressive; between November 1944 and the end of the war JG 7, the main unit employing the fighter version, claimed 427 kills – of which 300 or more were four-engined bombers. JV 44, commanded by Adolf Galland, claimed fifty bomber victories in thirty days, using both the 30 millimetre gun armament and R4M rockets. Given more time (six more *Geschwader* were forming in 1945), the

aircraft might well have become a major problem to the Allies.

Two more jet aircraft saw service with the Luftwaffe; the twin-engined Arado Ar 234 reconnaissance bomber and the Me 163. The former was a twin-engined aircraft of advanced design, the Jumo 004B giving a speed of 461 mph (742 km/h). A four-engined version, the Ar 234C, had a top speed of 496 mph (798 km/h). This aircraft saw service as a reconnaissance and bomber type, its most famous exploit being a series of desperate attacks on the Remagen Bridge over the Rhine, which had been captured by the Americans. The Me 163 was actually a rocket-powered interceptor with a Walter HWK 109-509A. This gave it a phenomenal rate of climb and it could reach its ceiling of 39 700 feet (12 100 metres) in three and a half minutes. It was intended to give point defence to targets against the American bombers, but the highly volatile fuel mix caused many accidents. In addition the high speed of approach, even in a glide – landing speed was 137 mph (220 km/h) – coupled with the slow rate of fire and frequent stoppages of the 30-millimetre Mk-108 cannon, made hits difficult to achieve. A tail-less, swept-wing aircraft of only 32-foot (9.7-metre) span, it was as vulnerable as the Me 262 when, rocket fuel spent on the climb, it glided back to base after an attack.

The United States flew its first jet aircraft, the Bell P-59A Airacomet, on 1 October 1942, powered by two General Electric I-A jets, based on the British Whittle engine. Service versions, with the 2000-pound (907-kilogram) GE J31GE-3, proved no faster than current piston-engined fighters and the first operational United States jet was the Lockheed F-80 Shooting Star, delivered to squadrons from the end of 1945 and powered by the 4000-pound (1814-kilogram) thrust GE J33-A-11.

There is little doubt that the Germans were considerably ahead of the Allies in their plans to develop the jet aircraft. Not only were their production engines and

airframes considerably more advanced, but the scope and variety of their projects and experimental aircraft were prodigious. By 1943 it had become plain that the Thousand-Year Reich was not going to make it very far into its second decade unless someone came up with a wonder weapon or two. The pressures to survive undoubtedly made designers over-reach themselves and those aircraft that did reach production status – and the complex axial flow engines that powered them – were sometimes a little too far ahead of their time. But many of the better ideas were not lost. In the undignified scramble among the ruins of German research establishments after the war was over, Americans and Russians were ruthlessly collecting specimens and documentation. Top German scientists were invited to the United States, the most famous being Werner von Braun of V2 fame (if that is the word). Others quietly surfaced in remoter corners. Kurt Tank, designer of the Fw 190, went to the Argentine. Those unfortunate enough to be caught east of the Elbe and important enough to be interesting, disappeared into the Soviet Union. The handful of British investigators that the government saw fit to employ were left a very bad third.

Among the trophies removed to the United States were a set of swept wings intended for the Me 262. Mated to the North American FJ-1 Fury, they gave birth to the Sabre F-86, one of the most significant fighters of its time. German research into sharply swept wings was extensive and contained the key to delaying the compressibility effects on the air ahead of an aerofoil on approaching the speed of sound. The apparently limitless scope for extending the power of the jet engine held promise of greater and greater speeds; but there was a problem which might, as far as anyone knew, prove insuperable.

Some forty years earlier, an Austrian physicist called Ernst Mach had set out a theory dealing with the measuring of airflow, giving a numerical value to the speed of an object (in our case an aircraft's wing) through the air in terms of the speed of sound. The speed of sound being taken as 762 mph (1226 km/h) at sea-level, that speed becomes Mach 1. As that speed is approached in a conventional aircraft, the air ahead of the wing compresses into an impenetrable barrier. The excessive vibration, control problems and structural damage associated with this had become known during World War II when fighters dived at speeds approaching Mach 1, though stories claiming that Mach 1 was exceeded by Spitfires may be safely discounted. Post-war research produced wings of completely new aerofoil section

which eased the problem and on 14 November 1947, Captain Charles Yeager, USAF, became the first man in the world to fly past the speed of sound in level flight. The aircraft was a Bell X-1 research aircraft, the speed 670 mph (1078 km/h) at 42000 feet (12801 metres) (the speed of sound decreases with altitude). The X-1 was rocket-powered, no jet with the necessary thrust being then available. Only two weeks previously, the first flight of the F-86 Sabre had taken place.

Sabre production with the 4850-pound (2200-kilogram) J47-GE-1 engine, began in May 1948 and around that time the prototype became the first United States fighter to exceed Mach 1 in a shallow dive. In 1952, on 11 November, a Sabre F-86D (the Sabre-Dog) took the world air speed record to 698.505 mph (1124.104 km/h) and in July the following year another raised it to 715.697 mph (1151.771 km/h). The Sabre became famous also as the first American military aircraft to equip several other air forces under the Mutual Aid Pact, and to be built in numbers in other countries. British development of swept-wing fighters was slower than the American and 430 Sabres were supplied to the Royal Air Force, providing a state-of-the-art aircraft for front-line service with NATO from 1953 until the Hunter entered service in 1956. Royal Air Force Sabres were Canadian-built; later, Royal Canadian Air Force aircraft were powered by the Canadian Orenda engine. Production of Sabres continued until 1956.

The Sabre's most enduring claim to immortality, however, lies in its service in the Korean war. That unfortunate conflict, the first of the major confrontations between East and West, opened with the invasion of South Korea. Korea had been a subject of conflict between China and the rising power of Japan at the beginning of the century. Following Japan's victory, the ancient kingdom became a Japanese protectorate in 1910. In 1948 it was split along the 38th parallel of latitude into the Republic of (South) Korea, under United States patronage and the Democratic People's Republic of (North) Korea, under Soviet patronage – effectively a new communist state.

South Korean defence against the 130-odd Russian-supplied Yak-9 fighters and Il-10 attack aircraft was restricted to Piper Cubs and Harvards. An early casualty was an American C-54 transport of the 5th Air Force; F-82 Twin Mustang long-range fighters, covering the evacuation of United States citizens, shot down three Yaks.

The small United States force defending the base port of Pusan were joined by fifteen contingents from the United Nations, including Great Britain, Australia

and Turkey. Among those present was No. 77 Squadron, Royal Australian Air Force, equipped with F-51 Mustangs.

Reinforced and supplied from Japan, the newly-created United States Far Eastern Air Force introduced F-80 Shooting Star jet fighters with Douglas B-26 and Boeing B-29 piston-engined bombers and settled down to destroy the army investing Pusan and its airfields, bases and communications right back to the Chinese border. One hundred and ten North Korean aircraft were claimed to have been destroyed. The next stage of the war carried the United Nations forces, under General MacArthur, north towards the Yalu, with a powerful programme of close support, interdiction and air supply mounted by the air forces.

At this point, drawn in by the virtual destruction of the North Korean forces, the Chinese intervened across the Yalu and MiG-15 swept-wing fighters appeared in Korean skies. The Soviet air force's first swept-wing fighter, the MiG-15 was hurried into production to get level with Western developments. Although much work had been done in the Soviet Union on swept-wing fighters, the rapid appearance of the MiG-15 was in great part due to the work of Dr Betz (one of the German scientists co-opted into the Soviet Union). It was also encouraged by the sale of twenty-five Rolls-Royce Nene turbojets as part of the Anglo-Soviet Trade Agreement negotiated by the British government in 1946. Built in probably greater numbers than any other second-generation jet, it has been constructed in four countries and has served in no less than eighteen air forces.

The MiGs first appeared on 1 November 1950; on 8 November, the first decisive jet air combat took place, Lieutenant Russell Brown, flying an F-80, destroying a MiG-15. Strategic bombing by B-29s continued, but failed to prevent a successful Chinese offensive that winter that pushed the United Nations forces back through South Korea. Despite very effective air cover, the F-80 was not a match for the MiG and in December F-84 Thunderjets and F-86 Sabres began to arrive to redress the balance. On 17 November the first all-swept-wing jet battle in history took place, courtesy of 4th Fighter Interception Wing and their Sabres. No. 77 Squadron, Royal Australian Air Force, converted on to the Meteor 8, the definitive fighter Meteor that had entered Royal Air Force service with No. 245 Squadron in June 1950.

The war developed into a contest between air power and man power, the Chinese trying to build up supplies and re-inforcements for their next offensive and the United States and their allies hammering

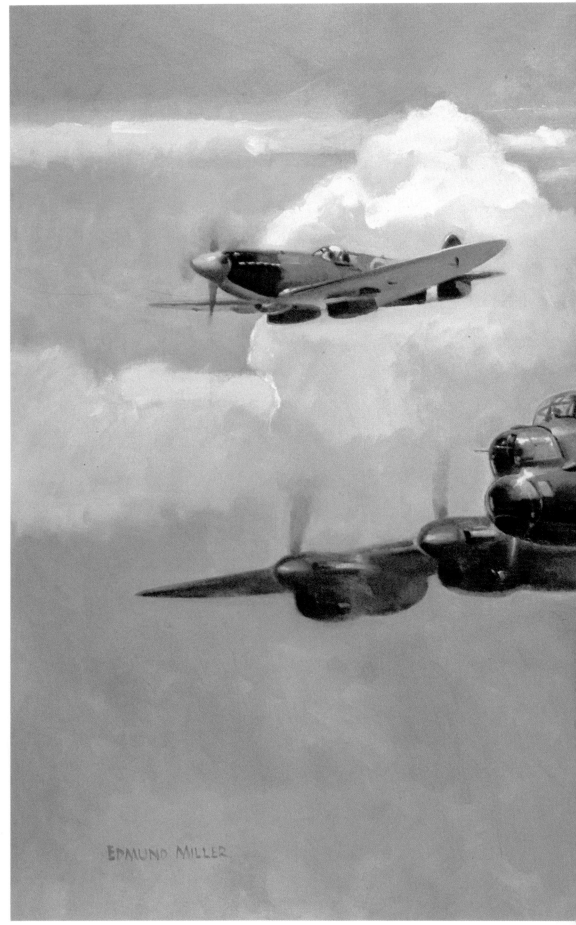

Forming Up EDMUND MILLER GAvA
The Battle of Britain Memorial Flight
(Rolls-Royce Merlin engines of various marks or
Griffons).

One of the most popular, evocative and
hardest-worked display teams of the Royal Air
Force, next to the Red Arrows and the parachute
team – the Falcons – is the Battle of Britain
Memorial Flight. The flight consists of the sole
surviving airworthy Avro Lancaster currently
flying, two Hawker Hurricane Mk IIcs (there are
no airworthy battle of Britain Mk I Hurricanes)
and four Spitfires. One of these, a Mk IIa flew in
the Battle of Britain; a second, presented to the
flight by the makers, is a Mk Vb, converted from
a Mk I on the production line and delivered in
1941. It was on this aircraft, during service with a
Maintenance Unit, that a member of the Women's
Auxiliary Air Force, helping to hold the tail down
during engine run-up, was inadvertently taken for
a short flight in this precarious position. The
remaining two Spitfires are Mk XIXs, with
Rolls-Royce Griffon engines, producing around
2500 hp and giving the last marks of Spitfires
speeds of up to 454 mph (731 km/h). One of them
is kept in the special blue PR markings of the
many aircraft that served in Photographic
Reconnaissance squadrons.

The Battle of Britain Flight was originally
formed at Biggin Hill in 1957 and in 1987 was
housed at RAF Coningsby.

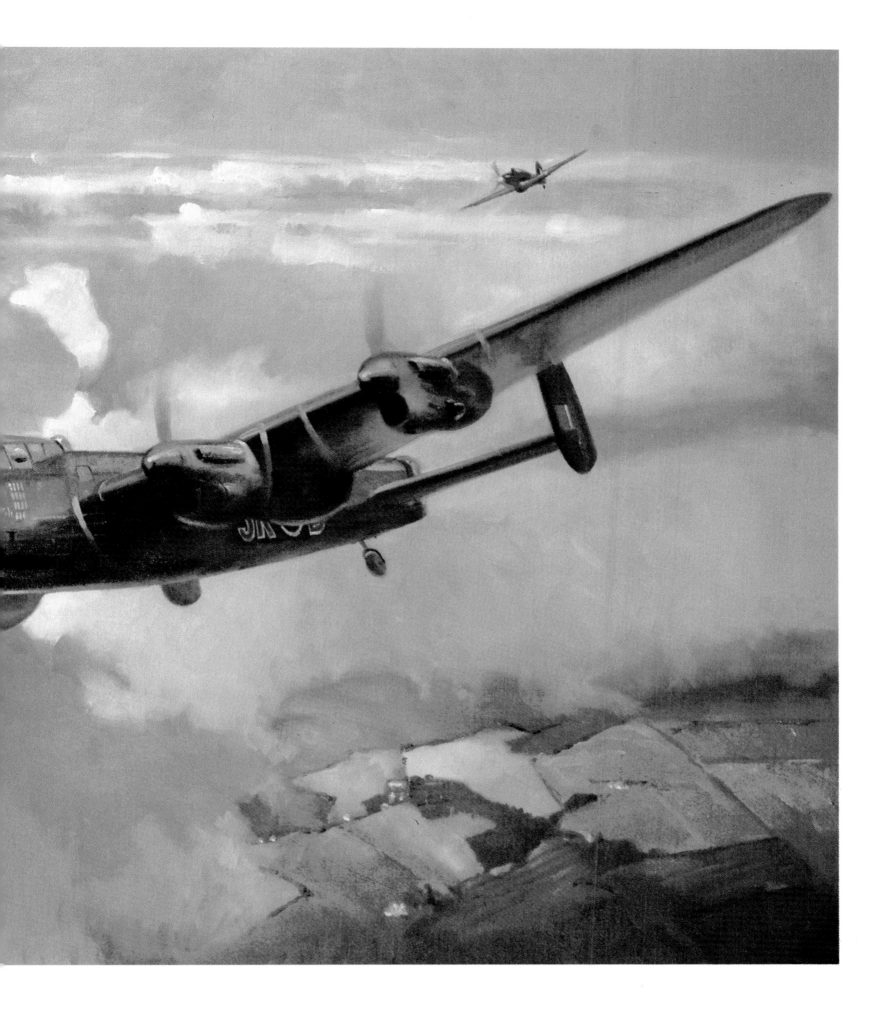

away at railways and industrial targets and maintaining a massive air support over the battlefield. In July 1951, peace talks began.

Enemy attempts to counter American air superiority led to their fielding over 500 MiG-15s – around a third of their total force – and savage battles in what became known as 'MiG Alley'. The 105 F-86s were reinforced, a second wing arriving in February 1952, and in the intensive fighting in 1953 the newly-introduced F-86F, a fighter bomber of some superiority to the MiG, clinched the question of who owned the sky. The final round-up of MiGs was largely the destruction of them on the ground.

Two further aspects of the Korean air war had profound effects on American strategic and tactical thinking: the introduction of the helicopter as a battlefield weapon (of which more later) and the massive intervention of naval air power. The Korean coastline is long, the total width of the country narrow in comparison to its length, and the North Korean navy of fifteen gunboats was erased swiftly by United Nations naval action. A total of thirteen American aircraft carriers took part in the war, mounting heavy and continuous attacks on land targets and covering B-29 bombing raids; each carrier withdrew in turn every three or four days to replenish.

The US Navy had just received its first generation jet fighters, the McDonnell F2H Banshee and the Grumman F9F Panther. Both these capable fighter-bombers were available in Korea. Both first flew in 1947 and both were originally conceived around multiple low-power engines, four for the F9F, six for the McDonnell design (then the FD-1 and called Phantom, which was confusing). They were accompanied on the carriers by piston-engined F4U Corsairs, long-ranged, fast, tough and carrying big loads and by the most astonishing aircraft to emerge from the conflict, the Douglas AD-1 Skyraider. The most versatile aircraft of the war, it had been designed as a single-seat dive-bomber/torpedo carrier and ordered in 1944. It was big, with a span of 50 feet (15 metres), and, with a 2700hp Wright R-3350 engine, could lift 4 tons (3.9 tonnes) of stores on no less than fifteen external strong points installed below the wings. It grossed around 9 tons (8.8 tonnes) and had a cruising endurance of about five hours. It must be the most powerful single-seat conventional warplane ever built.

In Korea, where it was known affec-tionately as the 'SPAD' from memories of that sturdy scout of World War I, the Skyraider came into its own, flying missions that included use of bombs, mines, depth-charges, napalm, rockets, cannon and torpedoes. In a mission unique in air warfare, eight Skyraiders from USS

Princeton torpedoed Hwachon dam – hitherto impregnable to bombing attack.

The Korean conflict enabled the United States Navy to formulate its jet-age policies and train its carrier force in full-scale war operations, using both jet and piston-engined aircraft in support of land operations. This form of warfare occupied much of maritime air power in the latter part of World War II and continues to be valid today; carriers possess a flexibility and mobility in deploying air support enjoyed by no other form of air power.

The Royal Air Force was not involved in the Korean war, British activity here being centred on the 13000-ton (12794-tonne) light fleet carriers equipped with Seafire 47s and Firefly 5s. First on the scene was HMS *Triumph*, which completed 895 sorties, mostly in support of ground forces, between the end of June 1950 and her withdrawal at the end of September. She was replaced by HMS *Theseus* with Sea Furies replacing Seafires and later, in turn, relieved by HMS *Glory* and the latter by HMS *Ocean*. HMS *Glory* did the longest stint and flew 9500 operational sorties in under eleven months. Operating alongside the Royal Navy carriers was an Australian one, HMAS *Sydney*. On 9 August 1952, Lieutenant Carmichael of No. 802 Squadron, flying a Sea Fury off HMS *Ocean*, shot down a MiG-15 (one suspects a great surprise to both of them). It was the Royal Navy that recovered, from the shallow water near Chinnampo, the first MiG-15 to be examined intact, in 1951. Austers, with army pilots, were the only other British aircraft, apart from some Sunderlands, to take active part in Korean operations.

The main reason for the absence of the Royal Air Force in Korea was the fact that its depleted peacetime strength was fully occupied elsewhere – in Malaya against the 'Malayan People's Anti-British Army', a precision of title rare in national armed forces of any kind. Despite the fact that the Royal Air Force had been the first to operate jets (and incidentally, the first to operate a jet off a carrier, when a Vampire landed on HMS *Ocean* on 3 December 1945), the campaign was fought almost entirely with piston-engined aircraft.

The Malayan emergency, code-named 'Operation Firedog', lasted from July 1948 until July 1960. As John W.R. Taylor has pointed out in *Pictorial History of the Royal Air Force* (co-author Philip Moyes), it was the longest continuous campaign by British armed forces since the Napoleonic wars. Based at Kuala Lumpur, the initial force consisted of two Spitfire squadrons, Nos. 60 and 28 with FR XVIIIs, No. 110 Squadron with Dakotas, and No. 45 Squadron with Beaufighters, which it exchanged two years later for Brigands,

then Hornets (the last front-line piston-engined fighters in the RAF). Most of the action consisted of bomb and cannon attacks on targets selected from air photographs, the bombing being thickened up by Lincoln squadrons and three squadrons of Sunderlands. Vampires arrived in 1951, Venoms in 1955, along with Canberras from No. 2 Squadron of the Royal Australian Air Force and from No. 75 Squadron of the Royal New Zealand Air Force.

As with the Americans in Korea, several valuable lessons were learned, including the importance of transport aircraft, the potential of the helicopter and the immense value of the small 'spotter' Austers of No. 656 AOP Squadron. These aircraft flew nearly a third of the total operational hours of the entire force in thirteen years.

Two other Royal Air Force activities must be noted in this period. In November 1945, Mosquito squadrons with bombs and rockets, together with Spitfires and Thunderbolts, had fought out a brief campaign in Indonesia, snuffing out insurgent radio stations, and covering the movements of British troops still gathering in surrendered Japanese. One of these attacks featured the use of air controllers in Austers, guiding Spitfires to a strike. In 1953 air controller operations, with hastily-armed Harvards, guided by Kenya Police Air Wing Piper Pacers 'held the fort' against the Mau-Mau until the arrival of Lincolns and Vampires.

It was not only in the Far East that confrontation with the Soviets occurred. On 21 June 1948, the last food train to run until 12 May 1949, entered Berlin. Following their own alien philosophies, the Russians sealed off the city, which was under quadripartite rule (as agreed by the European Advisory Commission of the United Kingdom, United States and the Soviet Union during World War II), from all save access by air.

Nobody expected the blockade to last more than about ten days; it lasted 383 days. Nobody expected more than a peak 750 short tons a day could be lifted – and coal was thought by some to be impossible to supply. The ultimate daily average was 4134 short tons. In addition to this total of 1583685 short tons flown in, 59909 short tons were flown out (over 50 per cent by British aircraft) and 67373 Germans were flown out of Berlin by the Royal Air Force. An additional 5882 short tons were flown in on the 12 May, the day rail traffic resumed.

The airlift began with thirty-two movements by C-47s (Dakotas) of United States Air Forces Europe from Wiesbaden into Templehof, carrying 80 short tons of food. At that time there were no C-54s

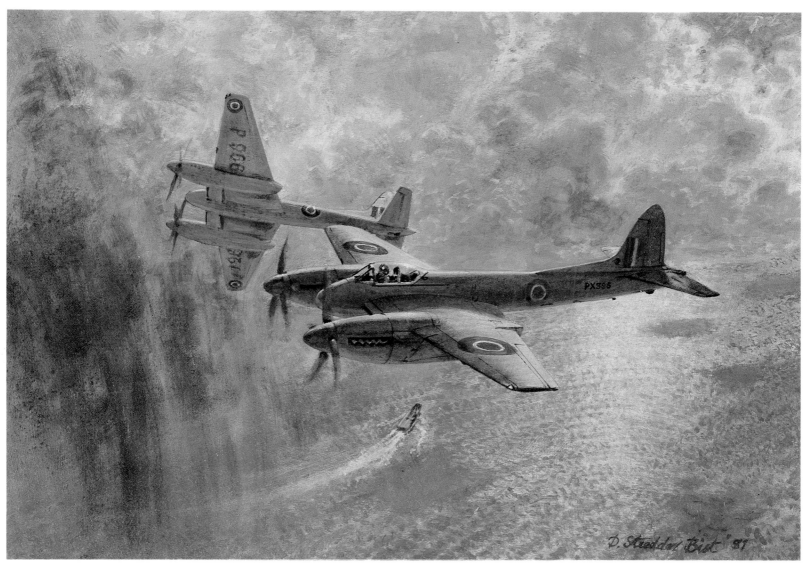

Sea Hornets Returning To Carrier D. STREDDER BIST GAvA
De Havilland Sea Hornet F 20 (two Rolls-Royce Merlin 130/131, 2080 ehp engine).

The Sea Hornet, developed for naval use from the Royal Air Force's Hornet F 3, was a medium-range, single-seat strike fighter, designed, like all naval aircraft, for operation from aircraft carriers. In that capacity it served with No. 801 Squadron in 1947 at their shore base of Arbroath (HMS *Condor* to the Royal Navy) and aboard HMS *Implacable* in 1949. *Implacable* was an '*Illustrious*' class vessel, launched in 1942. Seventy-eight Hornets were built, but served only partially with two other units in first-line service, Nos. 806 and 809 Squadrons. No. 801 served later at Ford (HMS *Peregrine*) and in HMS *Indomitable*, exchanging Sea Hornets for Sea Furies in 1951. Second-line squadrons that received the aircraft, and operated them as late as 1955, were Nos. 728, 736, 738, 739, 771 and 778. The Sea Hornet was the first single-seat, twin-engined deck-landing fighter operated by the navy.

available in Europe, and only about one hundred C-47s. On 28 June, Transport Command of the RAF started Dakota flights into Gatow from Wunsdorf. Starting at 0600 hours, thirteen aircraft lifted 44 short tons of food into Berlin. The Americans began ordering four-engined C-54s into Europe from Alaska, the Caribbean and from Tactical Air Command units in the United States. The main base for the American effort, code-named 'Operation Vittles' was Westover Air Force Base in Massachusetts. Throughout the operation, largely master-minded by Military Air

Transport Service, the four-engined C-54s, C-121s and one C-74 shuttled across the Atlantic via Keflavik or the Azores. The British effort was organized by No. 46 Group, Transport Command out of the United Kingdom and code-named 'Carter Paterson'. The whole operation was later to be designated 'Plainfare' as 'Carter Paterson' proved ambiguous, implying *removal* of things from Berlin!

The Royal Air Force threw in the Dakotas of 46 and 38 Groups, the Yorks of 37 Group and the Sunderlands of Coastal Command, alongside civil Tudors, Haltons, Halifaxes,

Lancastrians and Freighters (the civil aircraft lifting most of the fuel brought in). Fifteen of the RAF's new Hastings transports also took part. The United States contribution included 204 C-54s, 22 navy R5Ds, 5 C-82s, and a solitary C-97. Including back-up aircraft, the total came to 342.

The airfields involved, Templehof and Tegel in the United States zone, and Gatow in the British zone, needed virtually rebuilding to take the strain. This task was undertaken by the British, who were closer to hand. Lake Havel was also used for the Sunderlands. Total cost of the airlift to Britain was over seven million pounds; to the United States around 163 million dollars – without counting loss, wear and tear on aircraft, or incidental military costs.

Turning for the moment from wars and rumours of wars, the chronological sequence of the narrative takes a step backwards to survey one of the oldest, most sought after and most difficult to achieve of all man's aerial dreams – vertical flight.

There is a Chinese description of what might well be a helicopter, dated 320AD. There is a picture of a toy helicopter, worked by a draw-string, in 1325. Leonardo da Vinci sketched a helicopter at the end of the fifteenth century. Along the lines of the toy, in 1784 Launoy and Bienvenu in France flew a co-axial model helicopter, powered by a whalebone bowdrill. This was the first known self-propelled model helicopter

although a Russian, Lomonosov, had proposed a clockwork powered co-axial model for lifting meteorological instruments in 1754, which may have flown.

Sir George Cayley built a model on Launoy's lines in 1796; Degen built one in 1816 with contra-rotating blades and the Englishman W.H. Phillips flew a model with a rotor driven by steam jets from the tips (eliminating torque). Several other models

flew successfully, and there were thirty-odd proposals during the period for full-size, man-lifting helicopters. The main problems that defeated their authors were the instability of rotary-winged aircraft, which most attempted to solve with twin or contra-rotating co-axial rotors and – like fixed-wing aircraft – the lack of a suitable engine.

One of the earliest European pioneers to achieve at least partial success was Louis Bréguet, whose interest extended more profitably into fixed-wing flight. With Professor Richet he achieved a few wobbly and uncontrolled hops in 1907 and 1908. His machine was destroyed in a gale and he did not reappear on the rotary scene for twenty-two years. In 1907 Paul Cornu, another Frenchman, achieved free lift to about six feet, but seeing no way to overcome the stability and control problems, abandoned his researches. Ellehammer, in Denmark, made tentative flights between 1912 and 1916, but was also brought up short by control problems.

Etienne Oemichen, the first to achieve success in the field, built six helicopters in the early 1920s. He set the first helicopter

Feeding the Cats GEOFFREY LEA
Aérospatiale Puma (two Turboméca Turmo III C4 turboshafts, 1320 shp).

The Aérospatiale SA 330 Puma was designed to a requirement of the French army for a medium transport helicopter and first flew in 1965. It was later one of three helicopters selected for joint production in Britain and France, the other two being the Gazelle and Lynx. All three types are built in England by Westland, the Puma alone being exempt from considerable development by them. The first Westland-built Puma flew towards the end of 1970. Capable of carrying from sixteen to twenty people, it has a cruising speed of 159 mph (254 km/h) and forty were delivered to the RAF for use in the assault role. In this configuration it became the SA 330E. A highly successful helicopter, French sales amounting to 700 civil and military examples, it supplied six air arms besides the Royal Air Force and the French army. It is licence-built in Romania. Pumas serve with No. 33 Squadron, Odiham, No. 230 Squadron at Gutersloh, Germany, and with No. 1563 Flight, Belize, as well as with No. 240 Operational Conversion Unit at Odiham.

Geoffrey Lea has built this satisfying painting around a triangular base in composition and has managed to inject some of the sleek placidity of the cat into this tranquil scene of the RAF Pumas coming in to refuel in the field during an exercise.

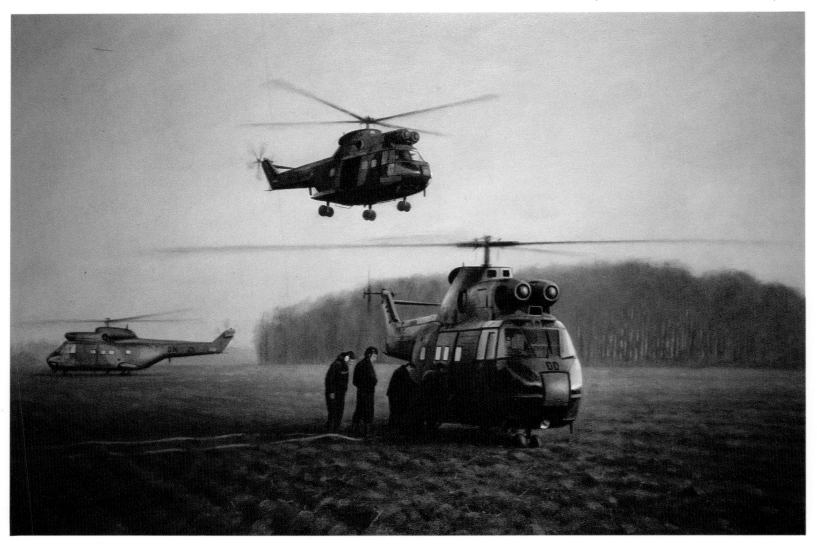

distance record accepted by the Fédération Aéronautique Internationale, of 1181 feet (360 metres) on 14 April 1924 and raised it to 1722 feet (524 metres) on 17 April. He also completed the first 1-kilometre (1.6-mile) closed-circuit flight by a helicopter and must, with his Spanish contemporary, the Marquis Pescara, be regarded as the father of the type. Pescara broke Oemichen's distance record of 1722 feet (524 metres), flying 2415 feet (736 metres) the next day; but his principal contribution to progress was that his No. 3 machine featured warping and tilting of the rotors, thus introducing the principles of cyclic and collective pitch control.

We now come to one of the most original aeronautical designers of all time; Juan de la Cierva, also a Spaniard, and contemporary of Pescara. His interest in rotating wings was primarily to find a means of overcoming the stalling problem of fixed-wing aircraft – then, as now, a potent cause of disaster. As a consequence of this conventional approach, his aircraft were basically normal fuselages with a tractor engine/propeller system, which relied upon creating enough forward speed to spin the rotor, thus providing sufficient lift for take-off. There was no drive direct to the rotor, unlike the helicopter, and therefore true vertical ascent and descent were not possible. He called his craft 'autogiros' and the word has passed into history as a definition of the type. Strictly speaking, autogyro is the generic term, autogiro a trade mark.

His first contribution to the art was the flapping hinge, the blades articulated to balance forces on advancing and retreating sides and to obtain stability. Following his first successful flight in January 1923, he made rapid progress and came to England in 1925, demonstrating his C 6A at the Royal Aircraft Establishment at Farnborough and forming his own company in England the following year. His designs now began to be manufactured in small numbers and in one of his production machines, the second C 8L, on 18 September 1928, he made the first rotary-wing crossing of the English Channel. Success continued with licence production in Britain, by A.V. Roe, who built about seventy of the later C 30As, selling ten to the RAF. Later refinements included folding blades, direct control of the rotor by a hanging stick from the rotor head, and enclosed cockpits. Licence production also took place in Germany and France and similar machines were built in the United States. Direct-drive for 'jump starts' was introduced, giving true vertical take-off and retaining the near-vertical, unpowered auto-rotational descent that was a prominent safety feature of the type. Very sadly, Cierva was killed in an air

crash in 1936; development of the autogyro tailed off and interest returned to the main-stream helicopter.

By the late thirties most of the problems involved with the helicopter had been solved or were capable of solution. Bréguet, returning to the attack, this time with René Dorand, built his Gyroplane Laboratoire, which flew in 1935, exhibiting complete control in all three axes and setting new records with speeds of 61 mph (98 km/h) and endurance of over an hour. Control was assured with co-axial rotors, cyclic and collective pitch movements. This was the first completely successful helicopter, although a rather better machine, the Focke-Wulf Fw 61, eclipsed it. By 1939 the Fw 61 had set records of 11 243.44 feet (3427 metres) for altitude, 143.069 miles (230.24 kilometres) for distance and 76.151 mph (122.549 km/h) for speed.

German interest in helicopters continued during World War II, and operational aircraft were built, but the emphasis in design now shifts across the Atlantic. In 1939 a Russian-American aircraft designer, Igor Sikorsky, built his first successful helicopter (he had built his first, unsuccessful, one in 1909). By 1942 he had established the now familiar layout for the rotor helicopter, with a small tail rotor to balance torque and the standard pitch controls. By the introducion of this simple layout, Sikorsky clearly demonstrated the commercial and military possibilities of the helicopter. His VS-316A, developed from the prototype VS-300, became the first to enter series production and fathered the huge families of current single-rotor types. It entered service in 1944 with the British and American air forces and navies, made the first deck landing on a ship and completed the first helicopter casualty evacuation (in Burma). The helicopter had arrived.

The early helicopters were not easy to fly. They were expensive to maintain, with the complex rotor heads and drive – and all the bits with different fatigue lives so that they were always being taken down to change something – and very thirsty on fuel. A lot of power was needed, compared with fixed-wing aircraft of comparable capacity. As a consequence, their use was initially largely by the military or by government. Militarily, they came of age in Korea, when their attributes of vertical take-off and landing (VTOL) and hover capability and their availability in large numbers (luckily, as casualties were horrendous) made them very useful. Apart from normal activities, they began to be employed in or beyond the front line, where a front existed, supplying outposts and isolated garrisons. They evacuated wounded and snatched downed pilots

from deep in enemy territory, often with a top cover of jets or SPADS, and deployed and moved mortar or ambush teams, whipping them away before counter action came in. They also began to get aggressive and carry offensive armament. This function had already been discovered by the British in Malaya, where a single soldier with a Bren gun in a helicopter could be confidently relied upon to ruin a bandit party's day.

Around the mid-fifties a most important change took place, with the replacement of piston engines by gas turbines. Not only did such turbines give greater performance flexibility and the promise of considerable power increases, but fuel consumption was significantly reduced. As costs came down, production increased and overall reliability improved, the use of helicopters became universal. VTOL and hover capability, good load carrying (external-slung loads of considerable weight and size can be carried by the larger helicopters) and excellent visibility render them ideal for survey and inspection. They can operate in areas where fixed wing aircraft cannot operate – the off-shore oil rig being a prime recent example – and, with increasing awareness since the 1960s of the uses of aircraft as business tools, they have entered the corporate and business fields.

As far as fixed-wing aircraft were concerned, the civil market immediately after the war was dominated by ex-military designs. Unlike the situation after the first world war, these were not converted bombers (funnily enough, that would come later) but genuine transport aircraft. Indeed, the most numerous of them all, the C-47 Dakota, had begun life as the civilian DC-3 and now, 'de-mobbed' in large numbers, was resuming that function. Virtually every airline in the West was reborn with the DC-3 and some still use them. Also numbers of four-engined transports were developed towards the end of the war, the principal type being the C-54/DC-4, big brother to the Dakota.

Although the British industry had been geared to production of only front-line aircraft and trainers during the war, while that of the United States had also designed and built transports, the popular theory that this fact alone accounts for subsequent dominance of the airline market by America is far from the whole truth. It ignores their far better use of available talent and more sensible priorities. There had, anyway, been admirable British designs for transatlantic four-engined aircraft in 1939 that could well have been revived and updated. Instead of which, after a period of the appalling so-called 'interim' types (that really were converted

bombers – Wellingtons, Lancasters and Sunderlands) Britain seemed to fall back into the same old trap of building only for the specialized need of the State corporations; needs that were not always understood and resulted in aircraft unsaleable anywhere else.

The basic American post-war airliner was the DC-4, designed before the conflict for trans-continental operation. With the same economics as the DC-3, but with a range of up to 1150 miles (1850 kilometres) with sixty-six passengers, it was snapped up by the airlines as the military released airframes for conversion. Seventy-nine more were built from scratch as civil airliners. In its high-density configuration it was responsible for the development of low fare 'coach' operations.

In 1943 Lockheed flew the first of its Constellations; little was heard of it. Early examples for Pan American and TWA were snatched by the military before they had flown. Only twenty-two had been built by the end of the war. Nothing was known of its performance outside the United States and to competitors in Britain and elsewhere, designing against the DC-4, its performance was an unwelcome surprise. It carried sixty-nine passengers 1500 miles (2414 kilometres) or thirty-nine passengers for 2600 miles (4184 kilometres); it cruised at 270 mph (435 km/h) at 20 000 feet (6096 km/h). The DC-4 cruised at 200 mph (321 km/h) at 10 000 feet (3048 metres); like the DC-3 it was unpressurized.

A tremendous trade war developed. Douglas produced the DC-6, originally intended as a short-range version of the DC-4, but stretched, re-engined with 2400 hp Pratt and Whitney R-2800s and pressurized. Its speed was 280 mph (450 km/h) at 16 000 feet (4877 metres),

Loading Mail at Keflavik, Iceland COLIN ASHFORD GAvA
Lockheed Constellation Model 749 (four Wright 749C-18BD-1, 2500 hp engines).

The first civil Lockheed Constellation, as opposed to the purely military transports, was the model 649, delivered to Eastern Airlines in May 1947. Prior to this, seventy-three Model 049s had been delivered to civilian customers, in addition to a military run of fifteen C-69s. The first batch of these early 'Connies' went in 1945-47 to TWA – originally Transcontinental and Western Air but now reflecting its greatly expanding routes as Trans-World Airlines. Twenty-eight of these were accepted by TWA who followed with an order for the 749 'overseas' version, which carried additional fuel tanks in the wings and could lift a total of 5820 US gallons at a maximum aircraft weight of nearly 70 tons (71 tonnes). This model, which normally grossed 50 tons (50.8 tonnes), carried fifty to eighty passengers. TWA were the most energetic of early users of the Constellation, starting with a New York – Washington – Paris service in 1946.

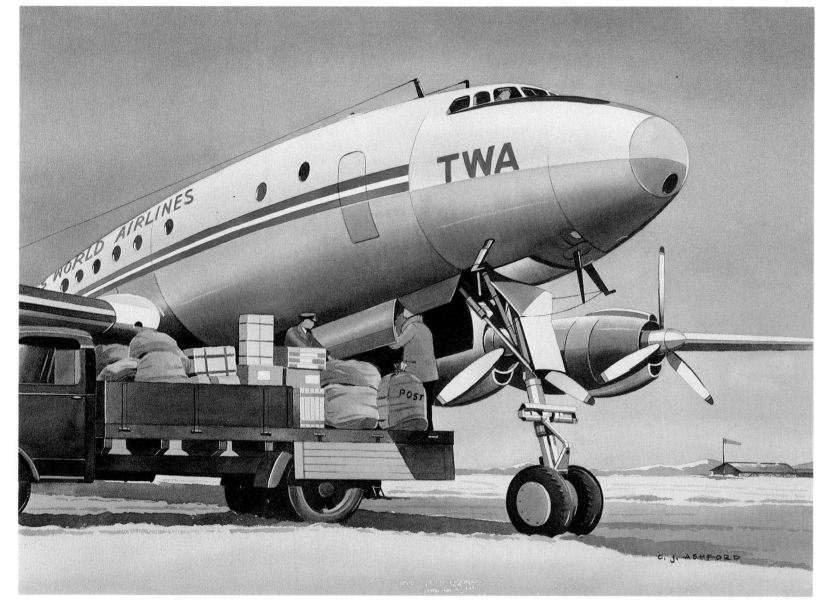

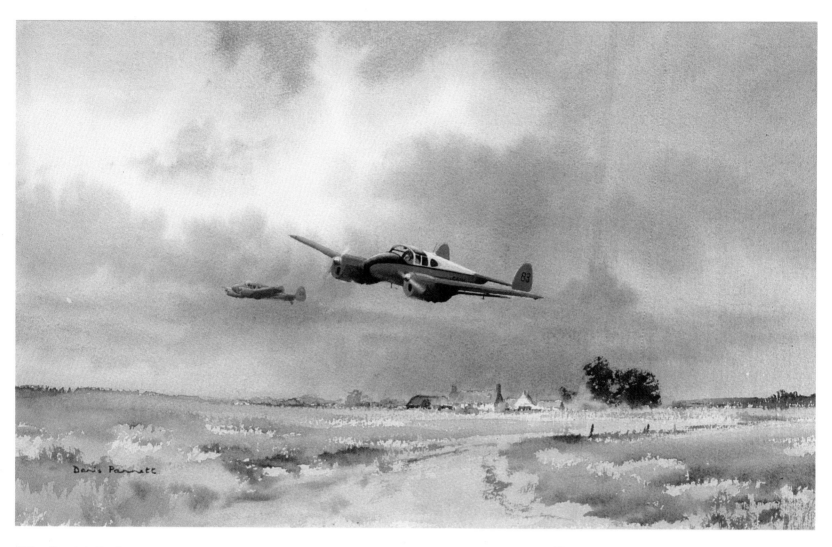

Miles Geminis Racing DENIS PANNETT GAvA
Miles M 65 Gemini (two Blackburn Cirrus Minor 2, 100 hp engines).

A highly successful traditional English watercolourist, Denis Pannett, although an enthusiast for the aviation scene, never leaves the viewer in any doubt that his first love is landscape; he always succeeds, however, in blending his two subjects effectively.

The Miles Gemini was the last of a long line of fast, elegant and desirable touring private aircraft designed and built by the talented Miles brothers, George and Fred. It was their first venture into the light twin market, intended to add the reliability of two engines to their single-engined products. This admirable intention was not initially totally fulfilled, the Cirrus being occasionally prone to crankshaft failure (until they beefed it up, then it was the crankcase that went). Cynics were wont to remark that having two engines merely doubled the chance of engine failure. The only real problem was that maintaining height at full load on a single 100 hp engine was not on; later Geminis, the Mark 3s, with the 145 hp DH Gipsy Major engines, were more capable. The aircraft, like all Miles aircraft, were delightful to fly and as well as being very popular tourers had a performance that encouraged several people to race them on handicap in the National Air Races from 1948. Owing to the limited life span of the glues then used in wooden aircraft, within twenty years or so most of these delightful aircraft were gone.

with sixty-eight passengers over 2150 miles (3460 kilometres). A further development, the DC-6B was stretched even further (more seats, more revenue, lower fares), with bigger engines and carrying eighty-two passengers 1900 miles (3057 kilometres). Built in bigger numbers than any other of the series, it was probably the best and most economical of any piston-engined transports. Lockheed responded to Douglas' pressure by lengthening the 'Connie' to become the Super Constellation,

with 2700 hp Wright Cyclones, carrying ninety-two passengers at 255 mph (450 km/h) for distances of nearly 2000 miles (3219 kilometres) – but still it did not achieve the popularity of the DC-6B.

The Super Constellation went into service with Eastern Airlines in late 1951, the DC-6B with American Airlines. But new events were about to shape the future. In 1949 the prototype de Havilland Comet, powered by four de Havilland Ghost turbojets, appeared at the Farnborough

Show, cruising at 490 mph (788 km/h) at 35 000 feet (56 325 metres) over stage lengths of 1750 miles (28 243 kilometres). The impact was enormous and orders began to pour in to Hatfield. Then disaster struck. Between March 1953 and April 1954, five of the twenty-two Comet 1s built had crashed on scheduled flights. The faults were found and put right, and the later Comet 4 had a successful career; but confidence was lost and even more vital, the lead over the Americans had also gone.

The piston-engined airliner was not yet dead. Introduction of the huge Wright Turbo-Compound engine, a beast of 3500 hp intended to shrug off the challenge of Rolls-Royce's turbo-propeller Dart and its developments, resulted in the DC-7 and DC-7C and the Lockheed L 1049 G Super Constellation. This was the first aircraft to enter service with the new engine. Unfortunatly, the new motor was rather too much for airframes not designed for it and noise and vibration levels were unacceptable. The DC-7Cs had lengthened wings putting the engines five feet (one and a half metres) further out, and holding more fuel gave very

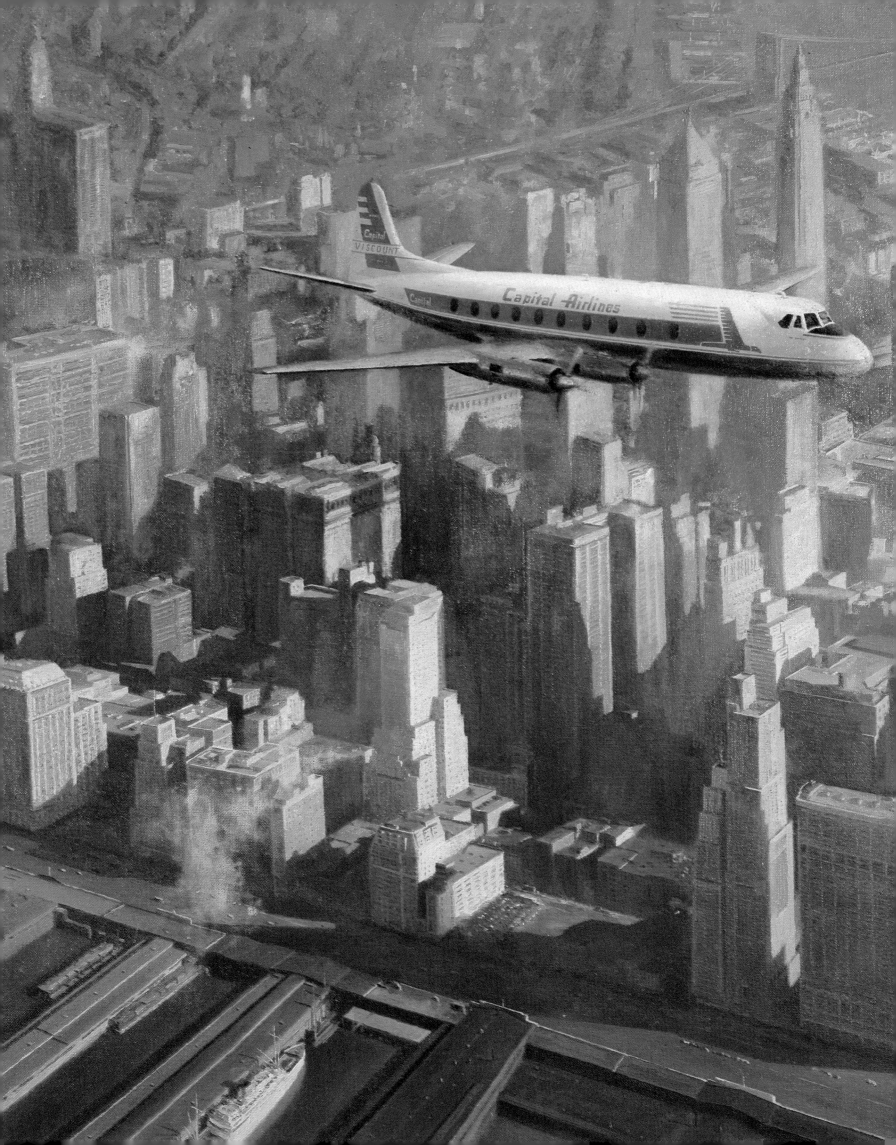

David Shepherd

attractive non-stop stage lengths. But, even with the Comet temporarily out of the way, these were the last of the old régime.

Before turning to the next development the introduction of the Dart must be noted. Vickers had produced a civil airliner in the family of aircraft that replaced the Wellington Trainer, the Viking, with two piston engines, but had seen the market taken over by the Convair Liner. The Viking's successor, designed under the inspired leadership of G.R. (later Sir George) Edwards, was the Viscount. With four Rolls-Royce Darts giving the quiet and smoothness of turbine travel, it swept the board. In its final form it could carry seventy-five passengers at 360mph (579km/h) and it became Britain's most successful airliner ever, with 459 built. It entered full service – the first propeller turbine scheduled service in the world – on 18 April 1953 and in the summer of 1987, it was still in service with British Air Ferries and about to undergo a fifteen-year life extension.

Viscount over Manhattan

DAVID SHEPHERD Vice-President GAvA
Vickers Type 745 Viscount of Capital Airways (four Rolls-Royce Darts, 1380-1990ehp engines).

The Viscount has several claims to its place in aeronautical history. It was the first gas-turbine-powered aircraft to be used on regular revenue services, powered by a variety of Rolls-Royce Dart engines. Power of the Dart rose progressively from 1380 equivalent horse power to nearly 2000ehp, enabling successive models of the Viscount to increase capacity from thirty-two to sixty-five passengers with greater speed and range also available. It must be remembered that airliners, like all aircraft, trade one advantage for another and maximum range normally means fewer passengers; maximum passengers a short stage length. Speeds quoted are normal cruising speeds, rather than top speeds as for military aircraft, and ranges or endurance usually include standard allowances for diversions.

The Viscount was also the first British airliner to sell in considerable numbers in North America. British European Airways was the launch customer in 1950, followed by Air France, Aer Lingus and Trans-Australia. After the economic and popular appeal of the Viscount was established, orders came from Trans-Canada Airlines in 1952 and the aircraft was re-designed in many details to match American requirements. In 1954 came the first order from Capital Airlines in the United States; the order eventually reached sixty aircraft and was the biggest dollar export order up to that time.

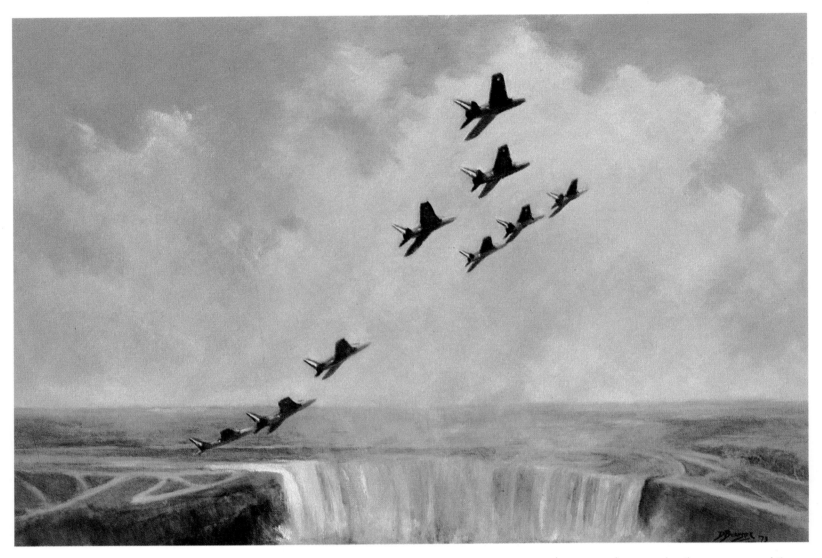

The Red Arrows over Niagara Falls DUDLEY BURNSIDE DSO, OBE, DFC, GAvA
Hawker Siddeley Gnat T I (Bristol Siddeley Orpheus 100, 4230-pound (1919-kilogram) thrust engine).

Dudley Burnside retains his normal, restrained palette in a spectrum of muted colours for this lively and balanced portrait of the Arrows on their first United States tour. In a neat piece of composition he has broken up the normal tight formation of the nine Gnats into a much more interesting triple grouping. The painting shows a moment in the 1972 tour, Operation Longbow, the team's first really extended foreign visit.

The Red Arrows were formed in 1965, following a previous team at the Central Flying School called the Yellowjacks, who had introduced the Gnat to formation aerobatics. The Red Arrows took over as the Royal Air Force aerobatic team from the Black Arrows and were the initiators of a policy decision to use trainers, not front-line fighters, for the national team. The Black Arrows' Hunters had been ideal, but the Lightnings that followed them into squadron service were not – and had a number of servicing problems in their early days. The Gnat came into use (in 1962) just in time. A lively, responsive, swept-wing aircraft, visually striking and ideal for close aerobatic formation work, it served the Arrows until the introduction of its successor, the Hawk in 1977.

In the 1930s Boeing had been seen off the airline stage by the Douglas DC-2 and DC-3 and never really came back with a piston-engined airliner. The Stratocruiser, an 'interim' type based on the B-29 and B-50 bombers which went into service over the Atlantic with Pan American in 1948, was never as good as the DC-6 or -7 or the 'Connie'; but with nearly 900 of the type sold to the United States Air Force as military transports, Boeing were laughing all the way to the bank. And in that situation lies at least some of Boeing's post-war success story, the research and development costs of their civil aircraft being underwritten by prior military contracts.

In 1947 Boeing rolled out the XB-47, a six-jet, highly swept-wing bomber that owed a great deal of its radical novelty to the work done in Germany on this sort of configuration and acquired by Boeing engineers after World War II. Ordered in large numbers under the pressure of the Korean war, the civil spin-off emerged as the 707. Aerodynamically ahead of the Comet (representing six years' technical advance) it was obviously the airliner of the future; there was an awkward period when nobody had the money to re-equip with this very expensive aircraft – which Boeing would not build without orders. Again, orders for the military transport version, the C-135, filled the gap and kept the production lines busy.

Now convincingly ahead of Douglas in the airliner game, Boeing produced a wide range of 707s for different requirements, the basic airframe lending itself to this. They introduced the three-jet 727 in 1960 for heavy-traffic, short-haul routes and a smaller twin-engined version in 1964.

Turbine engines having enormous capacity for development, airliner design has proliferated as never before. With the arrival of turbo-fan engines producing 43000 to 47000 pounds (19504 to 21319 kilograms) of thrust, Boeing evolved the 382-passenger 747, with a range of up to 6000 to 7000 miles (9655 to

11 265 kilometres), providing the airlines with a whole new ball-game of schedules and capacity. By 1987 the 747 would stage up to nearly 10 000 miles (16 093 kilometres), or carry 490 passengers. The engines that made this possible were (among others) the Rolls-Royce RB-211

high by-pass ratio, three shaft turbo-fans and, following the introduction of the 747 (the first jumbo jet), have sired a new generation of short-haul three-engined transports, such as the Lockheed Tri-Star and the Douglas DC-10. With the power available it was possible to lift heavy loads

off existing runways (comparatively short ones in this end of the market) and to have great flexibility. The DC-10 was designed for routes from 300 to 6000 miles (483 to 9656 kilometres), while the Tri-Star can carry up to 400 passengers and operate up to 42 000 feet (12 801 metres). It is these aircraft that are feeding the huge charter and inclusive tour industry.

Since the RB-211, developed in the sixties for the 747 and the wide-bodies, Rolls-Royce have introduced the 535, which powers the Boeing 757 (an alternative being the P & W 2037). Introduced in 1983, the 757 complements the wide-bodied 767, powered by the 48 000-pound (21 772-kilogram) thrust P & W JT9D-7R4D or General Electric CF6-80A. Both are twin-engined, medium-haul aircraft, the 757 abandoning the wide, two-aisle fuselage for a slender body and with a wing specially designed for short route

The New Breed J.W. PETRIE GAvA
British Aerospace Hawk T 1 (Rolls-Royce/Turboméca Mk 151 Adour turbofan, 5340-pound (2422-kilogram) thrust).

The arrival of the Hawk in the inventory of the RAF marked a considerable change in policy for the force's training establishment. The new aircraft, which first entered service with No. 4 Flying Training School at Valley in Anglesea in 1974, replaced not only the Jet Provost in its role as an advanced two-seat trainer, but also the Gnat and the Hunter T 1. It also equipped the Central Flying School and the two Tactical Weapons Units, No. 1 at Brawdy and No. 2 at Chivenor with the nameplates of Nos. 234 and 63 Squadrons. There is an export version of the Hawk with the more powerful 5700-pound (2585-kilogram) thrust Adour Mk 861.

Alone among RAF training aircraft, Hawks are required to be able to double as local defence interceptors, carrying the centre line 30-millimetre Aden gun pod. Total orders exceeded 300 for a number of air forces (175 were ordered for the RAF) and Hawk has also won a contract for training aircraft for the United States Navy in its 1990s programme.

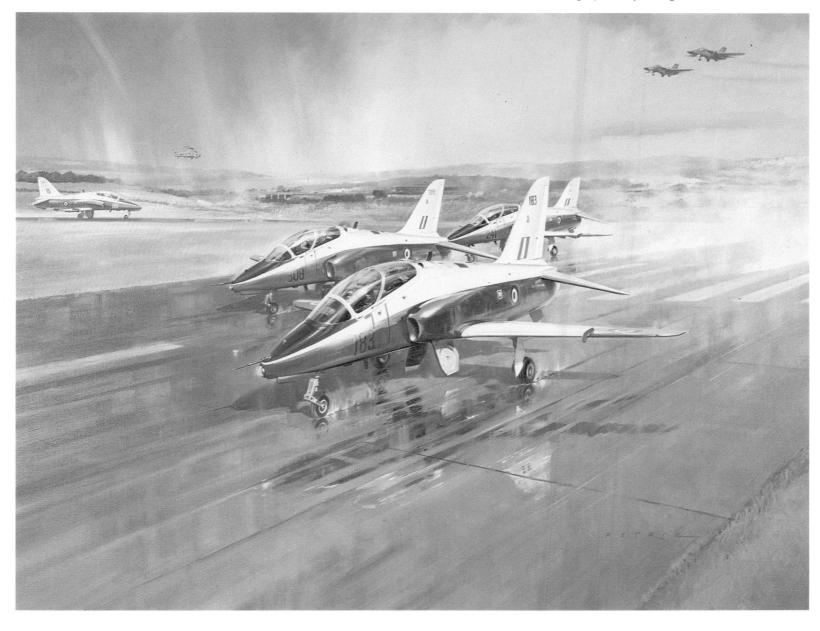

work. Both these new generation Boeings are selling well, but a challenge from Europe, something of a phenomenon, has arisen and is meeting with considerable success. The challenge is Airbus – a consortium of European companies: Aérospatiale of France, Deutsche Airbus of Germany, British Aerospace, CASA of Spain and Fokker of the Netherlands. The 330-seat, wide-body A300 flew in 1972 and the current, larger Series 600 has the 56 000-pound (25 402-kilogram) thrust version of the JT9D or CF6 giving a cruising speed of 536 mph (862 km/h) and a range of 3500 to 5300 miles (5632 to 8529 kilometres). Later versions include the A310, with a new technology, British-designed wing, and the A340.

Multi-national programmes are not new; indeed, with the enormous costs of designing and building a new aircraft they have become almost statutory (apart from delicate manoeuvring areas like technology transfer). Jaguar and Tornado are multinational aircraft and the habit is now spreading to the United States. One of the earliest (and on the face of it least likely) acts of collaboration was the Anglo-French Concorde. Still the only supersonic airliner in the world, it entered service on 21 January 1976 and by the spring of 1987 the fleet of twelve used by British Airways and Air France had carried over 1 539 000 passengers on schedules, and thousands more on charter flights. Cruising at Mach 2, Concorde's Rolls-Royce/SNECMA engines (another joint programme) cut the London-New York journey time to three and a half

Concorde RAY TOOTAL GAvA

British Aerospace/Aérospatiale Concorde (four Rolls Royce/SNECMA Olympus 593, Mk602, 38 050-pound (17 237-kilogram, thrust engines).

The Anglo-French Concorde, one of the first examples and the most dramatic and most successful case of international collaboration between ourselves and the French, has never ceased to be a violently emotional subject. Attacked with venomous ill will by various disordered persons, it has survived one of the world's largest and longest cost overruns (The Prime Minister of the day tried desperately to turn off the financial tap, but could not break the contract). It also survived the heat generated by two successful and dominant aircraft industries with divergent political views behind them, and traditions of national rivalry to overcome.

In the end, it triumphed. The world's only operational supersonic airliner, it carries 128 passengers over just under 4000 miles (6437 kilometres) and at a speed approaching Mach 2. It entered service simultaneously with Air France and British Airways in January 1976.

RAY TOOTALL

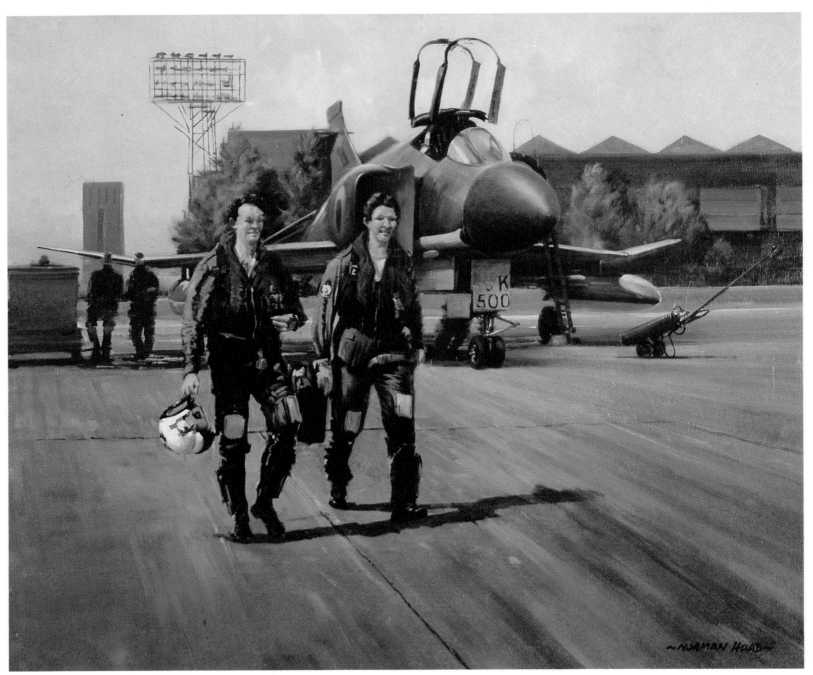

Mission Complete NORMAN HOAD CVO, CBE, AFC, GAvA
McDonnell Douglas Phantom FGR 2 of No. 56 Squadron, RAF (two Rolls Royce RB 168-25R Spey, 12250-pound (5560-kilogram) thrust engines).

Norman Hoad, who retired from the Royal Air Force as an Air Vice-Marshal, now devotes much of his time to painting, in a traditional style, landscape and equestrian subjects as well as aviation. His knowledge of service subjects and opportunities to observe scenes such as this have given a particular authenticity to his work.

The Phantom, or F 4 in American terminology, was originally designed as a naval carrier aircraft in 1960 but soon attracted orders from the United States Air Force and Marines. It was the first front-line aircraft to serve all three services. In 1964 it was ordered for the Royal Navy and went into service with No. 892 Squadron in 1969, joining HMS *Ark Royal* the following year. As this co-incided with the miserable decision by the government to scrap all Britains's carriers, no further units were formed. However, in the wake of another penny-pinching exercise that prevented the supersonic Hawker P 1154 seeing the light of day, the Phantom was ordered for the RAF, eventually equipping fourteen squadrons. A supremely efficient Mach 2 aircraft, it now serves the RAF on home defence duties. The painting shows a No. 56 Squadron crew after a sortie at RAF Wattisham.

hours. The Mk 610 Olympus 593 turbojets produce 38050 pounds (17236 kilograms) of re-heat thrust at take-off.

Returning now to military developments, after the end of the second world war the Royal Air Force suffered, inevitably, a massive reduction in strength. As in the period following the first world war, it was to be about five years before new equipment arrived for the squadrons. In the early fifties the conversion of the service to jets began, with the gentlemanly Meteor in Fighter Command and the elegant Canberra replacing the piston-engined Lincolns in Bomber Command. The Meteor, in fact, had been in squadron service from 1945, the definitive Mark 8 arriving in 1950. The Canberra became the first of the new generation of all-purpose aircraft, replacing virtually everything except the single-seater fighter and eventually no less than sixty-one squadrons employed it.

In other respects, the picture was nothing like so pretty. The post-war government was engrossed in its policies of social welfare (those who remember the decade of grim austerity that followed may wonder to what effect) and one result, encouraged by their scientific advisers, was an almost total run-down of research and development.

No attempt was made to benefit from the huge quantity of advanced German research that the United States and the Soviet Union were collecting avidly. As one result of this the first British swept-wing fighters did not come into service until long after those in Russia and America. The Soviets, in fact, were at an impasse, with no native engine available for the excellent MiG-15 – until the British

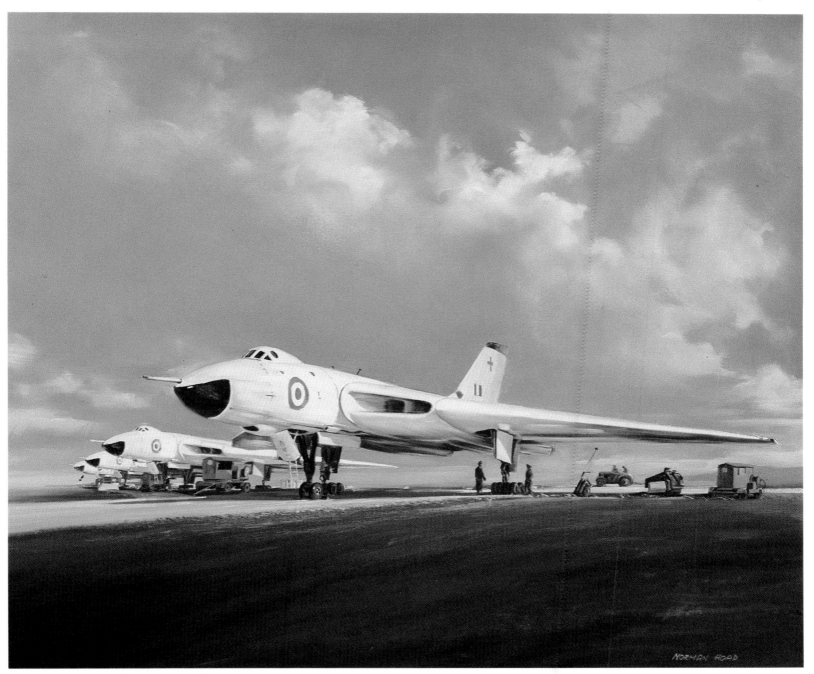

ORP, Waddington NORMAN HOAD GAvA
Avro Vulcan B 2 (four Bristol-Siddeley/Rolls-Royce Olympus 301, 20000-pound (90972-kilogram)
thrust engines).

The Vulcan was the first delta-wing heavy bomber to enter service in the world and formed part of the
Royal Air Force's strike force from 1957 until the last squadrons were replaced by Tornados in 1985.
Conceived as a very-long-range, very-high-altitude bomber, capable of carrying 21000 pounds (9525
kilograms) of bombs or nuclear weapons at near-sonic speed, the Vulcan later became the vehicle for
the British 'stand-off' bomb, the Avro Blue Steel supersonic cruise missile. The first squadron to equip
with this weapon and the Vulcan B 2A was No. 617, the Dambusters. When internal re-organization in
the defence forces created Strike Command and Bomber Command vanished for ever, in April 1968,
there were eight squadrons of Vulcans operational. For the previous two years they had been
re-mustered as low-level penetration units, following changes in NATO strategy. Speed of response of
these big aircraft, spanning 111 feet (33.8 metres), was remarkable; all four engines could be started at
the same time, with powered controls and instruments coming on line within 20 seconds. Four aircraft
could be airborne and clear of the airfield in two minutes from start-up on the ORP (Operational
Readiness Platform). The maximum achieved in this time was, in fact, seven aircraft.

government sold them twenty-five Nenes
and thirty Derwents.

In 1946 the Director-General of Scientific
Research (Air) announced the abandon-
ment of full-scale research into supersonic
flight, as being too dangerous to human
life. A year later Major Yeager made his
historic flight in the Bell X-1.

It was to be some time before the RAF
received a proper replacement for the
Lincoln as a long-range heavy bomber; the
first of the V-bombers, the Valiant, arrived
in 1955. In the meantime, eight squadrons
of borrowed 1B-29s served under the
name of the Washington. The build-up of
the V-force, with the Victor and Vulcan,

together with the decision to arm the RAF
with nuclear weapons, created a special
deterrent force within NATO and the
Washington squadrons, in fact, re-equipped
with Canberras.

The V-force was backed up by Thor
missiles, acquired from the United States,
and operational between 1958 and 1963.
Plans to extend the force's usefulness as a
strategic deterrent fell through with the
abandonment of the Skybolt missile with
which they were to be armed, and the
V-force role became a tactical one within
NATO's new trip-wire strategy. The deterrent
passed into the hands of the Royal Navy
and the Polaris submarines, where it has
remained ever since. By 1973 the V-force
consisted of the three Vulcan squadrons of
the Waddington Wing of No. 1 Group,
Strike Command.

Another effect of the changing political
scene was the increasing importance of
air transport, because of the abandonment
of the majority of overseas bases and
staging posts. The Strategic Reserve was

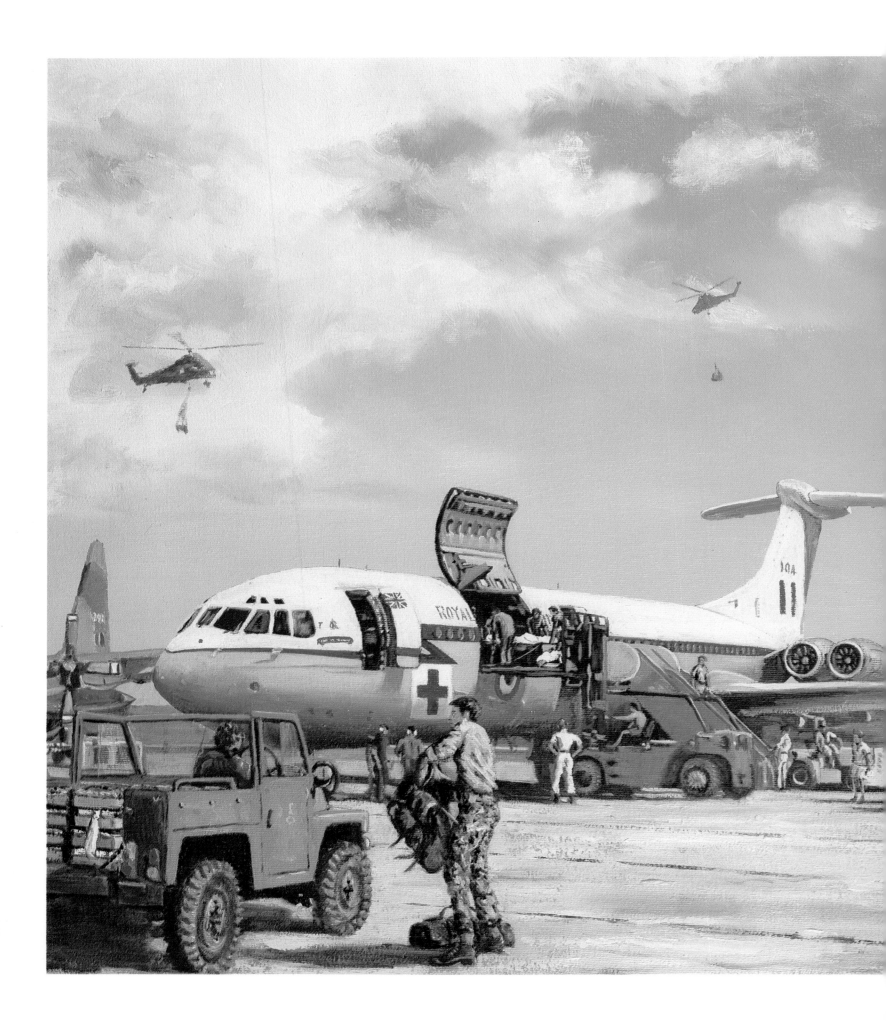

frequently lifted to trouble spots by the Britannias, Argosies and Comets of the RAF's No. 38 Group, reformed in 1960 as a tactical force to work with the army. They were deployed in Kuwait in 1961, Borneo in 1962, (as part of the Indonesian confrontation which lasted until 1966), Brunei in 1962, South Arabia, Aden and, more recently, in the Falkland Islands.

Major re-equipment took place in the 1960s; out went the ageing but excellent Hunter, the Canberra and the Argosies, Comets and Britannias. In came the F-4 Phantom (one of the world's supreme fighting aircraft), the Lightning, the Buccaneer and the Hercules. The fruits of that early starvation of research are ripening – an increasing number of the RAF's aircraft are American.

With all this there had been a major re-shaping of the command structure, partly as a result of the physical shrinking of the service and partly to reflect the changing roles and capabilities of the force. The old Bomber and Fighter Commands merged into Strike Command in 1968 and Signals and Coastal Commands followed the next year. Bomber Command became No. 1 Group, Coastal Command No. 18 Group. In 1972 Air Support Command – Transport Command up to 1967 – was also

Return From Conflict PENELOPE DOUGLAS GAvA Vickers VC 10 C1 Type 1106 (four Rolls-Royce Conway RCo43, 22500-pound (10 206-kilogram) thrust engines).

The Vickers VC 10, 115-135 passenger aircraft, went into service with BOAC on its Lagos routes in 1964 and was used throughout its African and Far East networks. In 1967 the Royal Air Force acquired a number as the VC 10 C1 for long-range trooping requirements, equipping No. 10 Squadron, which had previously been one of the Victor squadrons of the V-force. These took over such duties from the Comets of No. 216 Squadron and other types. During the Falklands action they were employed in Casevac (casualty evacuation) duties as well, operating through Ascension Island.

Later, a further batch from the fifty-four VC 10s built was transferred to the Royal Air Force as tanker aircraft, equipped for three-point flight refuelling, and operated by No. 101 Squadron as the VC 10 K Mk 2. A Super VC 10 was built, holding fuel for 7128 miles (11 471 kilometres) and cruising at 550 mph (885 km/h) and this became the VC 10 K Mk 3 as a service tanker.

Penelope Douglas paints a number of Royal Air Force subjects in refreshing variety. Here she has admirably conveyed the atmosphere of efficient action surrounding a hospital aircraft being unloaded. Even among professional members, paintings of animated ground subjects as convincingly handled as hers are sufficiently scarce as to attract immediate attention.

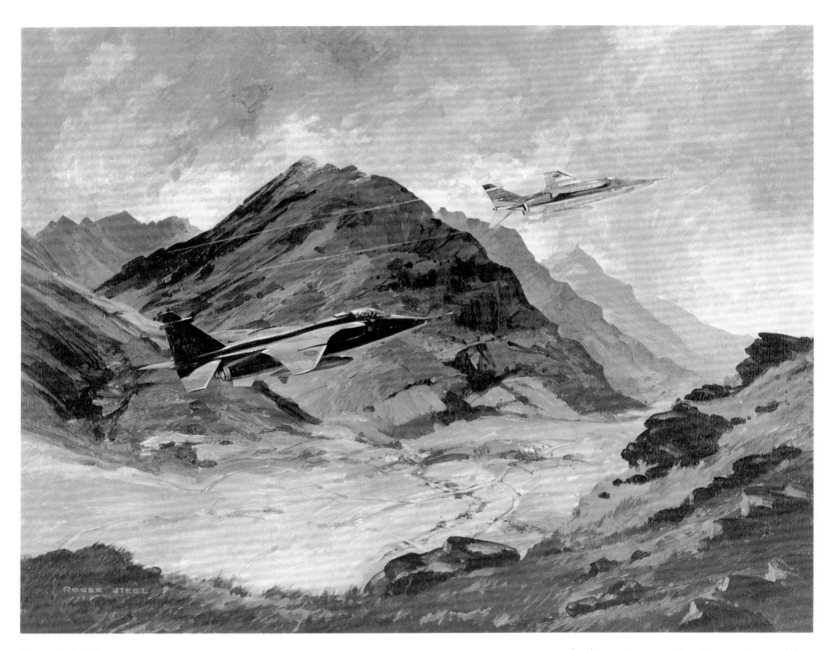

Through the Glen ROGER STEEL GAvA
SEPECAT Jaguar GR 1 (two Rolls-Royce-Turboméca Adour, 7305-pound (3313-kilogram) thrust engines).

Jaguar was the result of a collaborative venture between Dassault-Breguet, who originated the design, and British Aircraft Corporation (now British Aerospace) for a tactical support and ground attack single-seat aircraft. Armed with two 30-millimetre Aden cannon and capable of carrying up to 10 500 pounds (4763 kilograms) of external stores, the small, agile, difficult-to-hit Jaguar was regarded by the Royal Air Force and the Armée de l'Air as a powerful front-line weapon and 200 were ordered for each. These orders have been completed and a more powerful version of the supersonic Jaguar has been delivered to the air forces of Ecuador, Oman and Nigeria and is under production at Bangalore for the Indian Air Force. Total production runs to over 570. French Jaguars were deployed to and saw action in Chad, during the confrontation with Libya in 1984. Jaguar GR 1s equipped eight RAF squadrons and remained in 1987 with Nos. 6 and 54 at Coltishall in the strike role, No. 41 also at Coltishall, and No. 2 at Laarbruch, in the tactical reconnaissance role (retaining their strike capability). The remaining squadrons converted to the Tornado, Jaguar's strike successor. The Jaguar Operations Conversion Unit, No. 226, resides at Lossiemouth.

Roger Steel has painted a brace of Jaguars engaged in low-level training in one of the Scottish training areas. For those with a requirement for useless information, SEPECAT stands for the Société Européenne de Production de l'Avion d'Entrainement, Combat et Appui Tactique.

absorbed. Thus the 'sharp end' of the Royal Air Force became one single organization.

In 1974 the next re-equipment saw the introduction of the Anglo-French Jaguar, first product of the new European standardization and collaborative programme, replacing the Phantom and Lightning in eight squadrons (the latter giving up its home defence role to the Phantom). The Jaguar, in its turn, has been replaced by the multi-role combat aircraft, the Tornado, which has taken over the tasks of the Vulcans and the Jaguars and, in its ADV version, undertaken Strike Command's task of defending NATO's 'back door' into the Atlantic.

In the early seventies the controversial decision was taken to wind up the carrier force of the Royal Navy. This decision, presumably for economic reasons, was, in the face of historical example as recently as Korea, absurd. The theory that land-based air can take over the functions of carrier air has very seldom worked and very seldom will, in most people's opinion. It had never looked feasible to build the new, big replacement for HMS *Ark Royal*, but when her replacement, in fact the three 'through-deck' cruisers, came into service from 1978, the navy were left with their Sea King, Wessex, Wasp and Lynx helicopters and nothing more. Their Phantoms and Buccaneers were packed off to Strike Command, to the RAF's delight. It was a welcome reinforcement (to this day, RAF Phantoms have arrestor hooks). The remaining carrier, HMS *Hermes*, converted to a commando role in 1973, replacing HMS *Albion* which was up for disposal.

To this story, however, there is a happy ending, after a fashion. The Royal Air Force had accepted a revolutionary new vertical/short take-off and landing

(V/STOL) ground attack aircraft, the Harrier, powered by the vectored thrust Rolls-Royce (ex-Bristol) Pegasus engine. By 1970 it had three squadrons, one in the United Kingdom and two in Germany, with a more or less permanent detachment in Belize. The design of the new through-

deck cruisers (note that carrier was then such a dirty word in government circles it could not even be used for the new ships) permited operation of such an aircraft. The navy had a Harrier hopping on and off HMS *Hermes* in early 1977, following 1975 official sanction for a naval version, and the

Sea Harrier entered service with No. 700A Trials Squadron at Yeovilton in 1979.

In April 1982, the Argentine invaded the Falkland Islands. Seventy-two hours later, HMS *Hermes* and HMS *Invincible*, the first of the new carriers, were heading south out of Portsmouth Harbour. Each had on board ten Sea Harriers, drawn from Nos. 801 and 899 Squadrons; most of the rest of the navy's thirty-three Harriers later formed No. 809 Squadron and joined the party. As well as the small helicopters of ship's flights, there were the Sea Kings of Nos. 820 and 826 Squadrons, followed by those of Nos. 824 and 825 – a total of some forty helicopters. Upon these aircraft, and a small number of RAF Harriers, would fall the defence and attack burdens of the campaign and (for the helicopters) transport as well. The Argentinian air force deployed Skyhawks,

Harriers off Gibraltar WILF HARDY GAvA
British Aerospace Harrier GR3 (Rolls-Royce Pegasus 103, 21500-pound (9752-kilogram) thrust engine).

The Harrier was developed from the experimental Hawker P 1127 Kestrel to become the first operational vertical take-off and landing (VTOL) aircraft in the world. Power was from the unique vectored thrust Bristol Pegasus engine. Three Royal Air Force squadrons employ the Harrier, two of them in Germany. Here, in the event of a conflict, the Harrier's ability to move progressively out from damaged or destroyed formal bases into the woods (quite literally) and its agility, fire power and heavy war load would be used to greatest advantage. Hawker Aircraft became part of Hawker-Siddeley and then of British Aerospace; Rolls-Royce took over Bristol Engines, hence the change of name.

In 1969 a Harrier of No. 1 Squadron won a major prize in the Transatlantic Air Race, crossing London to New York with flight-refuelling in 6 hours, 11 minutes. Its arrival in New York added publicity to the acquisition of the type by the United States Marines. One hundred and twenty British-built AV-8As ordered the same year were followed by the AV-8B, 336 being delivered for eight Marine squadrons. These were all built with some modifications by McDonnell Douglas.

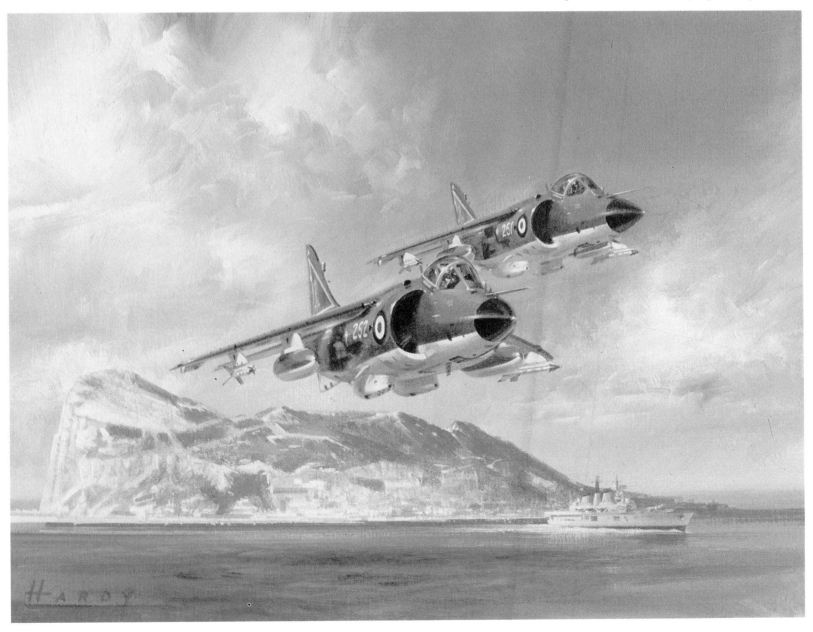

Mirage IIIEAs, Israeli-built Dagger interception and long-range fighter aircraft and a squadron of Canberras; they also had five or six Super Etendards, equipped with Exocet missiles.

Eight thousand miles separated the Falklands from Britain – the longest distance at which air operations had ever been carried out. A base at Ascension Island, roughly half-way, became a major factor in the immense supply problem. The Hercules of the RAF's four squadrons were hastily converted for in-flight refuelling and the tanker force joined them in the complex process of air supply. The Argentine air force faced a different problem, for the battle was very near the extreme range of their aircraft and time over target was limited. They had other problems, too – almost total lack of available, dedicated reconnaissance aircraft – a problem shared by the British since the removal of the Navy's fixed-wing aircraft.

Initial British strikes against airfields at Port Stanley and Goose Green were successful, destroying fifteen aircraft for no loss. But hastily-mounted strikes by two of the last Vulcans available, from No. 44 Squadron, although unique feats of

The Falklands Campaign – The Royal Engineers Supply the Fuel TERENCE CUNEO GAvA British Aerospace (Hawker) Harrier GR 3 (Rolls-Royce/Bristol Pegasus 103, 21500-pound (9752-kilogram) thrust engine).

Appropriately enough, it was to be No. 1 Squadron, Royal Air Force, that would be the first to receive the totally novel vertical take-off and landing Hawker Siddeley Harriers as replacement for its Hunter FGA 9s. Novelty had been a part of No. 1's existence for some time; with the Hunter 9 it formed the ground attack wing of No. 38 Group, Support Command. It shared this duty with No. 54 Squadron and the role dated from the organization in 1960 of a tactical air force within Transport (later Support) Command, to supply the army with helicopter, tactical transport and ground attack fighter support. This task continued with the Harrier, the RAF equipping two more squadrons with the type in Germany. No. 1 Squadron was in the limelight when Squadron Leader Leckie-Thompson was a winner in the 1969 Transatlantic Air Race, employing flight refuelling techniques. This came in useful when the Squadron re-inforced the navy's Sea Harriers in the Falklands campaign on 3-5 May, having hastily practised ski-jump take-offs at Yeovilton, joining HMS *Hermes* after a gruelling flight out to Ascension. Other GR 3s came out on HMS *Atlantic Conveyor* and flew off to join the carrier force on 18 and 19 May before the transport was set on fire. From 9 June operations were made possible from shore by the construction of an 800-foot (243-metre) aluminium plank strip with fuelling facilities constructed by the Royal Engineers. Other emergency grass strips also became available.

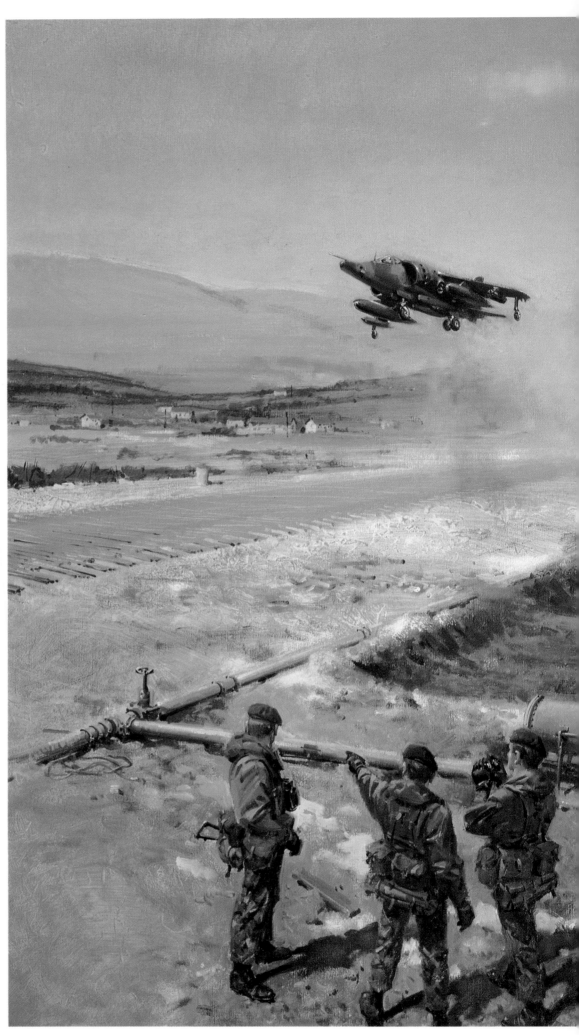

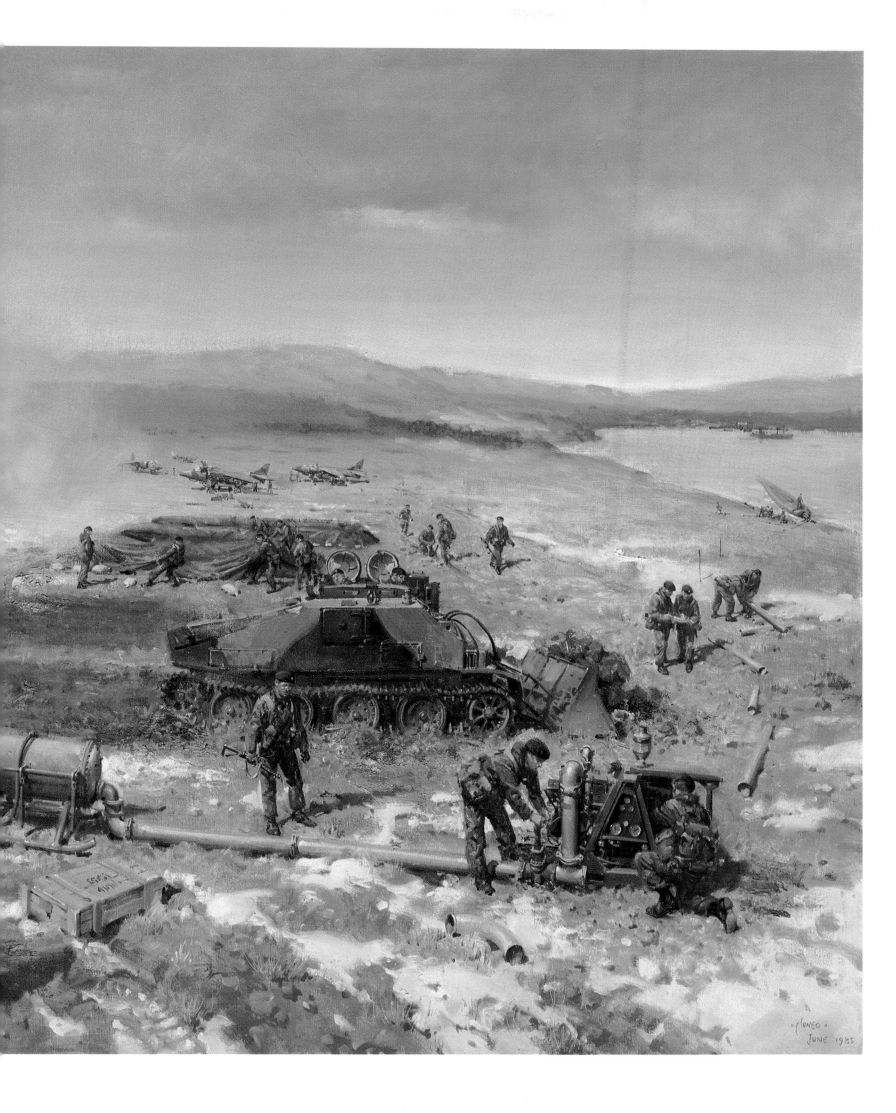

navigation and preparation, failed to do much damage. Argentinian reaction against the fleet, made easier by the stupidity of discarding naval AEW aircraft, sank HMS *Sheffield* for lack of such warning. While naval bombardment and clandestine landings prepared for the main assault, the hundred-odd ships in or near the battle zone were exposed to heavy attack. The Argentines lost a number of aircraft with little to show for it, since their bombs frequently failed to explode. Eight Harriers of No. 1 Squadron, RAF, arrived, equipped with Sidewinder dog-fight missiles, after a nine-hour, flight-refuelled epic from the United Kingdom. Further supplies of Harriers, Sea Harriers, Wessex and Chinook heavy-lift helicopters had been dispatched by sea.

The main assault was made on 21 May. After daylight, the enemy mounted a series of determined assaults, in the face of Rapier and ship's defences, sinking HMS *Ardent* and losing seventeen aircraft. Further attacks sank several ships, the worst loss being *Atlantic Conveyor* with all but one of the Chinooks. That survivor played a gallant part in the near-impossible task of supplying stores and ammunition to the advancing troops, besides on one occasion lifting eighty-one soldiers – twice the normal maximum load. Among other bizarre incidents were two attacks on a radar position by Vulcans with Shrike missiles.

Argentine forces surrendered after a seventy-four day occupation. The two outstanding comments on the campaign must be the remarkable and effective – and very swift – reaction by British forces hitherto assigned almost totally to NATO tasks, and the dreadful folly of depriving the naval force of its AEW capability by taking away its aircraft. The number of ships and lives that might have been saved by the presence of even a few Gannets cannot be estimated.

Westland Sea King and Atlantic Conveyor ROBERT TAYLOR
Westland Sea King (two Rolls-Royce Gnome H-1400 turboshafts, 1500 shp).

Robert Taylor has made a considerable name for himself as a recorder of recent history in paintings, both aviation and marine, often combining the two as shown here. He has painted a number of scenes from the Falklands war, of which this is undoubtedly the most dramatic.

The Westland Sea King was developed by Westland from the basic Sikorsky S-61B for which they held the licence. It was first introduced into the Fleet Air Arm in 1969 providing it with a very advanced hunter-killer anti-submarine helicopter. The first squadron, No. 824, was formed in 1970 in *Ark Royal*. Versions in the anti-submarine role include the HAS 1 and 2, and HAS 5, introduced in 1980, featuring more sophisticated equipment. The whole HAS force was eventually converted to Mk 5 standard (about seventy aircraft), carrying the Mk 44 or Mk 46 homing torpedo, nuclear depth charges or Sting Ray air-to-surface missiles. Another basic version, the HC 4, was designed as a troop transport and logistic support helicopter, working with Royal Marine Commandos.

Nos. 820 and 826 squadrons embarked in *Invincible* and *Hermes* with ten aircraft each for the Falklands war, followed by Nos. 824 and 825 Squadrons embarked in various Fleet Auxiliaries and merchant ships. Both HC 4 and HAS 5 were present. On 25 May during the landings, the *Atlantic Conveyor*, carrying the heavy-lift Chinook helicopters and other vital stores, was struck by an Exocet from a Super Étendard and set on fire. Helicopters played a vital part in rescue operations. On 2 June, RFA *Sir Galahad*, disembarking troops at Bluff Cove under enemy observation and before the shore-based Rapier anti-aircraft defence was set up, was set on fire by bombs from Skyhawks; in this helicopter rescue mission the Commanding Officer of No. 825 Squadron, Lieutenant-Commander Clark, won a DSC — one of three awards to helicopter pilots on this occasion.

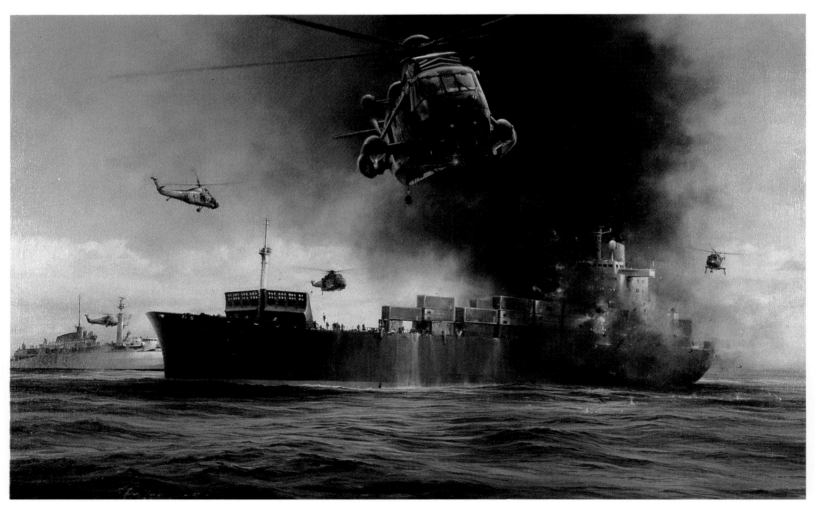

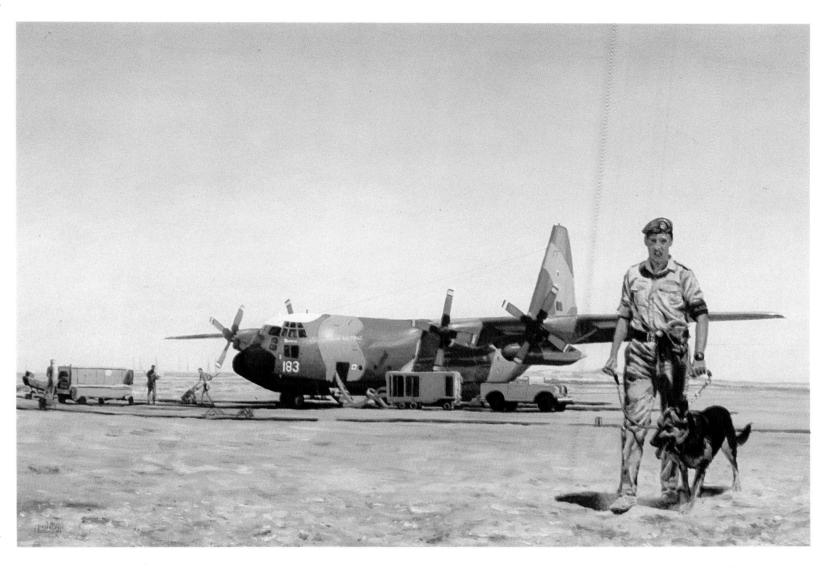

On Patrol – RAF Masirah PENELOPE DOUGLAS GAvA
Lockheed Hercules C 1 (four Allison T56-A-15 turboprops, 4910 eshp).

The Lockheed Hercules, the C-130 to the United States Air Force, is undoubtedly secure in its place in history as the finest tactical military transport ever built. No less than fifty-four different air forces operate it. Out of the total of 1804 sold at the end of 1986, 1767 had been delivered, including over 1100 to the USAF, sixty-six to the RAF and sixty to the Iranian air force. The first to receive the British version, the Hercules C-130K, was No. 36 Squadron in 1967 and at its height the Hercules force of Air Support Command numbered six squadrons. Following the 1975 defence cuts, this was later reduced to four, with the withdrawal of thirteen aircraft and the Hercules Wing at Lyneham then consisted of Nos. 24, 30, 47 and 70 Squadrons and 242 Operational Conversion Unit and was part of No. 1 Group, Strike Command. In 1978 the decision was taken to add 15 feet (4.5 metres) to the fuselage length in two 'plugs' and the result, issuing from the hangars of Marshalls of Cambridge, the official RAF Technical Centre for RAF Hercules, was the C-130H-30 or Hercules C 3. Thirty aircraft were converted. Two squadrons, Nos. 47 and 70, equipped for flight refuelling (in and out, so to speak) played a major part in the deployment to the South Atlantic in 1982 – where the Argentines, on at least two occasions, used *their* C-130s as high-level bombers, rolling the bombs off the ramps.

The United States Air Force did not officially come into existence until the National Security Act of 18 August 1947, largely as a result of the drive of General Hoyt Vandenberg. Prior to that it had been, like the Royal Flying Corps, part of the army. Starting in 1907 as part of the Signal Corps, it had a brief moment of independence as the Division of Military Aeronautics under the Overman Act of 20 May 1918, but two years later was back

as the Army Air Service, then Army Air Corps (2 July 1926 to 20 August 1941). During World War II it was the United States Army Air Force, its chief components the Air Corps and Air Force Combat Command, its units organized geographically in numbered air forces.

General Spaatz, Chief of Staff of the new force, inherited only two effective groups out of a notional fifty-two at the end of 1946. It was very clear to him that this

weakness would encourage Communist aggression and he was right. In Berlin in 1948 and in Korea in 1950 the Communists tried it on. Thanks to the energetic and heroic response of the United States Air Force, they turned out to be wrong on both occasions.

In America, as in Britain, the Korean war sparked off a rebuilding of the air force, a vast increase to 143 combat wings being authorized in 1954. New types of aircraft began to appear. the Century series of fighters and the first supersonic bomber, the B-58 Hustler. After World War II, as part of their re-organization, the old air forces were replaced by a functional command structure similar to that of the Royal Air Force. There were three main ones: Strategic Air Command, Tactical Air Command and Air Defence Command. Roughly, these absorbed the old 1st, 2nd, 3rd and 4th Air Forces in CONUS (Continental United States); 8th, 9th, 12th and 15th Air Forces became United States Air Forces Europe (from January 1944, these had been United States Strategic Air Forces in Europe), and 5th, 7th, 10th, 13th,

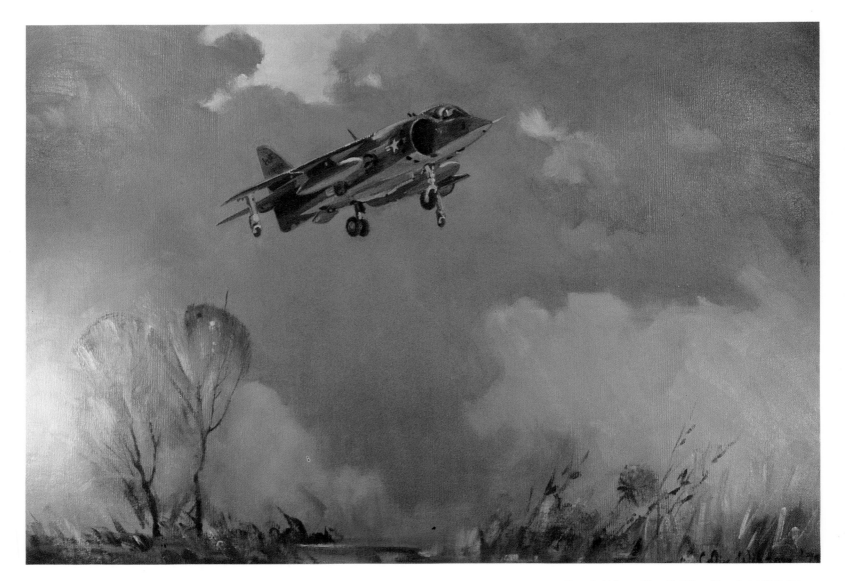

Raising the Dust C.J.WILSON GAvA
McDonnell Douglas AV-8A (Rolls Royce Pegasus 103,21500-pound (975-kilogram) thrust engine).
Mention has been made already of the development and career of the Harrier. In the hands of the
United States Marines it has provided them with the perfect aircraft to establish and maintain air
superiority over a beachhead during all stages of development; this is because of its ability to operate
directly with the ships of a normal Marine assault group. In conjunction with British Aerospace,
McDonnell Douglas have been undertaking an upgrading programme for the Harrier, with major
redesign of wings and major components of the engine air intakes and jet nozzles. This has resulted in
the AV-8B (or Harrier GR 5 in the RAF) with doubled short take-off and landing (STOL)
weight-lifting capacity, greater internal fuel and enhanced vertical take-off and landing (VTOL)
performance. Normal take-offs at full load are rolling, rather than VTOL, the latter using considerable
fuel, but landing and take-off vertically with full load is possible. The aircraft depicted is one from
VMA 513, USMC.

14th and 20th Air Forces became initially
the Far East Air Force, later Pacific Air
Forces. Numbered air forces remained
within Commands.

The first post-war weapon in SAC, as
Strategic Air Command was usually known,
was the vast Convair B-36, a 200-ton
(203-tonne), eight-engined behemoth that
would carry two 42000-pound (19051-
kilogram) bombs. It served until 12 February
1959 (the last was delivered in 1954) and its
birth sparked a massive navy-air force row

which led to a Congressional investigation.
The navy had not forgotten that old
100-mile (161-kilometre) limit; besides,
they wanted the money for super-carriers.

With the withdrawal of the B-36, SAC
became an all-jet force; deliveries of the
six-jet B-47s to the 306th (Medium) Bomb
Wing had begun in 1953 and of the epochal
eight-engined B-52s to the 93rd Heavy
Bombardment Wing in June 1955. On
15 March 1960, they were joined by the
1385 mph (2299 km/h) Hustlers of 43rd

Bomb Wing. The B-52, with eight P & W
J57-P-43W engines of 11 200-pound
(5080-kilogram) thrust, spanning 185 feet
(56 metres) and weighing, fully loaded,
240 tons (244 tonnes), could carry the
United States nuclear deterrent 10000 miles
(16093 kilometres) – and anywhere in the
world with flight refuelling. Even after the
arrival of ballistic missiles in 1957 (there
were 800 inter-continental ballistic missiles
in five SAC missile wings by 1965), with
the Hound Dog stand-off bomb it retained
its credibility. In the late eighties, with the
stalemate in the missile arena, astonishingly,
the B-52 armed with cruise missiles
survived, having served longer than any
United States bomber, and outliving its
supposed successor, the B-70 (cancelled),
while the B-1 (restored from cancellation)
worked out its problems. Two hundred and
sixty-four of the original 742 remained in
1984 and ninety cruise-missile G models
were due to retire in 1988.

A development of the Sabre, the F-100
Super Sabre, the first supersonic-in-
level-flight fighter, arrived in 1954. This

was followed by the Republic F-105 Thunderchief in 1959, and, in 1963, one of the most significant aircraft of the period, the McDonnell Douglas F-4 Phantom.

In 1964 one of the festering spots in the Far East erupted into open warfare after four years of semi-guerilla activity, involving the United States in the long, bitter and frustrating conflict in Vietnam. The set-up was parallel to that in Korea more than ten years earlier, with communist (North Vietnam) and American-supported (South Vietnam) sections of the old French colony of Indo-China. Full-scale hostilities opened in 1965 and dragged on for eight years. While the French in Indo-China had tried to fight a nineteenth century colonial war against well-armed, well-trained opponents, at very long distances from home, the United States found itself deploying the world's most sophisticated air power against an enemy who, with no air cover to speak of, faded out of sight under attack and successfully defied the doctrine that air power determines victory.

As United States ground forces built up their strength, the air force provided lavish close support; it mounted interdiction strikes on the enemy rear areas and flew endless supply, rescue and casualty evacuation missions. It also developed an entirely separate war of its own, attacking the enemy capital, Hanoi, and production and supply centres far to the North.

All of these campaigns, to a greater or lesser degree, went wrong. None of the lessons learned in Korea seemed to apply. Close support in dense jungle was a vastly different thing from in the bare hills of Korea; the same jungle hid the endless streams of supply columns – often just men, each with a bicycle and a sack of rice – and the anti-railroad campaign was wasted. Initial use of the supersonic fighter-bombers and the B-52s of SAC proved no solution and the air force turned to more suitable aircraft. Back came the stout Skyraider and the C-47, the latter, with the newer C-119 and C-130 transports, converted into heavily armed gunships. Helicopter gunships were also brought into action. Between the bombers and the gunships and the fighters, astronomical amounts of ammunition were expended. Tactical employment at low level, increasing use of helicopters to restore mobility eroded by the terrain configuration, and prodigal employment of forward air control aircraft cost heavy casualties, thousands of helicopters alone being lost.

An early attempt to get at the enemy by stripping off his jungle camouflage with wholesale defoliation, 'Operation Ranch-hand', in 1962, carried out by six C-123s, only resulted in cries of outrage in the United States. Interdiction attacks,

disastrously controlled – as was the whole war – from Washington, culminated in 1965 in 'Rolling Thunder', designed to break the North's will. Lack of precise targets and the inability to choose the right moment to strike from a Washington desk, negated its effects. One prime factor in all the fighting had emerged: the great concentrations of flak organized by the defence.

By 1965 the Americans were fully committed on the ground and in the air and the full inventory of air weapons was deployed, including air-to-air, ground-to-air and air-to-ground missiles and all the available electronic warfare equipment. F-100s, F-104s, F-105s and, best of them all, the F-4s were thrown in, with B-57s, B-52s and a host of other aircraft including the C-130 Hercules, and – from CONUS – the giant Starlifter.

Naval aircraft were also involved and one of the most successful was the Grumman A-6, which carried up to 15000 pounds (6804 kilograms) of bombs and was equipped to find targets accurately at night. Nevertheless, the greatest successes in the night interdiction campaign were probably the gunships, the C-47s and C-130s with batteries of broadside guns like those of Nelson's ships. Trucks were moving south down the Ho Chi-Min trail (really a network of tracks and roads) and these were located by infra-red equipment in fast fighters and marked electronically for the slow-circling gunships to destroy – an operation still clumsy, expensive and indecisive like everything else in that infuriating war.

One aircraft employed in Vietnam from 1968, the General Dynamics F-111, achieved results out of all proportion to the numbers involved and made a significant mark on history in so doing. Deployed by the 474th Tactical Fighter Wing the three squadrons (429th, 430th and 482nd) with forty-eight aircraft flew 4000 sorties, most in bad weather and at very low altitude, for the loss of only six aircraft. Modern equipment enabled them to attack point targets with great accuracy at supersonic speed on first pass and this mode of attack is current philosophy today.

The B-52 force persisted in its efforts and by 1967 there were 200 of them in action over Vietnam. Operating from Guam, Okinawa and Thailand, they gradually improved their accuracy and were often employed in tactical bombing close ahead of ground troops with great effect. The extension of their raids into northern Vietnam, against heavy SAM (surface-air-missile) and Triple A (anti-aircraft artillery) defences and MiG-21s, all under radar control, were less successful and many were lost. More successful were the elaborately-mounted raids by the F-105s

of 388th and 355th Tactical Fighter Wings, with radar jamming, flak suppression and SAM-foiling diversions. But by 1976, when the United States had already begun to pull out, attempting to leave a South Vietnamese army capable of self-defence, the final offensive from the North Vietnamese swept everything away and it was all over.

In the ten years after Vietnam, the United States Air Force, with the Soviets and the Europeans, entered a totally new world. In some respects the wheel had gone full circle. Although the bomber and fighter had vanished, replaced by multi-role aircraft flying near ground level, the good old dog fight had come back. Interception of enemy aircraft, self-defence missiles and the concept of air superiority were still around. Despite the Mach 2 + performance common with the fighting aircraft of the late 1980s, variable geometry and fly-by-wire capability, together with the snap-firing ability of modern missiles, restored the manoeuvrability of the first world war – or something near it.

In 1987, the next generation of fighting aircraft was beginning to show its form. The British Experimental Aircraft Programme was under way, the point aircraft, British Aerospace hoped, for a new generation of European Fighter Aircraft (EFA) which would be a major collaborative programme between Britain, West Germany, Italy and Spain. France withdrew from this programme, wishing to develop her own new generation fighter, Rafale, to a different set of requirements. In the United States the Grumman X-29 employed a vigorously swept-forward wing (another piece of German research from the 1940s) pointing perhaps to her new generation fighter. And 'stealth' was on its way. The name covers research into physical methods of defeating radar; of so shaping and building and painting an aircraft that it will slide through the waves of the radar screens without raising a ripple. Already there is talk of 'anti-stealth' radar, so it is difficult to say who is ahead here. In the meantime, the first wing of the conventional Rockwell B-1B long-range, multi-role strategic bomber is beginning to exercise its first squadron. Cancelled in its original form by President Carter, the B-1 was restored by President Reagan in a new form and with much new equipment, though with a less ambitious overall concept to bridge the gap between the B-52 and the 'stealth' bomber.

Helicopters showed much the same sort of development as other military aircraft with the growth of the multi-purpose concept. There is some subtlety between the new 'multi-purpose', which implies a basic weapons system capable of considerable flexibilty in choice and application of

weapons, and the old 'general purpose', the concept of which invariably resulted in a rather poor-performance aircraft over-burdened with the equipment for several contradictory tasks. With the defensive and offensive equipment, systems redundancy and sophisticated armament of modern military helicopters, the multi-purpose aircraft are considered to be able to survive in battlefield air and dominate the anti-armour strategy of the West in the 1980s. The numerical superiority of Warsaw Pact forces has always made the wholesale destruction and halting of armour a prime NATO consideration. The lessening of the once comfortable technological advantage of the West – or more particularly of the United States – has made inevitable the introduction of more and more sophisticated weapons, not only in the helicopters that are now largely tasked with battlefield duties, but in the strike aircraft as well. They will have to fill the dual role of conducting long-range strikes to neutralize the enemy's communications and bases and also fight for superiority in the sky to keep opposition off their backs. Hence the 'multi-purpose' – dog-fight and strike – nature of modern military aircraft.

Blackbird Mirage CHARLES THOMPSON GAvA
Lockheed SR-71 Blackbird (two P & W JT11D/J-58 engines, 32500-pound thrust, with afterburners).

The astonishing Lockheed SR-71 started life as a Mach 3 interceptor, part of the advanced bomber-defence programme, armed with Hughes Falcon air-to-air missiles, but when that programme was cancelled it was diverted to the reconnaissance role. As a high-altitude strategic reconnaissance vehicle it lives in a world of its own, untouchable, although now, in the latter part of its career, it is probably no longer invulnerable. At the time of its introduction, the greatest threat was the MiG-25 Foxbat, which fell short of SR-71's operational altitude by some 2000 feet (610 metres). Since the Blackbird could outrun the Acrid missile and a head-on intercept at Mach 5 closing speed at that height was highly improbable, little threat existed. Some thirty SR-71s have been built and operate largely out of Beale Air Force Base with the 9th Strategic Reconnaissance Wing – which also operates the 500mph (805km/h) U-2. With the Blackbird's Mach 3 capability they employ the fastest and the slowest strategic recce aircraft in the business.

No performance figures have been released, but the SR-71 is capable of Mach 3 + and has a ceiling over 80000 feet (24384 metres). Some of the records held are revealing: altitude in horizontal flight, 85068.997 feet (25929.031 metres); speed over a closed circuit 2193.167mph (3529.56km/h); and an official time, New York to London, of 1 hour, 55 minutes, 42 seconds.

The comfortable, cartel-ridden, regulated world of international air travel received some possibly salutary jolts in the 1980s. In the United States the whole process of route- and fare-fixing and allocation of facilities was deregulated. While there is no doubt but that some such action was needed, the fact that intense competition, not all of it for the best, was going to see a number of large and respected airlines go to the wall was probably neither foreseen nor intended. By 1987 the situation had stabilized more, with the surviving major airlines in the hands of a few giant corporations, the healthier of the

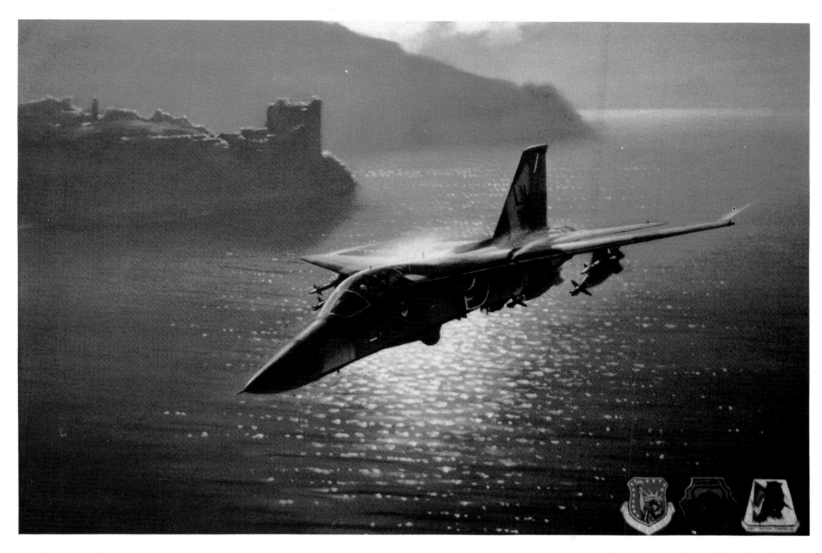

Aardvark over Loch Ness RONALD WONG GAvA
General Dynamics F-111F (two Pratt and Whitney TF30-P-100 turbofans, 25 100-pound
(11 385-kilogram) thrust – with afterburners).

Ronald Wong has been exhibiting with the Guild for a number of years, painting in a vigorous style
unimpaired by careful attention to the overall accuracy of his subject; the result is lively and faithful
portraits of the subject aircraft. In 1987 the United States 3rd Air Force (part of United States Air
Forces Europe) maintained two wings of F-111s in Britain: the 20th Tactical Fighter Wing at Upper
Heyford, consisting of the 55th, 77th and 79th Tactical Fighter Squadrons (deploying around seventy
F-111Es) and the 42nd Electronic Combat Squadron with twelve 'Electric Fox' EF-111A electronic
counter-measures aircraft; and the 48th Tactical Fighter Wing at RAF Lakenheath (all United States
Air Force bases in the United Kingdom are Royal Air Force property) with the 492nd, 493rd and
494th Tactical Fighter Squadrons equipped with F-111Fs, plus the 495th, which provided training
facilities. The painting shows an aircraft of the 494th engaged in low-level exercises in Scotland.

The F-111 is a variable-geometry, Mach 2.5 tactical strike aircraft, with up to 3100 miles
(4989 kilometres) unrefuelled range. It is a big aircraft, its fuel load alone weighing as much as a
complete F-16. The 48th's aircraft are equipped with Pave Tack laser-guided and GBU-15 data link
weapons delivery systems, giving unparalleled accuracy of delivery. The 48th is also the only
name-and-number unit in the United States Air Force, the name 'Statue of Liberty Wing' being
adopted by request of the French, following service in France. (After the famous North African raid in
1986, the Wing introduced a modified badge for the occasion, proclaiming them to be the 'Statue of
Libyan Raiders Wing'.)

domestics surviving and a fast growth of
smaller operators. The introduction of very
cheap, no-frills operations by some new
airlines did not survive in the free market.

In Europe, the situation was quite
different; the process of liberalization of
airline operations stopped very far short of
the wild swing of American deregulation.
Partly because caution was obviously
enjoined after the observation of events
in the United States, but more as a result
of national reluctances to throw the chosen
instruments of State-owned or State- aided
operators to the wolves, there was a more
measured approach in multi-national
Europe.

In the civil helicopter world, corporate
and business operations appeared to
have saturated the sales market by 1987
and apart from a few very small helicopters
reporting good sales, this area appeared to
have stagnated. Whether this was a result
of the recent recession or other market
forces is uncertain, but it was abundantly
clear that the private and corporate fixed-
wing aircraft market had taken a very
considerable beating at that time.

The private flying movement in England,
like gliding, was slow off the mark, though
not for precisely the same reasons. Before
the first world war, all non-military aircraft
were private, mostly owned by training
schools, with a few wealthy and avant-garde
private owners. After the war the numbers
of private owners was restricted to those
who could afford to run ex-fighting
machines (and who could fly them); there
was nothing else to buy. Government
encouragement and public interest was
virtually non-existent and any publicity
remained at the 'playboy of the air' level.
Until, in 1925, the whole situation

changed. There was a new and dynamic Director of Civil Aviation, Sir Sefton Brancker – hitherto, private flying had been looked after by the Air Ministry, which did not help. A remarkable man, A.J. (later Sir Alan) Cobham, began what was to be a lifetime of promoting air-mindedness in Britain with touring demonstrations of 'circus' flying and joy-riding. And Geoffrey de Havilland produced the Moth. It was the first practical light aeroplane in the world and on its shapely biplane wings not only Britain but Europe and the world began to take to the air. By 1936 private flying had become ordinary, respectable and (therefore) suitable for that remarkable abstraction, the man in the street. In the ensuing three years, the sport was also to be responsible for introducing countless young men to service flying, a process initiated in the twenties by the University Air Squadrons and the Reserve and Auxiliary Squadrons of the RAF.

In the United States, the catalyst came in 1927, with the thirty-three and a half hour solo flight from New York to Paris by Charles Lindberg. America virtually became air-minded overnight. Light aircraft flying in Britain was concentrated round the flying club, which provided social activity as well as training and aircraft for hire. But in the United States, with far greater distances and very cheap petrol (which encouraged more powerful engines and bigger aircraft), the private owner dominated the scene, often with three- or four-seater aircraft

Bo-peep MICHAEL JOSEPH
The Southdown Gliding Club, Firle Beacon, circa 1960.

After the second world war, sailplane activities increased swiftly right around the world. There has always been a strong bond between glider pilots internationally, and the skills and dedication required to excel at this most demanding and stimulating of sports has bred a series of remarkable pundits over the last forty years. Britain rose to a dominating position quite early, thanks to the peculiarly British habit of throwing up casual experts in sport and to the work of two glider-designing and building firms, Slingsby of Kirbymoorside in Yorkshire and Elliotts of Newbury (EoN). These two companies dominated the competition side of gliding in the first fifteen or twenty years. Both are gone now and the lead in design is shared among several nations. In recent years, with the advances in knowledge of aerodynamics and meteorology and the assistance of computers and the plastics and GRP industry, standards are being achieved – and records broken – that would have seemed incredible in the more club-like atmosphere of the group in the painting. Firle Beacon, on the South Downs, was the site of the first major gliding meeting in England, shortly after the first world war.

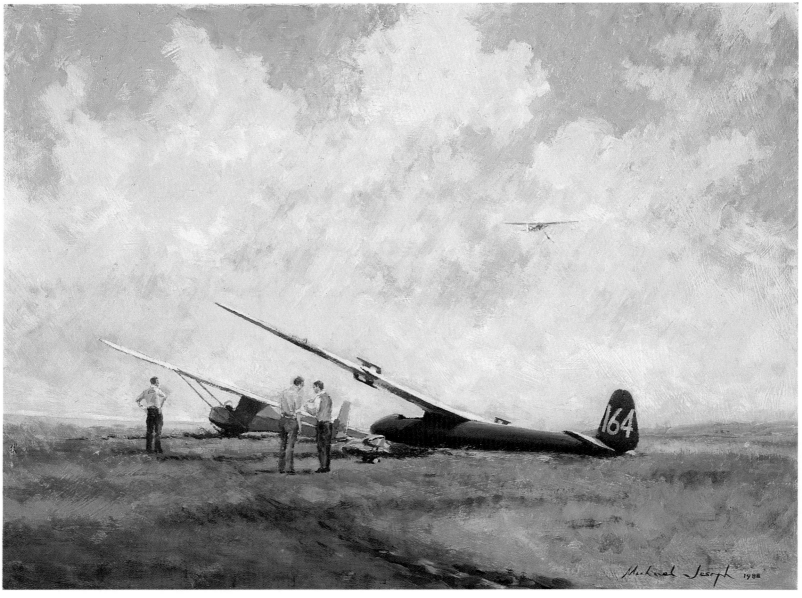

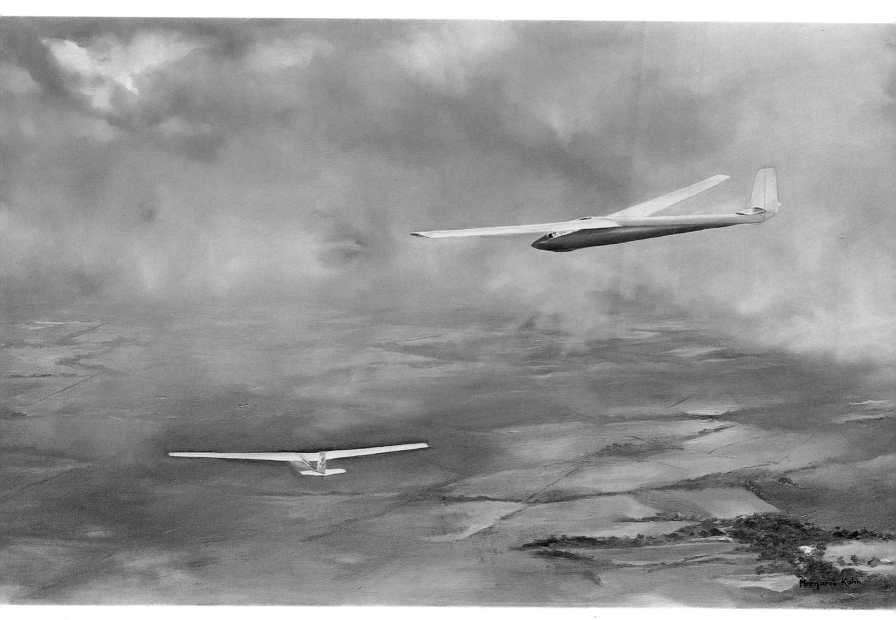

Gliders MARGARET KAHN GAvA
A reminiscence of the fifties.

Gliding has had a remarkably disjointed history, compared with powered flying. It has been seen that the earliest successful attempts by man to fly were made with gliders, before the practical availability of light power units. Once these were being produced, gliding faded from the scene. The reason was easy to see: these early unpowered aircraft were gliders in the strict, academic sense of the word; that is, they were capable of descending flight but were not capable of gaining height or soaring flight. The name is generally applied to all sailplanes today, although a high-performance or training type capable of gaining and holding height should be called a sailplane. True gliders in recent years have been restricted to military types.

Not until around 1930 was it appreciated that there were conditions under which rising air, either a standing wave off a ridge or convection or thermal generated, could lift suitably-designed sailplanes. From this understanding, thanks largely to the efforts of Robert Kronfeld, a celebrated Austrian pioneer, the modern gliding movement was born. Designs grew more and more refined as constructional methods and aerodynamic knowledge improved, and by the end of the peace in 1939 techniques and aircraft had attained the level of sophistication at which they largely remain.

Margaret Kahn and her husband have been among the most devoted gliding enthusiasts of the immediate post-war period in Britain, when the British Gliding Association, through its members, brought the United Kingdom into the forefront of the movement. Margaret was well known for her delightful, evocative paintings of sailplanes, combining great artistic skill with a deep feeling for the subject, born of personal experience.

(where the Europeans made do with two or occasionally three seats) and training was conducted in professional schools.

After World War II, the situation changed considerably. Britain soon found herself outside the light aircraft business, a situation viewed with alarm by those who remembered the Moth-dominated skies.

Moths had been built in Canada, Australia and the United States and copied elsewhere. The end of the war, however, released a flood of cheap trainers for shcools, clubs and owners, discouraging new enterprise among designers and the big companies (like de Havilland), who might have picked up the challenge were

now financially structured to much larger aircraft and strangled by their own accountancy procedures. So in Europe the French, whose government, determined to revive its once flourishing industry, was not only turning out masses of aircraft and giving them to clubs just to keep production lines going, but subsidizing private builders and encouraging towns to start airfields, thus achieving a dominance France has never lost.

In the United States, where large numbers of people had been exposed to military flying in recent years, the light aircraft movement began to expand very rapidly. Initially dominated by Bill Piper, whose two-seat Cub (a sort of monoplane Moth) had achieved fame as a liaison aircraft during World War II and was to be still in production forty years later, sparked a growing family of private aircraft. This attracted competition, largely from Cessna, who later on, in the seventies, took the lead, and from Beech, building a luxury article. Distance, cheap petrol and production of reliable and powerful aero engines, led to the introduction of twin-engined light aircraft and from the United States sprang the whole world of business

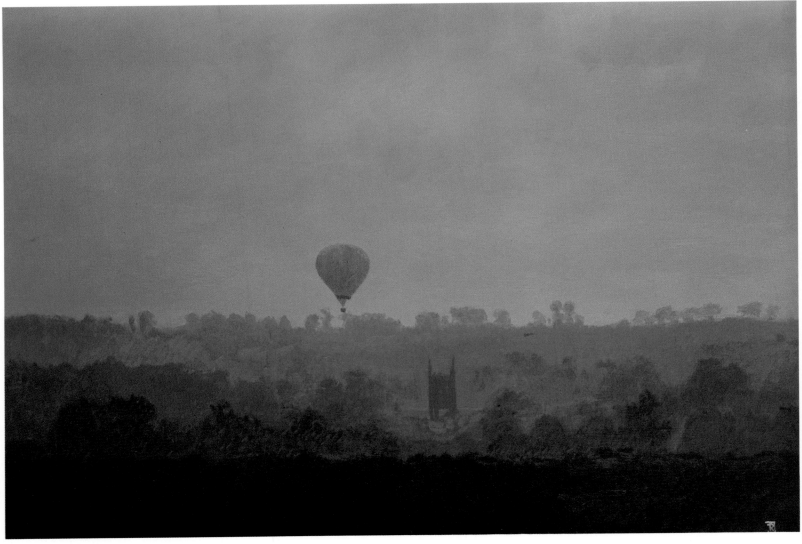

As it was in the Beginning RICHARD JONES GAvA
Hot-air balloon.

Man's first successful trip into the heavens was made with the aid of a hot-air balloon and so it is fitting that we should close our pictured history of the development of flight over 200 years with this evening scene by Richard Jones depicting the ascent of a modern hot-air balloon. For the private citizen, rising costs, complicated technology and increasing complexity of control in many areas have led to a tremendous revival of balloons and of hang gliders, virtually identical to those of the late nineteenth century in their principles.

As this has been a book for and about the members of the Guild of Aviation Artists, it seems only right that one of the most energetic supporters and prolific contributors to the Guild and one of its most popular members should have, so to speak, the last brush stroke.

and executive and corporate aviation. Proliferation of ground infrastructure, improved navigational aids and a very shrewd grasp of the economics of the operation turned the light aircraft into a most useful business tool.

The financial recessions of the eighties hit general aviation in the United States later and more severely than other sectors of flying to the extent that both Piper and Cessna, although the world's most prolific producers of light aircraft, had virtually shut down production of single-engined aircraft.

General aviation in the United States' meaning of the word, embraces far more

than it does in Europe, including all non-scheduled operations. Most of these are of comparatively recent growth, as the aircraft developed a hold on business life, and include charter flying, agricultural flying and various sporting activities – aerobatics, home-building, and even racing.

We will end this story of the development of the aircraft as that story itself began, with gliding. Here we must be precise and introduce a definition of terms. Strictly speaking, a glider is a non-powered aircraft that can sustain itself only in downward flight, delaying, but not over-riding the effects of gravity. Until the

arrival of suitable engines, this was the only means of attempting flight and acquiring the skills of control. Once powered flight became a reality, gliding waned in popularity until, some time after the first world war, the realization dawned that advantage could be taken of rising currents of air to sustain motorless flight and even to climb, beyond the prolongation of a gliding descent. At the first British gliding meeting, at Itford in 1922, the initial stirrings of knowledge about slope or ridge soaring were born, using the up-currents of wind blowing off the face of the hill. More would have been learned with better gliders; one man turned up with a machine made from a Bristol Fighter fuselage and the top wing of a Fokker D VII, which was immediately nicknamed the 'Brokker'. It even flew.

Forbidden to take any serious interest in aviation by the terms of the Treaty of Versailles, Germany concentrated on gliding to maintain interest in the air among new pilots and in the late 1920s much more about the true use of the air was discovered in that country. It was an

Austrian, Robert Kronfeld, who excelled in slope soaring and in the recently discovered use of thermal currents, the rising columns of heated air generated under certain meteorological conditions. Kronfeld with his beautiful, carefully-designed sailplanes, was the father of modern soaring flight. And that is our second definition: an aircraft that can soar in rising air is a sailplane, not a glider. And it is the sailplane that has created the modern science of what is still, confusingly, called gliding.

It was to be a sport at which Britain excelled and the early enthusiasts like Philip Wills set the standards of, and indeed the attitudes to, the new and exciting exploration of this world of silent flight. After the second world war, progress was rapid, with clubs, syndicates and private owners multiplying and western Europe, America and Australia joining the leaders. Designers like Slingsby and Elliots of Newbury kept Britain initially in the lead with modern gliders, but that lead

progressively spread to other countries. Austria, Germany, Finland, the United States and others now offer extremely high performance sailplanes in modern materials, with the benefit of the latest in design techniques and computer skills. International competitions are popular and the annual World Gliding Championships probably offer the finest combinations of human skills and, like any Championships, ingenuity, in the world.

Some of the earliest record times and speeds and distances set up by the pioneers have already been quoted. As a postscript, reference to the current sets of figures in these categories will give some idea of how far this thing, the flying machine, has come in eighty-five years.

The absolute speed record is held by a Lockheed SR-71 Blackbird, at 3529.56km/h (2193.16mph). The Soviet E-266M holds the altitude record at 37650 metres (123523.6 feet) and the distance record belongs to the good old Boeing B-52H at

20168.78 kilometres (12532.27 miles). (World records, superintended and confirmed by the Fédération Aéronautique Internationale in Paris, are always given in metric terms.)

Finally, to bring everything back into its proper perspective and to close with proper examples of the triumph of the individual over the environment, on 12 June 1979, seventy years after that first gallant flight across the English Channel by Louis Blériot, Bryan Allen, a young American, made the first crossing in a man-powered aircraft, the *Gossamer Albatross*. And on 23 December 1986, Jeana Yeager and Dick Rutan completed the first non-stop, non-refuelled circuit of the world in a craft called *Voyager*, designed by his brother, Burt Rutan; they returned tired but triumphant after 25012 miles (40252 kilometres) of flight made in 9 days, 3 minutes and 44 seconds in what may prove to be the truly ultimate personal achievement in aviation.

The Last Great Adventure

Rutan Voyager (Teledyne Continental 0-240, 130hp and Teledyne Continental I0L-200, 110hp engines).

Burt Rutan, the best known of all the dynamic light aircraft designers in the United States, designed this extraordinary aircraft for the attempt on the round-the-world, non-stop, non-refuelled record flight – the last great adventure. The main structure, an aerodynamic fuel tank, contained almost 1500 US gallons and the flight was conducted, at speeds around 100-150mph (160-241 km/h) on the rear, less powerful engine, the front engine being used for take-off and initial high-speed cruise only. With a span of almost 111 feet (33.8 metres) and an aspect ratio of 33.8 for a total area of 363 square feet (33.7 square metres), including the fore canard wing, the aerodynamics were exquisite and the handling terrifying. Dick Rutan, Burt's brother and pilot, with Jeana Yeager, on the flight, has described the extremes of flexing and torsional twisting of the wing in graphic terms and was adamant that the aircraft would be placed in a museum and never flown again.

Biographies of the artists

THIS SECTION of the book is devoted to details of those artists professional and non-professional, Full Members and Associates of the Guild, who have contributed paintings to this book.

Norman William Appleton GAvA

Born 27.1.1926. Served in the Royal Air Force as aircrew 1944-49, flying Anson, Marauder, Lancaster and Lincoln. Love of painting aircraft started in 1942 whilst in Air Training Corps. Art training mainly part-time over a long period, including help from well-known Yorkshire artist, William Dealtry, with whom he has had three exhibitions. Exhibits regularly in the Yorkshire area and has had one-man exhibitions at Malton, Yarm and Nunnington Hall, near York. Work may be seen at aviation centres and in private collections including many abroad. Specialist subjects are aviation, churches and portraits. Works mainly in acrylic, oil and watercolour.

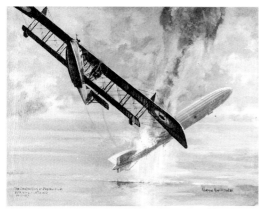

Colin James Ashford GAvA

Born 3.3.1919. Educated at Ackworth School, Yorkshire. Studied at Wakefield School of Art and Glasgow School of Art, where he won Drawing Diploma and art prizes. Associate of Glasgow School of Art. Served in the Middle East with the Royal Engineers as a camouflage development artist. Took training in a private studio and became a freelance painter and illustrator. Illustrations, including those for postage stamps, have been published world-wide. Has had a lifelong interest in aviation history, reflected in many fine paintings and also a particular interest in marine and transport history. Specializes mainly in watercolour techniques and has been influenced by

John Sell Cotman, Richard Parkes, Richard Bonington and E.W. Haslehurst. His work hangs in England in the RAF Museum, National Maritime Museum, Ashmolean Art Gallery, national museums in the United States and Canada and in private collections all over the world.

Derek Stredder Bist GAvA

Born 24.7.1919. Educated at John Ruskin's School, Croydon, and Croydon School of Art. Apprenticed to the London Art Service until the outbreak of war. Served with the Royal Tank Regiment. Taken prisoner and spent three and a half years in a German prison camp. Became a free-lance artist and illustrator and undertook special tasks for the Ministry of Defence. Flew with the Royal Air Force whenever possible on fixed wing and helicopter demonstration flights. Worked for Hawker Siddeley Aviation and Gloster Aviation. Has painted many portraits. Paintings on exhibition at United States Air Force bases. Received citation from the United

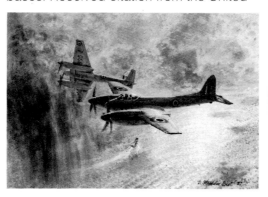

States Air Force. Style greatly influenced by Frank Brangwyn and Edward Seago. Other interests include model aircraft and photography.

John Henry Blake GAvA

Born 13.11.1924. Present occupation: exhibition executive with the Society of British Aerospace Companies. Founder full member and past Chairman of Guild of Aviation Artists. Took 'art' as school optional extra (ten shillings a term). Lifelong interest in aviation history, stimulated by ex-RFC father. Attended Glasgow School of Art after war service with Irish Guards. Competitions Manager, Royal Aero Club, for many years. European air rallying in 1955-66. International aerobatic judge. Private pilot, owner of small, open, single-seat biplane Curry Wot. Commentator at Farnborough and other airshows. Paints in watercolour, enjoying the challenge and response of the medium. Influenced considerably in his approach by John Sell Cotman and Peter de Wint. Successful one-man show 1985-86. Works exhibited in RAF Museum and private collections.

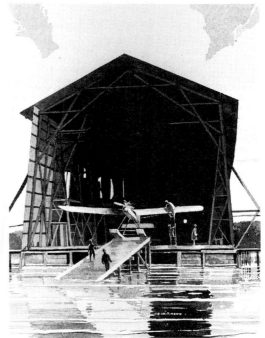

Charles Bradbury GAvA

Born 30.4.1917. Educated at Hamble School and Southampton University. Widely experienced in aircraft design: 1935 Armstrong Whitworth, 1938 Folland Aircraft, 1942 AFEE Ministry of Aircraft Production, 1944 Bristol, 1951 Percival, 1956 Blackburn, 1959 Hawker Siddeley Aviation, 1964 de Havilland Canada, 1966 Hawker Siddeley Aviation Hatfield. Flight test observer Bristol Sycamore helicopter. Cartoonist to *Flight* 1943-46, *Aeronautics* 1946-48. Joined de Havilland art group 1967. Also interested in landscape painting.

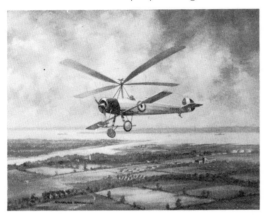

Dudley Henderson Burnside GAvA

Born 26.1.1912. Group Captain Dudley Burnside DSO, OBE, DFC and Bar, was educated at King Edward VI School, Bury St Edmunds. His early interest in aviation was aroused at the age of six on seeing a Sopwith Camel force-land and crash. Hendon Air Displays in the 1920s and a 'half-crown' flight in an Avro 504 of Alan Cobham's Flying Circus made him resolve to join the Royal Air Force. After four years as a territorial soldier in the London Scottish Regiment, he joined the RAF in 1935. After flying such aircraft as the Hawker Hart, he joined a Vickers Virginia night-bomber squadron. In 1937 came a posting to India to fly Vickers Valentias on operations on the North-West Frontier and Iraq. Fortunate to escape with his life from Burma, when his airfield was overrun by the Japanese in 1942, he survived two tours of operations in Bomber Command, flying Wellingtons and Halifaxes during the battle of the Ruhr, and then Lancasters in support of the Allied advance. 1950 found him commanding the Far East Flying Boat Wing which operated Sunderland sorties from Japan throughout the Korean war. On taking a less onerous post in NATO

Headquarters at Fontainebleau, he absorbed the influence of the French Impressionists. Painting in the fresh air, he adopted his customary free and spontaneous style. He is a past Chairman of the Guild of Aviation Artists. He has held a number of one-man exhibitions and his aviation, marine and landscape paintings in oil, watercolour and pastel are in many parts of the world.

Charles Edwin Coote GAvA

Born 17.4.1920. Received a technical education followed by a course at Ipswich School of Arts and Crafts. Took employment in an engineering works and became a draughtsman for Electric Motors, Miles-Beagle at Shoreham and Marshalls of Cambridge. Served with the Home Guard during World War II. Took one intrepid flying lesson in 1938. Exhibits locally and loves detail. Other interests include classical music and languages.

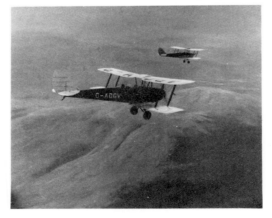

Gerald Davison Coulson GAvA

Born 11.12.1926. Educated in Durham, Coventry and Malvern. Served with the Royal Air Force from 1945-52. Became an aircraft engineer and then a technical illustrator. Prior to turning to full-time painting in 1969, years of practice resulted in a technique and quality suitable for work

to be submitted to galleries and publishers of fine art prints. Subjects ranged through English landscape, aviation, steam transport and wildlife. Publication of his work was such a success that it led to world-wide exposure. Included in the range was a series of aviation subjects produced as signed limited editions, many of which are displayed in aviation establishments around the world. Voted by the Fine Art Guild polls into the top ten best-selling artists twelve times in eight years (three times at number one). Artists known at the turn of the century, such as Henry Bright, Sidney Percy and Benjamin Leader, have been an influence. An experienced private pilot, he enjoys aerobatics and glider-towing. Founder member of the Guild of Aviation Artists.

Terence Cuneo, Vice-President GAvA

Born 1.11.1907. Educated at Sutton Valence School. Studied art at Chelsea Polytechnic. Born of artist parents, he showed an early gift for drawing. Is now famed for his portrayals of industrial and railway subjects, battles, parades, portraits and studies of horses. His working life began as an illustrator for magazines. In 1931 he joined The London Sketch Club. Around 1936 he began to work seriously in oils, having to dry illustrations in the linen cupboard and in front of the stove. At the outbreak of war he joined the Local Defence Volunteers, mounting guard at Hampton Court Bridge. However, it wasn't long before he was engaged on war illustrations and was sent to France in 1940 on a tour of armament factories, and was fortunate to get back to England on the last steamer leaving Le Havre. In 1941, whilst working as a staff artist for *Picture Post* on their 'War Diary', he received his call-up papers to the Royal Corps of Signals. On owning up to being an artist, he was given the inside of a Nissen hut to

paint. Then came an invitation from The Studio to produce *How To Draw Tanks*. This resulted in a new posting to the Royal Engineers, Ripon, where every type of tank was to be seen. Soon he took to drawing cartoons, producing a set for the Ministry of Information for propaganda in Europe. At last he was called to the War Office to assist with harbour drawings at possible invasion ports. A meeting with Mr George Garland in 1944 changed his life. An introduction to Sir William Russell Flint led him to work with the War Artists Advisory Committee. A series of drawings of Churchill tank production led to a series of aircraft commissions;in turn these led to his series of posters for the London and North Eastern Railways and British Railways. Lloyds commissioned a painting depicting their underwriting room, which hung in the 1949 Royal Academy Exhibition. Finally, to his disbelief, he was offered the highest honour and invited to paint the official picture of the coronation of Her Majesty the Queen in Westminster Abbey. His work has taken him to exciting and dangerous parts of the world, as far away as Thailand. In 1987 he was appointed an officer of the Order of the British Empire.

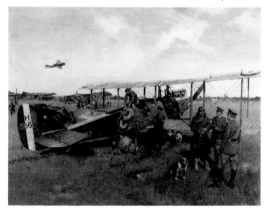

Rodney Ian Diggens

Born 2.8.1937. Studied art at the Camberwell and the Central School of Art. Served with the 1st Royal Tank Regiment during national service, which included the Suez crisis and a tour of Hong Kong. Took up a career in advertising and printing before becoming a full-time artist. A keen interest in motor sport led to racing saloon cars in the late fifties and sixties. Paints in oil, acrylic and gouache. Greatly influenced by Terence Cuneo, Roy Nockolds and Gordon Crosby, and at the 1983 British Grand Prix at Silverstone by the German artist Walter Gotschke. Has exhibited widely and has completed

private and commercial commissions world-wide. A member of the Guild of Motoring Writers and a founder member of the Guild of Motoring Artists.

Penelope Douglas GAvA

Artist and writer. Founder full member. Started painting in 1966 with landscapes and animal portraits, and aircraft in 1968. Paints in oils. Has painted for army, navy and Royal Air Force, and through commissions has travelled to Cyprus, Masirah, Gan, Gibraltar, Germany, Ascension Island, Kenya, Spain, Australia, and the United States of America. Influenced by David Shepherd and Norman Rockwell.

Alan Fearnley GAvA

Born 18.7.1942. Educated at Mirfield Grammar School. Studied at Batley Art College. Paints in oil on canvas and is well known for his nostalgic scenes of the past; many of his pictures have been published

Has had many amusing and interesting experiences through commissions, including being greeted with: 'Morning Sir!' in Gan; often dressing in flying suit and boots for a man of six feet two inches (she is five feet two inches); being interviewed many times on radio and television – Anglia TV made a short film on her work; going down in history for joining the army in record time in order to work with them; being airsick; watching turtles lay their eggs; riding circus horse in the ring at a performance, and giving slide shows with commentary, called 'Travel, Art and Aeroplanes'. Her interests are sheep farming, natural history, swimming and dressmaking. Her works are exhibited at the RAF Museum, and private collections.

as greetings cards. Is mainly interested in transport subjects and has exhibited with the Royal Society of Marine Artists and was a founder member and first Chairman of the Guild of Railway Artists in 1979. His works are exhibited in the RAF Museum, Fleet Air Arm Museum and the National Railway Museum.

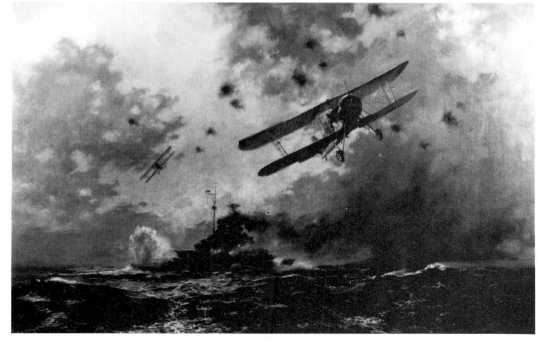

Theodore Glyn Fraser

Born 8.2.1933. Educated at Dorking County Grammar School, followed by a scholarship to Epsom and Ewell School of Arts and Crafts in 1947, specializing in typography and lettering. Apprenticed to a small printing company in 1950, remaining with them until 1977. In 1948 joined the Air Training Corps. Was a Leading Aircraftsman clerk in the Royal Air Force during national service. Flew at every opportunity, with piloting experience in a Tiger Moth. Presently occupied as a Section Inspector, Group 4 Securitas. Interest in aviation art inspired by Frank Wootton and Gerald Coulson. Joined the Guild of Aviation Artists as an associate member in 1974. Regularly exhibits at Guild exhibitions and in private galleries. Winner of the first

award for the Aviation Painting of the Year 1985 sponsored by Davis Gibson Advertising. Other interests include boat modelling and photography.

Richard G.L. Halfpenny

Born 29.4.1932. Was educated for a time at the Royce School in Abingdon before taking up a career in engineering. Was for several years a member of the Vintage Motorcycle Club of England. Builds flying models of veteran aircraft and has had his own construction details published. A transport enthusiast, he is an associate member of the Guild of Aviation Artists and the Guild of Railway Artists. Has had paintings exhibited by the Royal Society of Marine Artists, the Guild of Aviation Artists

and the Society of Sussex Artists. Paints in oil and watercolour and was greatly influenced and helped by the famous marine artist, the late Leslie Wilcox RI, RSMA. Is a keen horse-rider and motorist, still owning a 1959 Ford 100E car.

Wilfred Ralph Randall Hardy GAvA

Born 7.7.1938. Educated at grammar school, he took a Commission and served with the army during national service. Awarded Active Service Medal, Cyprus 1958. Flew various gliders in Cyprus and flew in civil and military aircraft whenever possible, such as Vampire T 11, RN Sea Prince, RAF Sea King. Worked in commercial studios and joined the Society of Aviation Artists. His father and uncle are both artists and he became a freelance artist in 1966. His work is exhibited world-wide, hanging in many RAF stations, USAF bases, Rolls-Royce Ansty, Coventry (Marine), Brazilian Air Force Museum and in private collections. Has exhibited in aid of the RAF Benevolent Fund. Other interests include marine painting, music and graphic design.

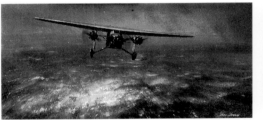

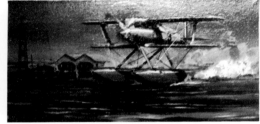

Maurice Victor Gardner

Born 22.8.1926. Educated at St Barnabas School, Oxford. Apprenticed to an electrical engineer during World War II, then served with the Royal Artillery as a Signals Instructor during national service. Studied commercial art and illustration at various art classes. Holds a Gliding

Certificate, having trained with Oxford Gliding Club. Now a maintenance engineer. Paints in both oil and watercolour. Joined the Kronfeld Aviation Art Society. Has a natural interest in military aircraft due to spending his youth in the atmosphere of World War II. Also interested in railway, wildlife and marine subjects. Has work in a variety of private collections.

Anthony Christopher Harold

Born 21.3.1944. Educated at Reading Blue Coat School and studied art at college for four years. Presently occupied as Keeper of Art at the Royal Air Force Museum. Worked as an archaeologist in 1965 and then became a freelance designer and illustrator. Joined the RAF Project Team in 1970. Has 2000 hours flying experience and is part-owner of a Tiger Moth. Has been a stunt pilot with Barnstormers Flying Circus, and has also piloted a Sopwith Camel and a Jet Provost. Has work in private collections both in the United Kingdom and the United States. Has a particular interest in abstract landscape.

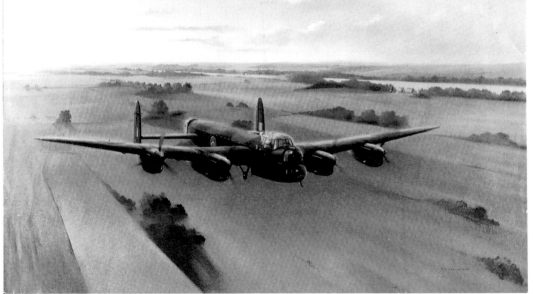

Writes books and articles. Other interests include photography and re-building vintage cars.

John Hellings GAvA

Born 30.8.1934. Educated at Gresham's School, Norfolk. No formal art training but studied art as a School Certificate subject. Following a lifelong interest in aviation he won an RAF flying scholarship and gained his private pilot's licence. In 1952 he joined de Havilland, which is now part of British Aerospace. Today he is chief designer for the Airbus at British Aerospace, Hatfield. Originally painted aviation art to portray the spirit of flight in contrast to the strict engineering terms of his profession. Paints mainly in oil on canvas and has latterly taken to water-colour. Has work exhibited in the RAF Museum. Chairman of the Guild of Aviation Artists 1985-87. Other interests include gliding, motor sport and photography.

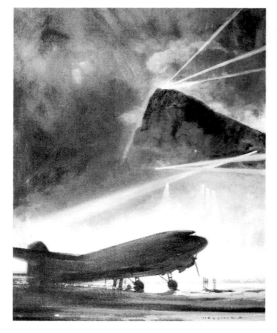

Norman Edward Hoad GAvA

Born in 1923, Air Vice-Marshal Norman Hoad CVO, CBE, AFC, joined the Royal Air Force in 1941 and operated as a Lancaster pilot with No. 61 Squadron, Bomber Command, until shot down and taken prisoner in 1944. Has held a variety of flying and staff appointments including command of No. 192 (Electronic Recce) Squadron, flying B-29s and Canberras and No. 216 Comet Jet Transport Squadron. As a Group Captain he commanded RAF Stations Lyneham and Abingdon, and as Air Commodore was the Armed Forces Attaché at the British Embassy in Paris. He is a military parachutist and as an Air Vice-Marshal was Commander, United Kingdom Joint Airborne Task Force. His last command appointment was as Air Officer Commanding No. 46 Group operating the RAF fleet of strategic and tactical transports. Studied part-time at the York College of Art 1950-52. Military aviation became the subject for most of his work, but in recent years he has become interested in equestrian art. Founder member of the Guild of Aviation Artists and for seven years was Chairman of the Society of Equestrian Artists.

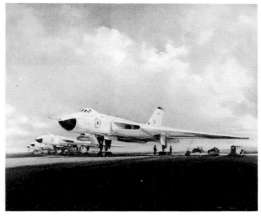

Howard Martin Hooker

Born in Kensington in 1923 and educated at Wembley Hill School and Hendon Technical College. Served with the Royal Engineers 1942-46. Visits to Hendon and Heston aerodromes in the thirties aroused a keen interest in aviation history. Flew as a passenger in Amy Mollison's Puss Moth 'Desert Cloud', AOP Austers, Bell Jetranger used for survey purposes, Mike Vaisey's Gipsy Moth G-ATBL and some air experience at the London Gliding Club. Has worked continuously in the engineering field as a draughtsman and technical illustrator. Howard Leigh and James Hay Stevens were artists whose work encouraged him to draw aviation subjects. Has exhibited at the Guild of Aviation Artists' annual exhibitions and local art society shows. Held a successful one-man show in 1984. Other interests include photography and supporting the Shuttleworth Collection.

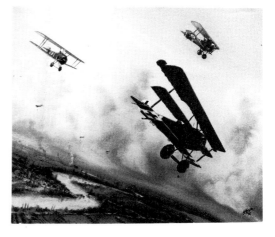

Richard Henry Louen Jones GAvA

Born 18.3.1945. Educated at Cathays High School. Obtained a BSc in physics and chemistry at Swansea University. Has since been a scientific civil servant. His talent for painting developed as a boy and he paints in several mediums, principally oil, specializing in aviation, portraits and landscape. Mounted a one-man exhibition at the Edinburgh Festival in the late sixties, followed by exhibitions in galleries as far apart as Canada, Sweden, Israel, United States, Austria and Holland. Work is also exhibited at the RAF Museum, the Technical Museum in Sweden, and in private collections such as those of Francis Chichester and Victor Lownes. He has also taught painting at the de Havilland College. Other interests include working as a film extra.

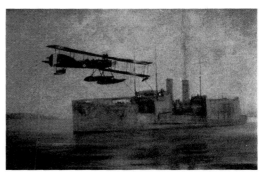

Michael Leslie Joseph GAvA

Born 28.5.1951, an identical twin. From school, joined Rolls-Royce Aero Engine Division as an engineering apprentice. In 1970 won a Rolls-Royce flying scholarship with the Merlin Flying Club at Hucknall. Learnt to fly on Austers. Formed Griffon Flying Group and operated Tipsy Nipper. For the successful operation of this aircraft and for the encouragement of others, was awarded Royal Aeronautical Society N.E. Rowe Medal in 1975. Currently co-owner of Chilton Monoplane G-AFGH. In 1974 transferred to British Airways for commercial pilot training at Hamble. On graduation joined British Caledonian, flying BAC 1-11, Boeing 707 and 747, enjoying the rank of Captain. Started painting in 1973. Mainly paints in oil and enjoys reflecting a first-hand love of flying and aviation. First exhibited in 1979. Shared the Joseph Brothers exhibition in London 1986. Winner of the 1987 Aviation Painting of the Year competition, sponsored by David Gibson Advertising.

Margaret Kahn GAvA

One of the few painters of gliders who meets with the approval of glider pilots, being able to capture the atmosphere of the soaring aircraft. Married to the well-known glider pilot Wally Kahn. Founder member of the Kronfeld Aviation Art Society and appointed an Honorary Member of the Guild of Aviation Artists.

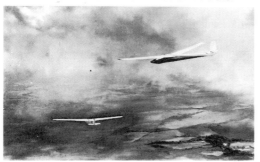

Brian Knight GAvA

Born in Reading, and educated at Wilson Senior School. Apprenticed to Miles Aircraft, he later joined their design team from 1942-47. After six months with an American tractor division as a draughtsman, he joined the United Kingdom Atomic Energy Authority, Harwell, setting up the Design Studio with the Ministry 1948-58. Managed a commercial studio in Bromley 1958-60. Started own freelance studio, working on marine and aviation subjects. Then a complete change to a machine toolsetter with Wellworthy Engineering for four years. Now, back to the drawing board and easel, using watercolour, acrylic and oil. First flying experience was in the back seat of a Miles Master 2, with the chief test pilot Tommy Rose. Other interests include model making, archery and fishing.

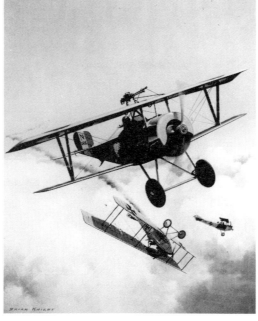

Geoffrey Ernest Lea

Born 20.11.1938. Educated at several schools in Leeds. Joined the Merchant Navy as a Radio Officer. Became a telecommunications technician with the Post Office in 1966. Now an executive engineer with British Telecom. Flew as a guest of the Royal Air Force in a Chinook, gathering airborne material in West Germany. Painted mainly landscapes and portraits until requested to paint a Lancaster. From then on his aviation paintings developed. Has work on exhibition in the Manchester Air and Space Museum, the Pentagon in Washington, the RAF Museum and in various locations and private collections. Has been influenced by British artists such as Terence Cuneo, Frank Wootten and David Shepherd.

Charles Leslie Lock

Born 15.6.1919. Studied art at Chiswick Polytechnic School of Fine and Commerical Art. Interest in aviation art was first inspired by a 'five-bob' flight in an Avro 504K, plus visits to Heston, Hanworth and Croydon aerodromes. Served with the Royal Air Force for twelve years as Armament Gunnery Instructor, in Bomb Disposal, and as an Explosives Inspector. Emigrated to the United States in 1951 and worked for United Airlines for twenty-five years. An accredited USMC Combat Artist. Paintings in USAF Art Collection, Naval Aviation Museum in Pensacola, US Navy Combat Art Collection, USCG Contemporary Art Programme, USMC Historic Art Collection, Colorado Aviation Historical Society, McClellan AFB Museum, The Ninety-Niners Museum in St Louis, Canadian Forces Base at Shearwater, No. 427 Squadron Canadian Forces, San Diego Aerospace Museum – Navy Carrier Exhibit, and the Smithsonian Institution. Published works in *Aerospace Historian Journal, American Aviation Historical Society Journal, AOPA Pilot Magazine, Airman Magazine, 75 years of USMC Aviation – a tribute.*

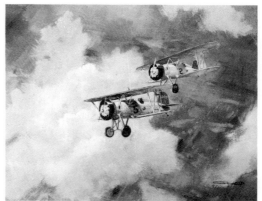

Maurice William Martin

Born 28.1.1920. Educated at grammar school and technical college. Chartered Engineer, MIMechE, MRAeS. Worked with Fairey Aviation, General Aircraft, Hawker Aircraft, Hawker Siddeley Aviation, British Aerospace. Flew as a passenger at every opportunity. Paints in watercolour, exhibiting at the Guildhall Gallery and the Royal Institute of Painters in Water Colours. Has been Honorary Secretary and Chairman of the Thames Valley Arts Club. Greatly influenced by Suffolk landscape painters, such as Leonard Squirrell. Also interested in classical music and delights in the company of his grandchildren.

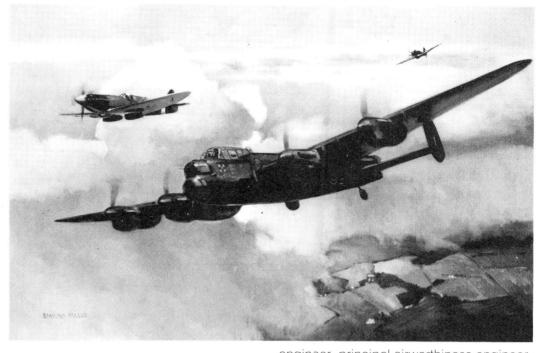

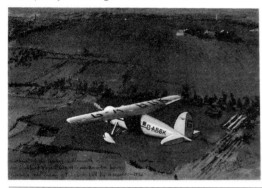

Edmund Miller GAvA

Born 5.7.1929. Educated at Sale Grammar School, and the Department of Aeronautical Engineering at Loughborough College of Technology. Awarded DLC, CEng, MRAeS. Served with the Royal Air Force during national service. Was structural design engineer with de Havilland Aircraft Company. Was senior airworthiness engineer, principal airworthiness engineer and now principal engineer with Hawker Siddeley Aviation. Interested in gliding, flying from Bristol and Cambridge. Chairman of the Guild of Aviation Artists 1983-85. Paintings on permanent exhibition at museums and in private collections. Influenced by Edward Seago, Frank Wootton and Terence Cuneo. Other interests include aviation history, vintage transport and portraiture.

Kenneth Alexander McDonough GAvA

Born 28.2.1921. Studied at Regent Street Polytechnic in 1938. Joined the army during the war 1941-46. Was the last regular artist on the *Illustrated London News*. His interest in model aircraft led to illustrating Airfix kits. Also designs greetings cards. Uses oil and gouache mediums. Greatly influenced by the Impressionists. His work is exhibited at the RAF Museum, Fleet Air Arm Museum, Brazilian Air Force Museum and Croydon Airport Society. His other interests include history, music and French literature.

Ernest John Moseling

Born 19.4.1931. Educated at the Royal Grammar School, Guildford, and the County Technical College. Served with the Royal Air Force during national service as an engine mechanic 1949-51. Flew solo in gliders as a cadet. Enthusiasm for aircraft was stimulated by the events of World War II. Paints in oil and gouache and particularly enjoys researching aviation history. Has paintings exhibited in a gallery in the United States. At present is a freelance mechanical engineering designer. Other interests include photography.

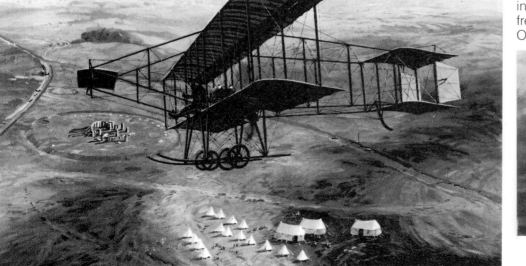

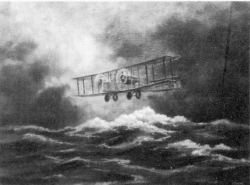

Frank Munger GAvA

Born 2.5.1920. Served with the Royal Air Force in Singapore during World War II and also with the Royal New Zealand Air Force in the South-West Pacific. On the basis of his technical knowledge and drawing ability joined the publishers of *Flight*, *Aircraft Production* and *Aeroplane Monthly* in 1945 as an editorial artist. Retired in 1985 after forty years in the industry. Elected Associate Member Royal Aeronautical Society 1974. Having joined the Kronfeld Art Society in the sixties, was a founder member of the Guild of Aviation Artists. Paints in oil and watercolour, but prefers the latter. Favours early aircraft in landscape settings with 'atmosphere'. Influenced mainly by Cotman, de Wint and the Impressionists. Has exhibited at a variety of exhibitions and galleries.

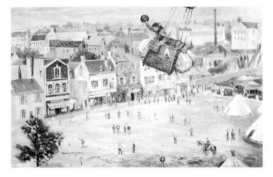

Roy Nockolds GAvA

1911-79. Started drawing at an early age, including Zeppelins as they flew over London. As a young man he was gripped by the excitement of motor sport and one of his first commissions was to illustrate a race, sitting by the track immersed in the smell of hot oil and tyres. Roy illustrated races in this way as far apart as Monte Carlo and Brooklands. At Brooklands, aviation subjects caught his interest as frail machines rose from the centre of the

track. During World War II he was an official war artist and invented several forms of camouflage as well as designing dramatic posters. He was later invited to paint the official Battle of Britain picture for the Royal Air Force. He was the instigator with Yvonne Bonham in founding the Kronfeld Aviation Art Society and also became a founder member, Trustee and Chairman of the Guild of Aviation Artists. Founder member and Chairman of the Brooklands Society, he was also Chairman of Farnborough District Motor Club. Roy was noted not only for his remarkable skills as an artist, but also for his enthusiasm for everything that he did.

Cedric de la Nougerede GAvA

Born 2.7.1934, Shillong, Assam, India. Studied at Brighton College of Art. Also obtained University of London Certificate in Field Archaeology. Member of the Institution of Engineering Designers. Served with the Royal Army Ordnance Corps during national service 1952-54. Became design draughtsman with Airwork. Chief draughtsman with the Mullard Space Science Laboratory of University College, London, working on experiments for rockets, satellites and space shuttle 1960-84. At present an aerospace design consultant. Has had work published in magazines and illustrated childrens' books. Works in a variety of mediums. Regularly exhibits watercolour paintings at the Sussex Gallery in Pulborough and Chichester. Influenced by Norman Rockwell and David Shepherd. Other interests include aero-modelling and archaeology, including reconstruction drawings for archaeological reports and of Roman villas.

Miles Patrick Terence O'Reilly GAvA

Born 4.5.1924, Calcutta, India. Educated at Ampleforth College, York. First interest in aviation was stimulated by Tangmere aerodrome in 1933, when still a schoolboy.

Served with the Royal Air Force as a navigator 1942-47. Joined BOAC in 1947, seconded to West African Airways Corporation, Nigeria, 1952-57 for flight operational duty. Executive with printing company 1958-81. Turned professional artist in 1981, specializing in local scenes portrayed in pen and ink. Paints mainly in watercolour and gouache. Has exhibited widely including RAF Museum, Fleet Air Arm Museum. Member of the Sherborne Art Society. Lectures on aviation art in local societies. Past Chairman of the Guild of Aviation Artists. Other interests include history and birdwatching.

John Charles Page

Born 3.4.1947. Served electrical apprenticeship on leaving school. Took various electrical inspection positions with Sperry Gyroscope and Sperry Engineering Labs (EMI). Since 1971 has been an avionics fitter with British Airways. Has thoroughly enjoyed flying a glider and was inspired to paint aircraft after visiting an exhibition of work by the Guild of Aviation Artists. Has been influenced by many artists including John Constable, Claude Monet, Frank Wootton and John Young. Exhibits with local art societies. Other interests include playing the lead guitar in rhythm and blues band, 'T Model Slim', landscape gardening and keeping fish.

Denis Richard Dalton Pannett GAvA

Born 7.9.1939. Educated at Uppingham. Was employed in the timber trade until national service 1960-62. Second Lieutenant Devon and Dorset Regiment. Served in Cyprus and North Africa. Became a diamond sorter and valuer for De Beers, and then a buyer of rough diamonds in West Africa. Latterly was Divisional Personnel Manager. Initially was taught watercolour painting by his mother, a well-known portrait painter, but has also been greatly influenced by Frank Wootton, Terence Cuneo, Edward Wesson, William Russel Flint and Edward Seago. Has often been involved in family shows with his mother, sister and aunt. Recently held a family exhibition in Hong Kong. Has had several one-man shows and exhibits in the Warwick Gallery and others throughout the home counties. Other interests include military history, tennis and travel.

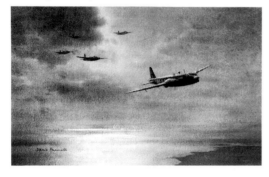

Harold Perrett

Born 20.8.1931. Attended St Martins Junior Art School in 1945. Mainly studio trained. Took a course in lettering at the Central School of Art. Served with the Royal Air Force 1950-52 becoming a Leading Aircraftsman. Worked in many fields including eight years as a packaging designer. Has been a freelance professional artist since 1968. Interest in

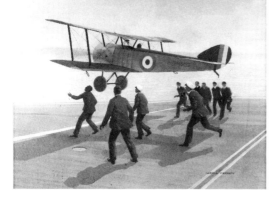

aviation art developed after moving close to Imperial War Museum, Duxford. Paints and illustrates architectural, industrial and aviation subjects. Early childhood drawings reflect city environment of London during World War II. Has exhibited with the Guild of Aviation Artists at the QANTAS Gallery, Gibraltar Arts Festival and Fleet Air Arm Museum. Has been influenced by Degas and Stanley Spencer and paints in a variety of mediums.

Brian Petch

Born 1.12.1936. Educated at Barton-upon-Humber Grammar School. Studied at Hull University, graduating in 1958 with a BSc (Hons) in zoology. Has since worked as a research scientist for a pharmaceutical company. His interest in aviation began during the war in Lincolnshire when, as a small boy, he was allowed to sit in the pilot's seat of a Lancaster bomber at a nearby airfield. Has exhibited with the Royal Society of British Artists, the United Society of Artists and 'Britain in Watercolour', and the Summer Exhibition of the Royal Academy. Is a member of the East Kent and Folkestone Art Societies. Had a one-man exhibition of paintings in Deal in 1986 followed by an exhibition in Folkestone in 1987. Paints in watercolour, acrylic and oil. Has been influenced by John Constable and David Shepherd. Other interests are mainly photography and classical music.

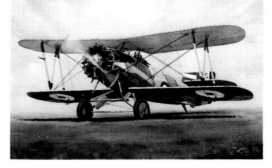

Harry Peters

Born 24.5.1920. Full-time painter in watercolour. Attended London Polytechnic School of Architecture, prior to becoming pupil to architect Paul Coleridge MC, FRIBA. Joined Royal Air Force Voluntary Reserve on outbreak of World War II, training as an air-gunner. On medical disqualification transferred to RAF Police. Crossed to Normandy on D-Day with 83 Group, 2nd

TAF. Remained with unit until termination of hostilities on Luneberg Heath, then employed on crime investigation duties in Germany and Denmark. Contact with Luftwaffe personnel led to continuing interest in their aircraft. After the war, joined Air Ministry Constabulary. Worked on many USAF bases, including Strategic Air Command at Brize Norton and 48th Tactical Fighter Wing, Lakenheath. Has progressed through surrealism and portraiture and finally settled with East Anglian landscape and aircraft painting. Has held many successful one-man exhibitions in Norwich and has work in private collections world-wide.

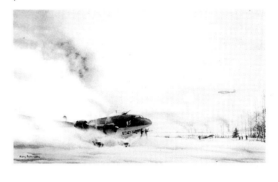

James Wilson Petrie GAvA

Born 23.11.1930. After leaving school at sixteen, he studied commercial art for two years. Additional tuition was provided by his father who was himself an artist. Became interested in aviation in the late thirties after visiting an air display at Tern Hill in Shropshire and the interest has never waned. Founder member of the Guild of Railway Artists. He is presently self-employed full-time as an illustrator, producing perspectives for architects, his main interests, aviation and railway art, having to take second place.

John Vincent Rayson GAvA

Born 22.8.1933. Educated at St Peter's School, York. Member of the Chartered Institute of Transport, Freeman of York. Served with the RAF during national service, commencing with crash rescue and finishing with maps, posters and signwriting. Connected with transportation for thirty-six years and now a professional artist. Influenced by the work of Frank Wootton. Exhibits annually at Yorkshire Air Museum, in which he has a great interest, devoting much time and work in fund raising. Paints in a variety of mediums and has been influenced by Graham Sutherland.

Roger Mark Steel GAvA

Born 26.8.1928. Educated at Churchers College, Petersfield. Served with the Royal Air Force during national service. Studied at Chelsea College of Art. Taught the rudiments of painting by his watercolourist grandfather and encouraged in draughts-manship by his naval architect father. Spent some time in the design department of Supermarine. Moved to Vickers-Armstrong Aircraft at Weybridge when the graphics department was formed in the early 1960s. Meanwhile his aviation paintings were in demand for boardrooms, service messes and by heads of airlines and air forces. Was involved with the Kronfeld Aviation Art Society, the Society

David Shepherd, Vice-President GAvA

Born in 1931, he was educated at Stowe. After leaving school in 1949, he went to Kenya in the hope of becoming a game warden. However, he failed in his ambition of the moment and was fortunate in meeting Robin Goodwin, the marine and portrait painter, who was able to tutor the promising young artist. David specialized in aviation and military subjects and in 1960 was guest of the Royal Air Force in Kenya. Painting the local wildlife inspired him and in 1962 his first exhibition of animal paintings appeared at the Tryon Gallery in London. Since then he has raised over a million pounds for wildlife conservation. In June 1975 he was able to establish three miles of track of his own East Somerset Railway at Cranmore, and is regularly seen on the foot-plate of 'Black Prince'. Although 'jumbos' are a favourite subject, his paintings range from aircraft to elm trees, from portraits of the famous to portraits of locomotives. He was appointed to the Order of the British Empire in 1979 and elected a Fellow of the Royal Society of Arts in 1986. Nothing daunts him and his energy and enthusiasm for his subjects and charitable causes seem boundless.

of Aviation Artists and was a founder member and first Chairman of the Guild of Aviation Artists. He is presently Personnel Manager for British Aerospace. His other interests include photography and sailing.

Robert Charles Taylor

Born 11.2.1946. Educated at Bath Art School. Became a picture frame-maker on leaving school, followed by picture restoring, working on all forms of art until 1977. Took up painting full-time, working mostly in oil on a wide variety of subjects including wildlife, marine and aviation. Many of his works have been published in thirty limited editions. Represented at the Fleet Air Arm Museum, Imperial War Museum, Australian War Memorial in Canberra, RAF Museum, San Diego Hall of Fame, Smithsonian Institute, Woolnorton and other museums and private collections throughout the world. Exhibited with the Society of Wildlife Artists and the Royal Society of Marine Artists. Influenced by the old Dutch school.

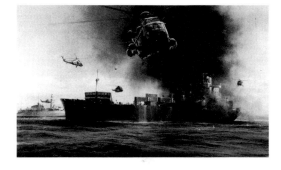

Charles John Thompson GAvA

Born 12.1.1931, Poona, India. Now retired after thirty-seven years with the Ford Motor Company. Joined as a trainee draughtsman with Briggs Motor Bodies which later became Ford. Junior 'stylist' in 1954, mainly responsible for first Cortina and

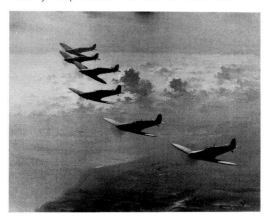

Corsair. Became executive designer 1964, and sent to Detroit, USA, for one year. In 1968 Ford Europe was formed and extensive commuting began between Dunton and Cologne. Served with the Royal Air Force during national service as an airframe mechanic SAC 1955-56. Founder member of the Guild of Motoring Artists. Experience at Ford developed his skills in the portrayal of man-made objects. Paintings on permanent exhibition in museums and private collections world-wide.

Ray Tootal GAvA

Born 29.7.1913. Studied at the Higginbottom School of Art, Ashton-under-Lyne. First employment was in a studio, and in 1934 went into advertising. During World War II he was an engineering draughtsman in the Daimler drawing office, working on Hercules engines. After the war, he returned to advertising, retiring as Art Director. On retirement, took to serious painting, specializing in aviation subjects, landscapes and portraits. His work is exhibited in the Manchester Air and Space Museum, Fleet Air Arm Museum, Derby Museum, Banqueting Suites at Manchester Airport, and in private collections including the Rolls-Royce Heritage Trust.

Michael Turner GAvA

Born 14.3.1934. Educated at the Lower School of John Lyon and spent a year at the Heatherley School of Fine Arts, London. Father was a keen amateur painter and mother was interested in motor cars. In 1947 went to a motor car race in the Isle of Man, which stimulated passion for motor sport. Already knowledgeable on World War II aircraft. Served with the Royal

Electrical and Mechanical Engineers during national service, attaining the rank of Sergeant and becoming a qualified marksman. Spent three years in advertising studios and became freelance in 1957. Electec member of Society of Aviation Artists and Industrial Painters Group. Exhibited with the Kronfeld Aviation Art Society. Founder member of the Guild of Aviation Artists and twice Chairman. Founder member of the Guild of Motoring Artists. Founder of International Racing Press Association. Member of the Guild of Motoring Writers. First-hand flying experience with the Royal Air Force, with fifteen aerobatic sorties with the Red Arrows in Folland Gnats. Flown in Lightnings, Jaguars, Hunters, a Nimrod, Battle of Britain Lancaster and a B29. Also flown in Tiger Moths and Harvards. Has had three books of his paintings and drawings published concerning respectively the Royal Air Force, the Luftwaffe, and Formula 1 motor racing. Illustrated many books and jackets, including a series for a French publisher. Started mail order publishing business in 1963, Studio 88, to market prints and cards of his paintings. Produced a pictorial history of the RAF in picture cards. Travels extensively to cover Formula 1 and major sports car races world-wide.

Paintings hang in the RAF Museum, Science Museum, Fleet Air Arm Museum, National Motor Museum, RAF Club, Brazilian Aerospace Museum, Society of Motor Manufacturers and Traders, and private collections. Five one-man shows in London and two in New York, and participated in a variety of specialist shows. Son Graham is following in his father's footsteps, painting motor sport and animals. Other interests include collecting military vehicles, aviation clothing and militaria, badminton, tennis and skiing.

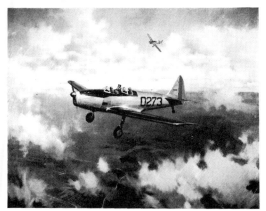

Valentine Alma Rosemary Vanstone GAvA

Born 14.2.1932. Educated at Richmond County School for Girls. Studied art at Hammersmith School of Building and Arts and Crafts. After working for George Newnes, became a freelance designer of toys, childrens' clothes, and craft subjects for national magazines. Had a design displayed in the Design Centre, Haymarket. Attended the first exhibition of the Guild of Aviation Artists on behalf of a local journalist. Became fascinated and

persuaded a test-pilot to show her over Concorde 002 at Fairford. Has since painted the subject several times, one painting being sent to Singapore. Has work exhibited in the RAF Museum, the New City Club, London, the RAF Regimental Headquarters and private collections world-wide. Paints mainly in oil and specializes in subjects portraying the early history of aviation. Greatly influenced by the French Impressionists and in particular Claude Monet. Other interests include breeding and showing Rough Collies.

Armstrong. Became a Fellow of the Royal Aeronautical Society. Career included a period of flight-testing Vanguards and VC10s as an observer and later, a three-year assignment to McDonnell Aircraft Company in the United States. Present position: Headquarters Director Projects with British Aerospace. First exhibited with the Kronfeld Aviation Art Society, winning special prizes. Has been influenced by the Norfolk School of landscape artists. Enjoys painting landscapes in oil direct. Other interests include photography and transportation.

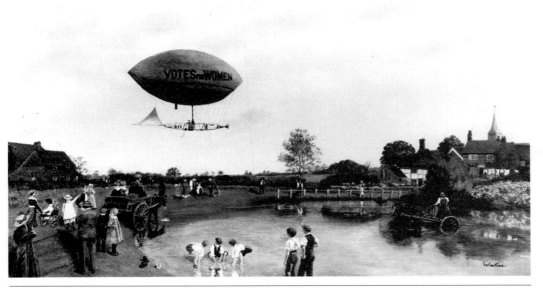

Brian Francis Withams GAvA

Born 2.9.1932. After leaving technical school, served with the Royal Electrical and Mechanical Engineers during national service 1951-53. Spent twenty-seven years as a design draughtsman and technical illustrator for various light engineering firms. Worked for six years in Canada for the British Aircraft Corporation/Hawkers on Avro Arrow. Also found time to become a driving instructor in Toronto. Fascinated by aircraft from childhood, he joined the Kronfeld Aviation Art Society in 1962. Founder member of the Guild of Aviation Artists. Paints in oils and has work exhibited in the Fleet Air Arm Museum, Brazilian Air Force Museum and private collections. Has clients as far afield as Alaska. Other interests include golf and he is also a qualified NSRA Rifle Instructor.

Claude William Ernest Waller GAvA

Born 22.12.1915. Educated at Hampton Grammar School. On leaving school, he joined Hawker Aircraft, working on Furies and Harts, followed by employment as an airframe fitter with the Hendon Aircraft Company, building such aeroplanes as the Phoenix and the Heston Napier Racer to attack the world speed record. Unfortunately, the latter crashed on landing from its first and only flight. Whilst working at Heston, he saw Neville Chamberlain leave and return (in a British Airways Lockheed 14) on his historic visit to Hitler. He volunteered for the RAF and was finally called up in 1943 and put on General Duties. During the war he was engaged on Spitfire repairs, in the course of which an accident destroyed the sight of one eye. After a brief spell at Heston after the war, he went to the British Aircraft Corporation, Weybridge. His first flight was in an Avro 504K at the age of eleven, and he learned to fly with the Civil Air Guard at Heston. Managed to study at the City of

York Art School whilst in the RAF, but started to paint in earnest whilst with BAC, having worked on all aircraft types from Varsity to Concorde. Has been influenced by Frank Wootton.

Colin John Wilson GAvA

Born 9.12.1939. Educated at Ottershaw School. Was encouraged to take Advanced level Art whilst sitting Ordinary level examinations and passed. Took an engineering apprenticeship with Vickers-

Ronald Wong GAvA

Born 15.11.1940, Shanghai, China. Educated in Hong Kong and a United Kingdom Polytechnic, obtaining a BSc (Hons) in biochemistry. Studied art at evening classes. After working as a Scientific Officer and Information Officer became a full-time painter. Has flown in light aircraft and gliders. Aviation is only one of the many subjects covered by this painter's brush. Work has been exhibited with the Royal Society of Marine Artists, Society of Wildlife Artists, Guild of Motoring Artists and in galleries.

Keith Woodcock

Born 19.4.1940. Educated at Belle Vue Grammar School, Bradford, and Salford College of Art. After pursuing a career in industry, became a freelance graphic designer and illustrator in 1969. A lifelong enthusiasm for aircraft persuaded him to devote his entire time to aviation art in 1982. Gained *par excellence* award at the 1985 Oshkosh International Aviation Art Competition in the United States. Won the award for the Aviation Painting of the Year 1986 sponsored by Davis Gibson Advertising. Paints in both gouache and oil and regularly produces aviation art for publishers in Europe and the United States for use as prints, book jackets, cards and illustrations for magazines and books. Oil paintings are owned by the Royal Air Force, aviation companies and private collectors at home and abroad.

Frank Wootton, President GAvA

Scholarship student of the Eastbourne College of Art. Awarded the Travelling Scholarship and Gold Medal. Worked as a freelance artist in London and New York. Volunteered for the Royal Air Force in 1939. Immediately engaged by Director of Public Relations to record the work of the RAF at Odiham, Digby, Waddington, Biggin Hill, etc.

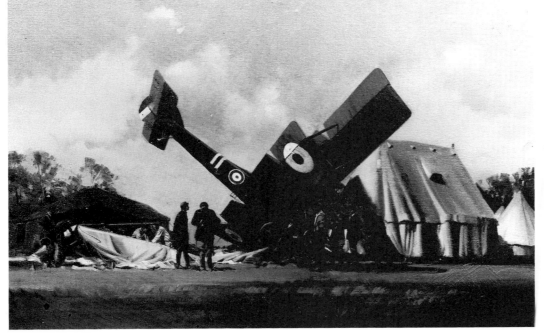

1944 summoned to supreme Headquarters by Commander-in-Chief, Sir Trafford Leigh Mallory, and invited to paint the war in France. Commissioned as an official war artist, RAF. Flew to Normandy and painted glider landings, air reconnaissance, ground defences, maintenance in the field, Typhoon rocket attacks at Falaise. Shot down over the English Channel. Returned to England. Invited to paint the war in the Far East by the Commander-in-Chief. Flew to India and Burma. After VJ day in 1945 held an exhibition of works at Headquarters South East Asia Command at Kandy, Ceylon.

Since the war has flown round the world painting for BOAC and RAF. Exhibitions in London, New York, Washington, Paris. Work purchased for permanent collections in Washington, New York, Ottawa, Canberra and Great Britain. Freeman of the Guild of Air Pilots and Air Navigators 1987. Publications: *The Aviation Art of Frank Wootton* (Peacock Press New York). *At Home in the Sky* (Smithsonian Press, USA).

William John Young GAvA

Born 2.6.1930. Educated at the Royal Grammar School and the School of Art at High Wycombe, Buckinghamshire. Has painted since 1950, following service in the Royal Air Force. His enthusiasm for aviation was fired by a visit from Sir Alan Cobham's Flying Circus to his neighbourhood in 1934. Units of the US 8th Air Force arrived in nearby Bovingdon during World War II, and he developed a style of painting which combined portrayal of technical subjects with natural, atmospheric situations. Established a career in illustration for many major industrial manufacturers, airlines, air forces and publishers. He became a freelance artist in the early sixties, expanding towards fine art. He exhibited in the inaugural exhibition of the Society of Aviation Artists. Chairman of the Kronfeld Aviation Art Society. Founder member of the Guild of Aviation Artists and was awarded the Guild Medal in 1983. Chairman of the Guild 1987. Long association with the RAF has taken him around the world. Forty-five of his paintings are in the RAF Museum. He has painted murals for airline offices in Nairobi, Santiago, Buenos Aires and Rio de Janeiro. His work hangs in museums of the Royal New Zealand Air Force and the Brazilian Air Force and another painting, of the Singapore Airlines hangar at Changi, was presented to the government of Singapore. He has flown in nearly sixty types of aircraft to such places as Gan, Kashmir, Tashkent and Moscow, over Vietnam and to Aden and Malaysia in a continual study of aviation and its history.

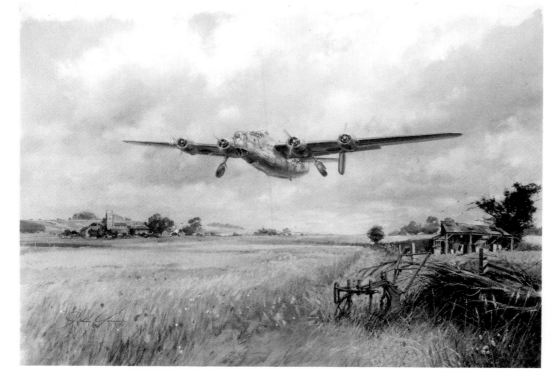

Index of people

Adam, Flight Lieutenant 49
Ader, Clement 18
Agello, Lieutenant Francesco 49, 51
Alcock, Captain John 47
Allen, Bryan 129
Anderson, Captain O.A. 49
Andrée, Salomon 13
Appleton, Norman W. GAvA 29, 133
Arnold, General H.H. 82
Asboth 63
Ashford, Colin J. GAvA 55, 104, 133

Ball, Captain Albert 26
Barés, Commandant 26
Barrington-Kennet, Lieutenant 25
Batten, Jean 49
Béchereau, Louis 26
Bellonte, Maurice 49
Betz, Dr 97
Bienvenu 102
Birgkit, Marc 26
Bist, Derek Stredder GAvA 101, 133
Blake, John H. GAvA 17, 95, 129, 133
Blanchard, Jean-Pierre 13
Blériot, Louis 20, 24, 129
Boeing, William 45
Boelcke, Oswald 26
Boland, Adrienne 48
Bonham, Yvonne 140
Bonnet, Adjutant 48
Borelli 13
Bossoutrot, Lucien 48
Bradbury, Charles GAvA 63, 134
Brancker, Sir Sefton 126
Braun, Werner von 97
Bréguet, Louis 22, 63, 102, 103
Brown, Lieutenant Arthur Whitten 47
Brown, Captain Roy 28
Brown, Lieutenant Russell 97
Burnside, Group Captain Dudley H. GAvA 58, 108, 134

Cabral, Captain 48
Campbell Black, T. 51
Carmichael, Lieutenant 100
Carter, President James 122
Castoldi, Mario 51
Cavallo, Tiberius 13
Cave-Brown-Cave, Group Captain 41
Cayley, Sir George 13, 102
Chadwick, Roy 86
Chamberlain, Neville 60, 64, 144
Chanute, Octave 20
Charles, Professor 13
Churchill, Winston 34
Clark, Lieutenant-Commander 120
Cobham, Sir Alan 126, 134, 146
Cody, Colonel Samuel 21
Columbus, Christopher 20

Coolidge, President Calvin 44
Coote, Charles GAvA 37, 134
Cornu, Paul 63, 102
Costes, Dieudonné 49
Coulson, Gerald D. GAvA 42, 79
Coupet, Louis 48
Coutelle, Captain 13
Couthino, Vice-Admiral 48
Coxwell, Henry 13
Cuneo, Terence, Vice-President GAvA 46, 118
Cunningham, Lieutenant A.A. 44
Curtiss, Glen 21, 44, 51

d'Arlandes, Marquis 13
d'Ascanio 63
da Vinci, Leonardo 13, 63, 102
de Havilland, Geoffrey 22, 34, 51, 126
de la Cierva, Juan 63, 103
de la Nougerede, Cedric GAvA 69, 140
de la Vaulx, Compte 13
de Rose, Commandant 26
de Rozier, Pilâtre 13
Degen 102
di Bernardi, Commandant 51
Dickson, Captain Bertram 22
Diggens, Rodney I. 54, 135
Doenitz, Admiral Karl 70, 76
Doolittle, General James 39, 51, 95
Dorand, René 103
Douglas, Donald 45, 62
Douglas, Penelope GAvA 115, 121, 135
Dowding, Air Marshal Sir Hugh 35, 66
du Temple, Felix 18
Dunning, Flight Commander 31

Eaker, Brigadier-General Ira 51, 82
Edwards, Sir George 107
Ellehammer, Jacob 102
Ellyson, Lieutenant T.G. 44
Ely, Eugene 21, 44

Fairey, John 43
Fairey, Sir Richard 43
Farman, Henri 20, 21, 24
Fearnley, Alan GAvA 41, 75, 135
Fisher, Lord 24, 30
Flettner 63
Focke, Professor 63
Fokker, Anthony 26, 44
Folland, Henry 26
Franco, Generalissimo 38, 39
Fraser, Theodore G. 48, 136
Fresson, Captain E.E. 35

Galland, General Adolph 96
Galpin, Flight Lieutenant 29
Gardner, Maurice V. 84, 86, 136
Garros, Roland 26
Giffard, Henri 16

Gilbark, Maurice 43
Glaisher, James 13
Goering, Reichsmarschall Hermann 64, 66
Greig, Flight Lieutenant d'Arcy 50
Grieve, Commander MacKenzie 47
Griffith, Doctor 96
Gromov, Colonel 49
Guynemer, Georges 26

Hafner, Raoul 63
Halfpenny, Richard G.L. 39, 136
Hall, John 43
Halsey, Admiral William 92, 93
Hardy, Wilfred R.R.H. GAvA 117, 136
Hargrave, Lawrence 20
Harold, Anthony C. 92, 136, 137
Harris, Air Chief Marshal Sir Arthur 64, 75, 79
Hawker, Harry 34, 47
Heinkel, Ernst 96
Hellings, John GAvA 65, 86, 137
Henshaw, Alex 49
Hinkler, Bert 49
Hitler, Adolf 60, 66, 67, 144
Hoad, Air Vice-Marshal Norman GAvA 112, 113, 137
Holman, Charles 51
Hooker, Howard 28, 137

Ilyushin, Sergei 44
Immelmann, Max 26

Jacquin-Thouvenot 64
Jeffries, Dr John 13
Johnson, Amy 49
Jones, Richard GAvA 30, 128, 137
Joseph, Graham 36
Joseph, John 36
Joseph, Michael GAvA 36, 126, 138

Kahn, Margaret GAvA 127, 138
Kahn, Wally 138
Kelly, Lieutenant O.G. 42, 48
Kelly-Rogers, Captain J.C. 58
Kidston, Lieutenant-Commander Glen 62
Kingsford-Smith, Air Commodore Sir Charles 48
Kinkhead, Flight Lieutenant S.M. 50
Kohnert 17
Knight, Brian GAvA 26, 138
Krebs 16
Kronfeld, Robert 127, 129
Kurita, Admiral 92

Latécoère, René 55
Launoy 102
Le Bris, Captain Joseph 18
Lea, Geoffrey 102, 138
Lebaudy brothers 16
Leckie, Flight Sub-Lieutenant 29

Leckie-Thompson, Squadron Leader T. 118
Lecointe, Sadi 49
Leigh Mallory, Sir Trafford 145
Lenoir, John Joseph 20
Lilienthal, Otto 20
Lindberg, Colonel Charles 48, 49, 60, 95, 126
Lloyd-George, David 34
Lock, Charles 45, 61, 138
Lomonosov 102
Longmore, Air Vice-Marshal Sir Arthur 77
Lord, Flight Lieutenant 86
Loughead, Allan 62
Lowe, Thaddeus 13

MacArthur, General Douglas 82, 90, 97
Mach, Dr Ernst 97
Macready, Lieutenant 42, 48
Martin, Glenn 76
Martin, Maurice 62, 139
Maxim, Hiram 18
McDonough, Kenneth GAvA 22, 52, 139
McKay, Stuart 36
Miles brothers 105
Miller, Edmund GAvA 35, 98, 139
Mitchell, Reginald J. 41, 42, 50, 51
Mitchell, General William 32, 34, 39, 49, 93, 95
Moffett, Captain W.A. 45
Mollison, Amy 51, 137
Mollison, James 49, 51
Montgolfier brothers 13
Morane, Léon 22
Moseley, Major 48
Moseling, Ernest 47, 139
Moyes, Philip 100
Mozhaiski, Alexander 18
Munger, Frank GAvA 16, 21, 140
Mussolini, Benito 67
Mussolini, Bruno 50

Nagumo, Admiral 78, 90
Nation, Lieutenant-Commander Barry 70
Nesterov, Captain 26
Nimitz, Admiral Chester 90
Nockolds, Roy GAvA 77, 80, 140
Northrop, John K. 61, 62
Nungesser, Charles 26

Oemichen, Etienne 63, 102, 103
Ohain, Hans-Joachim Pabst von 96
Olieslagers, Jan 25
O'Reilly, Miles GAvA 71, 140
Orlebar, Squadron Leader A.H. 51
Ozawa, Admiral 92, 93

Page, John 50, 140
Painlevé, M. 21

Pannett, Denis GAvA 78, 105, 141
Park, Air Vice-Marshal Keith 66
Peirse, Air Marshal Sir Richard 94
Pelletier d'Oisy, Captain 48
Perrett, Harold 31, 141
Pescara, Marquis 63, 103
Petch, Brian 43, 141
Peters, Harry 68, 141
Petrie, James GAvA 109, 141
Pezzi, Lieutenant-Colonel 49
Phillips, W.H. 102
Piccard, Professor Auguste 49
Pierson, Rex 78
Pilcher, Percy 20
Piper, William 127
Pitcairn, Gerald 63
Pixton, Howard 22
Platz, Reinhold 54
Popham, Hugh 70
Post, Wiley 49, 62
Prévost, Maurice 22, 50
Price, Alfred 75

Rayson, John GAvA 82, 142
Read, Lieutenant-Commander 47
Reagan, President Ronald 123
Renard 16
Richet, Professor 102
Rickenbacker, Captain Eddy 31
Richthofen, Freiherr Manfred von 26, 28
Richthofen, Generalmajor 66
Robert, Professor 13
Roe, A.V. 22
Rogers, Commander John 44
Rolls, Hon. Charles 14
Rommel, Field Marshal Erwin 78
Roosevelt, President Franklin D. 42
Roosevelt, President Theodore 20
Rose, Tommy 138
Rutan, Burt 129
Rutan, Richard 129

Santos-Dumont, Alberto 20
Saulnier, Raymond 26
Schroeder, Major R.W. 48, 49
Schubert 26
Scott, C.W.A. 51
Seeckt, General Hans von 38
Seguin brothers 21
Selfridge, Lieutenant 21
Shepherd, David, Vice-President GAvA 107, 142
Short brothers 20, 24
Sikorsky, Igor 43, 63, 103
Smith, Lieutenant Keith 47
Smith, Captain Ross 47
Somerville, Admiral 80

Sopwith, T.O.M. 24, 34
Spaatz, Major-General Carl 82, 121
Spruance, Admiral Raymond 90
Stainforth, Flight Lieutenant 51
Steel, Roger GAvA 116, 142
Stevens, Captain A.W. 49
Student, Colonel-General Kurt 67

Takagi, Admiral 90
Tank, Kurt 68, 97
Taylor, John W.R. 100
Taylor, Robert 120, 143
Thelen 26
Thompson, Charles GAvA 67, 124, 143
Tissandier brothers 16
Tootal, Ray GAvA 110, 143
Townsend, Flight Lieutenant 86
Trenchard, Major-General Sir Hugh 26, 29, 32, 34, 93
Tupolev, Andrei 44
Turner, Michael GAvA 81, 143
Turner, Roscoe 49, 51

Vandenburg, General Hoyt 121
Vanstone, Valentine GAvA 14, 18, 144
Veranzio 13
Voisin brothers 20
Vought, Chance M. 45, 93

Waghorn, Flying Officer H.R.D. 50
Waller, Claude GAvA 60, 144
Wallis, Sir Barnes 78, 86
Webster, Flight Lieutenant S.N. 50
Wendel, Flugkapitan Fritz 49
Wever, General Walter 68
Wheeler, Air Commodore Allen 37
Whitten-Brown, Lieutenant Arthur 47
Whittle, Air Commodore Sir Frank 92, 96
Wilkins, Sir Hubert 48
Wills, Philip 129
Wilson, Colin GAvA 122, 144
Wingate, Major-General Orde 94
Withams, Brian GAvA 70, 93, 144
Wong, Ronald GAvA 125, 145
Woodcock, Keith 56, 88, 90, 145
Wootton, Frank, President GAvA 32, 77, 91, 145
Wrangel, General 43
Wright brothers 20, 21, 24, 49

Yamamoto, Admiral 90, 91
Yeager, Captain Charles 97, 113
Yeager, Jeana 129
Youmachev, Commander 49
Young, John GAvA 25, 72, 76, 146

Zeppelin, Ferdinand Graf 16

Index of aircraft

Aérospatiale Puma 102
Airbus A300 110
—A310 110
—A340 110
Airships:
 Akron 63
 Astra 24
 Astra-Torres 24
 Clement-Bayard 24
 Chalais-Meudon 24
 Dixmude (L72) 62
 Goodyear 63
 Gross-Basenach 24
 La France 16, 18
 Le Jaune 16
 Lebaudy 24
 Los Angeles (LZ126) 63
 Macon 63
 Mediterranée 62
 North Sea 24
 Parseval 24
 R34 47
 R38 63
 R100 63
 R101 63
 Schutte-Lanz 24
 Shenandoah 63
 Spencer No 3 63
 Willows 24
 Zeppelin 17, 18, 24, 30
 Graf Zeppelin 55
 Graf Zeppelin II 56
 Hindenburg 55, 56, 62
 L22 29
 L72 (*Dixmude*) 62
 LZ 126 (*Los Angeles*) 63
 Zodiac 24
Albatros DI 26
—DII 26
—DIII 26
—DV 28
ANT-25 49
 —G-2 69
Arado Ar 234 96
Armstrong-Whitworth Argosy 115
—Atalanta 52
—Ensign 52
—Whitley 37, 64, 77
Auster 100
Aviatik CI 26
Avro 504 32, 44
—Baby 49
—Lancaster 79, 80, 81, 86, 91, 98, 104
—Lancastrian 101
—Lincoln 100, 112, 113
—Tudor 101
—Vulcan 113, 118
—York 101

BAC/Aérospatiale Concorde 110
Beech 127
Bell P-59A Airacomet 96
 —X-1 97, 113
Bernard-Ferbois racer 48
Blackburn Buccaneer 115, 116
Blériot XI 21, 25
—165 52
Blohm and Voss Ha 139 60
Boeing 247 51, 61, 62
—314 60
—707 108
—727 108
—747 108, 109
—757 109
—767 109
—B-9 42, 61
—B-17 Fortress 42, 43, 72, 82, 86, 90
—B-29 Superfortress 44, 95, 97, 100, 108
—B-47 Stratojet 108, 122
—B-50 Superfortress 108
—B-52 Stratofortress 122, 123, 129
—C-97 101
—C-135 108
—Chinook 120
—F4B-4 45
—Mailplane 60, 61
—Monomail 61
—P-12 45
—P-26 42
—XB-15 60
—XB-29 95
—XB-47 108
Boeing-Stearman PT-17 42
Breguet XIX 48, 49
—280T 52
Bristol Beaufighter 86, 94, 100
—Blenheim 37, 64, 66, 71, 76, 77, 80, 82
—Boxkite 22
—Brigand 100
—Britannia 115
—Fighter 35, 128
—Freighter 101
British Aerospace EAP 123
—Gnat 108
—Hawk 108, 109
—Jet Provost 109
Brokker 128

Caproni 38
Casa 44
Caudron G III 48
Cessna 127, 128
Chanute gliders 20
Charlière balloons 13
Cierva C 6A 63, 103
—C 8L 103
—C 30 103

Consolidated Catalina 71
—B-24 Liberator 71, 72, 75, 82
Convair B-36 122
—B-58 Hustler 121, 122
—Liner 107
Curtiss Condor 61
—H12 29
—Hawk 75 64
—JN-4 32
—June Bug 21
—Kittyhawk 78
—Pusher 21, 26
—PW-8 51
—R3C-1 51
—R3C-2 39
—Racer 49
—Seaplane 21

Dassault-Breguet Mirage III 118
—Rafale 123
—Super Etendard 118, 120
de Havilland 2 26
—DH4 29, 31, 39, 44
—DH9 46
—DH9a 35, 46
—DH10 35
—DH88 Comet 51
—DH106 Comet 105, 107, 108, 115
—Dragon 35
—Dragon Rapide 35
—Gipsy Moth 37
—Hornet 100
—Mosquito 82, 86, 100
—Moth 36, 49, 126, 127
—Sea Hornet 101
—Tiger Moth 37
—Vampire 100
—Venom 100
Deperdussin racer 22, 50
Dornier Do 17 64, 80
—Do 19 19, 68
—Do 26 60
—Wal 56
Douglas AD-1 Skyraider (SPAD) 100, 103, 123
—B-26 Invader 97
—Boston 78, 86
—C-54 97, 100, 101, 103
—C-74 101
—Dauntless 90
—DC-1 62
—DC-2 51, 54, 60, 61, 62, 68, 108
—DC-3 (Dakota, C-47, R50) 60, 62, 86, 87, 94, 100, 101, 103, 104, 108, 123
—DC-4 103,104
—DC-6, 6B 104, 105, 108
—DC-7, 7C 105, 108
—DC-10 109
—DST 62

—Skyhawk 117, 120
—World Cruiser 48

Elliots of Newbury 126
Enchantress balloon 14
English Electric Canberra 76, 100, 110, 113, 115, 118
—Lightning 115, 116
Explorer II balloon 49

Fairchild Argus 24W 69
—C-82 101
—C-119 123
—C-123 123
—Cornell 81
Fairey Albacore 75
—Battle 37, 64, 66, 80
—Firefly 94, 100
—Flycatcher 43
—Fulmar 70, 94
—Gannet 120
—Seaplane 48
—Swordfish 75
Farman Boxkite 22
—Goliath 48
Focke-Wulf Fw 61 103
—Fw 190 97
—Fw 200 68, 69, 70
Fokker D VII 28, 128
—Dr I 28
—E III 26
—F II 52
—F VIIB/3m 48, 54, 61, 62
—T-2 42, 48
Ford Tri-Motor 51, 61
Friedrichshaven FF 8 17

General Aircraft Monospar 35
General Dynamics F-16 125
—F-111 123, 125
Gliders, general 126, 127
Gloster G40 (E.28/39) 92, 96
—Gladiator 76, 77
—Meteor 96, 97, 112
Grumman A-6 123
—Avenger 94
—F9F Panther 100
—Hellcat 94
—Martlet/Wildcat 70, 71, 75
—X-29 123

Halberstadt DII 26
Handley Page Halifax 78, 79, 80, 81, 101
—Halton 101
—Hampden 37, 77
—Harrow 58

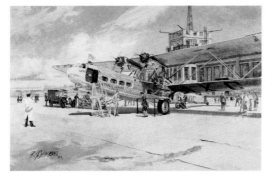

—Hastings 101
—Heracles 54
—O/100 29
—O/400 30
—Victor 113
Hawker Harrier 117, 118, 120, 122
—Sea Harrier 117, 118, 120
—Hunter 97, 108, 115, 118
—Hurricane 38, 64, 66, 70, 77, 78, 86, 98
—P1127 117
—P1154 112
—Sea Fury 100, 101
—Tornado 91
—Typhoon 86, 91
Heinkel He 51 79
—He 111 64, 80
—He 178 92, 96
—He 280 92
Helicopters, early 63, 102

I-15 44, 68
I-16 44, 68
IDI Dagger 118
Ilyushin Il-2 69
—Il-10 97
Imp balloon 14

Junkers F13 52, 54, 55
—JL-6 55
—Ju 52/3m 39, 44, 54, 55, 62, 66, 69
—Ju 87 66
—Ju 88 71
—Ju 89 68
—W33 49

Laird Solution 51
—Super Solution 51
Laird-Turner 51
Latécoère 631 60
Lepère-LUSAC 48
Lilienthal gliders 20
Lioré et Olivier 45 (LeO 45) 64
Lioré et Olivier H-49 60
Lockheed 14 60
—Alpha 61
—Altair 51, 61
—C-121 101
—Constellation 104, 105, 108
—F-104 Starfighter 123
—Hercules/C-130 115, 118, 121, 123
—Hudson 64
—Orion 51, 61
—P-38 Lightning 86
—P-80 (F80) Shooting Star 96, 97

—SR-71 124, 129
—Starlifter 123
—Super Constellation 105
—Tristar 109
—V-2 124
—Vega 49, 62

Macchi M 52 51
—M 72 51
Martin B-10 42
—B-26 Marauder 76, 90
B-57 76, 123
McDonnell F2H Banshee 100
—FD-1 Phantom 100
McDonnell-Douglas A4D Skyhawk 117
—AV-8A 117, 122
—AV-8B 117, 122
—F4 Phantom 112, 115, 116, 123
McReady *Gossamer Albatross* 129
Messerschmitt Bf 108 50
—Bf 109 50, 64, 65
—Bf 110 66
—Bf 209 49
—Me 163 96
—Me 262 96, 97
MiG-15 97, 100, 112
—-21 123
—-25 Foxbat 124
—E-266 129
Miles Gemini 105
Montgolfière balloons 13
Morane-Saulnier 26

Naval Aircraft Factory PN-9 44
Navy-Curtiss NC-4 47
Nieuport 11 26
—17 26
Nieuport-Delage racer 49
North American B-25 Mitchell 95
—B-70 122
—F-82 Twin Mustang 97
—F-86 Sabre 97, 100, 122
—F-100 Super Sabre 122, 123
—FJ-1 Fury 97
—Harvard 64, 97, 100
—P-51 (F-51) Mustang 82, 86, 88, 89, 90, 96, 97

Panavia Tornado 110, 116
Percival Gull 49
—Mew Gull 49
Pilcher, gliders 20
Piper Cub 97, 127
—Pacer 100
Potez 633 64
PZL Karas 65
—Los 65
—P7 65
—P11 65

R-1 44
R-5 44
Republic F-84 Thunderjet 97
—F-105 Thunderchief 123
—P-47 Thunderbolt 86, 94, 100
Rockwell B-1 122, 123
Royal Aircraft Factory RE 8 32
—SE 5a 26, 28
Rutan Voyager 129

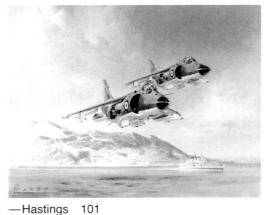

Savoia-Marchetti SM 79 50, 77
—SM 81 77
SB-2 44
SEPECAT Jaguar 110, 116
Short 184 30
—C-class Empire 58, 60
—G-class 58
—Stirling 37, 79, 80, 81
—Sunderland 38, 71, 79, 100, 101, 104
Sikorsky bomber (Ilya Mourometz) 43
—S-61B 120
—VS-300 63, 103
—VS-316A 103
Slingsby 126
Sopwith Atlantic 47
—Camel 26, 28, 30, 38
—fighters 22
—Pup 26, 31, 38
—Snipe 35, 36
—1½ strutter 26

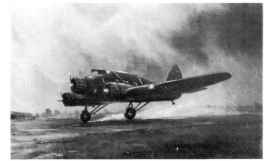

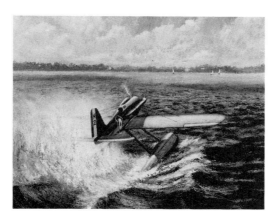

SPAD VII 26
—XIII 26
Stearman PT-13 42
—PT-17 42, 81
Stinson A 61
Supermarine S4 39, 50
—S 5 50
—S 6 51
—S 6B 51
—Seafire 94, 100
—Southampton 41
—Spitfire 38, 51, 64, 66, 67, 78, 86, 94, 97,
 98, 100

Vickers Valiant 113
—VC-10 115
—Vernon 35

—Viking 107
—Vimy 35, 47
—Viscount 107
—Wellington 77, 78, 80, 104, 107
Voisin 26
Vought Corsair 93, 94, 100

Westland Gazelle 102
—Lynx 102, 116
—Lysander 64
—Sea King 116, 117, 120
—Wasp 116
—Wessex 116, 120
Wright Flyer 14, 20, 21, 24
—glider 20
—Type A 21

Yakovlev Yak-9 97

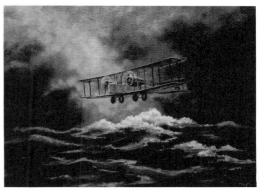